The life stories

of undistinguished

Americans as told

by themselves

The life stories
of undistinguished
Americans as told
by themselves

EXPANDED EDITION

Hamilton Holt

✧

WITH A NEW INTRODUCTION BY

Werner Sollors

Routledge, New York & London

Published in 2000 by

ROUTLEDGE
29 West 35th Street
New York, NY
10001

Published in Great Britain by
ROUTLEDGE
11 New Fetter Lane
London EC4P 4EE

☼

10 9 8 7 6 5 4 3 2 1

Library of Congress Cataloging-in-Publication Data

The life stories of undistinguished Americans as
told by themselves / edited by Hamilton Holt ;
with a new introduction by Werner Sollors.
—Expanded ed.
p. cm.
Includes bibliographical references.
ISBN 0-415-92510-X (bpk.)
1. Minorities—United States Biography.
2. United States Biography. 3. United States—Ethnic
relations. 4. United States—race relations. I. Holt,
Hamilton, 1872–1951.
E184.A1L52 1999
920.073
[B]—DC21 99-29904
CIP

TABLE OF CONTENTS

INTRODUCTION
by Werner Sollors

AMERICANS ALL! shouted the slogan of a famous poster of the last century. Who were these "Americans" of a hundred years ago? How can we get a sense of the many kinds of lives that native-born and immigrant men and women of different races and classes lived in this country? Few single books give us as vivid a picture of life in the United States as does the remarkable collection *The Life Stories of Undistinguished Americans As Told by Themselves*, originally put together by the reformist newspaper editor Hamilton Holt in 1906. In the brief autobiographies he collected, "lifelets" as they are here called, we hear the voices of immigrants from many lands, including not only European countries but also Syria, China, and Japan, as well as African American, Native American and Anglo-American stories of success and failure, of dreams and harsh realities, of saving and spending, of progress and loss. Their pasts go back to four continents; and their futures are not all tied to that of the United States.

Holt was the editor of the New York *Independent*, to which he gave a slant toward issues of "labor, social and government reforms, . . . politics, socialism, women's rights, simplified

spelling, immigration, race relations, birth control, and journalism," as his biographer put it, issues many of which have remained pressing to this day. In his journal, Holt wanted to let the common men speak, and he used the term "undistinguished" as a badge of honor in the collection that he drew from contributions to the *Independent*. His team of journalists looked for "average" and representative people in order to get answers to such questions as, where do you come from? if you were not born here, then why, when, and how did you come to America? are you better off or worse than you were in the past? what is your job? how much money do you make? what house do you live in? how do you spend your day? what are your pastime activities? and, are you happy?

The answers are touching and fascinating, and they go far beyond the sociological information they also provide, as bootblack and sweatshop worker, cook and nurse girl, butcher and businessman, peddler and minister, farmer's wife and peon speak or write about their lives, giving readers a strong sense of individual characters. The language of the lifelets ranges from native English expression to rich traces of translated sensibilities. More than fulfilling Holt's intention to present a "complete picture of America in all its strata," these lifelets give us glimpses of individual hopes and aspirations and of setbacks, of triumph and of despair, of happiness in America as well as of the wish to find it elsewhere.

Holt's book opens with Antanas Kaztauskis, a Lithuanian refugee from Russian oppression who works in the brutal Chicago stockyard and joins a union, and ends with the Chinese merchant's wish to return from New York's Chinatown to his native village in China: Lee Chew even draws a map of his father's house. The American Indian Ah-nen-la-de-ni is prevented at his Pennsylvania school from expressing himself in the only language he knows; and the African American experiences the hell of a Georgia peon camp. The farmer's wife in Illinois has to struggle against an overwhelming workload and her husband in order to be able to even begin to follow her calling as a writer; and the itinerant Southern Methodist minister pursues his career against the physical handicap of his defective eyesight. Nothing is more telling than the sweatshop worker Sadie Frowne's understated and almost casual remark: "Where the needle goes through the

nail it makes a sore finger, or where it splinters a bone it does much harm." Even the financially most successful immigrant autobiographers do not generally idealize America: the peddler remembers the flavor of fruit in Greece and mentions a ten percent reemigration rate; and the dressmaker knows that there is only one Paris and is looking forward to the voyage that will take her back to France. Yet in a harsh world that is hardly idealized in this book, there is also fun and leisure, and we hear of fortune tellers, cafés, the theater, picnics, or concerts, and again and again of Coney Island—where, however, the Igorrote chief is on display, brought to America from the recently conquered Philippines, and thus serves as a reminder of the stark inequality that is present even in the world of entertainment. And this is not the only instance of social tension among the various Americans who speak here: they belong to different classes, so much so that a part of the Greek peddler's income could have completely saved the African American from peonage: and because of their differences in culture, religion, and language they measure each other by incompatible yardsticks and at times look at each other with skeptical and biased eyes—as "foreigners" or "devils," "red haired savages" or "infidels." Is the freedom, is the growing wealth, of some Americans bought at the expense of the oppression and declining fortunes of others? the reader may ask—and find that, indeed, some "undistinguished" Americans directly respond to the lifelets of others. This was not only true in the original collection itself (here reprinted in its entirety), but also in the dozens of other life stories which appeared in the *Independent*, several of which have been selected (and are reproduced here exactly from the pages of that journal) to accompany Holt's collection in this new, enlarged edition.

In these additional life stories, there are explicit responses to the published lifelets, contrasting and correcting them at times. They also make the reader wonder what happened to all those undistinguished Americans. One could easily imagine more conversations, dialogues between some of the undistinguished Americans, between the Southern colored woman, for example, and the Swedish farmer and the Chinese businessman to whom she compares herself. More people at work appear, from the waitress, the chorus girl, and the football player, to the woman professor and the moonshiners. The ethnic groups broaden and

cross national and color lines, giving voice also to Afro-European, Franco-Italian, or Eurasian lives, to categories that do not easily "fit" into popularly accepted social types, and to tales of "passing," of difficult choices, and of the wish for more connections among the opposing groups. And there are true writers among these authors, whether they sign by name—Fannie Barrier Williams and Sui Sin Far—or whether they do not. Edmund Morris spoke of the Japanese manservant's lifelet as a "brokenly eloquent story," and that phrase also characterizes a great number of the previously uncollected tales.

The life stories that appear here together in book form for the first time give the reader an unusually rich sense of inwardness of the diverse lives lived in the modern world that already appears quite transnational. The lifelets take us back to a time at which immigration, the color line, and suffrage were fiercely debated, but they give us a sense of the people who lived these issues. One wonders who among our contemporaries, which among our new media in this century, would explore the world of average people and the key issues of class inequality, race discrimination, gender relations, immigration, and citizenship with the same sharpness and inwardness that Hamilton Holt and his *Independent* brought to the undistinguished Americans of a hundred years ago.

NOTE

THE INDEPENDENT has published during the last four years about seventy-five autobiographies of undistinguished American men and women. The aim of each autobiography was to typify the life of the average worker in some particular vocation, and to make each story the genuine experience of a real person. From this list have been selected the following sixteen lives as most representative of the humbler classes in the nation, and of individuals whose training and work have been the most diverse. Thus we have the story of the butcher, the sweatshop worker, the bootblack, the push-cart peddler, the lumber man, the dressmaker, the nurse girl, the cook, the cotton-picker, the head-hunter, the trained nurse, the editor, the minister, the butler and the laundryman. They also represent the five great races of mankind, the white, yellow, red, brown and black, and include immigrants from Lithuania, Poland, Sweden, Ireland, France, Germany, Italy, Greece,

NOTE

Syria, China and Japan. I am aware that some of these autobiographies, or "lifelets," are crude from a literary point of view, but they all have a deep human interest and perhaps some sociological importance.

<div align="right">HAMILTON HOLT.</div>

UNDISTINGUISHED AMERICANS

INTRODUCTION

THE LATE Jules Verne about a year before his death created something of a sensation by saying that the novel had reached its height and would soon be displaced from its present position of influence and popularity by new forms of literature. Whether the fact that his later romances had not sold as well as his earlier had anything to do with this pessimistic view of the outlook for his trade, there is much to indicate that he was right. It is true that there are more novels written and read than ever before, and there is no decline in quality, whether we consider the average or the exceptional. But the habitual readers of fiction, notwithstanding their conspicuousness and vocality, form only a small and continually smaller proportion of the total number of readers. Most men and many women prefer to come into closer touch with reality and seek it, often in vain, in the newspapers. Consequently fiction is undergoing

a process of fission; the cleft between the realistic and roman-
tic novels is widening. The former are becoming more nearly
a transcript of life, and the latter, no longer tethered to earth,
are soaring into the ether of the imaginary and impossible. In
the same way the old-fashioned melodrama is differentiating
into the drawing-room comedy and the burlesque opera.

When you propose to tell a story to children they interrupt
at the first sentence with the question, "Is it a true story?" As
we evade or ignore this natural and pertinent inquiry they
finally cease to ask it, and we blur for them the edges of reality
until it fades off into the mists. The hardest part of the training
of the scientist is to get back the clear sight of his childhood.
But nowadays our educators do not do quite so much as for-
merly to encourage the mythopoeic faculty of children. It has
been found that their imagination can be exercised by other
objects than the imaginary. Consequently the number of read-
ers who are impatient of any detectable deviation from truth
is increasing.

Besides this, most people—perhaps all—are more im-
pressed by the concrete than the abstract. The generalized
types of humanity as expressed by the artist in painting and
sculpture, romances and poems do not interest them so much
as do individuals. A composite photograph of a score of girls
is very beautiful, but one is not apt to fall in love with it,
notwithstanding the stories for which this has served as the
theme. The scientist has a very clear and definite conception
of kinetic energy when it is expressed by the formula mv^2, but
he is more forcibly struck by it when he is hit on the head with
a club. Formerly botanists used to talk a great deal about
species and types; later they turned their attention to varieties,
and now the men who are making the most progress are exper-
imenting with one plant and a single flower of that one. The
candidate for a Ph.D. watches a single amoeba under a micro-
scope and writes his thesis on one day's doings of its somewhat
monotonous life. The man who can describe the antics of a
squirrel in a tree has all the publishers after him, while the
zoologist has to pay for the publication of his monograph on
the *Sciuridae*. The type of the naturalist, the ideal statue of the
sculptor, the algebraic formula of the physicist and the hero

and heroine of the romancer have a symmetry, universality and beauty above that of any individual and in a sense they are truer, but their chief value is not in themselves but in their use as guides to the better understanding of the individual, from which they originate and to which they return.

To these two forces tending to develop new forms of literature, the love of truth and the interest in the concrete, we must add one other, the spirit of democracy, the discovery of the importance of the average man. This, after all, is the most profitable branch of nature study, the study of *Homo sapiens*, and of his wife, who, in this country at least, usually also belongs to the species *sapiens*. Wild adventures, erratic characters, strange scenes and impossible emotions are no longer required even in fiction. The ordinary man under ordinary circumstances interests us most because he is most akin to us. In politics he has gained his rights and in history and literature he is coming to be recognized. We realize now that a very good history of France could be written, better than most of the old-fashioned kind, without mentioning the name of Louis XIV or Napoleon.

The resultant of these three forces gives us the general direction of the literature of the future. It will be more realistic, more personal and less exceptional. The combination of these qualities is found in the autobiography, which, as Longfellow said years ago, "is what all biography ought to be." It has always been a favorite form in fiction, from "Apuleius," "Arabian Nights" and "Robinson Crusoe" to the present. Now when we publish a "Life and Letters" we lay the emphasis on the latter part. A great deal of fun has been made of those who preferred to read the love letters of the Brownings rather than the "Sonnets from the Portuguese" and "One Word More," but who will say that the verdict of the future will not vindicate these readers rather than their critics?

One other characteristic of the modern reader must be taken into consideration, his love of brevity. The short story is more popular than the novel, the vaudeville sketch than the drama. We have, then, a demand for the brief autobiography, the life story in a few pages. Since this form of literature seems likely to become a distinct type we might venture to give it the

provisional name of the "lifelet." Its relation to other literary forms is shown most succinctly by this equation:

lifelet : autobiography :: short story : novel

The short story is older than the art of writing but it is only recently that it has attained a perfection and definiteness of form which has caused it to be recognized and studied by rhetoricians. The lifelets now being written are like the average short stories of fifty years ago in crudity and indefiniteness of aim, but already we can see something of the laws and limitations of this new literary type. In its construction the same general rules apply as to the short story, and condensation, elimination, subordination and selection are necessary in order to make it readable and truthful. It really demands as much literary skill as any form of fiction, but when it is strictly autobiographical this is likely to be lacking. However, the number of persons who can write fairly well when they have the material is great and increasing with the spread of education. It has been said that every one's life contains the material for one good novel. It would evidently be more plausible to say this of the lifelet.

Short autobiographies of undistinguished people occasionally appear in most of our magazines, but *The Independent* has published more than any other, for its Managing Editor, Mr. Hamilton Holt, has for several years devoted himself to procuring such narratives with the object of ultimately presenting in this way a complete picture of American life in all its strata. These life stories found favor with the readers of *The Independent*, so a few of them have been selected for publication in this volume. In the selection the aim has been to include a representative of each of the races which go to make up our composite nationality, and of as many different industries as possible. The book has, therefore, a unity of theme and purpose that may compensate for its diversity of topic and style. It is a mosaic picture composed of living tesserae.

In procuring these stories two methods were used; first and preferably, to have the life written upon his own initiative by the person who lived it; second, in the case of one too ignorant or too impatient to write, to have the story written from interviews, and then read to and approved by the person

telling it. Since the author's name is often omitted or is
unknown to the reader, he will have to be content with the
Editor's assurance that great pains have been taken in all
cases to see that the account is truthful, both as to facts and
mode of thought, and that it is a representative, and not
exceptional experience of its class. These sketches, therefore,
are very different in character from those of professional writ-
ers of the wealthy or well-to-do class, who temporarily become
tramps, factory girls, or nursery governesses, or who join the
crowd of the unemployed for the purpose of later securing
employment as professors or editors.

This book is, then, intended not merely to satisfy our com-
mon curiosity as to "how the other half lives," but to have both
a present and a future value as a study in sociology. If Plutarch
had given us the life stories of a slave and a hoplite, a peasant
and a potter, we would willingly have dispensed with an equiva-
lent number of kings and philosophers. Carlyle gave to his vol-
ume of biographies the title "Heroes and Hero Worship."
Emerson gave to his the title "Representative Men." Both were
right. We can understand the significance of the great man only
when we view him both as a product of his times and as an inno-
vator. So, also, to understand a social class, we must study it both
statistically and individually. Biography and demography are
equally useful, the former more vivid, the latter more compre-
hensive. One who studies Charles Booth's nine large volumes on
the "Life and Labor of the Poor in London" will know as exactly as
possible how many men in that city are hungry and cold, but
he will be more likely to gain a definite realization of their
condition and a stronger impulse to remedy it, by reading Jack
London's "The People of the Abyss."

Lincoln said that "God must love the common people
because he made so many of them." In all countries the
question of national destiny is always ultimately settled by
the will of majority, whether the people vote or not. It is the
undistinguished people who move the world, or who pre-
vent it from moving. And the wise statesman is he who can
best read the minds of the non-vocal part of the population,
the silent partners who have the controlling vote in the gov-
ernmental firm.

<div align="right">EDWIN E. SLOSSON</div>

1. THE LIFE STORY OF

A LITHUANIAN

The Lithuanian, who told the following story of his life to Mr. Ernest Poole, is a workman in the Chicago Stockyards and gave his name as Antanas Kaztauskis.

THIS IS not my real name, because if this story is printed it may be read back in Lithuania, and I do not want to get my father and the ugly shoemaker into trouble with the Russian Government.

It was the shoemaker who made me want to come to America. He was a traveling shoemaker, for on our farms we tan our own cowhides, and the shoemaker came to make them into boots for us. By traveling he learned all the news and he smuggled in newspapers across the frontier from Germany. We were always glad to hear him talk.

I can never forget that evening four years ago. It was a cold December. We were in a big room in our log house in Lithuania. My good, kind, thin old mother sat near the wide fireplace, working her brown spinning wheel, with which she made cloth for our shirts and coats and pants. I sat on the floor in front of her with my knee-boots off and my feet stretched out

to the fire. My feet were cold, for I had been out with my young brother in the freezing sheds milking the cows and feeding the sheep and geese. I leaned my head on her dress and kept yawning and thinking about my big goose-feather bed. My father sat and smoked his pipe across the fireplace. Between was a kerosene lamp on a table, and under it sat the ugly shoemaker on a stool finishing a big yellow boot. His sleeves were rolled up; his arms were thin and bony, but you could see how strong the fingers and wrist were, for when he grabbed the needle he jerked it through and the whole arm's length up. This arm kept going up and down. Every time it went up he jerked back his long mixed-up red hair and grunted. And you could just see his face—bony and shut together tight, and his narrow sharp eyes looking down. Then his head would go down again, and his hair would get all mixed up. I kept watching him. My fat, older brother, who sat behind with his fat wife, grinned and said: "Look out or your eyes will make holes in the leather." My brother's eyes were always dull and sleepy. Men like him stay in Lithuania.

At last the boot was finished. The little shoemaker held it up and looked at it. My father stopped smoking and looked at it, "That's a good boot," said my father. The shoemaker grunted. "That's a damn poor boot," he replied (instead of "damn" he said "skatina"), "a rough boot like all your boots, and so when you grow old you are lame. You have only poor things, for rich Russians get your good things, and yet you will not kick up against them. Bah!"

"I don't like your talk," said my father, and he spit into the fire, as he always did when he began to think. "I am honest. I work hard. We get along. That's all. So what good will such talk do me?"

"You!" cried the shoemaker, and he now threw the boot on the floor so that our big dog lifted up his head and looked around. "It's not you at all. It's the boy—that boy there!" and he pointed to me. "That boy must go to America!"

Now I quickly stopped yawning and I looked at him all the time after this. My mother looked frightened and she put her hand on my head. "No, no; he is only a boy," she said. "Bah!" cried the shoemaker, pushing back his hair, and then I felt he was looking right through me. "He is eighteen and a man. You

know where he must go in three years more." We all knew he meant my five years in the army. "Where is your oldest son? Dead. Oh, I know the Russians—the man-wolves! I served my term, I know how it is. Your son served in Turkey in the mountains. Why not here? Because they want foreign soldiers here to beat us. He had four roubles ($2.08) pay for three months, and with that he had to pay men like me to make his shoes and clothes. Oh, the wolves! They let him soak in rain; standing guard all night in the snow and ice he froze, the food was God's food, the vodka was cheap and rotten! Then he died. The wolves—the man-wolves! Look at this book." He jerked a Roman Catholic prayer book from his bag on the floor. "Where would I go if they found this on me? Where is Wilhelm Birbell?"

At this my father spit hard again into the fire and puffed his pipe fast.

"Where is Wilhelm Birbell?" cried the shoemaker, and we all kept quiet. We all knew. Birbell was a rich farmer who smuggled in prayer books from Germany so that we all could pray as we liked, instead of the Russian Church way. He was caught one night and they kept him two years in the St. Petersburg jail, in a cell so narrow and short that he could not stretch out his legs, for they were very long. This made him lame for life. Then they sent him to Irkutsk, down in Siberia. There he sawed logs to get food. He escaped and now he is here in Chicago. But at that time he was in jail.

"Where is Wilhelm Birbell?" cried the shoemaker. "Oh, the wolves! And what is this?" He pulled out an old American newspaper, printed in the Lithuanian language, and I remember he tore it he was so angry. "The world's good news is all kept away. We can only read what Russian officials print in their papers. Read? No, you can't read or write your own language, because there is no Lithuanian school—only the Russian school—you can only read and write Russian. Can you? No, you can't! Because even those Russian schools make you pay to learn, and you have no money to pay. Will you never be ashamed—all you? Listen to me."

Now I looked at my mother and her face looked frightened, but the shoemaker cried still louder. "Why can't you have your own Lithuanian school? Because you are like dogs—you have

nothing to say—you have no town meetings or province meet-
ings, no elections. You are slaves! And why can't you even pay
to go to their Russian school? Because they get all your money.
Only twelve acres you own, but you pay eighty roubles ($40)
taxes. You must work twelve days on your Russian roads. Your
kind old wife must plow behind the oxen, for I saw her last sum-
mer, and she looked tired. You must all slave, but still your rye
and wheat brings little money, because they cheat you bad. Oh,
the wolves—how fat they are! And so your boy must never read
or write, or think like a man should think."

But now my mother cried out, and her voice was shaking.
"Leave us alone—you leave us! We need no money—we trade
our things for the things we need at the store—we have all we
need—leave us alone!"

Then my fat brother grinned and said to the shoemaker,
"You always stir up young men to go to America. Why don't
you go yourself?"

I remember that the little shoemaker had pulled a big
crooked pipe out of his bag. Now he took a splinter from the
basket of splinters which hung on the wall and he lit his pipe
and puffed it. His face showed me that he felt bad. "I am too
old," he said, "to learn a new trade. These boots are no good
in America. America is no place for us old rascals. My son is
in Chicago in the stockyards, and he writes to me. They have
hard knocks. If you are sick or old there and have no money
you must die. That Chicago place has trouble, too. Do you see
that light? That is kerosene. Do you remember the price went
up last year? That is Rockefeller. My son writes me about him.
He is another man-wolf. A few men like him are grabbing all
the good things—the oil and coal and meat and everything.
But against these men you can strike if you are young. You
can read free papers and prayer books. In Chicago there are
prayer books for every man and woman. You can have free
meetings and talk out what you think. And so if you are young
you can change all these troubles. But I am old. I can feel it
now, this winter. So I only tell young men to go." He looked
hard at me and I looked at him. He kept talking. "I tell them
to go where they can choose their own kind of God—where
they can learn to read and write, and talk, and think like
men—and have good things!"

He kept looking at me, but he opened the newspaper and held it up. "Some day," he said, "I will be caught and sent to jail, but I don't care. I got this from my son, who reads all he can find at night. It had to be smuggled in. I lend it many times to many young men. My son got it from the night school and he put it in Lithuanian for me to see." Then he bent over the paper a long time and his lips moved. At last he looked into the fire and fixed his hair, and then his voice was shaking and very low:

"'We know these are true things—that all men are born free and equal—that God gives them rights which no man can take away—that among these rights are life, liberty and the getting of happiness.' "

He stopped, I remember, and looked at me, and I was not breathing. He said it again. " 'Life, liberty and the getting of happiness.' Oh, that is what you want."

My mother began to cry. "He cannot go if his father commands him to stay," she kept saying. I knew this was true, for in Lithuania a father can command his son till he dies.

"No, he must not go," said the shoemaker, "if his father commands him to stay." He turned and looked hard at my father. My father was looking into the fire. "If he goes," said my father, "those Russians will never let him come back." My mother cried harder. We all waited for him to say something else. In about five minutes the shoemaker got up and asked, "Well, what do you say,—the army or America?" But my father shook his head and would not say anything. Soon my brother began yawning and took his fat wife and went to bed. The little shoemaker gathered his tools into his big bag and threw it over his shoulder. His shoulder was crooked. Then he came close to me and looked at me hard.

"I am old," he said, "I wish I was young. And you must be old soon and that will be too late. The army—the man-wolves! Bah! it is terrible."

After he was gone my father and I kept looking at the fire. My mother stopped crying and went out. Our house was in two parts of two rooms each. Between the parts was an open shed and in this shed was a big oven, where she was baking bread that night. I could hear her pull it out to look at it and

then push it back. Then she came in and sat down beside me and began spinning again. I leaned against her dress and watched the fire and thought about America. Sometimes I looked at my father, and she kept looking at him, too, but he would not say anything. At last my old mother stopped spinning and put her hand on my forehead.

"Alexandria is a fine girl," she whispered. This gave me a quick, bad feeling. Alexandria was the girl I wanted to marry. She lived about ten miles away. Her father liked my father and they seemed to be glad that I loved her. I had often been thinking at night how in a few years I would go with my uncle to her house and ask her father and mother to give her to me. I could see the wedding all ahead—how we would go to her house on Saturday night and they would have music there and many people and we would have a sociable time. Then in the morning we would go to the church and be married and come back to my father's house and live with him. I saw it all ahead, and I was sure we would be very happy. Now I began thinking of this. I could see her fine soft eyes and I hated to go away. My old mother kept her hands moving on my forehead. "Yes, she is a nice girl; a kind, beautiful girl," she kept whispering. We sat there till the lamp went out. Then the fire got low and the room was cold and we went to bed. But I could not sleep and kept thinking.

The next day my father told me that I could not go until the time came for the army, three years ahead. "Stay until then and then we will see," he said. My mother was very glad and so was I, because of Alexandria. But in the coldest part of that winter my dear old mother got sick and died. The neighbors all came in and sang holy songs for two days and nights. The priest was there and my father bought fine candles. Two of the neighbors made a coffin. At last it was all over. For a long time our log house was always quiet.

That summer the shoemaker came again and talked with me. This time I was very eager to go to America, and my father told me I could go.

One morning I walked over to say good-by to Alexandria. It was ten miles and the road was dusty, so I carried my boots over my shoulder, as we always did, and I put them on when I came near her house. When I saw her I felt very bad, and so

did she. I had the strongest wish I ever had to take hold of her and keep her all my life. We stayed together till it was dark and night fogs came up out of the field grass, and we could hardly see the house. Then she said good-by. For many nights I kept remembering the way she looked up at me.

The next night after supper I started. It is against the law to sell tickets to America, but my father saw the secret agent in the village and he got a ticket from Germany and found us a guide. I had bread and cheese and honey and vodka and clothes in my bag. Some of the neighbors walked a few miles and said good-by and then went back. My father and my younger brother walked on all night with the guide and me. At daylight we came to the house of a man the guide knew. We slept there and that night I left my father and young brother. My father gave me $50 besides my ticket. The next morning before light we were going through the woods and we came to the frontier. Three roads run along the frontier. On the first road there is a soldier every mile, who stands there all night. On the second road is a soldier every half mile, and on the third road is a soldier every quarter of a mile. The guide went ahead through the woods. I hid with my big bag behind a bush and whenever he raised his hand I sneaked along. I felt cold all over and sometimes hot. He told me that sometimes he took twenty immigrants together, all without passports, and then he could not pass the soldiers and so he paid a soldier he knew one dollar a head to let them by. He said the soldier was very strict and counted them to see that he was not being cheated.

So I was in Germany. Two days after that we reached Tilsit and the guide took me to the railroad man. This man had a crowd of immigrants in a room, and we started that night on the railroad—fourth class. It was bad riding sometimes. I used to think of Alexandria. We were all green and slow. The railroad man used to say to me, "You will have to be quicker than this in Chicago," and he was right. We were very slow in the stations where we changed trains, and he used to shout at us then, and one old German man who spoke Lithuanian told me what the man was calling us. When he told me this I hurried, and so did the others, and we began to learn to be quicker. It took three days to get to Hamburg. There we were

put in a big house called a barracks, and we waited a week. The old German man told me that the barracks men were cheating us. He had been once to Cincinnati in America to visit his son, who kept a saloon. His old, long pipe was stolen there. He kept saying, "Dem grafters, dem grafters," in a low voice whenever they brought food to sell, for our bags were now empty. They kept us there till our money was half spent on food. I asked the old man what kind of American men were grafters, and he said, "All kinds in Cincinnati, but more in Chicago!" I knew I was going to Chicago, and I began to think quicker. I thought quicker yet on the boat. I saw men playing cards. I played and lost $1.80 in my new money, till the old man came behind me and said, "Dem grafters." When I heard this I got scared and threw down my cards. That old man used to point up at the rich people looking down at us and say, "Dem grafters." They were the richest people I had ever seen— the boat was the biggest boat I had ever seen—the machine that made it go was very big, and so was the horn that blew in a fog. I felt everything get bigger and go quicker every day.

It was the most when we came to New York. We were driven in a thick crowd to the railroad station. The old man kept pointing and saying, "Grafters, grafters," till the guide punched him and said, "Be quick, damn you, be quick." . . . "I will be quick pretty soon," said the old man to me, "and den I will get back dot pipe in Cincinnati. And when I will be quicker still, alreddy, I will steal some odder man's pipe. Every quick American man is a grafter." I began to believe that this was true, but I was mixed up and could not think long at one time. Everything got quicker—worse and worse— till then at last I was in a boarding house by the stockyards in Chicago with three Lithuanians, who knew my father's sisters at home.

That first night we sat around in the house and they asked me, "Well, why did you come?" I told them about that first night and what the ugly shoemaker said about "life, liberty and the getting of happiness." They all leaned back and laughed. "What you need is money," they said. "It was all right at home. You wanted nothing. You ate your own meat and your own things on the farm. You made your own clothes and had your own leather. The other things you got at the Jew

man's store and paid him with sacks of rye. But here you want a hundred things. Whenever you walk out you see new things you want, and you must have money to buy everything."

Then one man asked me, "How much have you?" and I told him $30. "You must buy clothes to look rich, even if you are not rich," he said. "With good clothes you will have friends."

The next morning three of these men took me to a store near the stockyards to buy a coat and pants. "Look out," said one of them. "Is he a grafter?" I asked. They all laughed. "You stand still. That is all you have to do," they said. So the Jew man kept putting on coats and I moved my arms and back and sides when they told me. We stayed there till it was time for dinner. Then we bought a suit. I paid $5 and then I was to pay $1 a week for five weeks.

In the afternoon I went to a big store. There was a man named Elias. "He is not a grafter," said my friends. He was nice to me and gave me good advice how to get a job. I bought two shirts, a hat, a collar, a necktie, two pairs of socks and some shoes. We kept going upstairs and downstairs. I saw one Lithuanian man buying everything for his wife and three children, who would come here the next week from Lithuania. My things cost me $8. I put these on right away and then I began to feel better.

The next night they took me for a walk down town. We would not pay to ride, so we walked so long that I wanted to take my shoes off, but I did not tell them this. When we came there I forgot my feet. We stood by one theater and watched for half an hour. Then we walked all around a store that filled one whole block and had walls of glass. Then we had a drink of whiskey, and this is better than vodka. We felt happier and looked into *cafés*. We saw shiny carriages and automobiles. I saw men with dress suits, I saw women with such clothes that I could not think at all. Then my friends punched me and I turned around and saw one of these women, and with her was a gentleman in a fine dress suit. I began looking harder. It was the Jew man that sold me my suit. "He is a grafter," said my friends. "See what money can do." Then we walked home and I felt poor and my shoes got very bad.

That night I felt worse. We were tired out when we reached the stockyards, so we stopped on the bridge and looked into

the river out there. It was so full of grease and dirt and sticks and boxes that it looked like a big, wide, dirty street, except in some places, where it boiled up. It made me sick to look at it. When I looked away I could see on one side some big fields full of holes, and these were the city dumps. On the other side were the stockyards, with twenty tall slaughter house chimneys. The wind blew a big smell from them to us. Then we walked on between the yards and the dumps and all the houses looked bad and poor. In our house my room was in the basement. I lay down on the floor with three other men and the air was rotten. I did not go to sleep for a long time. I knew then that money was everything I needed. My money was almost gone and I thought that I would soon die unless I got a job, for this was not like home. Here money was everything and a man without money must die.

The next morning my friends woke me up at five o'clock and said, "Now, if you want life, liberty and happiness," they laughed, "you must push for yourself. You must get a job. Come with us." And we went to the yards. Men and women were walking in by thousands as far as we could see. We went to the doors of one big slaughter house. There was a crowd of about 200 men waiting there for a job. They looked hungry and kept watching the door. At last a special policeman came out and began pointing to men, one by one. Each one jumped forward. Twenty-three were taken. Then they all went inside, and all the others turned their faces away and looked tired. I remember one boy sat down and cried, just next to me, on a pile of boards. Some policemen waved their clubs and we all walked on. I found some Lithuanians to talk with, who told me they had come every morning for three weeks. Soon we met other crowds coming away from other slaughter houses, and we all walked around and felt bad and tired and hungry.

That night I told my friends that I would not do this many days, but would go some place else. "Where?" they asked me, and I began to see then that I was in bad trouble, because I spoke no English. Then one man told me to give him $5 to give the special policeman. I did this and the next morning the policeman pointed me out, so I had a job. I have heard some big talk since then about my American freedom of contract, but I do not think I had much freedom in bargaining for this

job with the Meat Trust. My job was in the cattle killing room. I pushed the blood along the gutter. Some people think these jobs make men bad. I do not think so. The men who do the killing are not as bad as the ladies with fine clothes who come every day to look at it, because they have to do it. The cattle do not suffer. They are knocked senseless with a big hammer and are dead before they wake up. This is done not to spare them pain, but because if they got hot and sweating with fear and pain the meat would not be so good. I soon saw that every job in the room was done like this—so as to save everything and make money. One Lithuanian who worked with me, said, "They get all the blood out of those cattle and all the work out of us men." This was true, for we worked that first day from six in the morning till seven at night. The next day we worked from six in the morning till eight at night. The next day we had no work. So we had no good, regular hours. It was hot in the room that summer, and the hot blood made it worse.

I held this job six weeks and then I was turned off. I think some other man had paid for my job, or perhaps I was too slow. The foreman in that room wanted quick men to make the work rush, because he was paid more if the work was done cheaper and quicker. I saw now that every man was helping himself, always trying to get all the money he could. At that time I believed that all men in Chicago were grafters when they had to be. They only wanted to push themselves. Now, when I was idle I began to look about, and everywhere I saw sharp men beating out slow men like me. Even if we worked hard it did us no good. I had saved $13—$5 a week for six weeks makes $30, and take off $15 for six weeks' board and lodging and $2 for other things. I showed this to a Lithuanian, who had been here two years, and he laughed. "It will be taken from you," he said. He had saved a hundred dollars once and had begun to buy a house on the installment plan, but something had happened that he did not know about and his landlord put him out and kept the hundred dollars. I found that many Lithuanians had been beaten this way. At home we never made a man sign contract papers. We only had him make the sign of a cross and promise he would do what he said. But this was no good in Chicago. So these sharp men were beating us.

I saw this, too, in the newspaper. I was beginning to learn English, and at night in the boarding house the men who did not play cards used to read the paper to us. The biggest word was "Graft" in red letters on the front page. Another word was "Trust." This paper kept putting these two words together. Then I began to see how every American man was trying to get money for himself. I wondered if the old German man in Cincinnati had found his pipe yet. I felt very bad and sorrowful in that month. I kept walking around with many other Lithuanians who had no job. Our money was going and we could find nothing to do. At night we got homesick for our fine green mountains. We read all the news about home in our Lithuanian Chicago newspaper, *The Katalikas*. It is a good paper and gives all the news. In the same office we bought this song, which was written in Brooklyn by P. Brandukas. He, too, was homesick. It is sung all over Chicago and you can hear it in the summer evenings through the open windows. In English it is something like this:

"Oh, Lithuania, so dear to me,
Good-by to you, my Fatherland.
Sorrowful in my heart I leave you.
I know not who will stay to guard you.
Is it enough for me to live and enjoy between my neighbors,
In the woods with the flowers and birds?
Is it enough for me to live peaceful between my friends?
No, I must go away from my old father and mother.

The sun shines bright,
The flowers smell sweet,
The birds are singing,
They make the country glad:
But I cannot sing because I must leave you."

Those were bad days and nights. At last I had a chance to help myself. Summer was over and Election Day was coming. The Republican boss in our district, Jonidas, was a saloon keeper. A friend took me there. Jonidas shook hands and treated me fine. He taught me to sign my name, and the next week I went with him to an office and signed some paper, and then I could vote. I voted as I was told, and then they got me back into the yards to work, because one big politician owns

stock in one of those houses. Then I felt that I was getting in beside the game. I was in a combine like other sharp men. Even when work was slack I was all right, because they got me a job in the street cleaning department. I felt proud, and I went to the back room in Jonidas's saloon and got him to write a letter to Alexandrìa to tell her she must come soon and be my wife.

But this was just the trouble. All of us were telling our friends to come soon. Soon they came—even thousands. The employers in the yard liked this, because those sharp foremen are inventing new machines and the work is easier to learn, and so these slow Lithuanians and even green girls can learn to do it, and then the Americans and Germans and Irish are put out and the employer saves money, because the Lithuanians work cheaper. This was why the American labor unions began to organize us all just the same as they had organized the Bohemians and Poles before us.

Well, we were glad to be organized. We had learned that in Chicago every man must push himself always, and Jonidas had taught us how much better we could push ourselves by getting into a combine. Now, we saw that this union was the best combine for us, because it was the only combine that could say, "It is our business to raise your wages."

But that Jonidas—he spoilt our first union. He was sharp. First he got us to hire the room over his saloon. He used to come in at our meetings and sit in the back seat and grin. There was an Irishman there from the union headquarters, and he was trying to teach us to run ourselves. He talked to a Lithuanian, and the Lithuanian said it to us, but we were slow to do things, and we were jealous and were always jumping up to shout and fight. So the Irishman used to wipe his hot, red face and call us bad names. He told the Lithuanian not to say these names to us, but Jonidas heard them, and in his saloon, where we all went down after the meeting when the Irishman was gone, Jonidas gave us free drinks and then told us the names. I will not write them here.

One night that Irishman did not come and Jonidas saw his chance and took the chair. He talked very fine and we elected him President. We made him Treasurer, too. Down in the saloon he gave us free drinks and told us we must break away from the Irish grafters. The next week he made us strike, all

by himself. We met twice a day in his saloon and spent all of our money on drinks, and then the strike was over. I got out of this union after that. I had been working hard in the cattle killing room and I had a better job. I was called a cattle butcher now and I joined the Cattle Butchers' Union. This union is honest and it has done me a great deal of good.

It has raised my wages. The man who worked at my job before the union came was getting through the year an average of $9 a week. I am getting $11. In my first job I got $5 a week. The man who works there now gets $5.75.

It has given me more time to learn to read and speak and enjoy life like an American. I never work now from 6 A. M. to 9 P. M. and then be idle the next day. I work now from 7 A. M. to 5:30 P. M., and there are not so many idle days. The work is evened up.

With more time and more money I live much better and I am very happy. So is Alexandria. She came a year ago and has learned to speak English already. Some of the women go to the big store the day they get here, when they have not enough sense to pick out the clothes that look right, but Alexandria waited three weeks till she knew, and so now she looks the finest of any woman in the district. We have four nice rooms, which she keeps very clean, and she has flowers growing in boxes in the two front windows. We do not go much to church, because the church seems to be too slow. But we belong to a Lithuanian society that gives two picnics in summer and two big balls in winter, where we have a fine time. I go one night a week to the Lithuanian Concertina Club. On Sundays we go on the trolley out into the country.

But we like to stay at home more now because we have a baby. When he grows up I will not send him to the Lithuanian Catholic school. They have only two bad rooms and two priests who teach only in Lithuanian from prayer books. I will send him to the American school, which is very big and good. The teachers there are Americans and they belong to the Teachers' Labor Union, which has three thousand teachers and belongs to our Chicago Federation of Labor. I am sure that such teachers will give him a good chance.

Our union sent a committee to Springfield last year and they passed a law which prevents boys and girls below sixteen from working in the stockyards.

We are trying to make the employers pay on Saturday night in cash. Now they pay in checks and the men have to get money the same night to buy things for Sunday, and the saloons cash checks by thousands. You have to take one drink to have the check cashed. It is hard to take one drink.

The union is doing another good thing. It is combining all the nationalities. The night I joined the Cattle Butchers' Union I was led into the room by a negro member. With me were Bohemians, Germans and Poles, and Mike Donnelly, the President, is an Irishman. He spoke to us in English and then three interpreters told us what he said. We swore to be loyal to our union above everything else except the country, the city and the State—to be faithful to each other—to protect the women-workers—to do our best to understand the history of the labor movement, and to do all we could to help it on. Since then I have gone there every two weeks and I help the movement by being an interpreter for the other Lithuanians who come in. That is why I have learned to speak and write good English. The others do not need me long. They soon learn English, too, and when they have done that they are quickly becoming Americans.

But the best thing the union does is to make me feel more independent. I do not have to pay to get a job and I cannot be discharged unless I am no good. For almost the whole 30,000 men and women are organized now in some one of our unions and they all are directed by our central council. No man knows what it means to be sure of his job unless he has been fired like I was once without any reason being given.

So this is why I joined the labor union. There are many better stories than mine, for my story is very common. There are thousands of immigrants like me. Over 300,000 immigrants have been organized in the last three years by the American Federation of Labor. The immigrants are glad to be organized if the leaders are as honest as Mike Donnelly is. You must get money to live well, and to get money you must combine. I cannot bargain alone with the Meat Trust. I tried it and it does not work.

2. THE LIFE STORY OF

A POLISH SWEATSHOP GIRL

Sadie Frowne is the real name of the sixteen-year-old girl whose story follows. It was dictated by her to Mr. Sidney Reid, who has also procured many of the other life stories for this volume, and was afterward read over to herself and relatives and pronounced accurate in all respects. Brownsville is the Jewish sweatshop district of Brooklyn, N.Y.

MY MOTHER was a tall, handsome, dark complexioned woman with red cheeks, large brown eyes and a great quantity of jet black, wavy hair. She was well educated, being able to talk in Russian, German, Polish and French, and even to read English print, though of course she did not know what it meant. She kept a little grocer's shop in the little village where we lived at first. That was in Poland, somewhere on the frontier, and mother had charge of a gate between the countries, so that everybody who came through the gate had to show her a pass. She was much looked up to by the people, who used to come and ask her for advice. Her word was like law among them.

She had a wagon in which she used to drive about the country, selling her groceries, and sometimes she worked in the fields with my father.

The grocer's shop was only one story high, and had one window, with very small panes of glass. We had two rooms

behind it, and were happy while my father lived, although we had to work very hard. By the time I was six years of age I was able to wash dishes and scrub floors, and by the time I was eight I attended to the shop while my mother was away driving her wagon or working in the fields with my father. She was strong and could work like a man.

When I was a little more than ten years of age my father died. He was a good man and a steady worker, and we never knew what it was to be hungry while he lived. After he died troubles began, for the rent of our shop was about $6 a month and then there were food and clothes to provide. We needed little, it is true, but even soup, black bread and onions we could not always get.

We struggled along till I was nearly thirteen years of age and quite handy at housework and shop-keeping, so far as I could learn them there. But we fell behind in the rent and mother kept thinking more and more that we should have to leave Poland and go across the sea to America where we heard it was much easier to make money. Mother wrote to Aunt Fanny, who lived in New York, and told her how hard it was to live in Poland, and Aunt Fanny advised her to come and bring me. I was out at service at this time and mother thought she would leave me—as I had a good place—and come to this country alone, sending for me afterward. But Aunt Fanny would not hear of this. She said we should both come at once, and she went around among our relatives in New York and took up a subscription for our passage.

We came by steerage on a steamship in a very dark place that smelt dreadfully. There were hundreds of other people packed in with us, men, women and children, and almost all of them were sick. It took us twelve days to cross the sea, and we thought we should die, but at last the voyage was over, and we came up and saw the beautiful bay and the big woman with the spikes on her head and the lamp that is lighted at night in her hand (Goddess of Liberty).

Aunt Fanny and her husband met us at the gate of this country and were very good to us, and soon I had a place to live out (domestic servant), while my mother got work in a factory making white goods.

I was only a little over thirteen years of age and a greenhorn,

so I received $9 a month and board and lodging, which I thought was doing well. Mother, who, as I have said, was very clever, made $9 a week on white goods, which means all sorts of underclothing, and is high class work.

But mother had a very gay disposition. She liked to go around and see everything, and friends took her about New York at night and she caught a bad cold and coughed and coughed. She really had hasty consumption, but she didn't know it, and I didn't know it, and she tried to keep on working, but it was no use. She had not the strength. Two doctors attended her, but they could do nothing, and at last she died and I was left alone. I had saved money while out at service, but mother's sickness and funeral swept it all away and now I had to begin all over again.

Aunt Fanny had always been anxious for me to get an education, as I did not know how to read or write, and she thought that was wrong. Schools are different in Poland from what they are in this country, and I was always too busy to learn to read and write. So when mother died I thought I would try to learn a trade and then I could go to school at night and learn to speak the English language well.

So I went to work in Allen street (Manhattan) in what they call a sweatshop, making skirts by machine. I was new at the work and the foreman scolded me a great deal.

"Now, then," he would say, "this place is not for you to be looking around in. Attend to your work. That is what you have to do."

I did not know at first that you must not look around and talk, and I made many mistakes with the sewing, so that I was often called a "stupid animal." But I made $4 a week by working six days in the week. For there are two Sabbaths here—our own Sabbath, that comes on a Saturday, and the Christian Sabbath that comes on Sunday. It is against our law to work on our own Sabbath, so we work on their Sabbath.

In Poland I and my father and mother used to go to the synagogue on the Sabbath, but here the women don't go to the synagogue much, though the men do. They are shut up working hard all the week long and when the Sabbath comes they like to sleep long in bed and afterward they must go out

where they can breathe the air. The rabbis are strict here, but not so strict as in the old country.

I lived at this time with a girl named Ella, who worked in the same factory and made $5 a week. We had the room all to ourselves, paying $1.50 a week for it, and doing light housekeeping. It was in Allen street, and the window looked out of the back, which was good, because there was an elevated railroad in front, and in summer time a great deal of dust and dirt came in at the front windows. We were on the fourth story and could see all that was going on in the back rooms of the houses behind us, and early in the morning the sun used to come in our window.

We did our cooking on an oil stove, and lived well, as this list of our expenses for one week will show:

ELLA AND SADIE FOR FOOD (ONE WEEK)

Tea	$0.06
Cocoa	10
Bread and rolls	40
Canned vegetables	20
Potatoes	10
Milk	21
Fruit	20
Butter	15
Meat	60
Fish	15
Laundry	25
Total	$2.42
Add rent	1.50
Grand total	$3.92

Of course, we could have lived cheaper, but we are both fond of good things and felt that we could afford them.

We paid 18¢ for a half pound of tea so as to get it good, and it lasted us three weeks, because we had cocoa for breakfast. We paid 5¢ for six rolls and 5¢ a loaf for bread, which was the best quality. Oatmeal cost us 10¢ for three and one-half pounds, and we often had it in the morning, or Indian meal porridge in the place of it, costing about the same. Half a dozen eggs cost about 13¢ on an average, and we could get all the meat we wanted for a good hearty meal for 20¢—two

pounds of chops, or a steak, or a bit of veal, or a neck of lamb—
something like that. Fish included butter fish, porgies, codfish
and smelts, averaging about 8¢ a pound.

Some people who buy at the last of the market, when the men
with the carts want to go home, can get things very cheap, but
they are likely to be stale, and we did not often do that with fish,
fresh vegetables, fruit, milk or meat. Things that kept well we
did buy that way and got good bargains. I got thirty potatoes
for 10¢ one time, though generally I could not get more than
fifteen of them for that amount. Tomatoes, onions and cab-
bages, too, we bought that way and did well, and we found a
factory where we could buy the finest broken crackers for 3¢ a
pound, and another place where we got broken candy for 10¢ a
pound. Our cooking was done on an oil stove, and the oil for the
stove and the lamp cost us 10¢ a week.

It cost me $2 a week to live, and I had a dollar a week to
spend on clothing and pleasure, and saved the other dollar. I
went to night school, but it was hard work learning at first as
I did not know much English.

Two years ago I came to Brownsville, where so many of my
people are, and where I have friends. I got work in a factory
making underskirts—all sorts of cheap underskirts, like cotton
and calico for the summer and woolen for the winter, but
never the silk, satin or velvet underskirts. I earned $4.50 a
week and lived on $2 a week, the same as before. I got a room
in the house of some friends who lived near the factory. I pay
$1 a week for the room and am allowed to do light housekeep-
ing—that is, cook my meals in it. I get my own breakfast in
the morning, just a cup of coffee and a roll, and at noon time
I come home to dinner and take a plate of soup and a slice of
bread with the lady of the house. My food for a week costs a
dollar, just as it did in Allen street, and I have the rest of my
money to do as I like with. I am earning $5.50 a week now,
and will probably get another increase soon.

It isn't piecework in our factory, but one is paid by the
amount of work done just the same. So it is like piecework.
All the hands get different amounts, some as low as $3.50 and
some of the men as high as $16 a week. The factory is in the
third story of a brick building. It is in a room twenty feet long
and fourteen broad. There are fourteen machines in it. I and

the daughter of the people with whom I live work two of these machines. The other operators are all men some young and some old.

At first a few of the young men were rude. When they passed me they would touch my hair and talk about my eyes and my red cheeks, and make jokes. I cried and said that if they did not stop I would leave the place. The boss said that that should not be, that no one must annoy me. Some of the other men stood up for me, too, especially Henry, who said two or three times that he wanted to fight. Now the men all treat me very nicely. It was just that some of them did not know better, not being educated.

Henry is tall and dark, and he has a small mustache. His eyes are brown and large. He is pale and much educated, having been to school. He knows a great many things and has some money saved. I think nearly $400. He is not going to be in a sweatshop all the time, but will soon be in the real estate business, for a lawyer that knows him well has promised to open an office and pay him to manage it.

Henry has seen me home every night for a long time and makes love to me. He wants me to marry him, but I am not seventeen yet, and I think that is too young. He is only nineteen, so we can wait.

I have been to the fortune teller's three or four times, and she always tells me that though I have had such a lot of trouble I am to be very rich and happy. I believe her because she has told me so many things that have come true. So I will keep on working in the factory for a time. Of course it is hard, but I would have to work hard even if I was married.

I get up at half-past five o'clock every morning and make myself a cup of coffee on the oil stove. I eat a bit of bread and perhaps some fruit and then go to work. Often I get there soon after six o'clock so as to be in good time, though the factory does not open till seven. I have heard that there is a sort of clock that calls you at the very time you want to get up, but I can't believe that because I don't see how the clock would know.

At seven o'clock we all sit down to our machines and the boss brings to each one the pile of work that he or she is to finish during the day, what they call in English their "stint." This pile is put down beside the machine and as soon as a skirt

is done it is laid on the other side of the machine. Sometimes the work is not all finished by six o'clock and then the one who is behind must work overtime. Sometimes one is finished ahead of time and gets away at four or five o'clock, but generally we are not done till six o'clock.

The machines go like mad all day, because the faster you work the more money you get. Sometimes in my haste I get my finger caught and the needle goes right through it. It goes so quick, though, that it does not hurt much. I bind the finger up with a piece of cotton and go on working. We all have accidents like that. Where the needle goes through the nail it makes a sore finger, or where it splinters a bone it does much harm. Sometimes a finger has to come off. Generally, though, one can be cured by a salve.

All the time we are working the boss walks about examining the finished garments and making us do them over again if they are not just right. So we have to be careful as well as swift. But I am getting so good at the work that within a year I will be making $7 a week, and then I can save at least $3.50 a week. I have over $200 saved now.

The machines are all run by foot-power, and at the end of the day one feels so weak that there is a great temptation to lie right down and sleep. But you must go out and get air, and have some pleasure. So instead of lying down I go out, generally with Henry. Sometimes we go to Coney Island, where there are good dancing places, and sometimes we go to Ulmer Park to picnics. I am very fond of dancing, and, in fact, all sorts of pleasure. I go to the theater quite often, and like those plays that make you cry a great deal. "The Two Orphans" is good. Last time I saw it I cried all night because of the hard times that the children had in the play. I am going to see it again when it comes here.

For the last two winters I have been going to night school. I have learned reading, writing and arithmetic. I can read quite well in English now and I look at the newspapers every day. I read English books, too, sometimes. The last one that I read was "A Mad Marriage," by Charlotte Braeme. She's a grand writer and makes things just like real to you. You feel as if you were the poor girl yourself going to get married to a rich duke.

I am going back to night school again this winter. Plenty of my friends go there. Some of the women in my class are more than forty years of age. Like me, they did not have a chance to learn anything in the old country. It is good to have an education; it makes you feel higher. Ignorant people are all low. People say now that I am clever and fine in conversation.

We recently finished a strike in our business. It spread all over and the United Brotherhood of Garment Workers was in it. That takes in the cloakmakers, coatmakers, and all the others. We struck for shorter hours, and after being out four weeks won the fight. We only have to work nine and a half hours a day and we get the same pay as before. So the union does good after all in spite of what some people say against it—that it just takes our money and does nothing.

I pay 25¢ a month to the union, but I do not begrudge that because it is for our benefit. The next strike is going to be for a raise of wages, which we all ought to have. But though I belong to the Union I am not a Socialist or an Anarchist. I don't know exactly what those things mean. There is a little expense for charity, too. If any worker is injured or sick we all give money to help.

Some of the women blame me very much because I spend so much money on clothes. They say that instead of a dollar a week I ought not to spend more than 25¢ a week on clothes, and that I should save the rest. But a girl must have clothes if she is to go into good society at Ulmer Park or Coney Island or the theater. Those who blame me are the old country people who have old-fashioned notions, but the people who have been here a long time know better. A girl who does not dress well is stuck in a corner, even if she is pretty, and Aunt Fanny says that I do just right to put on plenty of style.

I have many friends and we often have jolly parties. Many of the young men like to talk to me, but I don't go out with any except Henry.

Lately he has been urging me more and more to get married—but I think I'll wait.

3. THE LIFE STORY OF

AN ITALIAN BOOTBLACK

Rocco Corresca is the official name of the young
bootblack who is the hero of this chapter, although
he is known to most of his friends and patrons as
"Joe." He claims that he has always been called
Rocco but that the name Corresca was given him
when he went aboard the ship that brought him to
America. It was thus entered on the steerage list and
he has since kept it.

WHEN I was a very small boy I lived in Italy in a large house
with many other small boys, who were all dressed alike and
were taken care of by some nuns. It was a good place, situated
on the side of the mountain, where grapes were growing and
melons and oranges and plums.

They taught us our letters and how to pray and say the
catechism, and we worked in the fields during the middle of
the day. We always had enough to eat and good beds to sleep
in at night, and sometimes there were feast days, when we
marched about wearing flowers.

Those were good times and they lasted till I was nearly
eight years of age. Then an old man came and said he was my
grandfather. He showed some papers and cried over me and
said that the money had come at last and now he could take
me to his beautiful home. He seemed very glad to see me and
after they looked at his papers he took me away and we went

to the big city—Naples. He kept talking about his beautiful house, but when we got there it was a dark cellar that he lived in and I did not like it at all. Very rich people were on the first floor. They had carriages and servants and music and plenty of good things to eat, but we were down below in the cellar and had nothing. There were four.other boys in the cellar and the old man said they were all my brothers. All were larger than I and they beat me at first till one day Francesco said that they should not beat me any more, and then Paolo, who was the largest of all, fought him till Francesco drew a knife and gave him a cut. Then Paolo, too, got a knife and said that he would kill Francesco, but the old man knocked them both down with a stick and took their knives away and gave them beatings.

Each morning we boys all went out to beg and we begged all day near the churches and at night near the theaters, running to the carriages and opening the doors and then getting in the way of the people so that they had to give us money or walk over us. The old man often watched us and at night he took all the money, except when we could hide something.

We played tricks on the people, for when we saw some coming that we thought were rich I began to cry and covered my face and stood on one foot, and the others gathered around me and said:

"Don't cry! Don't cry!"

Then the ladies would stop and ask: "What is he crying about? What is the matter, little boy?"

Francesco or Paolo would answer: "He is very sad because his mother is dead and they have laid her in the grave."

Then the ladies would give me money and the others would take most of it from me.

The old man told us to follow the Americans and the English people, as they were all rich, and if we annoyed them enough they would give us plenty of money. He taught us that if a young man was walking with a young woman he would always give us silver because he would be ashamed to let the young woman see him give us less. There was also a great church where sick people were cured by the saints, and when they came out they were so glad that they gave us money.

Begging was not bad in the summer time because we went all over the streets and there was plenty to see, and if we got much money we could spend some buying things to eat. The old man knew we did that. He used to feel us and smell us to see if we had eaten anything, and he often beat us for eating when we had not eaten.

Early in the morning we had breakfast of black bread rubbed over with garlic or with a herring to give it a flavor. The old man would eat the garlic or the herring himself, but he would rub our bread with it, which he said was as good. He told us that boys should not be greedy and that it was good to fast and that all the saints had fasted. He had a figure of a saint in one corner of the cellar and prayed night and morning that the saint would help him to get money. He made us pray, too, for he said that it was good luck to be religious.

We used to sleep on the floor, but often we could not sleep much because men came in very late at night and played cards with the old man. He sold them wine from a barrel that stood on one end of the table that was there, and if they drank much he won their money. One night he won so much that he was glad and promised the saint some candles for his altar in the church. But that was to get more money. Two nights after that the same men who had lost the money came back and said that they wanted to play again. They were very friendly and laughing, but they won all the money and the old man said they were cheating. So they beat him and went away. When he got up again he took a stick and knocked down the saint's figure and said that he would give no more candles.

I was with the old man for three years. I don't believe that he was my grandfather, though he must have known something about me because he had those papers.

It was very hard in the winter time for we had no shoes and we shivered a great deal. The old man said that we were no good, that we were ruining him, that we did not bring in enough money. He told me that I was fat and that people would not give money to fat beggars. He beat me, too, because I didn't like to steal, as I had heard it was wrong.

"Ah!" said he, "that is what they taught you at that place, is it? To disobey your grandfather that fought with Garibaldi! That is a fine religion!"

The others all stole as well as begged, but I didn't like it and Francesco didn't like it either.

Then the old man said to me: "If you don't want to be a thief you can be a cripple. That is an easy life and they make a great deal of money."

I was frightened then, and that night I heard him talking to one of the men that came to see him. He asked how much he would charge to make me a good cripple like those that crawl about the church. They had a dispute, but at last they agreed and the man said that I should be made so that people would shudder and give me plenty of money.

I was much frightened, but I did not make a sound and in the morning I went out to beg with Francesco. I said to him: "I am going to run away. I don't believe 'Tony is my grandfather. I don't believe that he fought for Garibaldi, and I don't want to be a cripple, no matter how much money the people may give."

"Where will you go?" Francesco asked me.

"I don't know," I said; "somewhere."

He thought awhile and then he said: "I will go, too."

So we ran away out of the city and begged from the country people as we went along. We came to a village down by the sea and a long way from Naples and there we found some fishermen and they took us aboard their boat. We were with them five years, and though it was a very hard life we liked it well because there was always plenty to eat. Fish do not keep long and those that we did not sell we ate.

The chief fisherman, whose name was Ciguciano, had a daughter, Teresa, who was very beautiful, and though she was two years younger than I, she could cook and keep house quite well. She was a kind, good girl and he was a good man. When we told him about the old man who told us he was our grandfather, the fisherman said he was an old rascal who should be in prison for life. Teresa cried much when she heard that he was going to make me a cripple. Ciguciano said that all the old man had taught us was wrong—that it was bad to beg, to steal and to tell lies. He called in the priest and the priest said the same thing and was very angry at the old man in Naples, and he taught us to read and write in the evenings. He also taught us our duties to the church and said that the saints

were good and would only help men to do good things, and
that it was a wonder that lightning from heaven had not struck
the old man dead when he knocked down the saint's figure.
We grew large and strong with the fisherman and he told
us that we were getting too big for him, that he could not
afford to pay us the money that we were worth. He was a fine,
honest man—one in a thousand.

Now and then I had heard things about America—that it
was a far-off country where everybody was rich and that Ital-
ians went there and made plenty of money, so that they could
return to Italy and live in pleasure ever after. One day I met
a young man who pulled out a handful of gold and told me he
had made that in America in a few days.

I said I should like to go there, and he told me that if I
went he would take care of me and see that I was safe. I told
Francesco and he wanted to go, too. So we said good-bye to
our good friends. Teresa cried and kissed us both and the
priest came and shook our hands and told us to be good men,
and that no matter where we went God and his saints were
always near us and that if we lived well we should all meet
again in heaven. We cried, too, for it was our home, that place.
Ciguciano gave us money and slapped us on the back and said
that we should be great. But he felt bad, too, at seeing us go
away after all that time.

The young man took us to a big ship and got us work away
down where the fires are. We had to carry coal to the place
where it could be thrown on the fires. Francesco and I were
very sick from the great heat at first and lay on the coal for a
long time, but they threw water on us and made us get up. We
could not stand on our feet well, for everything was going
around and we had no strength. We said that we wished we
had stayed in Italy no matter how much gold there was in
America. We could not eat for three days and could not do
much work. Then we got better and sometimes we went up
above and looked about. There was no land anywhere and we
were much surprised. How could the people tell where to go
when there was no land to steer by?

We were so long on the water that we began to think we
should never get to America or that, perhaps, there was not any
such place, but at last we saw land and came up to New York.

We were glad to get over without giving money, but I have heard since that we should have been paid for our work among the coal and that the young man who had sent us got money for it. We were all landed on an island and the bosses there said that Francesco and I must go back because we had not enough money, but a man named Bartolo came up and told them that we were brothers and he was our uncle and would take care of us. He brought two other men who swore that they knew us in Italy and that Bartolo was our uncle. I had never seen any of them before, but even then Bartolo might be my uncle, so I did not say anything. The bosses of the island let us go out with Bartolo after he had made the oath.

We came to Brooklyn, New York, to a wooden house in Adams street that was full of Italians from Naples. Bartolo had a room on the third floor and there were fifteen men in the room, all boarding with Bartolo. He did the cooking on a stove in the middle of the room and there were beds all around the sides, one bed above another. It was very hot in the room, but we were soon asleep, for we were very tired.

The next morning, early, Bartolo told us to go out and pick rags and get bottles. He gave us bags and hooks and showed us the ash barrels. On the streets where the fine houses are the people are very careless and put out good things, like mattresses and umbrellas, clothes, bats and boots. We brought all these to Bartolo and he made them new again and sold them on the sidewalk; but mostly we brought rags and bones. The rags we had to wash in the back yard and then we hung them to dry on lines under the ceiling in our room. The bones we kept under the beds till Bartolo could find a man to buy them.

Most of the men in our room worked at digging the sewer. Bartolo got them the work and they paid him about one-quarter of their wages. Then he charged them for board and he bought the clothes for them, too. So they got little money after all.

Bartolo was always saying that the rent of the room was so high that he could not make anything, but he was really making plenty. He was what they call a padrone and is now a very rich man. The men that were living with him had just come to the country and could not speak English. They had all been

sent by the young man we met in Italy. Bartolo told us all that we must work for him and that if we did not the police would come and put us in prison.

He gave us very little money, and our clothes were some of those that were found on the street. Still we had enough to eat and we had meat quite often, which we never had in Italy. Bartolo got it from the butcher—the meat that he could not sell to the other people—but it was quite good meat. Bartolo cooked it in the pan while we all sat on our beds in the evening. Then he cut it into small bits and passed the pan around, saying:

"See what I do for you and yet you are not glad. I am too kind a man, that is why I am so poor."

We were with Bartolo nearly a year, but some of our countrymen who had been in the place a long time said that Bartolo had no right to us and we could get work for a dollar and a half a day, which, when you make it *lire* (reckoned in the Italian currency) is very much. So we went away one day to Newark and got work on the street. Bartolo came after us and make a great noise, but the boss said that if he did not go away soon the police would have him. Then he went, saying that there was no justice in this country.

We paid a man five dollars each for getting us the work and we were with that boss for six months. He was Irish, but a good man and he gave us our money every Saturday night. We lived much better than with Bartolo, and when the work was done we each had nearly $200 saved. Plenty of the men spoke English and they taught us, and we taught them to read and write. That was at night, for we had a lamp in our room, and there were only five other men who lived in that room with us.

We got up at half-past five o'clock every morning and made coffee on the stove and had a breakfast of bread and cheese, onions, garlic and red herrings. We went to work at seven o'clock and in the middle of the day we had soup and bread in a place where we got it for 2¢ a plate. In the evenings we had a good dinner with meat of some kind and potatoes. We got from the butcher the meat that other people would not buy because they said it was old, but they don't know what is good. We paid 4¢ or 5¢ a pound for it and it was the best, though I have heard of people paying 16¢ a pound.

When the Newark boss told us that there was no more work Francesco and I talked about what we would do and we went back to Brooklyn to a saloon near Hamilton Ferry where we got a job cleaning it out and slept in a little room upstairs. There was a bootblack named Michael on the corner and when I had time I helped him and learned the business. Francesco cooked the lunch in the saloon and he, too, worked for the bootblack and we were soon able to make the best polish.

Then we thought we would go into business and we got a basement on Hamilton avenue, near the Ferry, and put four chairs in it. We paid $75 for the chairs and all the other things. We had tables and looking glasses there and curtains. We took the papers that have the pictures in and made the place high toned. Outside we had a big sign that said:

> THE BEST SHINE FOR TEN CENTS

Men that did not want to pay 10¢ could get a good shine for 5¢ but it was not an oil shine. We had two boys helping us and paid each of them 50¢ a day. The rent of the place was $20 a month, so the expenses were very great, but we made money from the beginning. We slept in the basement, but got our meals in the saloon till we could put a stove in our place, and then Francesco cooked for us all. That would not do, though, because some of our customers said that they did not like to smell garlic and onions and red herrings. I thought that was strange, but we had to do what the customers said. So we got the woman who lived upstairs to give us our meals and paid her $1.50 a week each. She gave the boys soup in the middle of the day—5¢ for two plates.

We remembered the priest, the friend of Ciguciano, and what he had said to us about religion, and as soon as we came to the country we began to go to the Italian church. The priest we found here was a good man, but he asked the people for money for the church. The Italians did not like to give because they said it looked like buying religion. The priest says it is different here from Italy because all the churches there are what they call endowed, while here all they have is what the people give. Of course I and Francesco understand that, but

the Italians who cannot read and write shake their heads and say that it is wrong for a priest to want money.

We had said that when we saved $1,000 each we would go back to Italy and buy a farm, but now that the time is coming we are so busy and making so much money that we think we will stay. We have opened another parlor near South Ferry, in New York. We have to pay $30 a month rent, but the business is very good. The boys in this place charge 60¢ a day because there is so much work.

At first we did not know much of this country, but by and by we learned. There are here plenty of Protestants who are heretics, but they have a religion, too. Many of the finest churches are Protestant, but they have no saints and no altars, which seems strange.

These people are without a king such as ours in Italy. It is what they call a Republic, as Garibaldi wanted, and every year in the fall the people vote. They wanted us to vote last fall, but we did not. A man came and said that he would get us made Americans for 50¢ and then we could get $2 for our votes. I talked to some of our people and they told me that we should have to put a paper in a box telling who we wanted to govern us.

I went with five men to the court and when they asked me how long I had been in the country I told them two years. Afterward my countrymen said I was a fool and would never learn politics.

"You should have said you were five years here and then we would swear to it," was what they told me.

I and Francesco are to be Americans in three years. The court gave us papers and said we must wait and we must be able to read some things and tell who the ruler of the country is.

There are plenty of rich Italians here, men who a few years ago had nothing and now have so much money that they could not count all their dollars in a week. The richest ones go away from the other Italians and live with the Americans.

We have joined a club and have much pleasure in the evenings. The club has rooms down in Sackett street and we meet many people and are learning new things all the time. We were very ignorant when we came here, but now we have learned much.

On Sundays we get a horse and carriage from the grocer and go down to Coney Island. We go to the theaters often, and other evenings we go to the houses of our friends and play cards.

I am now nineteen years of age and have $700 saved. Francesco is twenty-one and has about $900. We shall open some more parlors soon. I know an Italian who was a bootblack ten years ago and now bosses bootblacks all over the city, who has so much money that if it was turned into gold it would weigh more than himself.

Francesco and I have a room to ourselves and some people call us "swells." Ciguciano said that we should be great men. Francisco bought a gold watch with a gold chain as thick as his thumb. He is a very handsome fellow and I think he likes a young lady that he met at a picnic out at Ridgewood.

I often think of Ciguciano and Teresa. He is a good man, one in a thousand, and she was very beautiful. Maybe I shall write to them about coming to this country.

4. THE LIFE STORY OF
A GREEK PEDDLER

This chapter is contributed by a Spartan now living
in a suburb near New York City.

I WAS born about forty years ago in a little hamlet among the
mountains of Laconia in Greece. There were only about 200
people in this place, and they lived in stone huts or cottages,
some of which were two stories high, but most of them only
one story. The people were shepherds or small farmers, with
the exception of the priest and schoolmaster.

Two of the houses pretended to the character of village
stores, but they kept only the simplest, cheapest things, and
as a general rule, when we wanted to buy anything we had to
go down to Sparta, the chief town of our State, which was two
hours' walk away from our village. There was not even a
blacksmith shop in our town.

But the people did very well without shops. They made
almost everything for themselves. The inside of the cottage
consisted of one large room with a board floor. Sometimes
there were partitions inside the cottage, making several

rooms, but everything was very simple. The fireplace at one end of the room was large and open; beds were made of boards covered with hay, and stools and tables comprised about all the remainder of the furniture. Cooking was done on an iron tripod with the fire underneath.

Cotton goods we bought in Sparta, but we seldom bought anything else. We made all our own clothing, shearing the sheep, washing the wool, carding, spinning and weaving by hand as they did in the time of Homer. We made our own butter and our own wine, ground our own wheat and oats into flour and meal and did our own baking.

Our farms varied in size from ten to forty acres, and we raised on them such things as are raised here in America—all the grains and most of the fruits and vegetables. We plowed with oxen, thrashed with flails, winnowed by hand, and ground our grain in a mortar.

We had very little money, and so little use for money that the currency might almost as well have been the iron sort of our remote forefathers.

There was a little school in the town—there are schools all over Greece now—and most of the people could read and write, so they were not entirely ignorant; yet they had small knowledge of the world, and there were many, especially among the women, who knew almost nothing of what lay beyond the boundaries of their farms.

True, by climbing Mount Taygetos, where the Spartans used to expose their children not physically perfect, one could get a wide view of the surrounding sea with its ships and the shore with its cities, but the top of Taygetos was a day's journey from our village, and few of us had time or inclination to make the trip.

All people who were able worked from sunrise to sunset, the men on their farms or with the sheep, the women in the houses, spinning, weaving, making clothes or baking. If they did not know much about the great world, they also cared less. Now and then some one went down to Sparta and came home filled with its wonders, for Sparta has 15,000 inhabitants and is quite a bright little modern city, with horse cars, street gas lamps and a mayor.

Narrow as our lives might be considered by Americans,

there was plenty to interest us in the success or failure of our crops and our little plans, and, considering matters from the standpoint of our wants and our needs, we were certainly prosperous and happy. Most of us eat only one meal a day, but it was a hearty, healthy meal, and though we knew that some of the richer people ate two, the fashion did not commend itself to us. Like all Greeks, we were naturally inclined to temperance. There was no gluttony and no drunkenness, although we had plenty of good strong wine.

Forty days of the year were saints' days, and on those we feasted and did no work. We dressed in our best clothes and, gathering in one of the best houses, we danced to the music of the violin and guitar.

Sometimes there came an election, and then the men always carried rifles with them to the polling places, and around their waists were sashes stuck full of daggers and pistols, making them look wild and dangerous. But really there was seldom any fighting. In the first place, there were soldiers around the polling places and the elections were honest; in the second place, the armed peasants stayed sober, and in the third place, there was no stump speaking such as here, and no newspaper attacks, where the candidate of the opposite party is called a robber and accused of all manner of crimes. Feeling ran high at our elections and partisanship was bitter, but did not often lead to fights, because there was no speaking, no incitement.

The people are naturally very peaceful. They carry arms because it is their custom, coming down from the times when the Turks were in the country and the Greeks had to retire into the mountains and maintain constant watch in order to save themselves and their families from Turkish outrage and brutality.

I don't know on what lines the parties were drawn, or what principles they advocated. I think that the difference was just that some were in power and some were out, and that those who were out wanted to get in.

All loved our king and the royal family. Next to God we revered the king, and his whole family shared our love for him. Greeks are very democratic, but the members of this royal family are fit to be the first citizens in a pure democracy—they have done so much for the country and for all the people.

As I said, the people, in spite of their arms, are very peaceful. There is no brigandage, and murder in our locality occurred not more than once in ten years. There used to be a great deal of what was called brigandage in Turkish times, but it has all passed away. When the Turks retired, two-thirds of the land which had belonged to Turks came into the hands of the nation, and since that time the class of people who were formerly robbed and harried and oppressed until they were driven into brigandage has been encouraged to take to agriculture. Now there is no more Government land. The people have bought it all up, and although they have little money they are tolerably happy and prosperous.

On Sundays in our little village we dressed in our best clothes, and went to the church, where we heard the old priest, whom we all respected. There was only one church there, the Greek Orthodox, and though religion was free and a man could worship as he pleased, or not worship at all, there were no dissenters among us.

At the same time there was little superstition, to the best of my knowledge. Few believed in ghosts or fairies, or any sort of supernatural appearances; nor did they believe in modern miracles, and our respect for the saints was for men who had laid down their lives for Christianity. We had no sacred relics that miraculously restored health, and knew of none.

The only encounter with the supernatural that I ever had occurred when I was about ten years of age.

My grandmother needed a pound of wool to finish some sort of blanket she was weaving, and she sent me to the house of a neighbor, who lived far away. I set out riding a jackass and followed by a dog. I had not gone far when I met a little girl carrying a cat.

At the sight of my dog, down jumped the cat and ran for her life; the dog dashed after her, I dashed after the dog, the little girl after me. The only one who maintained his dignity was the jackass. Cat, dog and myself all fell into a stream, and when I emerged and presented the cat to the little girl I was dripping. She invited me to her house to dry, and there her mother fitted me out with the clothes of her little son, who had died a short time before. She said I looked just like him,

and tearfully begged me to stay over night. I finally consented as my grandmother would not expect me back the next day.

She put me in the little boy's bed, and went away, after bidding me good night. I went to sleep immediately, but woke up later and was horrified to see a large, round eye glaring at me. It was very large, about ten inches in diameter. I tried to scream, but I could not, and my fear was increased by the sound of footsteps coming toward me. I was sure it was the dead boy coming to avenge my taking his clothes and bed. Finally I was able to speak, and I said:

"Don't hurt me; I am going away, and I will not take the clothes with me."

But the footsteps continued to come directly toward me.

Then I jumped from my bed and desperately grabbed at the approaching thing. I seized a hairy head and pair of horns, and was more frightened than ever, feeling sure that I had caught the devil. But when the woman and the little girl came in laughing, with a light, the devil turned into the pet goat, which used to play with the little boy. The round eye also turned into a mirror.

Of the past of our country we knew little. We only knew that once Greece had been great, the light of the world, and we hoped that the time was coming when she would again resume her leadership of men. There were no ruins and no legends and traditions among us.

The school in my little village had only four grades, and when I had gone through those I was sent to Sparta to the High School. There I continued my education much as an American boy would do. Greece has a fine system of schools, established by the Government.

We had play in plenty. We played with marbles and tops and kites, and we practiced many of the classic sports, like running, and pitching flat stones at a mark, like quoits, or throwing the discus. We were great hands at wrestling, and in certain seasons of the year we hunted and shot partridges, rabbits and ducks.

When I had finished in the High School, I went to Athens, to an uncle who was in the drug business. I worked for him for a few years, and then had to enter the army, where I

spent two years in which there was nothing of particular interest.

All these later years I had been hearing from America. An elder brother was there who had found it a fine country and was urging me to join him. Fortunes could easily be made, he said. I got a great desire to see it, and in one way and another I raised the money for fare—250 francs—and set sail from the Piraeus, the old port of Athens, situated five miles from that city. The ship was a French liner of 6,000 tons, and I was a deck passenger, carrying my own food and sleeping on the boards as long as we were in the Mediterranean Sea, which was four days.

As soon as we entered the ocean matters changed for the better. I got a berth and the ship supplied my food. Nothing extraordinary occurred on the voyage and when I reached New York I got ashore without any trouble.

New York astonished me by its size and magnificence, the buildings shooting up like mountain peaks, the bridge hanging in the sky, the crowds of ships and the elevated railways. I think that the elevated railways astonished me more than anything else.

I got work immediately as a push-cart man. There was six of us in a company. We all lived together in two rooms down on Washington street and kept the push-carts in the cellar. Five of us took out carts every day and one was buyer, whom we called boss. He had no authority over us; we were all free. At the end of our day's work we all divided up our money even, each man getting the same amount out of the common fund— the boss no more than any other.

That system prevails among all the push-cart men in the City of New York—practical communism, all sharing alike. The buyer is chosen by vote.

The buyer goes to the markets and gets the stock for the next day, which is carried to the cellar in a wagon. Sometimes buying takes a long time, if the price of fruit is up, for the buyer has to get things as cheaply as possible. Sometimes when prices are down he buys enough for a week. He gets the fruit home before evening, and then it is ready for the next day.

I found the push-cart work not unpleasant, so far as the

work itself was concerned. I began at nine o'clock in the morn-
ing and quit about six o'clock at night. I could not speak
English and did not know enough to pay the police, so I was
hunted when I tried to get the good place like Nassau Street,
or near the Bridge entrance. Once a policeman struck me on
the leg with his club so hard that I could not work for two
weeks. That is wrong to strike like that a man who could not
speak English.

Push-cart peddlers who pay the police, make $500 to $1,000
a year clear of board and all expenses, and actually save that
amount in the bank; but those who don't pay the police make
from $200 to $300 a year. All the men in the good places pay
the police. Some pay $2 a day each and some $1 a day, and
from that down to 25¢. A policeman collects regularly, and we
don't know what he does with the money, but, of course, we
suspect. The captain passes by and he must know; the sergeant
comes along and he must know.

We don't care. It is better to pay and have the good place;
we can afford to pay. One day I made free and clear $10.25 on
eighteen boxes of cherries. That was the most I ever made in
a day. That was after I paid $1 a day for a good place.

There have been many attempts to organize us for political
purposes, but all these have failed. We vote as we please, for
the best man. No party owns us.

I soon went on to Chicago and got work there from a coun-
tryman who kept a fruit store. He gave me $12 a month and
my board, but he wouldn't teach me English. I got so I could
say such words as "Cent each," "Five cents for three," "Ten
cents a quart," but if I asked the boss the names of things he
would say never mind, it was not good for me to learn English.

I wrote home to my uncle in Athens to send me a Greek-
English dictionary, and when it came I studied it all the time
and in three months I could speak English quite well. I did
not spend a cent and soon found a better job, getting $17 a
month and my board. In a little while I had $100 saved, and
I opened a little fruit store of my own near the Academy of
Music.

One night after ten o'clock my lamp went down very low
and I wanted to fill it again. I had a five gallon can of kerosene
and a five gallon can of gasolene standing together under the

stall, and in the darkness I got out the can of gasolene. I filled
the lamp while it was still burning. It exploded over me and
I ran out of the place all in flames. The people were just coming
out of the Academy of Music when I rushed among them
shouting. Men threw their overcoats about me and put out the
flames, but I nearly lost my life. I was taken to a hospital,
where I lay for four months. All my hair was burned off, my
eyebrows and the skin of my neck and head, and I was in great
pain.

Finally I was able to get out, and my landlord took charge
of me and started me in business again.

He was a German; I think his name was Hackenbush. At
any rate he was very kind. I had not had sense enough to get
my store insured, and so had no money when I walked out of
the hospital. My landlord stocked it for me with fruits, cigars
and candies, and did all he could to put me on my feet, but I
had bad luck and gave up.

Then I left Chicago and went roaming, riding about on
freight cars looking for work. I had $20 in my pocket when I
set out, but it was soon gone. I could get no work. I fell in with
a gang of tramps, mostly Irish fellows; we rode generally in
the cabooses of freight cars. They used to beg, but I said "No,
I'll starve first."

I slept at nights in cemeteries for fear of being arrested as
a hobo if I slept in the parks, and for seven days I lived on 11¢.
On the eighth day I got a job carrying lumber on my shoulder.
I worked two days at this and earned three dollars, but was
so weak that I had to give it up.

So I went on, riding on top of a freight car. There were three
of us on top of that car, two lying down and one sitting up
reading a paper. We came to a tunnel, and when we had passed
through the man who was reading the paper was gone. When
the train made its next stop I and my companion went back
and found the missing man lying dead on the track. That
ended my riding on top of freight cars. I never tried it again.

I got a job in a bicycle factory soon after this. It paid me $9
a week and I could save seven, so I soon had money again; but
when the war with Turkey broke out I thought I would go back
and fight for Greece and I did, but the war was a disappoint-
ment. I was in several battles, such as they were, but no sooner

were we soldiers ready to fight than we would all be ordered to go back.

When the war was over I returned to this good country and became a citizen. I got down to business, worked hard and am worth about $50,000 to-day. I have fruit stores and confectionery stores.

There are about 10,000 Greeks in New York now, living in and about Roosevelt, Madison and Washington streets; about 200 of them are women. They all think this is a fine country. Most of them are citizens. Only about ten per cent. go home again, and of these many return to America, finding that they like their new home better than their old one.

The Greeks here are almost all doing well, there are no beggars and no drunkards among them, and the worst vice they have is gambling.

From Christmas till January 5 of each year there is great gambling in the Greek quarter, especially in the back rooms of the four restaurants. The police know all about it and it is allowed. Each of these restaurants takes in from $50 to $200 a night from gambling during the Christmas celebration. I suppose the police get their share. Poker is a favorite game, and other card games are played, thousands of dollars changing hands among the players.

That is our big spree, taking place once a year. Aside from that, we are very quiet and law abiding.

The Greek push-cart men are the Greek newcomers. They all save and they all get up. When they have a little money they open stores of their own, confectionery, flowers and fruit.

We think that the push-cart business is good for the city. The fruit is fresh every day, and people get what they want as they pass along the street. When the push-cart men finish selling dear to the people with plenty of money they go and sell cheap to the poor in the evenings. Plenty of fruit is a fine thing for health.

The fruit here, though, is not as good to eat as it is in Greece. The reason is that here it is picked before it is ripe and lies in an icehouse for weeks. That takes all the flavor, and so, though the fruit looks so fine, it has no good taste. The icebox is a bad thing. There is no ice to the fruit in Greece.

We Greeks are doing well here, we are taking citizenship

and we like this country; but the condition of the country we
have left disturbs us, and we would give all we possess, every
cent, all our money and goods, to see Greece free.

Greece, the country as it is to-day, has only 2,500,000 inhab-
itants, but there are 18,000,000 Greeks living in Turkey under
virtual slavery. In the city of Constantinople three out of four
inhabitants are Greeks. We want to see them all free.

They are ready for freedom, they are educated. There are
ten Greek schools, for every Turkish school in Turkey, and the
people are intelligent. The American schools there have done
great things, so it would be easy to set up free Greece again in
all the country formerly ruled over from Constantinople before
the coming of the Turks.

That would have been done long ago were it not for the
jealousy of European powers. Even as it is it must soon come—
the Turk in Europe is dying fast.

In addition to the schools set up and maintained by the Greek
Government and the Americans, there is another source of light
in Greece. That is the returned emigrants. Everywhere in
Greece now one meets men who have been in America and un-
derstand how happy a country may be. They have carried back
American ways and ideas, and are Americanizing the whole
country. In all the little towns and villages now English is
spoken.

Greeks are perhaps better fitted than any others in South
Europe to enjoy freedom. They take politics seriously, and
believe in voting for the best man.

Free Greece must come soon, but in precisely what shape
no one knows. There are so many things to be considered.
Constantinople ought to be the capital, but Russia wants Con-
stantinople. Russia is jealous of Greece, as matters are now,
because the patriarch head of her church is Greek and resides
in Constantinople. She would resist an extension of our power.

Germany and Austria, also, look upon those parts of old
Greece which are under Turkish sway with covetous eyes. When
Turkey dies they will present themselves as the natural heirs.

And yet, in spite of all, we Greeks feel that our country will
rise again, happy and prosperous, free and glorious, standing
once more as leader of the nations.

How this will come we know not; but it will be so, and that
within a generation.

5. THE LIFE STORY OF
A SWEDISH FARMER

Axel Jarlson, the author of the following biography,
is twenty-two years of age and a fine specimen of
the large, strong, energetic, blonde Norseman. He
speaks good English and his story, written from an
interview given on his way through New York to
spend the Christmas holidays with his parents in
the old country, is practically given in his own
words. His family's experience resembles that of
great numbers of his countrymen, who come here
intending to return finally to the old country, but
find themselves unconsciously Americanized.

I CAN remember perfectly well the day when my elder brother,
Gustaf, started for America. It was in April, 1891, and there
was snow on the ground about our cottage, while the forest
that covered the hills near by was still deep with snow. The
roads were very bad, but my uncle Olaf, who had been to
America often on the ships, said that this was the time to start,
because work on the farms there would just be beginning.

We were ten in the family, father and mother and eight
children, and we had lived very happily in our cottage until
the last year, when father and mother were both sick and we
got into debt. Father had a little piece of land—about two
acres—which he rented, and besides, he worked in the summer
time for a farmer. Two of my sisters and three of my brothers
also worked in the fields, but the pay was so very small that
it was hard for us to get enough to eat. A good farm hand in
our part of Sweden, which is 200 miles north of Stockholm

and near the Baltic Sea, can earn about 100 kroner a season, and a kroner is 27¢. But the winter is six months long, and most of that time the days are dark, except from ten o'clock in the morning to four o'clock in the afternoon. The only way our family could get money during the winter was by making something that could be sold in the market town, ten miles away. So my father and brothers did wood carving and cabinet making, and my mother and sisters knitted stockings, caps and mufflers and made homespun cloth, and also butter and cheese, for we owned two cows.

But the Swedish people who have money hold on to it very tight, and often we took things to market and then had to bring them home again, for no one would buy.

My uncle Olaf used to come to us between voyages, and he was all the time talking about America; what a fine place it was to make money in. He said that he would long ago have settled down on shore there, but that he had a mate's place on a ship and hoped some day to be captain. In America they gave you good land for nothing, and in two years you could be a rich man; and no one had to go in the army unless he wanted to. That was what my uncle told us.

There was a school house to which I and two of my sisters went all the winter—for education is compulsory in Sweden—and the schoolmaster told us one day about the great things that poor Swedes had done in America. They grew rich and powerful like noblemen and they even held Government offices. It was true, also, that no one had to go in the army unless he wanted to be a soldier. With us all the young men who are strong have to go in the army, because Sweden expects to have to fight Russia some day. The army takes the young men away from their work and makes hard times in the family.

A man who had been living in America once came to visit the little village that was near our cottage. He wore gold rings set with jewels and had a fine watch. He said that food was cheap in America and that a man could earn nearly ten times as much there as in Sweden. He treated all the men to brandvin, or brandy wine, as some call it, and there seemed to be no end to his money.

It was after this that father and mother were both sick during all of one winter, and we had nothing to eat, except black

bread and a sort of potato soup or gruel, with now and then a herring. We had to sell our cows and we missed the milk and cheese.

So at last it was decided that my brother was to go to America, and we spent the last day bidding him good-bye, as if we should never see him again. My mother and sisters cried a great deal, and begged him to write, my father told him not to forget us in that far off country, but to do right and all would be well, and my uncle said that he would become a leader of the people.

Next morning before daylight my brother and my uncle went away. They had twenty miles to walk to reach the railroad, which would take them to Gothenburg. My uncle had paid the money for the ticket which was to carry Gustaf to Minnesota. It cost a great deal—about $90, I believe.

In the following August we got our first letter from America. I can remember some parts of it, in which my brother said:

> I have work with a farmer who pays me 64 kroner a month, and my board. I send you 20 kroner, and will try to send that every month. This is a good country. It is like Sweden in some ways. The winter is long, and there are some cold days, but everything grows that we can grow in our country, and there is plenty. All about me are Swedes, who have taken farms and are getting rich. They eat white bread and plenty of meat. The people here do not work such long hours as in Sweden, but they work much harder, and they have a great deal of machinery, so that the crop one farmer gathers will fill two big barns. One farmer, a Swede, made more than 25,000 kroner on his crop last year.

After that we got a letter every month from my brother. He kept doing better and better, and at last he wrote that a farm had been given to him by the Government. It was sixty acres of land, good soil, with plenty of timber on it and a river running alongside. He had two fine horses and a wagon and sleigh, and he was busy clearing the land. He wanted his brother, Eric, to go to him, but we could not spare Eric, and so Knut, the third brother, was sent. He helped Gustaf for two years, and then he took a sixty-acre farm. Both sent money home to us, and soon they sent tickets for Hilda and Christine, two of my sisters.

People said that Hilda was very beautiful. She was eighteen of age, and had long shining golden hair, red cheeks and blue eyes. She was merry and a line dancer; far the best among the girls in all the country round, and she could spin and knit grandly.

She and Christine got work in families of Minneapolis, and soon were earning almost as much as my brothers had earned at first, and sending money to us. Hilda married a man who belonged to the Government of Minneapolis before she had lived there six months. He is a Swede, but has been away from home a long time. Hilda now went to live in a fine house, and she said in her letter that the only trouble she had was with shoes. In the country parts of Sweden they wear no shoes in the summer time, but in Minneapolis they wear them all the year round.

Father and mother kept writing to the children in America that now they had made their fortunes they should come home and live, but they put it off. Once Gustaf did return to see us, but he hurried back again, because the people thought so much of him that they had made him sheriff of a county. So it would not do to be long away.

I and my sister Helene came to this country together in 1899, Hilda having sent us the money, 600 kroner. We came over in the steerage from Gothenburg, on the west coast. The voyage wasn't so bad. They give people beds in the steerage now, and all their food, and it is very good food and well cooked. It took us twelve days to cross the sea, but we did not feel it long, as when people got over the sea sickness there was plenty of dancing, for most of those people in the steerage were Swedes and very pleasant and friendly. On fine days we could walk outside on the deck. Two men had concertinas and one had a violin.

When we got to Minneapolis we found Hilda living in a large brick house, and she had two servants and a carriage. She cried with joy when she saw us, and bought us new clothes because we were in homespun and no one wears that in Minneapolis. But she laid the homespun away in a chest and said that she would always keep it to remind her.

I stayed with Hilda two weeks and then went out to my brother Knut's farm, which is fifty miles northwest of Minne-

apolis. It was in August when I reached him, and I helped with the harvest and the threshing. He had built a log house, with six windows in it. It looked very much like the log house where my parents live in Sweden, only it was not painted red like theirs.

I worked for my brother from August 1899, to March, 1901, at $16 a month, making $304, of which I spent only $12 in that time, as I had clothes.

On the first day of March I went to a farm that I had bought for $150, paying $50 down. It was a bush farm, ten miles from my brother's place and seven miles from the nearest cross roads store. A man had owned it and cleared two acres, and then fallen sick and the storekeeper got it for a debt and sold it to me. My brother heard of it and advised me to buy it.

I went on this land in company with a French Canadian named Joachim. He was part Indian, and yet was laughing all the time, very gay, very full of fun, and yet the best axman I ever saw. He wore the red trimmed white blanket overcoat of the Hudson Bay Company, with white blanket trousers and fancy moccasins, and a red sash around his waist and a capote that went over his head.

We took two toboggans loaded with our goods and provisions, and made the ten-mile journey from my brother's house in three hours. The snow was eighteen inches deep on the level, but there was a good hard crust that bore us perfectly most of the way. The cold was about 10 below zero, but we were steaming when we got to the end of our journey. I wore two pairs of thick woolen stockings, with shoe-packs outside them—the shoe-pack is a moccasin made of red sole leather, its top is of strong blanket; it is very warm and keeps out wet. I wore heavy underclothes, two woolen shirts, two vests, a pilot jacket and an overcoat, a woolen cap and a fur cap. Each of us had about 300 pounds weight on his toboggan.

Before this I had looked over my farm and decided where to build my house, so now I went straight to that place. It was the side of a hill that sloped southward to a creek that emptied into a river a mile away.

We went into a pine grove about half way up the hill and

picked out a fallen tree, with a trunk nearly five feet thick, to make one side of our first house. This tree lay from east to west. So we made a platform near the root on the south side by stamping the snow down hard. On top of this platform we laid spruce boughs a foot deep and covered the spruce boughs over with a rubber blanket. We cut poles, about twenty of them, and laid them sloping from the snow up to the top of the tree trunk. Over these we spread canvas, and over that again large pieces of oilcloth. Then we banked up the snow on back and side, built a fire in front in the angle made by the tree root, and, as we each had two pairs of blankets, we were ready for anything from a flood to a hurricane. We made the fire place of flat stones that we got near the top of the hill and kindled the fire with loose birch bark. We had a box of matches, and good fuel was all about us. Soon we had a roaring fire going and a big heap of fuel standing by. We slung our pot by means of a chain to a pole that rested one end on the fallen tree trunk and the other on the crotch of a small tree six feet away; we put the pan on top of the fire and used the coffee or tea pot the same way—we made tea and coffee in the same pot. We had brought to camp:

FIRST OUTFIT

Cornmeal, 25 pounds	$0.47
Flour, 100 pounds	2.00
Lard, 10 pounds	1.00
Butter, 10 pounds	1.80
Codfish, 25 pounds	2.25
Ham, 12 pounds	1.20
Potatoes, 120 pounds	1.40
Rice, 25 pounds	2.15
Coffee, 10 pounds	2.75
Bacon, 80 pounds	1.50
Herrings, 200	1.75
Molasses, 2 gallons	.60
Axes, 8	8.55
Toboggans, 2	3.25
Pair blankets	5.00
Pot, coffee pot, frying pan	1.60
Knives, 2	.75
Salt, pepper, mustard	.15

Tea, 9 pounds	2.70
Matches	.10
Pickax	1.25
Spades, 2	3.00
Hoes, 2	2.00
Sugar, 80 pounds	1.80
Snow shoes, 1 pair	1.75
Gun	9.00
Powder and shot	.65
Total	$60.42

"Jake," as we all called the Frenchman, was a fine cook. He made damper in the pan, and we ate it swimming with butter along with slices of bacon and some roast potatoes and tea. "Jake," like all the lumbermen, made tea very strong. So did I, but I didn't like the same kind of tea. The backwoodsmen have got used to a sort of tea that bites like acid; it is very bad, but they won't take any other. I liked a different sort. So as we couldn't have both, we mixed the two together.

The sun went down soon after four o'clock, but the moon rose, the stars were very big and bright and the air quite still and so dry that no one could tell it was cold. "Jake" had brought a fiddle with him and he sat in the doorway of our house and played and sang silly French Canadian songs, and told stories in his own language. I could not understand a word he said, but he didn't care; he was talking to the fire and the woods as much as to me. He got up and acted some of the stories and made me laugh, though I didn't understand. We went to bed soon after eight o'clock, and slept finely. I never had a better bed than those spruce boughs.

Next morning, after a breakfast of cornmeal mush, herrings, coffee and bacon, we took our axes and went to work, and by working steadily for six hours we chopped an acre of ground and cut four cords of wood, which we stacked up ready for hauling. It was birch, beech, oak, maple, hickory, ironwood and elm, for we left the pine alone and set out to clear the land on the side of the creek first. The small stuff that was not good for cord wood we piled up for our own fire or for fence rails.

We found the fire out when we returned to our camp, but it was easy to light it again, and we had damper and butter, boiled rice and molasses, tea with sugar and slices of ham for

supper. A workingman living out of doors in that air can eat as much as three men who live in the city. A light snow fell, but it made no difference, as our fire was protected by the tree root, and we could draw a strip of canvas down over the doorway of our house.

So we lived till near the first of April when the sun began to grow warm and the ice and snow to melt. In that time we chopped about nine acres and made forty-five cords of wood, which we dragged to the bank of the river and left there for the boats to take, the storekeeper giving me credit for it on his books at $1.25 a cord. We also cut two roads through the bush. In order to haul the wood and break the roads I had to buy an ox team and bob sleigh which I got with harness, a ton of hay and four bushels of turnips for $63. I made the oxen a shelter of poles and boughs and birch bark sloping up to the top of an old tree root.

By April 15th the ground which we had chopped over was ready for planting, for all the snow and ice was gone and the sun was warm. I bought a lot of seed of several kinds, and went to work with spade and hoe, among the stumps of the clearing, putting in potatoes, corn, wheat, turnips, carrots, and a few onions, melons and pumpkins. We used spade and hoe in planting.

The soil was black loam on top of fine red sand, and the corn seemed to spring up the day after it was planted.

We planted nearly twelve acres of the land in a scattering way, and then set to work to build a log house of pine logs. "Jake" was a master hand at this, and in two weeks we had the house up. It was made of logs about 12 by 8 inches on the sides. It was 18 feet long and 12 feet deep, and had three small windows in the sides and back and a door. The ends of the logs were chopped so that those of the sides fitted into those of the front and back. The only nails were in the door. I had to buy the windows. The only furniture was two trunks, a table, a stool and a bench, all made with the axe. The roof was of birch bark.

About the first of June my sister Helene came with a preserving kettle, a lot of glass jars and a big scheme. We got a cook stove and a barrel of sugar, and put a sign on the river bank

announcing that we would pay 50¢ cash for 12 quarts of straw-
berries, raspberries or blackberries. All through June, July
and August Indians kept bringing us the berries, and my sister
kept preserving, canning and labeling them. Meanwhile we
dug a roothouse into the side of the hill and sided it up and
roofed it over with logs, and we built a log stable for cattle. A
load of lumber that we got for $2 had some planed boards in
it, of which we made doors. The rest we used for roofs, which
we finally shingled before winter came on again. The result of
my first season's work was as follows:

EXPENSES
(From March 1st to December 31st, 1901)

Farm, paid on account	$50.00
Axes, 4, with handles	5.00
Spades, 2	3.00
Hoes, 2	2.00
Oil lantern	1.25
Lamp with bracket	1.50
Oil, 4 gallons	.40
Cow with calf	25.00
Yoke of oxen, with harness, sleigh, etc.	63.00
Seed	12.50
"Jake's" wages, 6 months	120.00
Helene's wages, 7 months	112.00
Windows for house	6.50
Lumber	2.00
Kitchen utensils, dishes	5.40
Toboggans, 2	2.75
Blankets, 2 pairs	10.00
Pickaxe	1.25
Mutton, 35 pounds	2.10
Beef, 86 pounds	6.02
Corned beef, 70 pounds	3.50
Bacon, 82 pounds	4.10
Flour, 3 barrels	10.50
Cornmeal, 80 pounds	2.40
Codfish, 40 pounds	3.60
Sugar, 400 pounds	20.00
Oatmeal, 75 pounds	2.25
Molasses, 9 gallons	2.70

Tobacco, 10 pounds90
Candles... .10
Tea, 18 pounds ... 5.40
Coffee, 10 pounds .. 5.40
Plough .. 6.50
Rice, 25 pounds.. 2.15
Preserve jars, 400 .. 7.50
Stump extracting ... 17.00
Stove.. 3.00
Preserve jar labels, 500 2.50
All other expenses.. 21.00
 Total .. $552.17

INCOME AND CASH IN HAND
(March 1st to December 31st, 1901).

Cash in hand... $292.00
Wood, 45 cords at $1.25...................................... 56.25
Preserves, 400 quarts.. 66.50
Wheat, 67 bushels... 46.50
Corn, 350 bushels... 163.30
Carrots, 185 bushels ... 90.45
Turnips, 80 bushels... 32.00
Potatoes, 150 bushels.. 75.00
 Total .. $822.00
 Total expenses ... 552.17
 Balance on hand $269.83

That comparison of income and expenses looks more unfavorable than it really was because we had five months' provisions on hand on December 31st. We raised almost all our own provisions after the first three months. In 1902 my income was above $1,200, and my expenses after paying $50 on the farm and $62 for road making and stump extracting and labor, less than $600.

I have no trouble selling my produce, as the storekeeper takes it all and sells it down the river. He also owns a threshing machine and stump extractor.

The Frenchman went away in August, 1901. I don't know where he is. I have had other good workmen since but none like him.

I studied English coming out on the vessel, but I was here

six months before I could speak it well. I like this country very much, and will become a citizen.

One thing I like about this country is that you do not have to be always taking off your hat to people. In Sweden you take off your hat to everybody you meet, and if you enter a store you take off your hat to the clerk. Another thing that makes me like this country is that I can share in the government. In Sweden my father never had a vote, and my brothers never could have voted because there is a property qualification that keeps out the poor people, and they had no chance to make money. Here any man of good character can have a vote after he has been a short time in the country, and people can elect him to any office. There are no aristocrats to push him down. and say that he is not worthy because his father was poor. Some Swedes have become Governors of States, and many who landed here poor boys are now very rich.

I am going over to Sweden soon to keep Christmas there. Six hundred other Swedes will sail on our ship. Many are from Minnesota. They have done their fall planting, and the snow is on the ground up there, and they can easily get away for two months or more. So we are all going to our old home, but will come back again, and may be bring other people with us. Some Swedes go to the old country every Christmas.

We're going in the steerage and pay a low special rate because the ships need passengers at this time of the year. We'll have the steerage all to ourselves, and it ought to be very comfortable and jolly. We will dance and play cards all the way over.

Christmas is Sweden's great day; in fact, it is wrong to speak of it as a day because it keeps up for two weeks. The people have been preparing for it since November last. Near our place there are twelve farm houses and about ten people living in each house. In the last letter that I got from my mother two weeks ago she told me about the preparations for Christmas. I know who the maskers are, who will go around on Christmas Eve knocking at the doors of the houses and giving the presents. That's supposed to be a secret, but mother has found out.

I expect to return to America in February, and will try to bring my elder brother, Eric, and my youngest sister, Minna,

with me. Eric has never seen a city, neither has Minna, and they don't think that they would like America much because the ways of the people are so different and they work so much harder while they are working.

My father says that Sweden is the finest country in the world, and he will never leave, but he is only sixty years of age, and so he could move very well. Mother is younger, and they are both strong, so I think they will come to us in Minnesota next year, and then our whole family will be in America, for Uncle Olaf is now in New York in a shipping office.

Gustaf is married and has three children, and Knut is to be married shortly, but either of them would be glad to have the father and mother. I think, though, that they will come to my house.

I am carrying with me two trunks, and one of them is full of Christmas presents from Knut and Gustaf, Hilda and Christine to father, mother, Eric and Minna. When I return to America my trunk will be filled with presents from those in the old home to those in the new.

Among these presents are books of pictures showing Minneapolis, Duluth and New York, and photographs of our houses. My father and the other old men will not believe that there are any great cities in America. They say that it is a wild country, and that it is quite impossible that New York can be as large as Stockholm. When they hear about the tall buildings they laugh, and say that travelers always tell such wild tales. Maybe they will believe the photographs.

Some of the pictures that I am carrying to Sweden are of women in America. They have a better time than in Sweden. At least, they do not have to do such heavy work, and they dress much more expensively. Minna will be greatly surprised when she sees how Hilda dresses now, and I feel sure that she, too, will want to come here and try her fortune, where there are so many rich husbands to be had.

The Swedes who live in America like the old country girls, because they know how to save money.

6. THE LIFE STORY OF
A FRENCH DRESSMAKER

Amelia des Moulins is a French girl who, as her story
shows, is making her fortune in America, but is
going back to France to live.

I WAS born in a country district of France, on the edge of a
great forest, about 150 miles southwest of Paris. When I first
came to identify myself, I was a little red-cheeked, roly-poly,
black-haired, black-eyed baby of four years or so, tumbling
about under the trees trying to gather fagots.

My father had been one of the men in charge of the forest,
and when he was killed by the caving in of an earthbank the
great man who owned the estate on which we lived allowed
my mother to continue gathering firewood as before, which
was to us quite a valuable privilege, as fuel is scarce and dear
in France.

Our cottage was of stone. It was about 200 years old and
had tiled roof, though most of the cottages of the neighborhood
were thatched. The walls were nearly two feet thick and all
the front and sides were covered with ivy. There were only
two rooms on the ground floor, but overhead was a large loft,

with the floor boards loose on the beams. My brothers Jean and Francois slept in the loft, which they reached by a ladder, and sometimes the straw from their bed would come sifting down through the cracks above.

The large room on the ground floor was kitchen, dining room, sitting room and parlor. It had a great hearth, where a big iron pot hung on a thick chain, and both chain and pot were relics that had long been in my father's family. The only furniture here was a bench, four wooden stools and an old table, and the only picture on the plastered walls was a print of the Madonna. The other room was mother's bedroom, and I and my sister Madeline had a cot in the corner.

In comparison with some of our neighbors we were looked upon as wealthy, seeing that mother owned the house and field of two acres, and that she had about $400 saved up and buried in an old iron pot in the earthen floor of the little cellar, which was under the middle of the big room and reached through a trap door.

Mother was a large, stout, full blooded woman of great strength. She could not read or write and yet she was well thought of. There are all sorts of educations, and though reading and writing are very well in their way, they would not have done mother any good. She had the sort of education that was needed for her work. Nobody knew more about raising vegetables, ducks, chickens and pigeons than she did. There were some among the neighbors who could read and write and so thought themselves above mother, but when they went to market they found their mistake. Her peas, beans, cauliflower, cabbages, pumpkins, melons, potatoes, beets and onions sold for the highest price of any, and that ought to show whose education was the best, because it is the highest education that produces the finest work.

Mother used to take me frequently to the market. We had a big dog and a little cart (mother and the dog pulled the cart)—one can see hundreds of them in any French market town to-day. The cart was filled high with fowls and vegetables, and when I was very small I sat on the top holding our lunch, which was wrapped in a napkin. It was always the same, a half loaf of black bread to be eaten with an onion. I was inclined to be particular, and sometimes I would not eat

the black bread, which was hard and sour, but mother would just lay it aside and say that I would go to it before it would go to me, and I always did go to it, except one day when mother got impatient with me for being sulky and gave my bread to the dog, Hero, who ate it like the greedy thing that he was. I boxed his ears for that, but he only smiled at me. He was a big, black Newfoundland fellow, very good-natured.

We used to reach the market place about half-past five o'clock in the morning, and when we got there mother would back the cart up against the sidewalk and begin to shout about the chickens, eggs and vegetables. All the women with the carts were shouting and all the dogs barking, and there was great business.

The market women were a big, rough, fat, jolly set, who did not know what sickness was, and it might have been well for me if I had stayed among them and grown to be like mother. They had so much hard, healthy work that it gave them no time to worry.

One time in the market place I saw a totally different set of women. It was about eight o'clock in the morning, when some people began to shout:

"Here come the rich Americans! Now we will sell things!"

We saw a large party of travelers coming through the crowd. They looked very queer. Their clothes seemed queer, as they were so different from ours. They wore leather boots instead of wooden shoes, and they all looked weak and pale. The women were tall and thin, like bean-poles, and their shoulders were stooped and narrow; most of them wore glasses or spectacles, showing that their eyes were weak. The corners of their mouths were all pulled down and their faces were crossed and crisscrossed with lines and wrinkles, as though they were carrying all the care in the world.

Our women all began to laugh and dance and shout at the strangers. It was not very polite on our part, but the travelers certainly did look funny.

I was about six years old when that happened, and the sight of those people gave me my first idea of America. I heard that the women there never worked, laced themselves too tightly, and were always ill.

I would have grown up like mother and her friends but that

I did not seem to be good at their work. I took to reading, writing, sewing and embroidering, and I did not take to gardening and selling things, while I cried when they killed pigeons or chickens. So I was sent to Paris to live with my Aunt Celestina, a dressmaker, employed by one of the great establishments.

My aunt, though mother's sister, was not at all like her. She was small, thin and pale, with quick, black eyes and a snappy sort of way, though she was quite good hearted.

It was not very long before I found out just how the fashions are made. There are three great establishments in Paris that lead all others. These have very clever men working for them as designers of cloaks, hats and dresses. These designers not only know all the recent fashions, but also all the fashions that there were in the world hundreds of years ago. They have books full of pictures to help them, and what they try to do is to make the women change their dresses just as often as possible. That's the reason they keep changing the fashions.

Each time they make a new fashion they make it just as unlike the one that went before as can be, so that things that are six months old look ridiculous, and the women all over the world who are trying to follow the fashions put the old dresses away, even though they have only been worn once or twice. One time the sleeves are big at the shoulders and narrow at the wrists and at another time narrow at the shoulders and big at the wrists. One time the dress is tight at the waist and another time loose, and there are all sorts of changes in the size, shape and hang of the skirt; and in addition all the changes of fashion in colors and materials.

The keynote of fashion making is change, for the women all over the world are watching Paris, and they say, "You might as well be out of the world, as out of the fashion." The greater the changes the more dresses sold.

When these great milliners have decided on the new fashions they get some of the best known women in the city to lead off with them. These women are given magnificent costumes of the newest design to wear, and, in some cases, are even paid for wearing them. Of course these women are great beauties, and when they appear in the parks, or at the opera, all the

other women envy them, and all those who can, run away and get something of the same kind.

My aunt and I lived in a room on the fifth floor of an old brick house in one of the back streets. They were all poor people in the house, and I found the children very different from those in the country. They were not religious. The boys swore and smoked—even little ones of my own age—and the girls knew all sorts of bad things. There was no place to play but in the streets, and, for a time, I was very homesick. The other children laughed at me, but they were not altogether bad. They were good natured in their way. Most of them had never been in the country and they thought I was telling stories when I described the forest where you could walk for miles and see nothing but the trees.

Some of these children belonged to people who beat them, and a few had hardly any clothes. My aunt used to pity them so much, and in the evening she taught me dressmaking by making things for those children. She taught me measuring, cutting out, basting and stitching. In the day time I went to school. Mother sent aunt some money to help keep me, and as I had a natural love for dressmaking I got along. In the afternoons when school was over and before my aunt returned from her work I used to go and see all the beautiful things in the museums and art galleries.

I was with my aunt, learning all she could teach, till I was fourteen years of age, which was in 1895. I was quite a well grown girl then, and my aunt was going to get me employment in the place where she worked, when she died of a heavy cold, pneumonia, I suppose. After she caught the cold she went to work, and grew worse, but she wouldn't stop for two days. On the third day she was in a high fever and so dizzy that she could not stand when she rose from bed. I got her some medicine, but I did not know what to ask for and the druggist did not exactly know what to give. It did no good. So at last I called in a doctor, but she grew worse very fast and seemed choking. Some of the neighbors sat up with her in the early part of the night, but at three o'clock in the morning I was the only watcher. My aunt, who had been breathing very heavily and seemed unconscious,

suddenly sat up in bed, with her eyes staring. She was
frightened and began to cry.

"I'm dying," she said, "and I'm not fit to die; I have been so
wicked."

I spoke to her and held her hands, but I could not comfort
her.

"You are not dying, and you have not been wicked," I said.

"Oh! Oh! I have been so wicked!" she cried, again and again.
I declared that she had not done anything wrong, but she
answered:

"Those clothes that I made for the poor children, I stole all
the goods from our customers, because I could not bear to see
the little ones in such a state. Oh, it was very bad. If I wanted
to give the children something it should have been my own."

I was so frightened that I called up the people who lived in
the next room and one of them went for the priest, and after
he had talked with my aunt for a few minutes she seemed
comforted, but she died the next morning.

I went back to my mother's house for two weeks, but I could
not stay there, so I returned to Paris, where I went to work in
the shop that had employed my aunt.

Many of our best customers were Americans. They were all
very rich, and we heard that everybody in America was rich.
They drove up to our shop in carriages and automobiles, and
they wanted dresses like those of the queens and princesses.
Some of them spent whole weeks in our shop.

Part of the time I had to help try on and heard a great deal
of the conversation of these ladies. It was all about dress and
money. They said that Paris was just like their idea of heaven,
though the ones who said that had seen very little except our
shop. They were mostly daughters of working people, common
laborers, butchers and shopkeepers who had grown rich some
way, yet they were more haughty and proud than our own
aristocrats. In fact, they were pretending to be aristocrats. I
remember one of this sort who declared that she hated
America because it was a republic and contained so many
common people. She was sorry that France was a republic
and hoped it would again soon have a king. Our forewoman
always agreed with all the customers, and she agreed with
this one till her back was turned. Then she said:

"What a fool that woman is! She is coarse enough for the fish market, yet she thinks she can make people believe she is an aristocrat. I wonder what she is proud of?"

Most of the Americans I disliked, but there were a few of a different sort. One very beautiful, tall girl, whose father owned 10,000 miles of telegraph wires and something like $40,000,000, was as gentle, simple and pleasant as if she had been poor. She smiled at me when I was helping her to try on a new dress, and said:

"What good taste you have. If one as clever as you came to America she could do very well."

I had been for a long time thinking that same thing. If the Americans whom I had seen could have so much money, why not I? I said that to Annette, my room mate, and she also wanted to go to America.

Of course, it was all on account of the money, as there is no country like France and no city like Paris. We heard that some dressmakers in America received as much as 100 francs for a week's work. That seemed to me a great fortune.

By working at night Annette and I saved 300 francs, but it was stolen from our room and we had to begin all over again.

That was the reason why we did not reach America till 1899. We saved and saved, and we pinched ourselves hard, but it takes a long time for two sewing girls in Paris to scrape together 500 francs, and we could not start with less, because we wanted to have some money in our pockets when we landed.

It was in September when we started. I had never seen the ocean before and the voyage was all strange. When we approached America a man came to us and asked how much money we had. We showed him 40 francs.

"That is not enough," he said; "you will be sent back. No one is allowed to land in America unless he has 100 francs."

We were dreadfully frightened, but the man said that if we gave him 20 francs he would lend each of us $50 till we passed through the immigrants' gate and got into the city of New York. We gave him 20 francs and he gave each of us a $50 bill.

"But will they not think it strange that I and Annette have each a $50 bill in American money?" I asked.

"Not at all," said he. "American money is now good all over the world."

When we reached the immigrants' gate, however, the men there told us that the $50 bills were no good. They were what is called Confederate. The man who had given them to us had slipped away. We would have been sent back to France if some other immigrants had not taken pity on us and lent us some money.

Oh, how glad we were to get away from that place and into the city. We landed in a sort of park, and a good woman, who was one of those that helped us, treated us to peaches and popcorn. The peaches were the largest and ripest I ever ate. They fairly melted in our mouths.

A car took us to a place in South Fifth Avenue where there are many French people. We were horrified when we found that we must pay $2 a week for a miserable room, but we could do no better. We had only 10 francs left, and all the first week after our landing we lived on potatoes—that we roasted over the gas flame—and stale bread. The woman who kept the house walked about in the passage smelling the air and saying that some one was cooking in one of the bedrooms, but she did not find us out.

That was a horrible place. Most of the people in it seemed to be mad; they made such awful noises in the night—singing, shouting, banging pianos, dancing and quarreling.

The partition that separated our room from the one next door to it was thin and there was a hole in it, through which a man once peeped. He talked at us, but we nailed a piece of tin over the hole; and as for his talk, we never answered it.

I don't think that that house had been dusted or swept in six months; the servants looked most untidy. Most of the women lodgers slept till noon each day and then walked about the passages wearing old wrappers. Their hair was done up in curl papers and their faces were covered with a white paste to improve their complexions. They looked hideous till they washed themselves later in the day. These were all married women who had no children and nothing to do but gad about.

Each day after our arrival in New York we wandered about the streets looking for work, but we did not know where to look and had no luck. We could not speak English and that made it very hard. We might have starved but that Annette made $2 posing for an artist, whom she met quite by chance.

He had been in Paris and he knew immediately that she was French. He saw by the way she looked at the shop signs that she was strange to the city and he spoke to her in French. Of course she answered, and they became acquainted.

"How did you know I was French?" she asked, and he answered:

"A French girl! Ah, how could I mistake you for one of another nation?"

That is the truth, too, though I say it myself. All the world knows that we French have the true artistic taste, and we show it most in our dress. The Germans or the English cannot make dresses or hats, and even when we make for them they cannot wear the clothes properly. There is something wrong somewhere, probably with the color scheme. Those other people do not understand, they cannot comprehend, it is impossible to convey to them the conception of true harmony. It is like trying to teach the blind about light. They lack the soul of the artist, and so their dresses are shocking, hideous discords of form and color. When I see them I simply want to scream.

Berlin has lately been trying to make fashions of her own. Pah! Pooh! What presumption!

Annette is tall and fair, while I am dark and not more than medium height. The artist posed her as a Venetian flower girl with bare feet. I saw the picture lately hanging in a great gallery. It is very beautiful and exactly like Annette—though she always says that I am the beauty. Of course that is not true.

After we had been for eight days looking for work without finding any we spoke to the woman who kept the house where we lived. She knew a little French.

"I think that I can get you situations," she said, "but they will cost you $10 for each."

I told her that we had no money.

"No matter," said she; "you can pay me after you are paid, and I will then pay the forewoman. But you must not say anything to her about paying, because the proprietor does not know about it." The next day we went with the woman to a Sixth Avenue dressmaker, where we were engaged at $7 a week each, which seemed to us good pay. We had to give the woman of our house $5 a week each for two weeks, and as we

paid $1 a week each for our room, we nearly starved trying
to live on the remainder. At the end of two weeks we were
discharged by the forewoman, though there was plenty of
work. I learned afterward that the forewoman made a great
deal of money that way, by receiving pay for hiring girls whom
she afterward discharged.

We seemed to be in a worse state than ever and cried all
the night after we were sent away from the Sixth Avenue place.
But at six o'clock in the next morning we rose and said long
prayers, and I wrote a sort of letter to be shown. It said like
this:

> "MADAME : Please to behold us as two girls who have of Paris
> the art dressmaker from the best models taken to make the
> dress for the American, we will comprehend so well if you but
> try. If you please.
>
> <div align="right">ANNETTE ,
AMELIA "</div>

I wrote that because I could take time and use the correct
language, as I had found when I spoke the English, Americans
did not understand.

We hurried into the street, having no breakfast, but full of
hope, for it was the season of dressmaking and we surely must
get something.

We entered a fine place on Twenty-third Street and a man
behind a counter sent us upstairs, where we found twenty
women engaged. The proprietress read my letter and asked us
questions. She did not seem to understand well and called a
German girl who spoke French.

I had all my life hated Germans, but I could not hate this
girl as she spoke to us so kindly.

I told her where we had had experience, and what we could
do, and she said to the proprietress:

"We must have these, Miss G____. They come from the best
place in Paris and look clever."

"Nonsense!" said the proprietress; "we don't want them.
They are mere apprentices."

I understood what she meant and said in French that we
were not apprentices, but of long experience, and Annette, too,
joined in.

But the proprietress was only pretending. She wanted us all the time. So at last she said:

"But how much money would you want?"

"Seven dollars a week," said I, because I thought that I might as well ask for plenty.

The proprietress almost screamed:

"Seven dollars a week, and you have just landed!"

"Oh, no," I said; "we have been here nearly a month."

At last we were engaged at $6 a week each and they put us at work immediately. Our hours were from eight o'clock in the morning till six o'clock in the evening. When we went home that night we were very happy and treated ourselves to a little feast in our room. On $6 a week we knew that we could live finely and we felt sure that we could keep this place, as they had put us on good work at once and we knew that we had done well.

Our proprietress was full of tricks. In appearance she was a tall, thin, sharp faced woman with fair hair. She was very quick in speech and action, and a great driver among the girls. She did all the measuring and cutting out and her perquisites included all the materials that were left over from the dresses.

A tall woman would need seventeen yards of silk or other narrow goods, while one who was shorter might get along very well with fourteen yards. Our proprietress would always exaggerate the amount of material needed and then, in cutting out, would be able to reserve some for herself. Often she got as much as two yards. These pieces she slipped into a private drawer, of which she had the key. It did not take her long, therefore, to get enough to make herself a new skirt or a waist, and odd pieces could be used as piping or as trimming for hats.

Accordingly she was always very well dressed, and though sometimes customers recognized parts of their own materials in her costume, they seldom said anything.

Once, though, I thought there was going to be a scene. A stout lady who was one of our best customers came in one day and saw our proprietress just going out to lunch. The stout lady immediately stood still and glared at the proprietress's new hat, which was on her head. It was a very stylish hat and the silk trimming was precisely the same as the piping of the lady's dress that had recently been made at our place.

"Why, you've got my piping!" she cried.

The proprietress flushed and smiled, but she was equal to the occasion.

"Yes, Mrs. Miller," she said, "it's the very same as yours. The truth is I admired the material so much that I sent out and bought some. Don't you like my hat?"

"Oh, yes," said the stout lady. "Where did you get that material?"

This was a catch, because there was only one store in town where it could have been bought, but our proprietress was not to be trapped.

"One of my girls got it for me. I don't know where she got it," she said.

"Humph!" exclaimed the stout lady, and wandered away without another word.

She came back later on and gave us more custom. She knew that she was being robbed, but she knew, also, that it was the dressmakers' rule to help themselves from their customers' material.

On another occasion a lady who had given five yards of wide ribbon for trimming came back after she had received the dress.

"I don't understand how it is, Miss ____," she said. "I gave you five yards of this ribbon. There's only four yards on the dress. I measured it with the tape measure."

The proprietress produced tape measure and gravely measured the trimming.

"Dear me! you're right," she exclaimed. "Now, what can have happened to that other yard? Where can it be? Girls, did you see it any place?"

The customer just sniffed.

We all buzzed about, but it was the proprietress herself who found the missing ribbon under a pile of goods. She appeared to be greatly surprised, and the customer sniffed again.

Our proprietress, I think, never told the truth while she was at business. She would promise most solemnly to have a dress made up in three days when she knew quite well that it could not be done in two weeks.

Sometimes when the bell rang she would look out and say:

"Oh, girls! There's that Mrs. K____ come again. I promised

for sure that her dress would be ready to try on this afternoon and I haven't put the scissors in it yet. Run down, Katie, and keep her in the parlor."

Then she would rush at the goods and the pattern, cut out with lightning speed and toss the various parts to different girls to baste. In half an hour there was the dress, basted, ready to try on, and the customer none the wiser as to how it was done.

Some of our customers suffered greatly in their efforts to be fashionable, for fashion takes no account of the natural shape of the human body. It did not matter so much to the thin women, because all they had to do was to stuff their figures, but some of the stout women were martyrs.

One very beautiful woman was fat and would not acknowledge it, as she had been quite slim.

"My waist measure," she said, "is twenty-four inches."

She insisted on this and made two of us girls pull her corset strings till we secured the right girth.

My! that was a job! The squeezing must have hurt her awfully. She was gasping for breath and perspiring rivers, but she would not give up.

When we sent the dress home she brought it back.

"It doesn't fit," she said.

"Where?" asked the proprietress.

"The waist is too small."

"The waist is twenty-four inches. You gave that yourself as your measurement. All you have to do is to have your corsets tightened as they were on the day when you were measured."

The poor lady looked at us and we all nodded assent. We had heard her insist that 24 was her measurement. Soon she was again in the hands of the tighteners, gasping and perspiring.

When the corsets were well pulled in the dress fitted like a glove, but the poor lady's face was the color of blood and she could hardly speak.

"I m—m—must—have—been mistaken!" she gasped.

"Certainly!" said our proprietress. "I never saw a better fit."

The poor lady staggered away trying to look comfortable. I don't believe she could wear that dress, though, as she was growing stouter.

The only thing to be done for stout people is to make every-thing plain, avoid bright colors and have all lines running up and down. That gives the appearance of greater height and less girth.

Lines running up and down make short women look taller. As to tall women, they don't want to look shorter now. It's the fashion to be tall. The plump, cosy, little woman is out of date.

The first thing that I and Annette did when we began to have a little money was to move away from the horrible place in South Fifth Avenue. We never could understand those peo-ple. Most of them were connected with theaters, and they kept hours that seemed crazy. We got a room in West Twenty-fourth Street for $3 a week—a very good room, too—and made arrangement with a restaurant to give us breakfast and supper for $2.50 per week each.

So our starvation was at an end, and we had $2 a week to do with as we pleased. In a few weeks we had good clothing, and after that we were able to save a little.

Annette came to me one day with her eyes as big as saucers. "What do you think!" she said. "That girl Rosa gets $12 a week and she is not as clever as us."

We were both very angry at Rosa, though I suppose it was not her fault. Still she had no right to get more. It was ridicu-lous; we were the better workwomen.

"Wait," said I; "we are learning the English."

We waited six months and then asked the proprietress to give us $12 a week. She screamed at us with rage.

"What impudence!" she said.

But we only smiled; we knew enough of the English now and were not afraid.

She gave us $9 a week each and we stayed there six months more. Then, when the holiday season was coming on, we went to a great dressmaking place in Fifth Avenue and told the proprietress about our Paris experience and where we were now working. She asked how much we were getting and we said $18 a week.

That was true, too, because each of us got $9. We would not tell what was not true.

The proprietress said: "Well, if they give you $18 a week in Twenty-third Street we will give you $20 a week here."

When we told the proprietress of the Twenty-third Street shop she screamed again, and said that we could not go, that she would give us a bad character. We said it was no matter, we would not ask the character from her. Then she cried, and said that we had ingratitude and she would give us $12 a week each.

We cried, too. Because after all she was not such a bad one to work for. But we had to go, as it was too much money that we wanted for staying.

So we began in Fifth Avenue, and now it was quite new the sort of trade. We have been in that place ever since. We have been in the very finest houses of New York, talking with all the beauties and trying on their dresses for them.

The girls here are very beautiful, but I cannot like them. They have not the heart of French women. All that is given to them they take as their due and they are not grateful. They love, but it is only themselves. They do not care for men, except to have them as slaves bringing them the money that they so much need. For fine dress they will do anything.

I have told of the tricks that dressmakers play on ladies, but they are no worse than those that ladies play on dressmakers and on other people. In the first place, many of them won't pay their bills. In the second place they get costumes made and delivered that they wear one night and then return, saying that they have changed their minds, or that the costume doesn't fit—they deny that they have worn it except to try on—they get $50 or $100 cash and have it charged as a dress or hats in the bill, so as to deceive their husbands. They are finicky and want things changed because their minds have changed. They expect us to remake them in spite of nature. All the fat women insist that we shall make them look thin.

Then if they quarrel with us they use slander.

One of our customers, a very sweet little lady, who is quite wealthy, said the other day to our proprietress:

"How have you offended Mrs. L____?"

"Have I offended her?" the proprietress asked.

"It seems so. I was walking with her on the street the other day when you passed. You bowed to me and I responded, when Mrs. L____ said: 'Oh, do you know that person?' 'Why, yes,' said I, 'that's my dressmaker.' 'Indeed!' said she; 'how can you

stand her? She fits so badly.' 'I've always found her a true artist,' said I."

Our proprietress was very angry when she heard this story. "Now I will tell the whole truth," she said. "That woman owes me $850, and it would be more than $1,000, but the last costume I sent C. O. D. 'My husband is not home and I have no money,' said she to the girl. The girl in spite of her protests brought the costume away. She came to me and said, 'I have to wear that costume this evening. I am going to the ball!' 'Then you must pay for it,' said I. 'But I have not the money and my husband is away.' 'Get the money,' said I. She did get it and I gave her the costume, but she has slandered me ever since."

Ah! it is a good country to work in, no doubt. Annette is now getting $40 a week and I almost as much, and we have plenty saved; but I am not to live here.

To one born in England, Germany, Austria, Holland or Scandinavia this may appear fine, but not so to the French.

There is but one France and only one Paris in all the world, and soon, very soon, Annette and I will be aboard some great ship that will bear us back there.

7. THE LIFE STORY OF
A GERMAN NURSE GIRL

The first name of the pretty nurse girl who writes
this chapter is Agnes, but it's not worth while giving
her last name because, as the last paragraph im-
plies, it is liable soon to be changed.

I WAS born just twenty years ago in the old, old city of Treves,
in what was once France, but is now Germany. There were
eight children in our family, five girls and three boys, and we
were comfortably off until my father died, which happened
when I was only three years old.

My father was a truckman, carrying goods from the railway
stations to the shops; he had a number of wagons going and
had built up a good business, though he was always ill from
some disease that he contracted when a soldier in the war
with France. It was consumption, I believe, and it finally car-
ried him off. We were living at the time in a fine new house
that he had built near the Moselle, but we were soon obliged
to move, because though my mother was a good business
woman, every one robbed her, and even my uncle made the
mortgage come down on our house without telling her—which
she said was very mean.

By the time I was five years old my mother had lost every-
thing except the money she got from the Government, which
was enough to keep her, but the family had to break up, and
I went away to a school kept by Sisters of Christian Liebe, in
another city. The Government paid for me there on account of
my being a soldier's orphan—all of us children had allowances
like that.

From the time I went away to that school till I was fifteen
years of age I did not once see my mother, but stayed in school
during all the holidays. But in spite of that I was not sad. It
was the pleasantest time of my life, and I often wonder if I
shall ever be as happy again.

The school was for Catholics, and I was glad I was a Catholic
it was so good to be there; and I heard that at the school to
which the Lutheran children went the teachers were very
severe. However that might be, our Sisters were among the
kindest women that ever lived and they loved us all dearly.

Every one at the school made much of me because I was so
little—a gay little thing with fuzzy, light hair and blue eyes,
and plenty to say for myself and a good voice for singing. I
learned quickly, too, and when play time came I played hard.

We got up at half-past six o'clock each morning, and had
mass three times a week and morning prayer when there was
no mass. At eight o'clock school began and lasted to ten, when
there was half an hour for play, then an hour more school,
then more play and then lunch, after which we worked in the
garden or sewed or sang or played till six o'clock, when we
had dinner, and we all went to bed at eight. We did not always
go to sleep though, but sometimes lit candles after the Sisters
had gone away and had feasts of apples and cakes and candies.

There were about eighty boys in this school and fifty-five
girls—none of them older than fifteen years. We had a very
large playground, and though the boys and girls were kept
separate they yet found means of conversing, and when I was
eleven years of age I fell in love with a tall, slim, thoughtful,
dark-haired boy named Fritz, whose parents lived in Frank-
furt. We used to talk to each other through the bars of the
fence which divided our playground. He was a year and a half
older than I, and I thought him a man. The only time I was
ever beaten at that school was on his account. We had been

talking together on the playground; I did not heed the bell and was late getting in, and when the Sister asked what kept me I did not answer. She insisted on knowing, and Fritz and I looked at each other. The Sister caught us laughing.

Whipping on the hands with a rod was the punishment that they had there for very naughty children, and that is what I got. It did not hurt much, and that night at half past nine o'clock, when all the house was still, there came a tapping at our dormitory window, and when it was opened we found Fritz there crying about the way I had been whipped. He had climbed up one of the veranda posts and had an orange for me. The other girls never told. They said it was so fine and romantic.

Fritz and I kept up our friendship till he had to leave the place, which was when I had grown to be nearly thirteen years of age. He climbed to our dormitory again to bid me good-bye, and tell me that when I was free from the school he would seek me out and marry me. We cried together as he told me his plans for being a great man, and all that night and the next night, too, I cried alone; but I never saw him again, and I'm afraid that his plans must have miscarried.

When I was fifteen years of age I left school and returned to my mother, who was then living in a flat with some of my brothers and sisters. Two of my brothers were in the army and one of my sisters was in America, while another sister was married in Germany.

I did not like it much at home. My mother was almost a stranger to me, and after the kindness of the Sisters and the pleasantness of their school she seemed very stern.

I went to work for a milliner. The hours were from eight o'clock in the morning till six in the evening, but when there was much business the milliner would keep us till nine o'clock at night. I got no money, and was to serve for two years for nothing as an apprentice.

But the milliner found that I was already so clever with the needle that she set me to work making hats and dresses after the first two weeks that I was working for her, and when I had been there six months I could see that I had nothing more to learn in her place and that staying there was just throwing away my time.

Needlework seemed to come naturally to me, while I disliked cooking and was not much good at it. My two elder sisters, on the other hand, were stupid at sewing and embroidery, but master hands at cooking. My eldest sister was such a good cook that her husband started a restaurant so that she might have a chance to use her talents; and as for my second eldest sister, within two months after she landed in America—where she was sent by my eldest sister—she was earning $35 a month as a cook for one of the rich families.

My sister in America sent money for my eldest brother to go to her when his time in the army was done. We were all glad to see him go, because he had been a sergeant and was so used to commanding that he tried to command everybody he met. He even tried to command me!

Such ways won't do outside of the army. Another thing that we disliked was that, having been a sergeant, he was too proud to work, so we were glad to see him go to America. He lived for awhile by borrowing money from my sister till she got married to a mechanical engineer, who would not have him about the house when he heard of his actions.

So he had to do something, and became a butler, and a very good one, too, making plenty of money but spending it all on himself. He is employed by a family on the east side of Central Park now, getting $60 a month. When I went to see him a year ago he pretended that he did not know me. He has also forgotten my sister who helped him to come out here, and he has never sent a dollar to mother.

I heard about how easy it was to make money in America and became very anxious to go there, and very tired of making hats and dresses for nothing for a woman who was selling them at high prices. I was restless in my home also; mother seemed so stern and could not understand that I wanted amusement.

I was not giddy and not at all inclined to flirt, but I had been used to plenty of play at the school, and this all work and no play and no money to spend was hard.

If I had been inclined to flirt there was plenty to do in Treves, for the city was full of soldiers, young fellows who, when they wore their uniforms, thought that a girl could not fail to be in love with them; but they made a mistake when

they met me. They used to chirrup after me, just like birds, but I would turn and make faces to show what I thought of them—I was not quite sixteen then.

There were officers there, too, but they never noticed me. They belong to the high families, and go about the streets with their noses up in the air and their mustaches waxed up, trying to look like the Emperor. I thought they were horrid.

I grew more and more tired of all work and no play, and more and more anxious to go to America; and at last mother, too, grew anxious to see me go. She met me one night walking in the street with a young man, and said to me afterward: "It is better that you go."

There was nothing at all in my walking with that young man, but she thought there was and asked my eldest sister to lend me the money to go to America to my second eldest sister, and a month later I sailed from Antwerp, the fare costing $55.

My second eldest sister with her husband met me at Ellis Island and they were very glad to see me, and I went to live with them in their flat in West Thirty-fourth Street. A week later I was an apprentice in a Sixth Avenue millinery store earning $4 a week. I only paid $3 a week for board, and was soon earning extra money by making dresses and hats at home for customers of my own, so that it was a great change from Germany. But the hours in the millinery store were the same as in Germany, and there was overtime, too, occasionally; and though I was now paid for it I felt that I wanted something different—more time to myself and a different way of living. I wanted more pleasure. Our house was dull, and though I went to Coney Island or to a Harlem picnic park with the other girls now and then, I thought I'd like a change.

So I went out to service, getting $22 a month as a nursery governess in a family where there were three servants besides the cook.

I had three children to attend to, one four, one six and one seven years of age. The one who was six years of age was a boy; the other two were girls. I had to look after them, to play with them, to take them about and amuse them, and to teach them German—which was easy to me, because I knew so little English. They were the children of a German mother, who talked to them in their own language, so they already knew

something of it. I got along with these children very well and
stayed with them for two years, teaching them what I knew
and going out to a picnic or a ball or something of that sort
about once a week, for I am very fond of dancing.

We went to Newport and took a cottage there in the summer
time, and our house was full of company. A certain gentleman
there once told me that I was the prettiest girl in the place,
with a great deal more of the same sort of talk. I was dressed
in gray, with white insertion, and was wearing roses at the
time he said that. He caught me passing through the parlor
when the others were away. Of course I paid no attention to
him, but it was early in the day. It was generally late in the
evening when gentlemen paid such compliments.

I enjoyed life with this family and they seemed to like me,
for they kept me till the children were ready to go to school.
After I left them I went into another family, where there were
a very old man and his son and granddaughter who was mar-
ried and had two children. They had a house up on Riverside
Drive, and the old man was very rich. The house was splendid
and they had five carriages and ten horses, and a pair of
Shetland ponies for the children. There were twelve servants.
and I dined with the housekeeper and butler, of course—be-
cause we had to draw the line. I got $25 a month here and two
afternoons a week, and if I wanted to go any place in particular
they let me off for it.

These people had a fine place down on Long Island to which
we all went in the summer, and there I had to ramble around
with the children, boating, bathing, crabbing, fishing and
playing all their games. It was good fun, and I grew healthy
and strong.

The children were a boy of ten and girl of eight years. They
were restless and full of life but good natured, and as they
liked me I would have stayed there till they grew too old to
need me any more, but that something awful happened during
the second summer that we were spending on Long Island.

It was one night in June, when the moon was very large and
some big stars were shining. I had been to the village with the
housekeeper to get the mail, and at the post office we met the
butler and a young man who sailed the boats for us. Our way
home lay across the fields and the young man with me kept

stopping to admire things, so that the others got away ahead of us.

He admired the moon and the stars and the sky, and the shine of the water on the waves and the way that the trees cast their shadows, and he didn't seem to be thinking about me at all, just talking to me as he might to any friend. But when we walked into a shadowy place he said:

"Aren't you afraid of catching cold?" and touched my wrap.

"Oh, no," I said.

"You had better draw that together," said he, and put his arm about it to make it tight. He made it very tight, and the first thing I knew he kissed me.

It was done so quickly that I had no idea—I never saw a man kiss any one so quickly.

I gave such a scream that one could hear it a mile and boxed his ears, and as soon as I could tear myself away I ran as fast as I could to the house, and he ran as fast as he could to the village.

I was very angry and crying. He had given me no warning at all, and besides I did not like him enough. Such impudence! But I probably would not have said anything about the matter at the house, but that the next day all the people in the village were talking about it. My mistress heard of it and called me in, and I told her the truth; but she seemed to think that I could help being kissed, and I grew stubborn then and said I would not stay any more.

I am of a very yielding disposition when coaxed, and anything that I possess I will give away to any one who persists in asking me for it. That's one of my faults; my friends all tell me that I am too generous. But at the same time, when treated unjustly, I grow stubborn and won't give way.

And it was unjust to blame me for what that young man did. Who would have thought he would dare to do such a thing as kiss me? Why, he was only the young man who sailed the boat! And as to my screaming so loudly I could not help it; any girl would have screamed as loudly if she had been kissed as suddenly.

I went back to my sister's house in New York after I left this place, and stayed there a month resting. I had been nearly four years in the country, and in spite of sending $6 a month

to mother during all that time and sending money to bring my second eldest brother here I had $485 in the savings bank. A girl working as I was working does not need to spend much. I seldom had to buy a thing, there was so much that came to me just the least bit worn.

After I had rested and enjoyed a holiday I secured another situation, this time to mind the baby of a very rich young couple. It was the first and only baby of the mistress, and so it had been spoiled till I came to take charge. It had red hair and green eyes, and a fearful temper—really vicious.

I had thought that the place would be an easy one, but I soon found out that this was a great mistake. The baby was eighteen months old, and it had some settled bad habits. The maid and its mother used to give it its own way in everything.

"It won't go in the carriage," said the maid to me when I first took charge.

"It will with me," said I.

"It sleeps all day and cries all night," said the maid.

"It's been spoiled by getting its own way, that's the trouble," said I.

So I put it in the carriage and took it out to Central Park, in a shady place down by the lake. It fought and struggled and howled as if it would like to kill me, but I had brought a good book and I paid no attention to it.

It had an orange, a bottle of milk and some cakes, and threw them all away. I didn't even look at it. It cried for nearly four hours steadily, but we had the place to ourselves and I didn't mind.

When I was good and ready I took it to the restaurant and gave it a little ice cream, for I knew that it was sure to be hot and thirsty. I was sorry for doing that, however, because it cried and fought me again when I put it back in the carriage. It wanted me to carry it all the way in my arms, which I was determined not to do.

So the first day that I had it in charge the baby did not get any sleep, and was good and tired when its proper bedtime came. The maid told me that it would not go to sleep without being rocked; but I said that I was in charge of that baby now and it would have to give up its crankiness. I put it to bed and it did not wait for any rocking; it went right off to sleep.

The mistress came in and said that I was a clever, good girl, and she was sure that I would get along finely with the baby— that all it needed was some one who understood and sympathized with it. She also said that it looked like a little angel. I wondered at her taste in angels.

Next day I carried the baby out to the park again for another lesson. It was in a dreadful temper, and when it was being dressed it beat the maid. It used to slap its mother and the maid in the face, but it never treated me in that manner. I would not allow it. I would hold up my finger and say, "B-a-a-a-a-a-by!" and it would understand and stop. It saw something in my eye that made it keep quiet. I have great influence over children.

We went down by the lake again that second day, and I read a good German book and let the baby rage. When it was crying it could not be sleeping, and it was far better to have it cry in the daytime than at night, when it disturbed the whole house.

The baby threw everything out of its carriage, even its coverlets and pillows, and tried to fall out itself, but it was tied in. It cried till it exhausted itself inventing new ways of screaming. I sat at a distance from it, so that its screaming would not annoy me too much, and read my book till it had finished. Then I went and got some ice cream for myself, and gave the baby very little. I wanted to teach it to do without things. It had been in the habit of getting everything it cried for, and that had made it hard to live with. That night, again, the baby went to sleep without rocking, and the young mother was much pleased with my management and gave me a nice silk waist.

Day after day we went on like that. I took the baby some place where it could have its cry out without disturbing anybody, and I didn't allow it to sleep in the daytime, and so had it good and tired when night came on and other people wanted to sleep. It never failed to cry and struggle and throw its toys and food away, to show its rage, but I would have made a good baby of it had it not been for the mother and the maid. When I wasn't on hand they spoiled it by giving it all its own way. Even when I was on hand the mother was constantly running into the room and petting the baby. At its slightest cry she would come to see what it wanted, and hold things up for it to choose.

This made discipline impossible, and in the end the baby was too much for me. I was made to carry it about, and to get up and walk with it in the night, and at last my health broke down and I actually had to go to a hospital.

When I got out I stayed at my sister's for a month, and then went as a nursery governess in a family where there are three children, none of them over eight years of age. I have to teach them their lessons, including German, and to take them out driving and playing. I have recovered my health, but I will never again undertake to manage a strange baby. The duties are light; I have two afternoons a week to myself and practically all the clothing I need to wear. My salary is $25 a month.

Wherever I have been employed here the food has always been excellent; in fact, precisely the same as that furnished to the employer's families. In Germany it is not so. Servants are all put on an allowance, and their food is very different from that given to their masters.

I like this country. I have a great many friends in New York and I enjoy my outings with them. We go to South Beach or North Beach or Glen Island or Rockaway or Coney Island. If we go on a boat we dance all the way there and all the way back, and we dance nearly all the time we are there.

I like Coney Island best of all. It is a wonderful and beautiful place. I took a German friend, a girl who had just come out, down there last week, and when we had been on the razzle-dazzle, the chute and the loop-the-loop, and down in the coal mine and all over the Bowery, and up in the tower and everywhere else, I asked her how she liked it. She said:

"Ach, it is just like what I see when I dream of heaven."

Yet I have heard some of the high people with whom I have been living say that Coney Island is not tony. The trouble is that these high people don't know how to dance. I have to laugh when I see them at their balls and parties. If only I could get out on the floor and show them how—they would be astonished.

Two years ago, when I was with a friend at Rockaway Beach, I was introduced to a young man who has since asked me to marry him. He is a German from the Rhine country, and has been ten years in this country. Of course he is a tall, dark man, because I am so small and fair. It is always that

way. Some of our friends laugh at us and say that we look like a milestone walking with a mile, but I don't think that it is any of their business and tell them so. Such things are started by girls who are jealous because they have no steady company.

I don't want to get married yet, because when a girl marries she can't have so much fun—or rather, she can't go about with more than one young man. But being engaged is almost as bad. I went to the theater with another young man one night, and Herman was very angry. We had a good quarrel, and he did not come to see me for a week.

A good-looking girl can have a fine time when she is single, but if she stays single too long she loses her good looks, and then no one will marry her.

Of course I am young yet, but still, as my mother used to say, "It's better to be sure than sorry," and I think that I won't wait any longer. Some married women enjoy life almost as much as the young girls.

Herman is the assistant in a large grocery store. He has been there nine years, and knows all the customers. He has money saved, too, and soon will go into business for himself.

And then, again, I like him, because I think he's the best dancer I ever saw.

8. THE LIFE STORY OF

AN IRISH COOK

The cook whose story follows, lived for many years in the home of one of America's best known literary women, who has taken down her conversation in this form.

I DON'T know why anybody wants to hear my history. Nothing ever happened to me worth the tellin' except when my mother died. Now she was an extraordinary person. The neighbors all respected her, an' the minister. "Go ask Mrs. McNabb," he'd say to the women in the neighborhood here when they come wantin' advice.

But about me—I was born nigh to Limavaddy; it's a pretty town close to Londonderry. We lived in a peat cabin, but it had a good thatched roof. Mother put on that roof. It isn't a woman's work, but she—was able for it.

There were sivin childher of us. John an' Matthew they went to Australia. Mother was layin' by for five year to get their passage money. They went into the bush. We heard twice from thim and then no more. Not another word and that is forty year gone now—on account of them not reading and writing. Learning isn't cheap in them old countries as it is

here, you see. I suppose they're dead now—John would be
ninety now—and in heaven. They were honest men. My
mother sent Joseph to Londonderry to larn the weaver's trade.
My father he never was a steddy worker. He took to the drink
early in life. My mother an' me an' Tilly we worked in the field
for Squire Varney. Yes, plowin' an' seedin' and diggin'—any
farm work he'd give us. We did men's work, but we didn't get
men's pay. No, of course not. In winter we did lace work for
a merchant in Londonderry. (Ann still can embroider beauti-
fully.) It was pleasanter nor diggin' after my hands was fit for
it. But it took two weeks every year to clean and soften my
hands for the needle.

Pay was very small and the twins—that was Maria and
Philip—they were too young to work at all. What did we eat?
Well, just potatoes. On Sundays, once a month, we'd maybe
have a bit of flitch. When the potatoes rotted—that was the
hard times! Oh, yes, I mind the famine years. An' the cornmeal
that the 'Mericans sent. The folks said they'd rather starve nor
eat it. We didn't know how to cook it. Here I eat corn dodgers
and fried mush fast enough.

Maria—she was one of the twins—she died the famine year
of the typhus and—well, she sickened of the herbs and roots
we eat—we had no potatoes.

Mother said when Maria died, "There's a curse on ould
green Ireland and we'll get out of it." So we worked an' saved
for four year an' then Squire Varney helped a bit an' we sent
Tilly to America. She had always more head than me. She
came to Philadelphia and got a place for general housework
at Mrs. Bent's. Tilly got but $2 a week, bein' a greenhorn. But
she larned hand over hand, and Mrs. Pent kept no other help
and laid out to teach her. She larned her to cook and bake and
to wash and do up shirts—all American fashion. Then Tilly
axed $3 a week. Mother always said, "Don't ax a penny more
than you're worth. But know your own vally and ax that."

She had no expenses and laid by money enough to bring
me out before the year was gone. I sailed from Londonderry.
The ship was a sailin' vessel, the "Mary Jane." The passage
was $12. You brought your own eating, your tea an' meal, an'
most had flitch. There was two big stoves that we cooked on.
The steerage was a dirty place and we were eight weeks on

the voyage—over time three weeks. The food ran scarce, I tell you, but the captain gave some to us, and them that had plenty was kind to the others. I've heard bad stories of things that went on in the steerage in them old times—smallpox and fevers and starvation and worse. But I saw nothing of them in my ship. The folks were decent and the captain was kind.

When I got here Mrs. Bent let Tilly keep me for two months to teach me—me bein' such a greenhorn. Of course I worked for her. Mr. Bent was foreman then in Spangler's big mills. After two months I got a place. They were nice appearing people enough, but the second day I found out they were Jews. I never had seen a Jew before, so I packed my bag and said to the lady, "I beg your pardon, ma'am, but I can't eat the bread of them as crucified the Saviour." "But," she said. "he was a Jew." So at that I put out. I couldn't hear such talk. Then I got a place for general housework with Mrs. Carr. I got $2 till I learned to cook good, and then $3 and then $4. I was in that house as cook and nurse for twenty-two years. Tilly lived with the Bents till she died, eighteen years. Mr. Bent come to be partner in the mills and got rich, and they moved into a big house in Germantown and kept a lot of help and Tilly was housekeeper. How did we keep our places so long? Well, I think me and Tilly was clean in our work and we was decent, and, of course, we was honest. Nobody living can say that one of the McNabbs ever wronged him of a cent. Mrs. Carr's interests was my interests. I took better care of her things than she did herself, and I loved the childher as if they was my own. She used to tell me my sin was I was stingy. I don't know. The McNabbs are no wasteful folk. I've worn one dress nine year and it looked decent then. Me and Tilly saved till we brought Joseph and Phil over, and they went into Mr. Bent's mills as weaver and spool boy and then they saved, and we all brought out my mother and father. We rented a little house in Kensington for them. There was a parlor in it and kitchen and two bedrooms and bathroom and marble door step, and a bell. That was in '66, and we paid $9 a month rent. You'd pay double that now. It took all our savings to furnish it, but Mrs. Bent and Mrs. Carr gave us lots of things to go m. To think of mother having a parlor and marble steps and a bell! They came on the old steamer "Indiana" and got here at night, and

we had supper for them and the house all lighted up. Well, you ought to have seen mother's old face! I'll never forget that night if I live to be a hundred. After that mother took in boarders and Joseph and Phil was there. We all put every cent we earned into building associations. So Tilly owned a house when she died and I own this one now. Our ladies told us how to put the money so as to breed more, and we never spent a cent we could save. Joseph pushed on and got big wages and started a flour store, and Phil went to night-school and got a place as clerk. He married a teacher in the Kensington public school. She was a showy miss! Silk dress and feathers in her hat!

Father died soon after he come. The drink here wasn't as wholesome for him as it was in Ireland. Poor father! He was a good-hearted man, but he wasn't worth a penny when he died.

Mother lived to be eighty. She was respected by all Kensington. The night she died she said: "I have much to praise God for. I haven't a child that is dependent on the day's work for the day's victuals. Every one of them owns a roof to cover him."

Joseph did well in his flour store. He has a big one on Market Street now and lives in a pretty house out in West Philadelphia. He's one of the wardens in his church out there and his girls gives teas and goes to reading clubs.

But Phil is the one to go ahead! His daughter Ann—she was named for me, but she calls herself Antoinette—is engaged to a young lawyer in New York. He gave her a diamond engagement ring the other day. And his son, young Phil, is in politics and a member of councils. He makes money hand over hand. He has an automobile and a fur coat, and you see his name at big dinners and him making speeches. No saving of pennies or building associations for Phil.

It was Phil that coaxed me to give up work at Mrs. Carr's and to open my house for boarders here in Kensington. His wife didn't like to hear it said I was working in somebody's kitchen. I've done well with the boarders. I know just how to feed them so as to lay by a little sum every year. I heard that young Phil told some of his friends that he had a queer old aunt up in Kensington who played poor, but had a great store

of money hoarded away. He shouldn't have told a story like that. But young folks will be young! I like the boy. He is certainly bringing the family into notice in the world. Last Sunday's paper had his picture and one of the young lady he is going to marry in New York. It called him the young millionaire McNabb. But I judge he's not that. He wanted to borrow the money I have laid by in the old bank at Walnut and Seventh the other day and said he'd double it in a week. No such work as that for me! But the boy certainly is a credit to the family!

9. THE LIFE STORY OF
A FARMER'S WIFE

This story of an Illinois farmer's wife is printed exactly as she penned it.

I HAVE been a farmer's wife in one of the States of the Middle West for thirteen years, and everybody knows that the farmer's wife must of a necessity be a very practical woman, if she would be a successful one.

I am not a practical woman and consequently have been accounted a failure by practical friends and especially by my husband, who is wholly practical.

We are told that the mating of people of opposite natures promotes intellectuality in the offspring; but I think that happy homes are of more consequence than extreme precocity of children. However, I believe that people who are thinking of mating do not even consider whether it is to be the one or the other.

We do know that when people of opposite tastes get married there's a discordant note runs through their entire married

life. It's only a question of which one has the stronger will in determining which tastes shall predominate.

In our case my husband has the stronger will; he is innocent of book learning, is a natural hustler who believes that the only way to make an honest living lies in digging it out of the ground, so to speak, and being a farmer, he finds plenty of digging to do; he has an inherited tendency to be miserly, loves money for its own sake rather than for its purchasing power, and when he has it in his possession he is loath to part with it, even for the most necessary articles, and prefers to eschew hired help in every possible instance that what he does make may be his very own.

No man can run a farm without some one to help him, and in this case I have always been called upon and expected to help do anything that a man would be expected to do; I began this when we were first married, when there were few household duties and no reasonable excuse for refusing to help.

I was reared on a farm, was healthy and strong, was ambitious, and the work was not disagreeable, and having no children for the first six years of married life, the habit of going whenever asked to became firmly fixed, and he had no thought of hiring a man to help him, since I could do anything for which he needed help.

I was always religiously inclined; brought up to attend Sunday school, not in a haphazard way, but to attend every Sunday all the year round. and when I was twelve years old I was appointed teacher to a Sunday school class, a position I proudly held until I married at eighteen years of age.

I was an apt student at school and before I was eighteen I had earned a teacher's certificate of the second grade and would gladly have remained in school a few more years, but I had, unwittingly, agreed to marry the man who is now my husband, and though I begged to be released, his will was so much stronger that I was unable to free myself without wounding a loving heart, and could not find it in my nature to do so.

All through life I have found my dislike for giving offense to be my undoing. When we were married and moved away from my home church, I fain would have adopted the church of my new residence, but my husband did not like to go to

church; had rather go visiting on Sundays, and rather than have my right hand give offense, I cut it off.

I always had a passion for reading; during girlhood it was along educational lines; in young womanhood it was for love stories, which remained ungratified because my father thought it sinful to read stories of any kind, and especially love stories.

Later, when I was married, I borrowed everything I could find in the line of novels and stories, and read them by stealth still, for my husband thought it a willful waste of time to read anything and that it showed a lack of love for him if I would rather read than to talk to him when I had a few moments of leisure, and, in order to avoid giving offense and still gratify my desire, I would only read when he was not at the house, thereby greatly curtailing my already too limited reading hours.

In reading miscellaneously I got glimpses now and then of the great poets and authors, which aroused a great desire for a thorough perusal of them all; but up till the present time I have not been permitted to satisfy this desire. As the years have rolled on there has been more work and less leisure until is only by the greatest effort that I may read current news.

It is only during the last three years that I have had the news to read, for my husband is so very penurious that he would never consent to subscribing for papers of any kind and that old habit of avoiding that which would give offense was so fixed that I did not dare to break it.

The addition of two children to our family never altered or interfered with the established order of things to any appreciable extent. My strenuous outdoor life agreed with me, and even when my children were born, I was splendidly prepared for the ordeal and made rapid recovery. I still hoed and tended the truck patches and garden, still watered the stock and put out feed for them, still went to the hay field and helped harvest and house the bounteous crops; still helped harvest the golden grain later on when the cereals ripened; often took one team and dragged ground to prepare the seed-bed for wheat for weeks at the time, while my husband was using the other team on another farm which he owns several miles away.

While the children were babies they were left at the house,

and when they were larger they would go with me to my work; now they are large enough to help a little during the summer and to go to school in winter; they help a great deal during the fruit canning season—in fact, can and do work at almost everything, pretty much as I do.

All the season, from the coming in of the first fruits until the making of mince-meat at Christmas time, I put up canned goods for future use; gather in many bushels of field beans and the other crops usually raised on the farm; make sour-kraut, ketchup, pickles, etc.

This is a vague, general idea of how I spend my time; my work is so varied that it would be difficult, indeed, to describe a typical day's work.

Any bright morning in the latter part of May I am out of bed at four o'clock; next, after I have dressed and combed my hair, I start a fire in the kitchen stove, and while the stove is getting hot I go to my flower garden and gather a choice, half-blown rose and a spray of bride's wreath, and arrange them in my hair, and sweep the floors and then cook breakfast.

While the other members of the family are eating breakfast I strain away the morning's milk (for my husband milks the cows while I get breakfast), and fill my husband's dinner-pail, for he will go to work on our other farm for the day.

By this time it is half-past five o'clock, my husband is gone to his work, and the stock loudly pleading to be turned into the pastures. The younger cattle, a half-dozen steers, are left in the pasture at night, and I now drive the two cows, a half-quarter mile and turn them in with the others, come back, and then there's a horse in the barn that belongs in a field where there is no water, which I take to a spring quite a distance from the barn; bring it back and turn it into a field with the sheep, a dozen in number, which are housed at night.

The young calves are then turned out into the warm sunshine, and the stock hogs, which are kept in a pen, are clamoring for feed, and I carry a pailful of swill to them, and hasten to the house and turn out the chickens and put out feed and water for them, and it is, perhaps, 6:30 A.M.

I have not eaten breakfast yet, but that can wait; I make the beds next and straighten things up in the living room, for

I dislike to have the early morning caller find my house topsy-turvy. When this is done I go to the kitchen, which also serves as a dining-room, and uncover the table, and take a mouthful of food occasionally as I pass to and fro at my work until my appetite is appeased.

By the time the work is done in the kitchen it is about 7:15 A.M. , and the cool morning hours have flown, and no hoeing done in the garden yet, and the children's toilet has to be attended to and churning has to be done.

Finally the children are washed and churning done, and it is eight o'clock, and the sun getting hot, but no matter, weeds die quickly when cut down in the heat of the day, and I use the hoe to a good advantage until the dinner hour, which is 11:30 A.M. We come in, and I comb my hair, and put fresh flowers in it, and eat a cold dinner, put out feed and water for the chickens; set a hen, perhaps, sweep the floors again; sit down and rest, and read a few moments, and it is nearly one o'clock, and I sweep the door yard while I am waiting for the clock to strike the hour.

I make and sow a flower bed, dig around some shrubbery, and go back to the garden to hoe until time to do the chores at night, but ere long some hogs come up to the back gate, through the wheat field, and when I go to see what is wrong I find that the cows have torn the fence down, and they, too, are in the wheat field.

With much difficulty I get them back into their own domain and repair the fence. I hoe in the garden till four o'clock; then I go into the house and get supper, and prepare something for the dinner pail to-morrow; when supper is all ready it is set aside, and I pull a few hundred plants of tomato, sweet potato or cabbage for transplanting, set them in a cool, moist place where they will not wilt, and I then go after the horse, water him, and put him in the barn; call the sheep and house them, and go after the cows and milk them, feed the hogs, put down hay for three horses, and put oats and corn in their troughs, and set those plants and come in and fasten up the chickens, and it is dark. By this time it is eight o'clock P.M. ; my husband has come home, and we are eating supper; when we are through eating I make the beds ready, and the children and

their father go to bed, and I wash the dishes and get things in shape to get breakfast quickly next morning.

It is now about nine o'clock P.M., and after a short prayer I retire for the night.

As a matter of course, there's hardly two days together which require the same routine, yet every day is as fully occupied in some way or other as this one, with varying tasks as the seasons change. In early spring we are planting potatoes, making plant beds, planting gardens, early corn patches, setting strawberries, planting corn, melons, cow peas, sugar cane, beans, popcorn, peanuts, etc.

Oats are sown in March and April, but I do not help do that, because the ground is too cold.

Later in June we harvest clover hay, in July timothy hay, and in August pea hay.

Winter wheat is ready to harvest the latter part of June, and oats the middle of July.

These are the main crops, supplemented by cabbages, melons, potatoes, tomatoes, etc.

Fully half of my time is devoted to helping my husband, more than half during the active work season, and not that much during the winter months; only a very small portion of my time is devoted to reading. My reading matter accumulates during the week, and I think I will stay at home on Sunday and read, but as we have many visitors on Sunday I am generally disappointed.

I sometimes visit my friends on Sunday because they are so insistent that I should, though I would prefer spending the day reading quietly at home. I have never had a vacation, but if I should be allowed one I should certainly be pleased to spend it in an art gallery.

As winter draws nigh I make snug all the vegetables and apples, pumpkins, and such things as would damage by being frozen, and gather in the various kinds of nuts which grow in our woods to eat during the long, cold winter.

My husband's work keeps him away from home during the. day all the winter, except in extremely inclement weather, and I feed and water the stock, which have been brought in off the pastures; milk the cows and do all the chores which are to be done about a farm in winter.

By getting up early and hustling around pretty lively I do all this and countless other things; keep house in a crude, simple manner; wash, make and mend our clothes; make rag carpets, cultivate and keep more flowers than anybody in the neighborhood, raise some chickens to sell and some to keep, and even teach instrumental music sometimes.

I have always had an itching to write, and, with all my multitudinous cares, I have written, in a fitful way, for several papers, which do not pay for such matter, just because I was pleased to see my articles in print.

I have a long list of correspondents, who write regularly and often to me, and, by hook and crook, I keep up with my letter-writing, for, next to reading, I love to write and receive letters, though my husband says I will break him up buying so much writing material; when, as a matter of course, I pay for it out of my own scanty income.

I am proud of my children, and have, from the time they were young babies, tried to make model children of them. They were not spoiled as some babies are, and their education was begun when I first began to speak to them, with the idea of not having the work to do over later on. True, they did not learn to spell until they were old enough to start to school, because I did not have time to teach them that; but, in going about my work, I told them stories of all kinds, in plain, simple language which they could understand, and after once hearing a story they could repeat it in their own way, which did not differ greatly from mine, to any one who cared to listen, for they were not timid or afraid of anybody.

I have watched them closely, and never have missed an opportunity to correct their errors until their language is as correct as that of the average adult, as far as their vocabulary goes, and I have tried to make it as exhaustive as my time would permit.

I must admit that there is very little time for the higher life for myself, but my soul cries out for it, and my heart is not in my homely duties; they are done in a mechanical abstracted way, not worthy of a woman of high ambitions; but my ambitions are along other lines.

I do not mean to say that I have no ambition to do my work well, and to be a model housekeeper, for I would scorn to

slight my work intentionally; it is just this way: There are so
many outdoor duties that the time left for household duties is
so limited that I must rush through them, with a view to
getting each one done in the shortest possible time, in order
to get as many things accomplished as possible, for there is
never time to do half as much as needs to be done.

All the time that I have been going about this work I have
been thinking of things I have read; of things I have on hand
to read when I can get time, and of other things which I have
a desire to read, but cannot hope to while the present condition
exists.

As a natural consequence, there are, daily, numerous in-
stances of absentmindedness on my part; many things left
undone that I really could have done by leaving off something
else of less importance, if I had not forgotten the thing of the
more importance. My husband never fails to remind me that
it is caused by my reading so much; that I would get along
much better if I should never see a book or paper, while really
I would be distracted if all reading matter was taken from me.

I use an old fashioned churn, and the process of churning
occupies from thirty minutes to three hours, according to the
condition of the cream, and I always read something while
churning, and though that may look like a poor way to attain
self-culture, yet if your reading is of the nature to bring about
that desirable result, one will surely be greatly benefited by
these daily exercises.

But if one is just reading for amusement, they might read
a great deal more than that and not derive any great benefit;
but my reading has always been for the purpose of becoming
well informed; and when knitting stockings for the family I
always have a book or paper in reading distance; or, if I have
a moment to rest or to wait on something, I pick up something
and read during the time. I even take a paper with me to the
fields and read while I stop for rest.

I often hear ladies remark that they do not have time to
read. I happen to know that they have a great deal more time
than I do, but not having any burning desire to read, the time
is spent in some other way; often spent at a neighbor's house
gossiping about the other neighbors.

I suppose it is impossible for a woman to do her best at

everything which she would like to do, but I really would like to. I almost cut sleep out of my routine in trying to keep up all the rows which I have started in on; in the short winter days I just get the cooking and house straightening done in addition to looking after the stock and poultry, and make a garment occasionally, and wash and iron the clothes; all the other work is done after night by lamp light, and when the work for the day is over, or at least the most pressing part of it, and the family are all asleep and no one to forbid it, I spend a few hours writing or reading.

The minister who performed the marriage ceremony for us has always taken a kindly interest in our fortunes and, knowing of my literary bent, has urged me to turn it to account; but there seemed to be so little time and opportunity that I could not think seriously of it, although I longed for a literary career; but my education had been dropped for a dozen years or more, and I knew that I was not properly equipped for that kind of a venture.

This friend was so insistent that I was induced to compete for a prize in a short story contest in a popular magazine not long since, though I entered it fully prepared for a failure.

About that time there came in my way the literature of a correspondence school which would teach, among other things, short story writing by mail; it set forth all the advantages of a literary career and proposed properly to equip its students in that course for a consideration.

This literature I greedily devoured, and felt that I could not let the opportunity slip, though I despaired of getting my husband's consent.

I presented the remunerative side of it to him, but be could only see the expense of taking the course, and wondered how I could find time to spend in the preparation, even if it should be profitable in the end; but he believed it was all a humbug; that they would get my money and I would hear from them no more.

When I had exhausted my arguments to no avail, I sent my literary friend to him, to try his persuasive powers. The two of us, finally, gained his consent, but it was on condition that the venture was to be kept profoundly secret, for he felt sure that there would be nothing but failure, and he desired that no one should know of it and have cause for ridicule.

Contrary to his expectations the school has proven very trustworthy, and I am in the midst of a course of instruction which is very pleasing to me; and I find time for study and exercise between the hours of eight and eleven at night, when the family are asleep and quiet. I am instructed to read a great deal, with a certain purpose in view, but that is impossible, since I had to promise my husband that I would drop all my papers, periodicals, etc., on which I was paying out money for subscription before he would consent to my taking the course. This I felt willing to do, that I might prepare myself for more congenial tasks; I hope to accomplish something worthy of note in a literary way since I have been a failure in all other pursuits. One cannot be anything in particular as long as they try to be everything, and my motto has always been: "Strive to Excel," and it has caused worry wrinkles to mar my countenance, because I could not, under the circumstances, excel in any particular thing.

I have a few friends who are so anxious for my success that they are having certain publications of reading matter sent to me at their own expense; however, there's only a very limited number who know of my ambitions.

My friends have always been so kind as not to hint that I had not come up to their expectations in various lines, but I inwardly knew that they regarded me as a financial failure; they knew that my husband would not allow the money that was made off the farm to be spent on the family, but still they knew of other men who did the same, yet the wives managed some way to have money of their own and to keep up the family expenses and clothe themselves and children nicely anyhow, but they did not seem to take into account that these thrifty wives had the time all for their own in which to earn a livelihood while my time was demanded by my husband, to be spent in doing things for him which would contribute to the general proceeds of the farm, yet would add nothing to my income, since I was supposed to look to my own resources for my spending money.

When critical housewives spend the day with me I always feel that my surroundings appear to a disadvantage. They cannot possibly know the inside workings of our home, and knowing myself to be capable of the proper management of a

home if I had the chance of others, I feel like I am receiving a mental criticism from them which is unmerited, and when these smart neighbors tell me proudly how many young chicks they have, and how many eggs and old hens they have sold during the year, I am made to feel that they are crowing over their shrewdness, which they regard as lacking in me, because they will persist in measuring my opportunities by their own.

I might add that the neighbors among whom I live are illiterate and unmusical, and that my redeeming qualities, in their eyes, are my superior education and musical abilities; they are kind enough to give me more than justice on these qualities because they are poor judges of such matters.

But money is king, and if I might turn my literary bent to account, and surround myself with the evidences of prosperity, I may yet hope fully to redeem myself in their eyes, and I know that I will have attained my ambition in that line.

10. THE LIFE STORY OF

AN ITINERANT MINISTER

This is the story of a handicapped life. Its author is
a preacher in the Southern Methodist Church.

I WAS born in a fine old county of one of the Southern States.
My father was a German, and came to this country when a
young man. He was a steady, industrious, frugal man, and
made many friends in his new home. He worked on one of the
first railroads built in the South, serving in the capacity of a
"track-raiser," or section foreman, for more than a dozen years.
He then bought a farm and moved to it when I was about five
years old, and it was on this farm that my childhood was
spent. My mother belonged to one of the oldest families of the
county, and was a woman of good sense and decided character.
There were eight children of us, three sons and five daughters.
My mother had two brothers who were afflicted with cataract.
And this same infirmity showed itself in our family in one of
those strange freaks of heredity. My oldest brother developed
cataract on his eyes several years after birth, while in my
younger brother and myself it was congenital. And my case

was the worst of the three, and worse than either of my maternal uncles. One of my earliest and most vivid recollections is the first of four operations on my eyes for this trouble. It was before I was five years old—and long before the days of local anesthesias. I was placed full length on a bench, tied hand and foot, my head was grasped firmly, and my eyes, first one and then the other, were held open, while the doctor inserted a sharp needle, and attempted to cut up the cataract, hoping that the particles would be taken up by absorption. It was only after the third of these operations that I experienced any great benefit. I was then thirteen years old, and large enough to submit quietly to the operation. I remember it all so well. It was a day in May. I sat down before a window, and the doctor inserted his needle in the right eye. A moment later he had pressed the cataract from over the sight. And then, as if a dense fog had suddenly rolled away, there burst upon my view such a vision of field and sky and sunlight as I had never looked upon before. I forgot the pain of the operation, and broke out into rapturous exclamations of delight. That was over forty years ago, but that day in May and that afternoon hour marked an epoch in my life. Afterwards I could see to read ordinary print.

But the sight these successive operations left with me was far from perfect vision. The reading I was enabled to do, and that which I have done all my life, was with the right eye—there is still some cataract on the left eye—and by the aid of the strongest glasses that could be had. These glasses were double convex, and looked like the lenses of a microscope.

I entered school at thirteen. The teachers were very kind to me, and took much interest in putting me forward in my studies. These were war times in the South, and spectacles, like many other things, were not easily obtained, so my younger brother and myself were forced to use the same pair of glasses in school. But I learned many of my lessons through the eye of others, especially two girl cousins of mine, and got on pretty well. By the end of the first year I could read readily, and had taken some lessons in geography and history, as well as arithmetic.

I attended school a part of every year after this until I was twenty-one years old, during which period I read some, or

all, of the works of Hume, Sir Walter Scott, Charles Dickens, Washington Irving, and many books by authors of less note and ability, and acquired a fair knowledge of Latin, a little knowledge of Greek, went into geometry in mathematics, and gained a pretty thorough acquaintance with the English branches. It was my hope that when I should be ready to go, I could enter the old college, whose bell we could almost hear from our home. But my father died very suddenly in June, when I was in my twentieth year, and while he left an estate of several thousand dollars, our affairs were not well managed, and I did not have the opportunity of completing my education in this way.

When I reached twenty-one I was confronted by a serious question: What should my life work be? Farm work was out of the question, the printer's trade, which I should have preferred to everything else, was equally so! No merchant wanted a clerk who was too blind to wait on his customers, and school-teaching seemed as impracticable as any of the rest. Through the help of an uncle, I got a little school, which was taught in one end of an abandoned log cabin. This lasted only a few months, and was the beginning and end of my experience in the work of a teacher.

Ours was a religious home. Family prayers was one of the institutions of the home, and my part in this—after I was ten years old—was to set the hymns, which my father lined out in the good old way of our ancestors. And I was a religious child. I often prayed that I might see well, and it would have been no surprise to my childish faith if the Heavenly Father had taken me at my word, and allowed me to open my eyes on the world with the sight that others had. I was consciously and satisfactorily converted when I was in my sixteenth year, and some time afterwards connected myself with the Methodist Church. Because I showed a religious bent, perhaps, and possibly because they could see nothing for me but the work of the ministry, my friends and family used to tell me that they thought I ought to preach. But what they said rather hindered than helped me. I believed then, as I do now, that every true preacher is called of God, as was Aaron, and to preach because I could do nothing else, seemed little less than sacrilege. But after a hard and very honest struggle over the

question, I decided to give my life to the ministry, and was licensed to preach at twenty-two. A year later I was recommended for admission on trial in the itinerancy, but the presiding elder under whom I was licensed to preach, told me very plainly that he did not think I could see well enough to be a traveling Methodist preacher. He was a brother of one of the bishops, and a man of much influence, and there seemed no appeal from his decision.

This decision quite upset me. My mother's affairs were in such a condition that I could no longer depend upon her for my living. But what should—rather, what could—I do ? There was still left to me my license as a local preacher; but there was nothing in this work in the way of an occupation, and no compensation whatever. And while I was willing enough to preach the Gospel "without money and without price," I must live the while. For some months this year I had the very uncomfortable consciousness of living a useless life. In the spring, however, a distant kinsman, whom my father, several years before, had set up in business, offered me a position in the railroad station and post office in the village, two miles away, saying as he did so: "I will give you your board at first, and if everything works well will give you some clothes later." I accepted the place at once, and went to work in five minutes after the offer was made. I worked here nearly six months before I received more than my board. I remained here three years and a half, the highest salary I received at any time being only $12 a month, out of which I paid $7 a month board. My duties were miscellaneous. I helped to load and unload freight, handled many a bale of cotton during the season from September till April, lifted numberless bags of highly scented commercial fertilizers, looked after the post office, and did just anything my employer could find for me to do. I had much leisure in the summer, which, with odd times at other seasons, I spent in reading and writing. I went over the Bible every year, took up the course of study for young preachers, and did what preaching I could, often walking five or six miles to an appointment. All the time I was longing and hoping against hope that one day I might be admitted to the Conference, and give my whole time to the ministry. At last this longed-for opportunity came. Some of my friends took it into their heads

that I could see sufficiently well to do the work of an itinerant preacher, used their influence with the presiding elder, the same one who had kept me waiting over three years, and just as I was nearing my twenty-seventh birthday I found myself enrolled as a member of one of the Conferences of my Church— and about the happiest man in it.

My experiences at the first annual Conference I ever attended were of the superlative degree. I alternated between hope and fear at first as to whether I should be received, and after this suspense was over, I wondered with fear and trembling what my appointment would be. And when, on the last day of the session—appointments are always read out just before the Conference adjourns *sine die*—I sat with two hundred men, who, like myself, were waiting for the Bishop to announce our fields of labor for another year, I think I must have had some of the feelings of a soldier just on the eve of battle. The Bishop read slowly, allowing the secretary to copy his announcements—first the name of the charge and then the name of the preacher. I was sitting with a neighbor-boy who, like myself, had just been accepted by the Conference. The Bishop came to his name first, giving him a place as junior preacher on the hardest work, perhaps, in the whole territory embraced in the Conference. And then, after some time, which really seemed very long, he came to me. "_____ _____," he read, and then, after the secretary had written the name, he read out my name. And I was delighted. The town was only twenty-five miles from my home, the circuit seemed very desirable for many reasons, and I really felt flattered by the appointment. But my rejoicing was not for long. I discovered in a little while that the course of the itinerant is like the course of true love, in that it doesn't always run smoothly.

I left home about the 1st of January with a small trunk that held a few clothes and a small number of books, and about $3 in money, which some of my friends were kind enough to give me. The welcome I received was about as cold as the day's ride in an open buggy had been. Things were in confusion. The town church had been cut off from a strong circuit, and associated with it were three weak churches. The people of the town church had held a meeting and passed resolutions to the effect that, "if they were not restored to their original

circuit, they would withdraw from the connection." There was nothing for me to do but to wait until the proper authorities decided the question at issue. and to go on with my work with as little friction as might be. On Saturday before the first Sunday I walked four miles through the snow, facing a bitter northwest wind, to one of the country churches, and found two brethren awaiting me. To these I talked on some verses of the Thirty-fourth Psalm. The next day more came, and I preached on Philippians 3: 13, 14. That first week I visited and prayed with fifteen families, walking five and six miles a day through the mud and melting snow.

I remained on this circuit about three weeks, when I was ordered by my presiding elder to go to the _____ mission. Here I had some new towns on a new line of railroad, with two country churches, to which I walked over roads that were little better than bridle paths. The country was hilly and much broken; the people outside of the towns lived in very plain houses, often with only one room; my fare for days together, when away from home, was only coarse corn bread, fat bacon, and coffee without cream or sugar—and not a church on the work had a stove, or was ceiled. One of them was even without a door shutter. But the people were kind, open-hearted folk, my boarding place was very agreeable and I was quite contented. I remained there two years, receiving an average salary of about $165 a year. I paid my landlady $10 a month, from which she deducted the time that I was away from home. I bought as many books as my salary would warrant, but it was years after this before I had a full set of commentaries on the Bible, or anything in the way of an encyclopedia. This lack forced me to be my own commentator, which I have continued to be most of my life since. I have found that it is better to read the Bible than to read about it.

The next year I had a circuit with two towns and four country churches, and which paid me less than $150. The fourth year, however, I got on better. I had a charge that embraced six churches, all in a rough country, and twenty-five miles from one extreme to another. I rode this circuit on a mule, which, together, with board, washing and the kindest attention, was furnished me by Brother H____, for $8 a month. My home was in the country, three miles from the post office,

and I did the most satisfactory year's reading of my whole life. Brother H's wife was the hardest worked woman I have ever known, I think. She cooked, did her washing and house-cleaning, milked a cow or two, looked after three small children, and found time to help her husband in the field. I received about $300 this year, and saved enough out of it to buy a beautiful pony the next year.

I spent the next three years in the county of _____. Here I had much success in my work. A great revival swept over the county, in which others were more useful than myself, and I received about 175 into the Church. Five young men, who are now preachers, took their start in religious work during these years, and I call them "my boys."

After being in the itinerancy nine years, I decided to marry. I had received an average salary of $200 a year, but I was assured by my presiding elder that if I would marry, better provision would be made for me. I found a sensible, religious country girl, who, after some persuasion, consented to share my itinerant lot, and so, just before Conference met, we were married, and went to the session a very happy bridal couple. And we got a good appointment.

Our first parsonage was a three-room cottage, unpainted, with only one room ceiled, and a little veranda, on which morning glories were trained to grow in great luxuriance that summer. We remained here two years, during which the church prospered greatly. About a hundred members were taken in, and the finances of the charge improved considerably; and our salary of some $450 a year gave us a comfortable support. Our first child was born this year, a boy, who is nearly eighteen now.

The most trying period of my life came some years later. We spent some time in a malarial section of the State, and my nervous system was so much affected by this poison that I was unable to preach for several months. And before I had fully recovered from this attack the mother of my children sickened and died of rapid consumption. She left me with three children, six, nine and twelve years of age respectively, with no settled home, and health much broken. But I was among my kindred at the time, my old mother came to my house, and

after a year and a half, I found another good woman as my wife, and the mother of my children. I have now been an itinerant Methodist preacher almost twenty-eight years. My salary, since I was married, has averaged $380 a year, exclusive of house rent. I have only once or twice left a circuit in debt to any one in it, and am to-day free from financial embarrassment. I am now serving my twentieth pastoral charge, and these frequent changes from one pastorate to another, which have in one or two instances involved moves of two hundred miles or more, have greatly added to the expenses of the work. I have paid out $300 or $400 in railroad and hack fares, and in freight charges, besides the loss incident to breaking up and moving from one place to another. I have kept a horse fifteen years, and a buggy about a dozen, have had one horse to die and another to go blind, and the buggy I now have is almost like the wonderful one-horse chaise, just before that classic vehicle went to pieces. My sight is sufficient to enable me to drive over plain and familiar roads.

We find it necessary to be economical. Our living is simple. In the morning we have biscuit and butter and bacon gravy, with a little ham now and then, and chicken in the summer, and fresh pork—when our neighbors furnish it—in winter. We also have coffee for my wife and myself, and "kettle tea" for the children. At dinner, we have vegetables, such as beans, potatoes and corn, during the summer, with good bread, home-made, and sometimes a simple dessert. At supper, which we generally have about night-fall, we have bread and butter, with fruit, when we can get it, and milk or tea. We have occupied nine different parsonages, and attached to these have generally been lots large enough for a good garden and sundry patches. On our present lot we hope to make a light bale of cotton this year. I usually buy one good suit of clothes every two or three years, which I save for marriages, funerals and strictly Sunday wear, making less costly clothes answer for everyday wear. These best suits usually cost about $15, and I get them ready-made out of the stores. My wife usually makes her own dresses, and does most of the sewing for the family. We keep no servants, but put out the washing and

ironing, which costs about 50¢ a week. We generally rise about six, have breakfast an hour later, the little girls go to school, after washing the dishes—my son has been away from home most of the time for a year, attending school—and my wife and I put things to rights in our room, and then sit down for a quiet morning's work. I find the hours before twelve o'clock in the day much the best time in the whole twenty-four for study. I find it hard to be regular in my habits of study. A trip of six to twelve miles in the country must be made every other week to preach at the churches away from my home, and the demand for visiting is a constant draft on my time. My preaching has been plain, and extemporaneous, after careful general preparation. I have tried to take the great themes of the Bible and present them in such ways and words as would bring them within the comprehension of the common people. I have had pastoral connection with about one hundred different congregations, in twenty-four different counties of my native State, and I am sure I have preached to at least fifty thousand different people. I have received about one thousand members into the Church, and have seen a number of gracious revivals. I have reason to know that I have done some good and reason to believe that I have done some of which I have had no knowledge. A few years ago, at a Conference session, I was introduced to a young preacher, who said, "Why, I know you already. At _____ campground, some ten or twelve years ago, I heard you preach on Sunday night. Under that sermon I was convicted and converted, and so were fifteen others." And this man had been preaching several years, though I had never met him before.

I have gathered a collection of good books, but have not been able to buy many new works as they have come from the press. I have not yet gotten over my penchant for literary work, and recently have written a novel, which seems not good enough, or mayhap, bad enough, to meet the demands of publishers. It deals with a living question, though it is not a "problem" novel. The scene is laid in the South, but there is not a "Colonel," nor a "Judge" in it, a fact which ought to commend it to the favor of intelligent people.

I suppose I have been hindered in my work by my defective sight. At any rate, I have been told a number of times that

nothing but this stood in the way of my promotion. But it has not hindered me from traveling some of the largest and hardest circuits in my Conference. But it has saved me from the envy and jealousy of other preachers, and that is something to be thankful for. This same defective sight has had its compensations in many ways. The world in which I have lived has had more mysteries in it than the world of those who see well, and larger room for imagination, and for those poetic fancies which give the earth and sky and sun and stars a beauty that is not otherwise their own. And there have been other compensations. The very effort necessary to acquire the knowledge that I have gathered has made me husband it all the more carefully. I could not lightly throw away that which cost me so much.

I have been a conservative in thought and faith. Two great facts in my experience, my conversion and my call to the ministry, have served as mordants to my faith. I have believed that it was my business to find out the truths, and not the errors of the Bible. My observation of men, and my reading of history, have taught me that the men who have had largest influence with God and their fellows, have been the men who have adhered most steadfastly to the standards of faith. Upon the whole, as Horace Bushnell says, it has been a great thing to me to have lived.

11. THE LIFE STORY OF

A NEGRO PEON

The following chapter was obtained from an inter-
view with a Georgia negro who is a victim of the
new slavery of the South.

I AM a negro and was born some time during the war in Elbert
County, Ga., and I reckon by this time I must be a little over
forty years old. My mother was not married when I was born,
and I never knew who my father was or anything about him.
Shortly after the war my mother died, and I was left to the
care of my uncle. All this happened before I was eight years
old, and so I can't remember very much about it. When I was
about ten years old my uncle hired me out to Captain _____. I
had already learned how to plow, and was also a good hand
at picking cotton. I was told that the Captain wanted me for
his house-boy, and that later on he was going to train me
to be his coachman. To be a coachman in those days was
considered a post of honor, and young as I was, I was glad of
the chance. But I had not been at the Captain's a month before
I was put to work on the farm, with some twenty or thirty other
negroes—men, women and children. From the beginning the

boys had the same tasks as the men and women. There was no difference. We all worked hard during the week, and would frolic on Saturday nights and often on Sundays. And everybody was happy. The men got $3 a week and the women $2. I don't know what the children got. Every week my uncle collected my money for me, but it was very little of it that I ever saw. My uncle fed and clothed me, gave me a place to sleep, and allowed me 10¢ or 15¢ a week for "spending change," as he called it. I must have been seventeen or eighteen years old before I got tired of that arrangement, and felt that I was man enough to be working for myself and handling my own wages. The other boys about my age and size were "drawing" their own pay, and they used to laugh at me and call me "Baby" because my old uncle was always on hand to "draw" my pay. Worked up by these things, I made a break for liberty. Unknown to my uncle or the Captain I went off to a neighboring plantation and hired myself out to another man. The new landlord agreed to give me 40¢ a day and furnish me one meal. I thought that was doing fine. Bright and early one Monday morning I started for work, still not letting the others know anything about it. But they found it out before sundown. The Captain came over to the new place and brought some kind of officer of the law. The officer pulled out a long piece of paper from his pocket and read it to my new employer. When this was done I heard my new boss say:

"I beg your pardon, Captain. I didn't know this nigger was bound out to you, or I wouldn't have hired him."

"He certainly is bound out to me," said the Captain. "He belongs to me until he is twenty-one, and I'm going to make him know his place."

So I was carried back to the Captain's. That night he made me strip off my clothing down to my waist, had me tied to a tree in his backyard, ordered his foreman to give me thirty lashes with a buggy whip across my bare back, and stood by until it was done. After that experience the Captain made me stay on his place night and day,—but my uncle still continued to "draw" my money.

I was a man nearly grown before I knew how to count from one to one hundred. I was a man nearly grown before I ever saw a colored school teacher. I never went to school a day in

my life. To-day I can't write my own name, though I can read a little. I was a man nearly grown before I ever rode on a railroad train, and then I went on an excursion from Elberton to Athens. What was true of me was true of hundreds of other negroes around me—'way off there in the country, fifteen or twenty miles from the nearest town.

When I reached twenty-one the Captain told me I was a free man, but he urged me to stay with him. He said he would treat me right, and pay me as much as anybody else would. The Captain's son and I were about the same age, and the Captain said that, as he had owned my mother and uncle during slavery, and as his son didn't want me to leave them (since I had been with them so long), he wanted me to stay with the old family. And I stayed. I signed a contract—that is, I made my mark—for one year. The Captain was to give me $3.50 a week, and furnish me a little house on the plantation—a one-room log cabin similar to those used by his other laborers.

During that year I married Mandy. For several years Mandy had been the house-servant for the Captain, his wife, his son and his three daughters, and they all seemed to think a good deal of her. As an evidence of their regard they gave us a suit of furniture, which cost about $25, and we set up housekeeping in one of the Captain's two-room shanties. I thought I was the biggest man in Georgia. Mandy still kept her place in the "Big House" after our marriage. We did so well for the first year that I renewed my contract for the second year, and for the third, fourth and fifth year I did the same thing. Before the end of the fifth year the Captain had died, and his son, who had married some two or three years before, took charge of the plantation. Also, for two or three years, this son had been serving at Atlanta in some big office to which he had been elected. I think it was in the Legislature or something of that sort—anyhow, all the people called him Senator. At the end of the fifth year the Senator suggested that I sign up a contract for ten years; then, he said, we wouldn't have to fix up papers every year. I asked my wife about it; she consented; and so I made a ten-year contract.

Not long afterward the Senator had a long, low shanty built on his place. A great big chimney, with a wide, open fireplace, was built at one end of it, and on each side of the house,

running lengthwise, there was a row of frames or stalls just large enough to hold a single mattress. The places for these mattresses were fixed one above the other; so that there was a double row of these stalls or pens on each side. They looked for all the world like stalls for horses. Since then I have seen cabooses similarly arranged as sleeping quarters for railroad laborers. Nobody seemed to know what the Senator was fixing for. All doubts were put aside one bright day in April when about forty able-bodied negroes, bound in iron chains, and some of them handcuffed, were brought out to the Senator's farm in three big wagons. They were quartered in the long, low shanty, and it was afterward called the stockade. This was the beginning of the Senator's convict camp. These men were prisoners who had been leased by the Senator from the State of Georgia at about $200 each per year, the State agreeing to pay for guards and physicians, for necessary inspection, for inquests, all rewards for escaped convicts, the cost of litigation and all other incidental camp expenses. When I saw these men in shackles, and the guards with their guns, I was scared nearly to death. I felt like running away, but I didn't know where to go. And if there had been any place to go to, I would have had to leave my wife and child behind. We free laborers held a meeting. We all wanted to quit. We sent a man to tell the Senator about it. Word came back that we were all under contract for ten years and that the Senator would hold us to the letter of the contract, or put us in chains and lock us up— the same as the other prisoners. It was made plain to us by some white people we talked to that in the contracts we had signed we had all agreed to be locked up in a stockade at night or at any other time that our employer saw fit; further, we learned that we could not lawfully break our contract for any reason and go and hire ourselves to somebody else without the consent of our employer; and, more than that, if we got mad and ran away, we could be run down by bloodhounds, arrested without process of law, and be returned to our employer, who, according to the contract, might beat us brutally or administer any other kind of punishment that he thought proper. In other words, we had sold ourselves into slavery— and what could we do about it? The white folks had all the courts, all the guns, all the hounds, all the railroads, all the

telegraph wires, all the newspapers, all the money, and nearly all the land—and we had only our ignorance, our poverty and our empty hands. We decided that the best thing to do was to shut our mouths, say nothing, and go back to work. And most of us worked side by side with those convicts during the remainder of the ten years.

But this first batch of convicts was only the beginning. Within six months another stockade was built, and twenty or thirty other convicts were brought to the plantation, among them six or eight women! The Senator had bought an additional thousand acres of land. and to his already large cotton plantation he added two great big saw-mills and went into the lumber business. Within two years the Senator had in all nearly 200 negroes working on his plantation—about half of them free laborers, so called, and about half of them convicts. The only difference between the free laborers and the others was that the free laborers could come and go as they pleased, at night—that is, they were not locked up at night, and were not, as a general thing, whipped for slight offenses. The troubles of the free laborers began at the close of the ten-year period. To a man, they all wanted to quit when the time was up. To a man, they all refused to sign new contracts—even for one year, not to say anything of ten years. And just when we thought that our bondage was at an end we found that it had really just begun. Two or three years before, or about a year and a half after the Senator had started his camp, he had established a large store, which was called the commissary. All of us free laborers were compelled to buy our supplies— food, clothing, etc.—from that store. We never used any money in our dealings with the commissary, only tickets or orders, and we had a general settlement once each year, in October. In this store we were charged all sorts of high prices for goods, because every year we would come out in debt to our employer. If not that, we seldom had more than $5 or $10 coming to us—and that for a whole year's work. Well, at the close of the tenth year, when we kicked and meant to leave the Senator, he said to some of us with a smile (and I never will forget that smile—I can see it now):

"Boys, I'm sorry you're going to leave me. I hope you will

do well in your new places—so well that you will be able to pay me the little balances which most of you owe me."

Word was sent out for all of us to meet him at the commissary at 2 o'clock. There he told us that, after we had signed what he called a written acknowledgment of our debts, we might go and look for new places. The storekeeper took us one by one and read to us statements of our accounts. According to the books there was no man of us who owed the Senator less than $100; some of us were put down for as much as $200. I owed $105, according to the bookkeeper. These debts were not accumulated during one year, but ran back for three and four years, so we were told—in spite of the fact that we understood that we had had a full settlement at the end of each year. But no one of us would have dared to dispute a white man's word—oh, no; not in those days. Besides, we fellows didn't care anything about the amounts—we were after getting away; and we had been told that we might go, if we signed the acknowledgments. We would have signed anything, just to get away. So we stepped up, we did, and made our marks. That same night we were rounded up by a constable and ten or twelve white men, who aided him, and we were locked up, every one of us, in one of the Senator's stockades. The next morning it was explained to us by the two guards appointed to watch us that, in the papers, we had signed the day before, we had not only made acknowledgment of our indebtedness, but that we had also agreed to work for the Senator until the debts were paid by hard labor. And from that day forward we were treated just like convicts. Really we had made ourselves lifetime slaves, or peons, as the laws called us. But, call it slavery, peonage, or what not, the truth is we lived in a hell on earth what time we spent in the Senator's peon camp.

I lived in that camp, as a peon, for nearly three years. My wife fared better than I did, as did the wives of some of the other negroes, because the white men about the camp used these unfortunate creatures as their mistresses. When I was first put in the stockade my wife was still kept for a while in the "Big House," but my little boy, who was only nine years old, was given away to a negro family across the river in South Carolina, and I never saw or heard of him after that. When I

left the camp my wife had had two children by some one of
the white bosses, and she was living in fairly good shape in a
little house off to herself. But the poor negro women who were
not in the class with my wife fared about as bad as the helpless
negro men. Most of the time the women who were peons or
convicts were compelled to wear men's clothes. Sometimes,
when I have seen them dressed like men, and plowing or
hoeing or hauling logs or working at the blacksmith's trade,
just the same as men, my heart would bleed and my blood
would boil, but I was powerless to raise a hand. It would have
meant death on the spot to have said a word. Of the first six
women brought to the camp, two of them gave birth to chil-
dren after they had been there more than twelve months—
and the babies had white men for their fathers!

The stockades in which we slept were, I believe, the filthiest
places in the world. They were cesspools of nastiness. During
the thirteen years that I was there I am willing to swear that
a mattress was never moved after it had been brought there,
except to turn it over once or twice a month. No sheets were
used, only dark-colored blankets. Most of the men slept every
night in the clothing that they had worked in all day. Some of
the worst characters were made to sleep in chains. The doors
were locked and barred each night, and tallow candles were
the only lights allowed. Really the stockades were but little
more than cow sheds, horse stables or hog pens. Strange to
say, not a great number of these people died while I was there,
though a great many came away maimed and bruised and, in
some cases, disabled for life. As far as I remember only about
ten died during the last ten years that I was there, two of these
being killed outright by the guards for trivial offenses.

It was a hard school that peon camp was, but I learned
more there in a few short months by contact with those poor
fellows from the outside world than ever I had known before.
Most of what I learned was evil, and I now know that I should
have been better off without the knowledge, but much of what
I learned was helpful to me. Barring two or three severe and
brutal whippings which I received, I got along very well, all
things considered; but the system is damnable. A favorite way
of whipping a man was to strap him down to a log, flat on his
back, and spank him fifty or sixty times on his bare feet with

a shingle or a huge piece of plank. When the man would get up with sore and blistered feet and an aching body, if he could not then keep up with the other men at work he would be strapped to the log again, this time face downward, and would be lashed with a buggy trace on his bare back. When a woman had to be whipped it was usually done in private, though they would be compelled to fall down across a barrel or something of the kind and receive the licks on their backsides.

The working day on a peon farm begins with sunrise and ends when the sun goes down; or, in other words, the average peon works from ten to twelve hours each day, with one hour (from 12 o'clock to 1 o'clock) for dinner. Hot or cold, sun or rain, this is the rule. As to their meals, the laborers are divided up into squads or companies, just the same as soldiers in a great military camp would be. Two or three men in each stockade are appointed as cooks. From thirty to forty men report to each cook. In the warm months (or eight or nine months out of the year) the cooking is done on the outside, just behind the stockades; in the cold months the cooking is done inside the stockades. Each peon is provided with a great big tin cup, a flat tin pan and two big tin spoons. No knives or forks are ever seen, except those used by the cooks. At meal time the peons pass in single file before the cooks, and hold out their pans and cups to receive their allowances. Cow peas (red or white, which when boiled turn black), fat bacon and old-fashioned Georgia corn bread, baked in pones from one to two and three inches thick, make up the chief articles of food. Black coffee, black molasses and brown sugar are also used abundantly. Once in a great while, on Sundays, biscuits would be made, but they would always be made from the kind of flour called "shorts." As a rule, breakfast consisted of coffee, fried bacon, corn bread, and sometimes molasses—and one "helping" of each was all that was allowed. Peas, boiled with huge hunks of fat bacon, and a hoe-cake, as big as a man's hand, usually answered for dinner. Sometimes this dinner bill of fare gave place to bacon and greens (collard or turnip) and pot liquor. Though we raised corn, potatoes and other vegetables, we never got a chance at such things unless we could steal them and cook them secretly. Supper consisted of coffee, fried bacon and molasses. But, although the food was

limited to certain things, I am sure we all got a plenty of the
things allowed. As coarse as these things were, we kept, as a
rule, fat and sleek and as strong as mules. And that, too, in
spite of the fact that we had no special arrangements for taking
regular baths. and no very great effort was made to keep us
regularly in clean clothes. No tables were used or allowed. In
summer we would sit down on the ground and eat our meals,
and in winter we would sit around inside the filthy stockades.
Each man was his own dish washer—that is to say, each man
was responsible for the care of his pan and cup and spoons.
My dishes got washed about once a week!

To-day, I am told, there are six or seven of these private
camps in Georgia—that is to say, camps where most of the
convicts are leased from the State of Georgia. But there are
hundreds and hundreds of farms all over the State where
negroes, and in some cases poor white folks, are held in bond-
age on the ground that they are working out debts, or where
the contracts which they have made hold them in a kind of
perpetual bondage, because, under those contracts, they may
not quit one employer and hire out to another except by and
with the knowledge and consent of the former employer. One
of the usual ways to secure laborers for a large peonage camp
is for the proprietor to send out an agent to the little courts in
the towns and villages, and where a man charged with some
petty offense has no friends or money the agent will urge him
to plead guilty, with the understanding that the agent will
pay his fine, and in that way save him from the disgrace of
being sent to jail or the chain-gang! For this high favor the
man must sign beforehand a paper signifying his willingness
to go to the farm and work out the amount of the fine imposed.
When he reaches the farm he has to be fed and clothed, to be
sure, and these things are charged up to his account. By the
time he has worked out his first debt another is hanging over
his head, and so on and so on, by a sort of endless chain,
for an indefinite period, as in every case the indebtedness is
arbitrarily arranged by the employer. In many cases it is very
evident that the court officials are in collusion with the propri-
etors or agents, and that they divide the "graft" among them-
selves. As an example of this dickering among the whites,
every year many convicts were brought to the Senator's camp

from a certain county in South Georgia, 'way down in the turpentine district. The majority of these men were charged with adultery, which is an offense against the laws of the great and sovereign State of Georgia! Upon inquiry I learned that down in that county a number of negro lewd women were employed by certain white men to entice negro men into their houses; and then, on a certain night, at a given signal, when all was in readiness, raids would be made by the officers upon these houses, and the men would be arrested and charged with living in adultery. Nine out of ten of these men, so arrested and so charged, would find their way ultimately to some convict camp, and, as I said, many of them found their way every year to the Senator's camp while I was there. The low-down women were never punished in any way. On the contrary, I was told that they always seemed to stand in high favor with the sheriffs, constables and other officers. There can be no room to doubt that they assisted very materially in furnishing laborers for the prison pens of Georgia, and the belief was general among the men that they were regularly paid for their work. I could tell more, but I've said enough to make anybody's heart sick. This great and terrible iniquity is, I know, widespread throughout Georgia and many other Southern States.

But I didn't tell you how I got out. I didn't get out—they put me out. When I had served as a peon for nearly three years—and you remember that they claimed that I owed them only $165—when I had served for nearly three years, one of the bosses came to me and said that my time was up. He happened to be the one who was said to be living with my wife. He gave me a new suit of overalls, which cost about 75¢, took me in a buggy and carried me across the Broad River into South Carolina, set me down and told me to "git." I didn't have a cent of money, and I wasn't feeling well, but somehow I managed to get a move on me. I begged my way to Columbia. In two or three days I ran across a man looking for laborers to carry to Birmingham, and I joined his gang. I have been here in the Birmingham district since they released me, and I reckon I'll die either in a coal mine or an iron furnace. It don't make much difference which. Either is better than a Georgia peon camp. And a Georgia peon camp is hell itself!

12. THE LIFE STORY OF

AN INDIAN

Ab-nen-la-de-ni, whose American name is Daniel La France, told his own story in neat typewritten form, and has been aided only to the extent of some very slight rewriting and rearrangement.

I WAS born in Gouverneur Village, N. Y., in April, 1879, during one of the periodical wanderings of my family, and my first recollection is concerning a house in Toronto, Canada, in which I was living with my father and mother, brother and grandmother. I could not have been much more than three years old at the time.

My father was a pure-blooded Indian of the Mohawk tribe of the Six Nations, and our home was in the St. Regis reservation in Franklin County, N. Y., but we were frequently away from that place because my father was an Indian medicine man, who made frequent journeys, taking his family with him and selling his pills and physics in various towns along the border line between Canada and the United States.

This house in Toronto was winter quarters for us. In the summer time we lived in a tent. We had the upper part of the house, while some gypsies lived in the lower part.

All sorts of people came to consult the "Indian doctor," and the gypsies sent them upstairs to us, and mother received them, and then retired into another room with my brother and myself. She did not know anything about my father's medicines, and seemed to hate to touch them. When my father was out mother was frequently asked to sell the medicines, but she would not, telling the patients that they must wait until the doctor came home. She was not pure-blooded Indian, her father being a French Canadian, while her mother, my grandmother, was a pure-blooded Indian, who lived with us.

What made it all the more strange that mother would have nothing to do with the medicines was the fact that grandmother was, herself, a doctor of a different sort than my father. Her remedies were probably the same but in cruder form. I could have learned much if I had paid attention to her, because as I grew older she took me about in the woods when she went there to gather herbs, and she told me what roots and leaves to collect, and how to dry and prepare them and how to make the extracts and what sicknesses they were good for. But I was soon tired of such matters, and would stray off by myself picking the berries—raspberry and blackberry, strawberry and blueberry—in their seasons, and hunting the birds and little animals with my bow and arrows. So I learned very little from all this lore.

My father was rather a striking figure. His hair was long and black, and he wore a long Prince Albert coat while in the winter quarters, and Indian costume, fringed and beaded, while in the tent. His medicines were put up in pill boxes and labeled bottles, and were the results of knowledge that had been handed down through many generations in our tribe.

My brother and I also wore long hair, and were strange enough in appearance to attract attention from the white people about us, but mother kept us away from them as much as possible.

My father was not only a doctor, but also a trapper, fisherman, farmer and basket maker.

The reservation in Franklin County is a very beautiful place, fronting on the main St. Lawrence River. Tributaries of the St. Lawrence wander through it, and its woods still preserve their wild beauty. On this reservation we had our permanent

home in a log house surrounded by land, on which we planted corn, potatoes and such other vegetables as suited our fancies. The house was more than fifty years old.

The woods provided my father and grandmother with their herbs and roots, and they gathered there the materials for basket making. There were also as late as 1880 some beavers, muskrats and minks to be trapped and pickerel, salmon and white perch to be caught in the streams. These last sources of revenue for the Indians no longer exist; the beavers, minks and muskrats are extinct, while the mills of the ever encroaching white man have filled the streams with sawdust and banished the fish.

We were generally on the reservation in early spring, planting, fishing, basket making, gathering herbs and making medicine, and then in the fall, when our little crop was brought in, we would depart on our tour of the white man's towns and cities, camping in a tent on the outskirts of some place, selling our wares, which included bead work that mother and grandmother were clever at making, and moving on as the fancy took us until cold weather came, when my father would generally build a little log house in some wood, plastering the chinks with moss and clay, and there we would abide, warm amid ice and snow, till it was time to go to the reservation again.

One might imagine that with such a great variety of occupations we would soon become rich—especially as we raised much of our own food and seldom had any rent to pay—but this was not the case. I do not know how much my father charged for his treatment of sick people, but his prices were probably moderate, and as to our trade in baskets, furs and bead work, we were not any better business people than Indians generally.

Nevertheless, it was a happy life that we led, and lack of money troubled us little. We were healthy and our wants were few.

Father did not always take his family with him on his expeditions, and as I grew older I passed a good deal of time on the reservation. Here, though the people farmed and dressed somewhat after the fashion of the white man, they still kept up their ancient tribal ceremonies, laws and customs, and preserved their language. The general government was in the

hands of twelve chiefs, elected for life on account of supposed merit and ability.

There were four Indian day schools on the reservation, all taught by young white women. I sometimes went to one of these, but learned practically nothing. The teachers did not understand our language, and we knew nothing of theirs, so much progress was not possible.

Our lessons consisted of learning to repeat all the English words in the books that were given us. Thus, after a time, some of us, myself included, became able to pronounce all the words in the Fifth and Sixth readers, and took great pride in the exercise. But we did not know what any of the words meant.

Our arithmetic stopped at simple numeration, and the only other exercise we had was in writing, which, with us, resolved itself into a contest of speed without regard to the form of letters.

The Indian parents were disgusted with the schools, and did not urge their children to attend, and when the boys and girls did go of their own free will it was more for sociability and curiosity than from a desire to learn. Many of the boys and girls were so large that the teachers could not preserve discipline, and we spent much of our time in the school in drawing pictures of each other and the teacher, and in exchanging in our own language such remarks as led to a great deal of fighting when we regained the open air. Often boys went home with their clothing torn off them in these fights.

Under the circumstances, it is not strange that the attendance at these schools was poor and irregular, and that on many days the teachers sat alone in the schoolhouses because there were no scholars. Since that time a great change has taken place, and there are now good schools on the reservation.

I was an official of one of the schools, to the extent that I chopped wood for it, but I did not often attend its sessions, and when I was thirteen years of age, and had been nominally a pupil of the school for six years, I was still so ignorant of English that I only knew one sentence, which was common property among us alleged pupils:

"Please, ma'am, can I go out?" pronounced: "Peezumganni-gowout!"

When I was thirteen a great change occurred, for the honey-tongued agent of a new Government contract Indian school appeared on the reservation, drumming up boys and girls for his institution. He made a great impression by going from house to house and describing, through an interpreter, all the glories and luxuries of the new place, the good food and teaching, the fine uniforms, the playground and its sports and toys.

All that a wild Indian boy had to do, according to the agent, was to attend this school for a year or two, and he was sure to emerge therefrom with all the knowledge and skill of the white man.

My father was away from the reservation at the time of the agent's arrival, but mother and grandmother heard him with growing wonder and interest, as I did myself, and we all finally decided that I ought to go to this wonderful school and become a great man—perhaps at last a chief of our tribe. Mother said that it was good for Indians to be educated, as white men were "so tricky with papers."

I had, up to this time. been leading a very happy life, helping with the planting, trapping, fishing, basket making and playing all the games of my tribe—which is famous at lacrosse—but the desire to travel and see new things and the hope of finding an easy way to much knowledge in the wonderful school outweighed my regard for my home and its joys, and so I was one of the twelve boys who in 1892 left our reservation to go to the Government contract school for Indians, situated in a large Pennsylvania city and known as the _____ Institute.

Till I arrived at the school I had never heard that there were any other Indians in the country other than those of our reservation, and I did not know that our tribe was called Mohawk. My people called themselves "Ganien-ge-ha-ga," meaning "People of the Beacon Stone," and Indians generally they termed "On-give-hon-we," meaning "Realmen" or "Primitive People."

My surprise, therefore, was great when I found myself surrounded in the school yard by strange Indian boys belonging to tribes of which I had never heard, and when it was said that my people were only the "civilized Mohawks," I at first thought

that "Mohawk" was a nickname and fought any boy who called me by it.

I had left home for the school with a great deal of hope, having said to my mother: "Do not worry. I shall soon return to you a better boy and with a good education!" Little did I dream that that was the last time I would ever see her kind face. She died two years later, and I was not allowed to go to her funeral.

The journey to Philadelphia had been very enjoyable and interesting. It was my first ride on the "great steel horse," as the Indians called the railway train, but my frame of mind changed as soon as my new home was reached.

The first thing that happened to me and to all other freshly caught young redskins when we arrived at the institution was a bath of a particularly disconcerting sort. We were used to baths of the swimming variety, for on the reservation we boys spent a good deal of our time in the water, but this first bath at the institution was different. For one thing, it was accompanied by plenty of soap, and for another thing, it was preceded by a haircut that is better described as a crop.

The little newcomer, thus cropped and delivered over to the untender mercies of larger Indian boys of tribes different from his own, who laughingly attacked his bare skin with very hot water and very hard scrubbing brushes, was likely to emerge from the encounter with a clean skin but perturbed mind. When, in addition, he was prevented from expressing his feelings in the only language he knew, what wonder if some rules of the school were broken.

After the astonishing bath the newcomer was freshly clothed from head to foot, while the raiment in which he came from the reservation was burned or buried. Thereafter he was released by the torturers, and could be seen sidling about the corridors like a lonely crab, silent, sulky, immaculately clean and most disconsolate.

After my bath and reclothing and after having had my name taken down in the records I was assigned to a dormitory, and began my regular school life, much to my dissatisfaction. The recording of my name was accompanied by a change which,

though it might seem trifling to the teachers, was very important to me. My name among my own people was "Ah-nen-la-de-ni," which in English means "Turning crowd" or "Turns the crowd," but my family had had the name "La France" bestowed on them by the French some generations before my birth, and at the institution my Indian name was discarded, and I was informed that I was henceforth to be known as Daniel La France.

It made me feel as if I had lost myself. I had been proud of myself and my possibilities as "Turns the crowd," for in spite of their civilized surroundings the Indians of our reservation in my time still looked back to the old warlike days when the Mohawks were great people, but Daniel La France was to me a stranger and a nobody with no possibilities. It seemed as if my prospect of a chiefship had vanished. I was very homesick for a long time.

The dormitory to which I was assigned had twenty beds in it, and was under a captain, who was one of the advanced scholars. It was his duty to teach and enforce the rules of the place in this room, and to report to the white authorities all breaches of discipline.

Out in the school yard there was the same sort of supervision. Whether at work or play, we were constantly watched, and there were those in authority over us. This displeased us Mohawks, who were warriors at fourteen years of age.

After the almost complete freedom of reservation life the cramped quarters and the dull routine of the school were maddening to all us strangers. There were endless rules for us to study and abide by, and hardest of all was the rule against speaking to each other in our own language. We must speak English or remain silent, and those who knew no English were forced to be dumb or else break the rules in secret. This last we did quite frequently, and were punished, when detected, by being made to stand in the "public hall" for a long time or to march about the yard while the other boys were at play.

There were about 115 boys at this school, and three miles from us was a similar Government school for Indian girls, which had nearly as many inmates.

The system when I first went to this school contemplated every Indian boy learning a trade as well as getting a grammar

school education. Accordingly we went to school in the morning and to work in the afternoon, or the other way about.

There were shoemakers, blacksmiths, tinsmiths, farmers, printers, all sorts of mechanics among us. I was set to learn the tailoring trade, and stuck at it for two and a half years, making such progress that I was about to be taught cutting when I began to cough, and it was said that outdoor work would be better for me. Accordingly I went, during the vacation of 1895, up into Bucks County, Pa., and worked on a farm with benefit to my health, though I was not a very successful farmer—the methods of the people who employed me were quite different from those of our reservation.

Though I was homesick soon after coming to the Institute I afterward recovered so completely that I did not care to go back to the reservation at vacation time, though at first I was offered the opportunity. I spent my vacations working for Quaker farmers. All the money I earned at this and other occupations was turned into the Institute bank, credited to my account, and I drew from thence money for my expenses and for special occasions like Christmas and the Fourth of July.

When I returned from Bucks County in 1895 I found that some of the boys of my class were attending the public school outside the institution, and on application I was allowed to join them, and finally graduated there from the grammar department, though held back by the fact that I was spending half my time in some workshop. I never went back to tailoring, except to finish a few suits that were left when the Institute shop closed, but I worked for a time at printing and afterward at making cooking apparatuses.

After I had finished with the grammar school I got a situation in the office of a lawyer while still residing in the institution. I also took a course of stenography and typewriting at the Philadelphia Young Men's Christian Association. So practically I was only a boarder at the Institute during the latter part of my eight years' stay there.

Nevertheless, I was valuable to the authorities there for certain purposes, and when I wanted to leave and go to Carlisle school, which I had heard was very good, I could not obtain permission.

This Institute, as I have said, was a contract Government

school for teaching Indians. The great exertions made by the agent, who visited our reservation in the first place, were caused by the fact that a certain number of Indian children had to be obtained before the school could be opened. I do not think that the Indian parents signed any papers, but we boys and girls were supposed to remain at the school for five years. After that, as I understand it, we were free from any obligation.

The reason why I and others like me were kept at the school was that we served as show scholars—as results of the system and evidences of the good work the Institute was doing.

When I first went to the school the superintendent was a clergyman, honest and well meaning, and during the first five years thereafter while he remained in charge the general administration was honest, but when he went away the school entered upon a period of changing administrations and general demoralization. New superintendents succeeded each other at short intervals, and some of them were violent and cruel, while all seemed to us boys more or less dishonest. Boys who had been inmates of the school for eight years were shown to visitors as results of two years' tuition, and shoes and other articles bought in Philadelphia stores were hung up on the walls at public exhibition or concert and exhibited as the work of us boys. I was good for various show purposes. I could sing and play a musical instrument, and I wrote essays which were thought to be very good. The authorities also were fond of displaying me as one who had come to the school a few years before unable to speak a word of English.

Some of my verses that visitors admired were as follows:

THE INDIAN'S CONCEPTION

When first the white man's ship appeared
 To Redmen of this wooded strand,
The Redmen gazed, and vastly feared,
 That they could not those "birds" withstand:
As they mistook the ships for birds.
 And this ill omen came quite true—
For later came more; hungrier birds.

SLEEP SONG FOR THE PAPOOSE

Look, little papoose, your cradle's unbound,
Its strappings let loose for you to be bound.

Refrain:—Oh little papoose.
 On cradle-board bound;
 My swinging papoose,
 Your slumber be sound.
Tawn little papoose, your mother is in:
She's roasting the goose on the sharp wooden pin.
 Ref.
Bound little papoose, your father is out;
He's hunting the moose that makes you grow stout.
 Ref.
Brawn little papoose, great hunter shall be;
And trap the great moose behind the pine tree.
 Ref.
My little papoose, swing, swing from the bough.
Grow; then you'll get loose—put plumes on your
brow!
 Ref.
So little papoose, dream, dream as you sleep;
While friendly old spruce shall watch o'er you keep.
 Ref.
Now, little papoose, swing on to your rest.
My red browed papoose, swing east and swing west.
 Ref.

Over the superintendent of the Institute there was a Board of Lady Managers with a Lady Directress, and these visited us occasionally, but there was no use laying any complaint before them. They were arbitrary and almost unapproachable. Matters went from bad to worse, and when the Spanish-American War broke out, and my employer, the lawyer, resolved to go to it in the Red Cross service, and offered to take me with him I greatly desired to go, but was not allowed. I suppose that the lawyer could easily have obtained my liberty, but did not wish to antagonize the Lady Managers, who considered any criticism of the institution as an attack on their own infallibility.

While waiting for a new situation after the young lawyer had gone away, I heard of the opportunities there were for young men who could become good nurses, and of the place where such training could be secured. I desired to go there, and presented this ambition to the superintendent, who at first encouraged me to the extent of giving a fair recommendation. But when the matter was laid before the Head Directress

in the shape of an application for admission ready to be sent by me to the authorities of the Nurses' Training School, she flatly refused it consideration without giving any good reason for so doing.

She, however, made the mistake of returning the application to me, and it was amended later and sent to the Training School in Manhattan. It went out through a secret channel, as all the regular mail of the institution's inmates, whether outgoing or incoming, was opened and examined in the office of the superintendent.

A few days before the Fourth of July, 1899, the answer to my application arrived in the form of notice to report at the school for the entrance examination. This communication found me in the school jail, where I had been placed for the first time in all my life at the institution.

I had been charged with throwing a nightgown out of the dormitory window, and truly it was my nightgown that was found in the school yard, for it had my number upon it. But I never threw it out of the window. I believe that one of the official underlings did that in order to found upon it a charge against me, for the school authorities had discovered that I and other boys of the institution had gone to members of the Indian Rights Association and had made complaint of conditions in the school, and that an investigation was coming. They, therefore, desired to disgrace and punish me as one of the leaders of those who were exposing them.

I heard about the letter from the Training School, and was very anxious to get away, but my liberation in time to attend that entrance examination seemed impossible. The days passed, and when the Fourth of July arrived I was still in the school jail, which was the rear part of a stable.

At one o'clock my meal of bread and water was brought to me by the guard detailed to look after my safe keeping. After he had delivered this to me he went outside, leaving the door open, but standing there. The only window of that stable was very small, very high on the wall and was protected by bars— but here was the door left open.

I fled, and singularly enough the guard had his back turned and was contemplating nature with great assiduity. As soon

as I got out of the inclosure I dashed after and caught a trolley car, and a few hours later I was in New York.

That was the last I saw of the Institute and it soon afterward went out of existence, but I heard that as a result of the demand for an investigation the Superintendent of Indian Schools had descended on it upon a given day and found everything beautiful—for her visit had been announced. But she returned again the next day, when it was supposed that she had left the city, and then things were not beautiful at all, and much that we had told about was proven.

I had $15 in the Lincoln Institute bank when I ran away, but I knew that was past crying for and I depended on $3 that I had in my pocket and with which I got a railroad ticket to New York.

I was assisted in my escape and afterward by a steadfast friend and had comparatively plain sailing, as I passed the entrance examination easily and was admitted to the Training School on probation.

The Institute people wrote and wrote after me, but could not get me back or cause the Training School to turn me out, and they soon had their own troubles to attend to. The school was closed in 1909 as the Government cut off all appropriations.

When I first entered the Training School on probation I was assigned to the general surgical ward and there took my first lessons in the duties of a nurse, being taught how to receive a patient—whether walking or carried—how to undress him and put him in bed, to make a list of his property, to make a neat bundle of his clothes, to enter his name and particulars about him in the records, and how properly to discharge patients, returning their property and clothes, and all about bed making, straightening out the ward, making bandages and scores of other details. I studied all books on nursing and attended all the lectures. Bed making, as I soon found, was an art in itself and a most important art, and so in regard to other details, all of which may look trivial to an outsider, but which count in sanitation.

This new life was very much to my liking. I was free, for one thing, and was working for myself with good hope of accomplishing something.

Our evenings were our own after our work was done, and though we had to return to the nurses' quarters at 10:30 o'clock at the latest, that was not a hardship and we could enjoy some of the pleasures of the city. While in the Training School I received my board and $19 a month pay, a very decided gain over the Institute. Besides, the food and quarters were far better.

After I had been for twelve months in the Training School I was allowed to go to our reservation for a ten days' vacation. It was the first time in nine years that I had seen my old home and I found things much changed. My mother and grandmother were dead, and there had died also a little sister whom I had never seen. My father was alive and still wandering as of old. Many of my playmates had scattered and I felt like a stranger. But it was very pleasant to renew acquaintance with the places and objects that had been familiar in my childhood—the woods, the streams, the bridge—that used to look so big and were now so small to me—the swimming hole, and with the friends who remained.

I found that our people had progressed. The past and its traditions were losing their hold on them and white man's ways were gaining.

During the visit I lived at the house of my brother, who is ten years older than I and is a farmer and manufacturer of snow shoes and lacrosse sticks. The ten days passed all too quickly.

Since that time I have paid one other and much longer visit to the reservation and have quite renewed touch with my own people, who are always glad to see me and who express much astonishment at the proficiency I show in my native tongue. Most of the boys who are away from the reservation for three or four years forget our language, but, as I have said, there were some of us at the Institute who practiced in secret.

What I saw in the reservation convinced me that our people are not yet ready for citizenship and that they desire and should be allowed to retain their reservation. They are greatly obliged to those who have aided them in defeating the Vreeland bill. The whole community is changing and when the change advances a little further it will be time to open the reservation gates and let in all the world.

Of course, so far as the old Indians are concerned, they will not and cannot change. They have given up the idea that the Mohawks will ever again be a great people, but they cannot alter their habits and it only remains for them to pass away. They want to end their days in comfort and peace, like the cat by the fireside—that is all.

To the white man these old people may not seem important, but to us young Indians they are very important. The family tie is strong among Indians. White people are aggravated because so many young Indians, after their schooling, go back to their reservations and are soon seen dressed and living just like the others. But they must do that if they desire to keep in touch with the others.

Supposing the young Indian who has been to school did not return to his father's house, but stayed out among the white men. The old folks would say: "He won't look at us now. He thinks himself above us." And all parents who observed this would add: "We won't send our children to school. They would never come back to us."

The young Indians are right to go back to the reservation and right to dress and act like the others, to cherish the old folks and make their way easy, and not to forget their tribe. It is a mistake to think that they soon lose all that they have learned in the school. Compare the school Indians with those who have not been at school and a very marked difference is found. You find on their farms improved methods and in their houses pianos, which their wives, who have also been at school, can play. All these boys and girls who have been to school are as missionaries to the reservation.

The schools are doing a great deal of good to the Indians and are changing them fast, and there is another force at work occupied with another change. On all the reservations the pure blooded Indians are becoming rarer and rarer, and the half and quarter breeds more and more common—technically they are Indians. Thus though the tribe is increasing, the real Indians are decreasing. They are becoming more and more white. On our reserve now you can see boys and girls with light hair and blue eyes, children of white fathers and Indian mothers. They have the rosy cheeks of English children, but they cannot speak a word of English.

After returning to the Training School I completed the two years' course and afterward took a special course in massage treatment for paralysis. I have since been employed principally in private practice. I like the work and the pay, though the former is very exacting. The nurse must be very clean and very regular in his habits; he must be firm and yet good-tempered—able to command the patient when necessary. He must maintain a cheerful attitude of mind and demeanor toward a patient, who is often most abusive and ill-tempered. He must please the doctor, the patient's family, and to as great an extent as possible the patient himself. He must be watchful without appearing to watch. He must be strong and healthy. Nursing is tiresome and confining. Nevertheless I console myself with the remunerations financial and educational, and with the thought that my present occupation, assisting in saving lives, is an advance beyond that of my scalp-taking ancestors.

I have been asked as to prejudice against Indians among white people. There is some, but I don't think it amounts to much. Perhaps there were some in my Training School class who objected to being associated with an Indian. I never perceived it, and I don't think I have suffered anywhere from prejudice.

I have suffered many times from being mistaken for a Japanese.

Some people when they find I am an Indian seek me out and have much to say to me, but it is generally merely for curiosity and I do not encourage them. On the other hand I have good, steadfast, old-time friends among white people.

When I first began to learn I thought that when I knew English and could read and write it would be enough. But the further I have climbed the higher the hills in front of me have grown. A few years ago the point I have reached would have seemed very high. Now it seems low, and I am studying much in my spare time. I don't know what the result will be.

Some ask me whether or not I will ever return to my tribe. How can I tell? The call from the woods and fields is very clear and moving, especially in the pleasant summer days.

13. THE LIFE STORY OF

AN IGORROTE CHIEF

The genial exponent of the simple life who furnished
the following article by talking through an inter-
preter, was a large, plump Filipino whose age was
probably forty-eight. He was clad in two necklaces,
two bracelets, some tattoo marks and a loin cloth.
He speaks no English and therefore only his ideas
and statements of fact are given. In regard to figures
he is quite impressionistic, "a thousand" represent-
ing any very large number. He was the leader of the
band of Igorrotes at Coney Island when he told this
story of his life.

I AM Chief Fomoaley, of the Bontoc Igorrotes, and I have come
to the United States with my people in order to show the white
people our civilization. The white man that lives in our town
asked me to come, and said that Americans were anxious to
see us. Since we have been here great crowds of white people
have come and watched us, and they seemed pleased.

We are the oldest people in the world. All others come from
us. The first man and woman—there were two women—lived
on our mountains and their children lived there after them,
till they grew bad and God sent a great flood that drowned
them, all except seven, who escaped in a canoe and landed,
after the flood went down, on a high mountain.

Three times a year our old men call the people together and
tell them the old stories of how God made the world and then
the animals, and lastly men. These stories have been handed
down in that way from the very beginning, so that we know

they are true. The white men have some stories, too, like that. Perhaps they may have heard them from one of us. At any rate, they are wrong about some things. There was a white man who told us that the place where the canoe landed after the flood was a high mountain on the other side of the world, but we know better, because we can see the mountain from our town. It is close by us and always has been there, and our old men point it out when they tell the story.

I was born in a hut in that town. I don't remember my father. He was killed in battle when I was very small. I had four brothers and three sisters. We did no work except a little in the fields, where the rice and sweet potatoes grow, or getting fruit in the woods. I swam and ran and played with the other boys. We had small hatchets and spears and bolos made of wood, and we hunted animals and birds and fought each other.

When I grew up to be a man I went out and took a head, and then I got married.

Among our people a young man must have taken a head before he is made a warrior. Our young women will not marry a man unless he has taken a head. We take the heads of our enemies. Sometimes these are the people of some other Igorrote town, sometimes they are the little black people who shoot with poisoned arrows, sometimes it may be some family that lives close by and has taken a head from our family. We used to get heads from the Spaniards when they were in our island, but now they have gone away. The Americans don't like us to take heads, but what can we do? Other people take heads from us. We have always done it. The women won't marry our men if they do not take heads.

I got my head among the black people by waiting near a spring until a man came to drink. I shouted, and he shot at me with arrows, but I caught them on my shield. Then I speared him and cut off his head with my bolo.

When I returned to my town I went straight to the house where the girl lived, but she would not look at me till I showed her my head. That pleased her very much, because it showed that I was a warrior and could kill enemies. So we were married.

Soon after this there came a white man to Bontoc, who said that we must go and work for his people and give them

things—our buffaloes, our rice and sugar cane and sweet pota-
toes. They were not going to do anything for us.

This white man was a Spaniard. Our chiefs laughed at him
and said that they owed us things instead of us owing them.
We were there for a thousand lives before the Spaniards came,
and they were in our island yet. We never tried to make them
pay.

The Spaniard went away angry, but came back soon with
a thousand others to fight. And all the men of Bontoc went out
to meet them.

Our town is far up in the mountains and there are no roads,
only paths through the woods, and the Spaniards could only
come a few at a time. We waited for them in the narrow places
and rolled stones down on them and killed plenty. Some others
we killed with spears and some with bolos. They burned some
of our houses and spoiled some of our fields, but they had to
go away and we paid them nothing. We got nearly a hundred
heads.

The Spaniards came again and burned more houses and
spoiled more fields, but we killed more of them and they
stopped coming.

We did not owe them anything; why should we pay what
they call taxes? We were the owners of the island. We let the
Spaniards come because there is plenty of room for everybody.

They caught a few Igorrotes and were very bad to them,
whipping them to make them work. Some they whipped to
death because our people will not work. They do not like it.
God never meant us to work. That is why he makes our food
and clothing grow all about us on the trees and bushes.

Our God is the great God who lives in the sky and shines
through the sun. He makes our rice and sugar cane grow and
looks out for us—he gives us the heads of our enemies. We
have heard of the white man's God, but ours is better.

A long time ago, a white man all dressed in black came to
our town and told us about the white man's God. He was small
and fat. He could not run or jump, he could hardly walk and
there was no hair on the top of his head. He had a book with
him and he told us many things that were in that book.

Our Chief asked if his God looked like him. He said "yes";
we did not think he could be a good looking God. We never

saw our God, but he must be much better looking than that man was.

That man told us that God had a son who died for us, and that we ought to leave our God and go to him. But our Chief said: "We did not want him to die for us. We can die for ourselves."

No, we will be true to our own God, who has always been good to us. We never give him anything. How could a man give anything to God?

The fat white man told us that if we were very good and did what he said, we would go to the white man's heaven, up in the sky. He said that people there could fly like birds, and that they spent all their time singing praises of the white man's God.

We did not think we should care to go there. Our own heaven, where the fruit is always ripe and the game is plenty, suits us far better.

The fat white man who told us about God and heaven was a Spaniard. He said that God had sent him to us but we didn't believe it. A man from our town had been among the Spaniards and he said that they told lies.

If the Spaniard's God is good, why did he not keep them out of our country? They cannot be good men or else they would not want to make us work for them and they would not try to kill us. When the Spaniards came to fight us they had guns that only went off in long times. They had to put something in at the top of the gun and poke it down with a stick before they could shoot.

We laughed at them; our spears were so much quicker.

The Americans came and drove the Spaniards away. They have guns that go bang-bang-bang-bang, as fast as a man can talk. They are our friends, for they do not burn our houses or kill our people or whip them to make them work. That is the reason why we are over here, because the American people are our friends and want to learn our civilization, so that they, too, will not have to work. Our civilization is so much older than theirs that it is no wonder if they do not know some things.

The first American that came to our town made us laugh, though we liked him. He was very kind and gave us many

presents, and all he wanted in return was beetles and bugs and birds and bats and snakes. We watched to see if he would eat them, but he did not. He put them in boxes and bottles, and when he went away he had enough to load two buffaloes. He spent days watching the ants and bees.

The children of the place followed him, and he made us all laugh many times because he chased butterflies with a net on a long stick. He could run fast and caught many.

Some of our men who had been in the big city where the Americans live, said that the Americans often make themselves mad by things that they drank. They ran about the place shouting or fighting till they fell down asleep.

This man who came among us must have been mad, but he did no harm, so we liked to have him among us. When he could get any one to interpret for him he was always asking questions. He wanted to know all about our religion and about the animals in the forest. He had a book and a little stick that made a black mark, and when we told him anything he made black marks in the book, and he said that these marks would always tell him what we had said. That was part of his madness.

One day he went to the chief with a paper on which he had been making a picture of the country, showing our town and the mountains. He wanted to know where the river went to after it left the mountains. The chief showed which way it went for a day's journey, but he wanted to know where it went after that. But the chief said:

"What does it matter where the river goes?"

He was very mad, for he said that the world is round and that the sun does not go round it. We know better than that, because we can see the sun moving, and besides our old men have told us the story of those things that has come down to us from the very beginning.

If he was not mad, why should he, a stranger, be troubled about where the river ran? It was not his river. It was our river, and if we did not care, what did it matter to him?

An American came to us about two years ago. He was a very good and kind man. He gave us plenty of beads and looking-glasses and brass wire, and he wanted some men and women to go with him to America. He wanted enough to go with him

to a place where all the American people were gathered,* that
they might build a village and show our ways of living. He got
plenty of Bontoc men and women to go, and when they came
back they had so many wonders to tell us that it took six of
them three days and three nights, standing up before our
people talking all the time, and then they said that they had
forgotten or left out much.

They said that the Americans had small suns, so many that
they could not be counted, and these made the whole country
light on the darkest night. They said that the people traveled
about in houses on wheels, and these houses went of them-
selves like flying birds with all the people in them. They told
us that many of the Americans' houses were as tall as the
tallest trees. We didn't think that was good, because who
would want to climb a tree?

All the time that the travelers were talking of the wonders
that they had seen a great feast was going on in our town. It
was the greatest feast ever heard of among us. The people of
the other towns were all invited. One hundred and fifty buffa-
loes were killed for the feast, and there were pigs, goats and
all sorts of fowls, as well as sweet potatoes, rice, fruit and nuts,
and the chiefs ate twenty-five of the finest dogs.

The best dog is a male about four years of age. If he is
healthy and fat there is nothing so good when roasted with
sweet potatoes. Short-haired dogs are the best. We eat dogs
when we are going to war because they make us fierce and
help us to hear, see and smell well.

There was dancing every day while the big feast was going
on, and the people that came from the other towns stayed for
a week. When it was all over I went away from Bontoc with a
lot more men and women to come to America to see all the
wonders. It was the first time I had ever been more than a
day's journey from Bontoc. We went through the great forests,
and it was very hot when we got down from the mountains.
Up in our mountains it is cool, but in the valleys so hot that
some of the people fall like dead.

There are no roads, but just thin paths through the woods,

*The St. Louis Exposition.

and these are blocked with creepers that have thorns on them. The white men went very slowly; the thorns caught them and the creepers held them back as if they were big snakes. It made us laugh many times to see the way the white men tangled themselves up in the creepers. We were twenty days reaching the big water (130 miles), and then only half a day going the same distance in a fire canoe of the white men. We got to the big city of the white men where the Spaniards used to be, but where our friends, the Americans, now are.

We just had time to look at it and see that it was very wonderful when we had to go on a canoe that was as long as a man could run while he held three breaths. It was so big that it could have held all the people in our town. There were many people in it, and they lived all the time in different parts of that big canoe.

There was a place in the middle of it where a great fire burned all the time; a fire so great that it looked to me like the fire that is inside the burning mountain. I was afraid that it would burn us all up, but the white men knew how to shut it up.

It was this fire that made the canoe go. I don't know how, but that was the way. We went very fast all the time; just as fast at night as in the daytime. We never stopped at all. After the first day or two we saw no land. I would never have believed there was so much water. How could any man tell where we were going, yet our canoe rushed ahead all the time. There was a man up above who told the canoe where to go. But how did he know? For many days we saw no land, yet we kept on night and day. Even in dark nights when there was no moon or star we went on just as fast. We talked among ourselves, but we could not understand how the white men knew.

After a long time we came to America, and then we saw city after city, all packed with wonders. At every place the white people crowded about us and stared as though we looked very strange. We were carried for many days in houses that went on wheels and flew along like birds. And now it seemed as if the land would never end. We must have come nearly a hundred days' journey in a week. But at last we reached another big water again and then we stopped right on the shore of this great city of Coney Island, where there seems to be always feasting.

All about us there is always music, but it is not good music, not so good as ours.

Great crowds of people came to see us every day and we show them how we live. They are good people, but they do not look well. They all wear clothes, even the children. It is bad that any one should wear clothes, but much worse for the children. We pity them. They cannot be well, unless they leave their clothes off and let the wind and the sun get to their skins. Perhaps they are ashamed because they don't look well with their clothes off. They are thin and stooping and pale.

That is because they work so much. It is very foolish to work. Men who work hard do not live long.

Everything we want grows in the forest; we make our houses out of cane, rattan and leaves, our women weave our loin cloths, and we get our food from the trees and from the fields of rice and sweet potatoes and sugar cane.

Why cannot the Americans live like that? I would tell them about our ways if I could, because I feel sorry for them; they look sick and they should never put clothes on the children. If God had meant the children to wear clothes he would have clothed them himself.

Maybe many of the people cover themselves up because they know that they do not look well without clothes; they are too thin or too fat, or they are crooked. That is why the women hide their shapes, I suppose. But if they lived as our women do they would soon look as well as ours look. Our women by climbing about the mountains have large limbs and look handsome.

I have seen may wonders here, but we will not bring any of them home to Bontoc. We do not want them there.

We have the great sun and moon to light us; what do we want of your little suns? The houses that fly like birds would be no good to us, because we do not want to leave Bontoc.

The most wonderful thing that I have seen in the United States is the stick that you talk in and another man hears your voice a day's journey away. I have walked all around and looked at the back, but I can't see how it does it. But we don't need that; we can call as far as we want to by pounding on a hollow tree with a club.

This is a fine country and I like all the people, but I am going back to Bontoc to stay there till I die. I don't know when I'll die; some people with us live to be very old—maybe, 300 years.

14. THE LIFE STORY OF
A SYRIAN

The following chapter is a composite. Three young Syrians of Washington Street, New York, each lent a part of his life to the making of it, in order that the story might be nearly representative of the average Syrian immigrant.

THE HOUSE in which I was born was situated in a little hamlet about half way up one of the spurs of the southern part of the Lebanon mountain range at an elevation of something like 6,909 feet.

It was a house of two rooms, the largest of which was nearly twenty feet square and had a window of glass. It was a small window with four small panes in it. This with the door gave light by day, and at night a large stone lamp blazed.

The walls of the house were of rough stones and the floor of hard clay, covered over with skins of sheep and goats. Our house sat on a terrace and its front yard was the roof of a neighbor's house, while its own roof was the front yard of another neighbor's house on the first terrace above. The roofs are of thick clay carried on wooden beams and branches. These Lebanon hamlets come down the mountains in steps and the streets are like ladders.

From our front yard, where some orange and fig trees grew, we had a fine view of the western end of the Mediterranean Sea, which looked very close but really was twenty miles away. We could see ships more than fifty miles distant from us. We were within ten miles of a fine grove of the famous cedars of Lebanon and only a day's journey from Baalbec, where are the ruins that Americans think so wonderful, but which did not interest us at all. Baalbec lies over the mountains inland, while at about equal distance from us on the seacoast lies Beirut, where the Governor of the Lebanon district resides.

Lebanon district, which is only eighty-seven miles long, has a sort of independent government protected by the great Powers of Europe. The Pasha, though dependent on the Sultan, is a Christian, and we never see Turkish soldiers. If a small body of Turkish soldiers went into Lebanon they would never get out again. There have been no outrages in the district since the Druses, helped by the Turks, began a general massacre of Maronites in 1860. They killed 35,000 before the Powers interfered and established the new form of independent government, which many of us believe is worse than the old Turkish Domination, as all power is in the hands of the Maronite priests and monks, of whom there are nearly 12,000 in a population of less than 200,000, and they are very corrupt and grind the people unmercifully.

Almost all the Syrians in New York, about 5,000 in number, have come here during the past twenty years, attracted by what they have heard of America and driven out by the Maronite priests' misrule.

The Maronites are Roman Catholics, and the Patriarch, who is their ruler, obeys the Pope of Rome. The Jesuits are very active in the district, and within twenty years American Protestant missionaries, with headquarters at Beirut, have established many schools and missions and their influence has grown and is growing. Where they devote themselves to education they do a great deal of good, but where they engraft the theological subtleties of Protestant sects on the already sufficiently complex religious growth of Lebanon they produce as much harm and confusion as the Jesuits. Van Dyke as an

educator did fine work and his name is sacred in Syria to-day. Most of the people in Lebanon district now are Maronites, but there is a large minority of Greek Christians and Mohammedans.

The Maronite clergy own one-third of the land in the Lebanon district. They are untaxed and have many monopolies. Nominally their wealth is for the poor, but actually the poor man is lucky if he makes a bare living. Everything works to keep him down, no matter how clever and industrious he may be.

The rich men who own the land hire those who can't get land, agreeing to pay them from twenty to twenty-five per cent. of the value of crop raised. At the end of the season by various swindles this is reduced to about eight per cent., the rich man swearing falsely concerning the amount received for the crop. The poor men out of their small share have to pay a government tax that amounts to a tenth of all that they possess. They cannot get redress from the courts because these are corrupt, and the rich man can buy any decision that he pleases.

The principal product is silk cocoons, as the mulberry grows very well on Mount Lebanon.

There was a very beautiful view, as I have said, from our front yard. The sea was in front and the mountains behind and on both sides. These tapered up to snowy peaks. Much was bare red and brown rock and clay, but there were also beautiful valleys. Six other villages and hamlets were in sight in easy walking distance, so that we did not lack neighbors. There were no shops and merchandise was carried on the backs of camels and asses.

When I was five years old I went to school and studied the Arabic alphabet. I wore a shirt with a girdle, in which was a horn inkstand with a reed pen that had a big stub cut slantwise. All education in Lebanon district is in the hands of the Maronite monks and friars, and a friar was my teacher. Our class repeated the Arabic alphabet in unison for two hours at a time as one of the exercises. When I advanced I was taught to speak Arabic and also to repeat and sing the Psalms of David. My aspiration, like that of all the other Maronite boys, was to become a priest, to say mass and sing in the church.

We went to mass every day, and our appeals to Mary, who is the great saint of the country, were constant. However, we stole fruit and flowers, killed chickens and ran away from school just like other boys elsewhere, and the friar at times used to bastinado us—that is, beat us with a cane on the soles of the feet, an attention which made us howl till we could be heard about as far away as Cyprus.

We played marbles and ball, and when I was eight years old I used to go hunting with an elder brother. High up on the mountains there is still plenty of game—deer, partridge, rabbits, and occasionally a bear. We saw leopards twice, but my brother could not get a shot at them.

But the principal excitement of our lives was caused by our wars with other boys. A field lay half way between our village and the next one. It was a desirable one from the standpoint of boys, as we could run races and jump and play ball in it. The other boys wanted it, too, and so we fought with sticks and stones many times, inflicting wounds until the head men of our villages came out and beat us with sticks.

One evening we worked very late in order to make a sort of fort from which to fight the other boys with stones, and the darkness overtook us when we were on the way home. We had to pass a graveyard and there we saw a ghoul—at least my brother saw it, or said he saw it. We ran all the way home and I nearly died of fright. Ghouls devour the dead. They are quite common in Syria. I never heard of them hurting the living; still the people are madly afraid of them. My grandmother said that in her time there were two ghouls that came every night to the graveyard, but never before midnight, when no one could see them. My father thought it might have been a sheep or an ass in the graveyard, but my brother, who was twelve years old, was quite sure it was a ghoul. So we were careful to stay in the house after dark.

All the people of our village and all the villages about us were in mortal terror about jinns, which kidnap living people and carry them away, if they do not kill them on the spot. My grandmother once knew a whole family that was carried off by the jinns and never heard of again. Sometimes a jinn catches a man alone on the mountains and casts him down from a precipice—at least that is one of the beliefs of our people.

As I advanced in school I was taught penmanship. This is a most important accomplishment in Syria. When one says that a certain person is a penman it means much; it means that he is a scholar in the eyes of the community. Good penmen are much respected.

Grammar was far the hardest study. The Syrian grammar is famous for its complications and is, of course, a stumbling block on the road to useful learning. No one masters it, but all scholars spend years of their time struggling to commit its rules to memory. Books have been written about single letters of the alphabet, and these, also, are stumbling blocks.

I got a little arithmetic, some history and geography at this first school and then I went to an American mission school, where my education was continued.

It was about fifteen years ago when I first began to attend the American mission school. This was very different from that which was taught by the friar. At the first school there were few books and I got the impression that there were only about 500 different books in the world, the most important being the Syrian Bible and some writings of our saints. The friar told us that wicked men wrote other books sometimes, but no one read them or would be allowed to read them.

I believed that Syria was the grandest country in the world, the Mount Lebanon district the finest part of Syria, the Maronite monks and friars the most enlightened of men, and the Sultan the most powerful and urbane ruler.

Going to the American school broadened my horizon. I found that the world was larger than I had thought and that there were other great countries beside Syria. Gradually the idea of becoming a Maronite monk, forever chanting the psalms and swinging a censer, or domineering over the poor people, lost its charm for me and I began to think that there might be some other sort of life happier and more useful. I found that only a few priests really understood the Syriac service, and that their wisdom and knowledge were not nearly so great as I had believed.

There was an encyclopedia at the American school which I learned how to use after a time and this broadened my ideas. I read the articles on Syria and the United States, and found to my astonishment that the book made the United States out

to be a far larger and richer country than Syria or even Turkey. When I told my old teacher, the friar, about that he was very angry and complained to the Patriarch, who was scandalized to think that such a book should come to Mount Lebanon. He said that it told lies.

I asked the American teacher and he told me that the encyclopedia was very carefully prepared, each article on a country being written by the men who knew most about the various divisions of the subject. The teacher had a great many pictures of American cities, streets and scenes, and I could see that life in that land was very different from ours. I heard about the telephone, telegraph and railroad, and as I already knew about fire ships on account of seeing them go by on the water, it began to dawn on me that there was a very great and active world outside of Mount Lebanon, and that it might be possible to find something better to do than be a monk.

The American teacher never talked to me about religion; but I can see that those monks and priests are the curse of our country, keeping the people in ignorance and grinding the faces of the poor while pretending to be their friends.

The Americans who had established the mission schools on Mount Lebanon were greatly hated by the Maronite monks, because they go right into their field, but they have kindled a great light and it may result in the uplifting not only of Syria but also of all the surrounding lands.

Great changes have come in the minds of our people since I was a boy. They were like cattle in the old days and took the blows of their rulers as a matter of course, not knowing that such a thing as freedom for the common people existed. But at the time when I was going to the mission school new knowledge began to get about and there were whisperings of discontent that became louder and louder.

Some of the boldest of our men began to tell each other that the poor should have their own and that the courts should deal justice. One time a boy of about my own age told me that if I went up the mountain a mile and a half and looked under the exposed roots of a great tree to which he pointed I would find something good. He was a bold, wild boy and I did not know what he meant or whether he was just joking. Nevertheless I went as he directed and in a copper cylinder I found a

number of newspapers which were printed in Arabic. They were from New York, written by Syrians residing there, and they bitterly attacked the Government of Lebanon, the Maronite priests and the Sultan of Turkey, saying that Lebanon and Syria could never have freedom till all these were overthrown. I was much frightened at reading these papers and quickly put them back where I had found them and ran away from the place, for I thought that if any priest found me with them I might lose my life. When I again met the boy who told me about those papers I hung down my head and hurried past him. I was afraid, and besides I still thought that our Government was as good as any.

Little by little my mind began to change and my eyes to open, till I could see that our people really were suffering terrible wrongs which did not exist in some other countries, and at last I had a personal experience of the corruptness of the courts that made me feel that a revolution was needed.

My father, who died when I was young, left, in addition to our house, certain property in land, cattle and sheep that was of about the value of $6,000. This was in the hands of his best friend. Another man made claim to it, saying that my father had sold to him, and producing a forged bill of sale and receipt for the money. My mother went to the court with witnesses to prove the forgery and the judge put her off from time to time. Her witnesses were threatened and actually driven away from court on the day of the trial, and a decision was given in favor of the forger. My mother went to the judge with her uncle, who had the statements of our witnesses about the forgery, but the judge flew in a passion, insulted my uncle and drove him and my mother away. Then they appealed and for three years more were kept waiting. At the end of that time the court again decided against them, refusing to let our witnesses tell their story and seizing their property and the property of my uncle to pay the costs.

An appeal was then made to the Governor at Beirut, and there was much more delay, but we could never get him to listen to us, and every time we went it cost us money.

My uncle, who had a high temper, was very angry at this treatment and said one time in the hearing of a monk that the judges were rascals and the Governor not any better, and two

days later he was put in prison and his friends had to pay much money to get him out.

When he came to our house again he told us that we should all have to leave the country now, for the officials would give us no rest. He went to Beirut and asked about the steamships there, and we found that we could get one that would take us direct to New York, the place where the Arabic newspapers that attacked our Government were printed. We knew that that was in the United States, and we had heard that poor people were not oppressed there.

We sold all our remaining possessions and found that we had about $60 left after we had paid for our passage on the steamer. The passage cost us $170 and we were three weeks making it, for we stopped at Egypt and Italy and some French and Spanish cities before we stretched out on that run across the Atlantic Ocean. I had never seen any city except Beirut before, and the voyage up the Mediterranean was to me a series of the most astonishing pictures. But all these seemed small after I came into New York bay and found myself almost surrounded by cities, any one of which was far larger and grander than any I had seen in Europe. We passed close by the grand Statue of Liberty and saw in the distance the beautiful white bridge a way up in the blue sky and the big buildings towering up like our own mountain peaks. I was almost prepared to see snow on their tops, though it was the summer time nine years ago.

My uncle had a friend who met us at Ellis Island and helped to get us quickly out of the vessel, and ten hours after we had come into the bay we were established in two rooms in the third story of a brick house in Washington Street, only three blocks away from Battery Park. Two minutes' walk from us was roaring Broadway, seven minutes' walking brought us to the Bridge entrance, and fifteen minutes' walk brought us to the center of the bridge, where, high up above the city and in air that rushed in from the ocean and was as fresh as that in mid-Atlantic, we saw a part of the wonderful picture of New York spread out. It was stunning after the quiet of our hamlet. I took in that picture day after day during the first week after my landing here. There was so much that was strange and new and suggestive of life and power that I never got tired of

looking at the buildings on the land and the vessels of all sorts that shot about through the waters.

I went at night also and saw the city more wonderful than ever, the buildings outlined in the darkness, in chains and rows and circles and ropes of various colored lights—illuminated diamonds and rubies, emeralds, pearls, topazes and all other gems. Never was there such an illumination.

I had learned English in the mission school and as I was a good penman I had no difficulty in securing work as a clerk in an Oriental goods store, where some other Syrians were employed. My uncle, who understands the art of inlaying with silver, ivory and mother of pearl, also got work, and my mother kept house for us and added to our joint income by embroidering slippers after the Lebanon fashion. Between us we earned $22 a week, and as our rent was only $10 a month and food did not cost any more than $6 a week, we saved money.

I remained a clerk for three years and then became a reporter for a Syrian newspaper, as I thought that my education entitled me to aspire. At first my paper was pro-Turkish, but when the recent Armenian atrocities began we found a state of affairs that we could not possibly defend and were impelled to assail the Turkish Government and especially the Sultan— in fact, made a great many bitter attacks on him.

Some of these papers by secret means we managed to circulate in Turkey and especially in Syria, and I soon found that I was a marked man.

In 1897, desiring to revisit Syria, I resigned from the newspaper and secured passage on a steamer; but I did not go, for I found that the Turkish Consul here had telegraphed to Beirut:

"A——— about to leave New York. Arrest him."

I went back to work on the newspaper, but a year later started a printing office of my own in Washington Street, which is the center of our quarter. Soon I had a newspaper of my own. This now comes out three times a week.

I attacked the Turkish Government, and especially the Sultan, more strongly than ever, and managed by secret contrivances to circulate my newspaper quite widely in Syria, as well as openly here. I spoke for the young Syria Association, which

was organized here four years ago and now includes most of our people. It wants freedom from Syria. Of course we do not suppose that Syria could be a nation standing alone, but, protected by the Powers, it could enjoy real self-government, and it is that and the banishment of the misrulers that we demand.

An effort was made to win me over to the pro-Turkish party. A priest walked into my office one day nearly two years ago and, after telling me that he represented the Patriarch, began to remonstrate concerning my attacks on the Sultan. He said:

"I have heard about you from the old country and I advise you not to write against the Sultan."

I said: "Father, what do you want?"

He answered: "My Patriarch has empowered me to tell you that, although you have been condemned as a criminal, we can procure your pardon and have you decorated and given the title of Bey, provided you stop attacking the Sultan and make your paper say that he is a good man who deserves the support of all loyal Syrians."

I replied: "Don't come here another time and say such things to me. If you were not a priest I would insult you."

He went away and I heard no more from him, but I afterward received a copy of a proclamation issued concerning me by Rasheed Bey, Governor of Beirut: It is dated March 12th, 1902. I translate it as follows:

TO THE PUBLIC:

Because L____ J____ A____, who is medium in height, dark complexioned, with chestnut eyes, light hair and mustache, and whose age is 29 and who is from the village of Rome, El Matten, Mount Lebanon, who has published many articles that make harm for his Imperial Highness, the Sultan, and which are full of treason and cursed, and who fled from this country because his doings are criminal, we hereby condemn him to death, according to Article 66 of the Criminal Code.

And this will give notice to the officials of the Government, military and civil, and the justices, that they are to arrest this A____ if he comes within their jurisdiction, and give him to the court.

My assistant editor has also since been condemned to death.

The authorities of the Syrian Church are pro-Turkish, having been captured by the Government. They wear the Sultan's

decorations and receive his gifts and they are not true to their own people. The Sultan rules by means of such people and the huge army of spies that he maintains all over the empire.

It is the Sultan of Turkey himself who is responsible for the Armenian massacres. He is a bloody minded tyrant, the very worst Sultan who ever sat on the Turkish throne. I have said so many times in my newspaper.

We look upon England as having much responsibility for the Armenian massacres. If she had not held Russia back Turkey would long ago have been wiped off the map, and the Christians now under her Government would be safe in the enjoyment of their property and the practice of their religion. But lately it has been Germany that has come to the front as the champion of Turkey. When he was in Palestine three years ago the Emperor of Germany met Zoab Pasha and publicly rebuked him for having surrendered Crete to the Powers.

The little Syrian city which we have established within the big city of New York has its distinctive life and its distinctive institutions. It has six newspapers printed in Arabic, one of them a daily; it has six churches conducted by Syrian priests, and many stores, whose signs, wares and owners are all Syrian.

There are two Syrian drug stores and many dry goods, notions, jewelry, antiques and French novelties stores, and manufacturers of brooches, kimonos, wrappers, suspenders, tobacco, cigarettes, silk embroidery, silk shawls, Oriental goods, rugs, arms, etc. A Syrian restaurant recently established in Cortlandt Street is the best in the city. Our people are active and are doing well in business here, as any one may know by looking at the number of advertisements in the newspapers.

When we first came we expected to return to Syria, but this country is very attractive and we have stayed until we have put out roots. Two-thirds of our men now are American citizens, and the others are fast progressing along the same lines. Still we feel friendship for the old country and a desire to secure her welfare and especially her freedom.

When we say that 300,000 Christian people have recently been butchered by the Turks in Armenia it does not convey any clear idea to the American mind because people here are

so used to peace and order and their imaginations simply refuse to think out the details.

Let us, then, take a village of 300 Armenians that has offended the Pasha of the district but has forgotten the incident. In the morning all the people get up and go about their work; the whole place hums with life and merriment. Suddenly there is an alarm; "The soldiers are coming!" Then the people remember that the Pasha is offended and the wildest confusion results. Then women and children run shrieking through the streets, calling to each, collecting their families, and then trying to run to some place of concealment.

But the laughing soldiers are upon them, making sport of their fear and their sufferings. The guns soon quiet the fighting men and the youths, and then the boys and old women are slaughtered at leisure and with true relish. The pretty women are left till the last.

Soon after the site of that village is covered with ashes and corpses.

If Americans repeat that picture a thousand times they may have some conception of what the Armenian massacres really are.

They express the Turk at his very worst as we find him in the person of the Sultan.

Such things are not done in Syria, because Syria is on the seacoast and the war ships of the Christian Powers are very convenient. In 1860 the Druses began massacring Christians in Syria, but the Christian Powers interfered and since then the Christians there have been under the protection of those Powers.

But Armenia is remote and the Turkish Government can lie about the causes and results of trouble there.

15. THE LIFE STORY OF
A JAPANESE SERVANT

Those who have wondered what was behind the
uniform politeness and unreadable face of a Japa-
nese servant will be interested in this very frank
confession of one, whose preconceived ideal of
America as a land of opportunity and equality has
been disproved by his experience here. No alter-
ations whatever have been made in the manuscript
for his occasional use of Japanese idioms and of
bookish English makes his narrative all the more
personal and naive. He requests his name withheld,
but possibly some of his employers will recognize
themselves as seen in a Japanese mirror.

THE DESIRE to see America was burning at my boyish heart.
The land of freedom and civilization of which I heard so much
from missionaries and the wonderful story of America I heard
of those of my race who returned from here made my longing
ungovernable. Meantime I have been reading a popular novel
among the boys, "The Adventurous Life of Tsurukichi Tanaka,
Japanese Robinson Crusoe." How he acquired new knowledge
from America and how he is honored and favored by the capi-
talists in Japan. How willingly he has endured the hardships
in order to achieve the success. The story made a strong im-
pression on my mind. Finally I made up my mind to come to
this country to receive an American education.

I was an orphan and the first great trouble was who will
help me the expense? I have some property my father left for
me. But a minor has not legally inherited, hence no power to
dispossess them. There must be at least 200 yen for the fare

and equipment. While 200 yen has only exchange value to $100 of American gold, the sum is really a considerable amount for a boy. Two hundred yen will be a sufficient capital to start a small grocery store in the country town or to start a prospective fish market in the city. Of course, my uncle shook his head and would not allow me to go to America. After a great deal of difficulty and delay I have prevailed over his objection. My heart swelled joy when I got a passport, Government permission to leave the country, after waiting thirty days investigated if really I am a student and who are the guardians to pay money in case of necessity. A few days later I found myself on board the *Empress of Japan*, of the Canadian Pacific Line. The moment steamer commence to leave Yokohama I wished to jump back to shore, but was too late and I was too old and ashamed to cry.

After the thirteen days' weary voyage we reached Victoria, B. C. When I have landed there I have disappointed as there not any wonderful sight to be seen not much different that of foreign settlement in Yokohama. My destination was Portland, Ore., where my cousin is studying. Before I took a boat in Puget Sound to Tacoma, Wash., we have to be examined by the immigration officer. To my surprise these officers looked to me like a plain citizen—no extravagant dignity, no authoritative air. I felt so envious, I said to myself, "Ah! Indeed this is the characteristic of democracy, equality of personal right so well shown." I respect the officers more on this account. They asked me several questions. I answered with my broken English I have learned at Yokohama Commercial School. Finally they said: "So you are a student? How much money have you at hand?" I showed them $50. The law requires $30. The officers gave me a piece of stamped paper—certificate—to permit me go into the United States. I left Victoria 8 P. M. and arrived Tacoma, Wash., 6 A. M. Again I have surprised with the muddy streets and the dirty wharf. I thought the wharf of Yokohama is hundred times better. Next morning I left for Portland, Ore.

Great disappointment and regret I have experienced when I was told that I, the boy of 17 years old, smaller in stature indeed than an ordinary 14 years old American boy, imperfect in English knowledge, I can be any use here, but

become a domestic servant, as the field for Japanese very narrow and limited. Thus reluctantly I have submitted to be a recruit of the army of domestic servants of which I ever dreamed up to this time. The place where I got to work in the first time was a boarding house. My duties were to peel potatoes, wash the dishes, a few laundry work, and also I was expected to do whatever mistress, waitress and cook has told me.

When I first entered the kitchen wearing a white apron what an uncomfortable and mortifying feeling I experienced. I thought I shall never be able to proceed the work. I felt as if I am pressed down on my shoulder with loaded tons of weight. My heart palpitates. I did not know what I am and what to say. I stood by the door of kitchen motionless like a stone, with a dumbfounded silence. The cook gave me a scornful look and said nothing. Perhaps at her first glance she perceived me entirely unfit to be her help. A kindly looking waitress, slender, alert Swedish girl, sympathetically put the question to me if I am first time to work. She said, "Oh! well, you will get learn and soon be used to it!" as if she has fully understand the situation. Indeed, this ordinary remarks were such a encouragement. She and cook soon opened the conference how to rescue me. In a moment I was to the mercy of Diana of the kitchen like Arethusa. Whistling up the courage I started to work. The work being entirely new and also such an unaccustomed one, I felt exceedingly unpleasant and hard. Sonorous voice from the cook of my slowness in peeling potatoes often vibrated into my tympanum. The waitress occasionally called out for the butter plates and saucers at the top of her displeasing voice. Frequently the words "Hurry up!" were added. I always noticed her lips at the motion rather than hands. The proprietor, an old lady, painstakingly taught me to work how. Almost always commencing the phrase "I show you" and ending "Did you understand?" The words were so prominently sounded; finally made me tired of it and latter grew hated to hear of it. Taking the advantage of my green hand Diana of kitchen often unloaded hers to me. Thus I have been working almost all the time from 5:30 A. M. to 9 P. M. When I got through the day's work I was tired.

Things went on, however, fairly well for the first six days,

forgetting my state and trying to adapt my own into the environment. But when Sunday come all my subsided emotions sprung up, recollecting how pleasantly I used spend the holidays. This memory of past pleasure vast contrast of the present one made me feel ache. What would the boys in Japan say if they found me out. I am thus employed in the kitchen receiving the orders from the maid-servant whom I have once looked down and thought never to be equal while I was dining at my uncle's house. I feel the home-sick. I was so lonesome and so sorry that I came to America. Ignoring the kind advice of my friends, rejecting the offer of help from my uncle at home, quickened by my youthful sentiment to be the independent, and believing the work alone to be the noble, I came to this country to educate myself worthy to my father's name. How beautiful idea it was while it existed in imagination, but how hard it is when it came to practice. There was no honor, no responsibility, no sense of duty, but the pliancy of servitude was the cardinal requirement. There is no personal liberty while your manhood is completely ignored.

Subduing my vanity, overcoming from the humiliation and swallowing down all the complaints, weariness and discouragement, I went on one week until Sunday. In spite of my determination to face into the world, manly defending my own in what I have within, together with my energy and ability, I could not resist the offspring from my broken-hearted emotions. Carrying the heavy and sad heart was simply dragged by the day's routine work. The old lady inquired me if I am not sick. I replied, "No." Thank enough for a first time she gave me a chance to rest from one o'clock to four afternoon. Sooner I retired into my room, locked the door, throwing the apron away. I cast myself down on the bed and sobbed to my heart contention. Thus let out all my suppressed emotion of grief from the morning. You might laugh at me, yet none the less it was a true state of my mind at that moment. After this free outburst of my passion I felt better. I was keenly felt the environment was altogether not congenial. I noticed myself I am inclining considerably sensitive.

After I stay there about ten days I asked the old lady that I should be discharged. She wanted me to state the reason. My real objection was that the work was indeed too hard and

unpleasant for me to bear and also there were no time even to read a book. But I thought it rather impolite to say so and partly my strange pride hated to confess my weakness, fearing the reflection as a lazy boy. Really I could not think how smoothly I should tell my reasons. So I kept silent rather with a stupefied look. She suggested me if the work were not too hard. It was just the point, but how foolish I was; I did positively denied. "Then why can you not stay here?" she went on. I said, childishly, "I have nothing to complain; simply I wants to go back to New York. My passion wants to." Then she smiled and said, "Poor boy; you better think over; I shall speak to you to-morrow." Next day she told me how she shall be sorry to lose me just when I have began to be handy to her after the hard task to taught me work how. Tactfully she persuaded me to stay. At the end of second week I asked my wages, but she refused on the ground that if she does I might leave her. Day by day my sorrow and regret grew stronger. My heavy heart made me feel so hard to work. At that moment I felt as if I am in the prison assigned to the hard labor. My coveted desire was to be freed from the yoke of this old lady. Believing the impossibility to obtain her sanction, early in the next morning while everybody still in the bed, I hide my satchel under the bush in the back yard. When mistress went on market afternoon, while everybody is busy, I have jumped out from the window and climbed up the fence to next door and slip away. Leaving the note and wages behind me, I hurried back to Japanese Christian Home.

Since then I have tried a few other places with a better success at each trial and in course of time I have quite accustomed to it and gradually become indifferent as the humiliation melted down. Though I never felt proud of this vocation, in several cases I have commenced to manifest the interest of my avocation as a professor of Dust and Ashes. The place where I worked nearly three years was an ideal position for a servant as could be had. The master was a manager of a local wholesale concern. He was a man of sunny side of age, cultured and careful, conservative gentleman, being a graduate of Princeton. His wife, Mrs. B., was young and pretty, dignified yet not boasted. She was wonderfully industrial lady. She attends woman's club, church and social functions. Yet never

neglect her home duty. Sometimes I found her before the sewing machine. She was such a devoted wife whenever she went out shopping, to club, or afternoon tea, or what not, she was always at home before her husband come back from the office. Often she went out a block or two to meet him and then both come home together side by side. Their home life was indeed an ideal one. Their differences were easily made out. It was very seldom the master alone goes out the evening, except in business. Occasionally they went to the theater and concert. Every Sunday both went together to the morning service and afternoon they drove to the cemetery, where the mistress's beloved mother resting eternally.

She was such a sympathetic young lady whenever I was busy, being near examination. She arranged for me not to have any company and very often they have dined out. Indeed, I adored her as much as Henry Esmond did to Lady Castlemond. She was, however, not angel or goddess. Sometimes she showed the weakness of human nature. One day while I was wiping the mirror of the hall stand the mirror slipped down and broken to pieces. Fortunately she was around and witnessed the whole process. It was indeed a pure accident. It is bad enough to break the mirror even in Japan, as we write figuratively the broken mirror, meaning the divorce. In old mythological way we regard the mirror as a woman's heart. I felt very bad with the mingling emotion of guilt and remorse. She repeated nearly rest of the day how it is a bad luck and were I only been careful so on. Made me exceedingly uncomfortable.

I was exceedingly hate to leave her place, but I got through High School and there was no colleges around. Hence I was compelled to bid farewell to my adored and respected mistress, who was kind enough to take me as her *protégé* and treated me an equal. It seems to me no language are too extravagant to compliment her in order to express my gratitude toward her.

Next position I had was in New York—a family of up-to-date fashionable mistress. I was engaged as a butler. I have surprised the formality she observe. The way to open the door, salute the guest, language to be used according to the rank of the guests and how to handle the name card. Characteristic simplicity of democracy could not be seen in this household. I am distinctly

felt I am a servant, as the mistress artificially created the wide gap between her and me. Her tone of speech were imperial dignity. I have only to obey her mechanically and perform automatically the assigned duty. To me this state of things were exceedingly dull. I know I am servant full well, yet I wished to be treated as a man. I thought she is so accustomed the sycophancy and servility of the servants she could not help but despise them. Perhaps the experience forced her to think the servants cannot be trusted and depended upon. I thought I might be able to improve the situation by convincing her my efficiency and also I have no mercenary spirit. Though the position may be a disgraceful one, I consoled my own, hoping to make it pure and exalt lithe higher by the recognition of my personality by my master and mistress. I was anxious to find out of my mistress's strongest principle of her self-regard. I have carefully listened her conversation in the dining table with her husband, of whom I regretfully observed the traces of the hard-hearted and close-fitted selfishness, and at the afternoon tea with her friends. But each occasion made me feel disappointed. One day she told me go out get for her the cigarettes. Out of my surprise I said to her, "Do you smoke?" I had not a least bit of idea that the respectful American lady would smoke. I was plainly told that I am her servant. I got to obey whatever she wants to. Same afternoon I have been told to serve the afternoon tea. The mistress seeing the tea cup, said to me, "No, no; put the glass for the champagne, of course." I was once more surprised. Meantime the luxuriously dressed, pretty looking creature whom, when I met at the hallway, they were so dignified with the majestic air and impressed me as if they were the living angels; but, to my utter disgust, these fair, supposed innocent sex drunk and smoke like men do. Next day I tendered my resignation to my ladyship.

Another new impression I have obtained in this household. One day I noticed a diagram map of the lineage of the family hanging on the wall of the reception room. The ancestor was a knight of Crusade. This phenomena has quite struck me. Before I came to this country I have told my uncle the worship of ancestor is a primitive idea and boast of ancestor is a remnant notion of Feudalism. I shall be my own ancestor. I remember how he reprimanded me with a red hot angry. Still at the bottom of my heart I have contended I am right. I thought I

rather worship Franklin and Emerson. Now I must say that human nature is everywhere just the same. One summer I worked at steam yacht as a cabin boy. Captain, Chief and sailors were all good-natured human being. I do not see why they have been called as sea dogs. When you come contact with them they are really the lovely fellow. Indeed, they are good for nothing; too honest and too simple-minded to succeed modern complicated business world. Of course they use the unbecoming languages, but they really does not mean so. They use swearing even when they expose their joy and appreciation. I am soon nicknamed as "Jap Politician," as I have always fight against the ship crew of their socialistic tendency, defending the statesmen and wealthy people. It is wonderful how the morbid socialistic sentiment saturated among the unhealthy mind of the sailors.

Although I has been advocated the gospel of wealth and extolled the rich, I hate the rich people who display their wealth and give me a tip in a boastful manner. I felt I am insulted and I have protested. Sometime the tip was handed down indirectly from the hands of the Captain. Each time when I have obliged to take the tip I am distinctly felt "the gift without giver is bare." I, however, thankfully accepted the offer from a lady who give me the money in such a kind and sympathetic manner. A gentleman gave $1, saying, "I wish this were ten times as much; still I want you keep it for me to help your study." Indeed this $1 how precious I felt. Once a fastidious lady was on the board. She used to kick one thing to another. Of course I did not pay any attention. Whenever she scold me, I said at heart, "It's your pleasure to blame me, lady. I, on my part, simply to hear you. I am not almighty; I cannot be a perfect. If I made mistake I shall correct. You might bully me as you please and treat me like a dog, I shall not object. I have a soul within me. My vital energy in self-denying struggle could not be impaired by your despise. On the contrary, it will be stimulated." That the way I used to swallowed down all the reprimand she gave me. I, however, getting tired to hear her sharp tongue and hoping to be on the good term with her. One morning I have exerted an exceptionally good care to clean her cabin. Right after I got through her compartment she called me back and told me

that I did not take a care of. I replied emphatically with a conviction, "I did my best under the circumstance." But she insisted I must do better next time. Then she took out dollar bill, gave it to me. I refused to take it. She thrust the money into my hand. I have thrown back the paper money to her feet. "Madam, this is the bribe and graft. I am amply paid from the owner of the yacht to serve you," said I. "No, madam; no tip for me." Without waiting her answer, while she seemed taken entirely surprised, I quickly withdrew from her. Since then she has entirely changed her attitude toward me.

While I was working on the boat I noticed the cook making a soup from a spring chicken and a good size of fine roast beef. I am amazed of the extravagant use of the material. I asked him why he do not use the soup meat and a cheaper roaster for making the soup. I was told it's none of my business and get out from the place. Daily I witnessed the terrible scene of wasting the food. I often thought something ought to be done. It's just economic crime. The foodstuff cook thrown away overboard would be more than enough to support five families in the East Side. Yet the fellow honored as an excellent cook and especially praised of his soup!

The owner of the yacht and mistress were very agreeable persons; the children, too, were also lovely and good-natured youngsters. I shall never forget the kindness and consideration shown by them. While I am waiting on the table I have often drawn into the conversation. The mistress, unlike the wife who commands an enormous fortune, possessed a good common sense and has a sensible judgment in treating of her dependence, as she was cultured lady. The owner of the boat was the man of affairs; a broad-minded man he was. He has had struggling days in his early life. He has shown me great deal of sympathy. I did indeed "just love" to serve them, as one of the sailors has said to me.

Next summer I have been told by Mr. C. to work his yacht again. He said he would pay me $40 per month and if I stayed whole season he would add to it $100, "This $100 is not charity; it my appreciation for your self-denying struggle, to help your school expenses," said he. How hard it was to reject for such a kind offer. I asked two days for the answer. Finally I have decided to refuse, as I had some reasons to believe there are

possibility to develop my ability in another direction more congenial line. For days I did not hear from him. I thought I am sure he has angered me. I was waiting the occasion to explain to him fully and apologize. About a month later I got the message to come to his office. To my surprise Mr. C. told me he would give me $50 at the fall to help me out my school expenses. He said, "I am interested with you. You will be a great man some day. I wanted to express by appreciation to the 'hard spot within you.' " How gratefully I felt. I did not find the suitable phrase to express my thanks, so I simply said, "Thank you." But inwardly I did almost worshiped him. I felt I am not alone in this world. What encouragement Mr. C.'s words to me; I felt as though I got the reinforcement of one regiment.

Shall I stop here with this happy memory? Yet before I close this confession I cannot pass on without disclosing a few incidence I suffered from the hands of inconsiderate millionaire. About three years ago I have worked as a butler in a millionaire's mansion at N. J. Mistress was the young lady about twenty-three years old and the master was forty-five years old. Every morning mistress would not get up till eleven o'clock. Master gets up at six. So we servants serve twice breakfast. At the dinner often mistress and master served the different sort of food. One day I was sick and asked three days' absent to consult Japanese physician in New York. According the advice of doctor I have written twice asking to be given two more days to rest. I did not get answer. After I stay out five days I took 1:30 P. M. train from Jersey City; returned house 4 P. M. As soon as I entered the mansion the master told me I ann discharged. This was the reward for my faithful service of eight months. I wanted to know the reason for. He simply said he wants to have waitress and told me to hurry to pack up my belonging and leave instantly. I asked, however, the reference to be given. He said he would send forward to New York by mail. I was everything ready in one hour; left his mansion at 5 P. M. to the station, where I waited one hour and a half. I returned New York again 9 P. M. , with hunger and exhausted from emotion, as I am not quite recovered from my illness. Since then three times I asked for reference; he never answered. Until now it is quite mystery what made him

angry me. His action handicapped me greatly to hunt new place. Once I was engaged as a second butler in the villa of a retired merchant. When I got there I found myself I am really a useful man as well as second butler, as I am requested to make the beds of coachmen, carry up the coal for the cook, help the work of chambermaid, laundress and housekeeper wanted me to do. The members of the family were only three, old gentleman, old lady and their daughter—old maid. They were proud and aristocratic. They would not speak to servants except to give order and reprimand. There were ten servants to serve them. An old lady and old maid has nothing to do but to watch rigidly how servants work. The old gentleman was lovely, good-natured man. So we servants called an old lady the queen regent, her daughter prosecute attorney, the house-keeper, detective. Every morning I wash the front door porch at 6 A. M. But sometime mail carrier or coachman leave the footmarks after I have cleaned the steps. Later prosecutor get up. If she found the marks she will upbraid me that I did not swept the place at all. When she come to reception room every morning first thing she would do was this, drew out her snow-white clean handkerchief, wrap up her forefinger and scrape the crossboard at the bottom of chair and also the corners of woodwork. If by chance any dust deposited to the handker-chief there will be a thunder of reprimand. The housekeeper-detective was a timid and sensitive woman. She enforced zeal-ously the oppressive domestic rules issued by the queen re-gent. We were told not to talk aloud or laugh. If we commence to gay and our voice began louder sure the detective come for explanation. I was always looked by her as suspicious boy. There must be complete silence be ruled, hence somewhat gloomy. I have openly called housekeeper "Miss Detective" and told her, "We ought make this household little cheerful. Let us have sunshine, Miss Detective," said I. While the luxuri-ous dishes are served in the table, the meals given for the servants was lamentably poor one. The dog meat or soup meat was given to our dinner. The morning papers was not allowed to be read until 9 P. M. Besides I was expected to work all the time; this was impossible physically. One afternoon I am so tired I sat down in the chair at the pantry and rested. Miss

Detective came inquired why I am not working. I said to her, "I have done everything assigned to me. I am not machine. I cannot work all the time." Soon I was called out before the queen. Her majesty asked me what I have been doing. I replied, "Nothing, madam." "But you must do something, B.," said her majesty. "Did you cleaned the windows of my room?" "I have washed that windows last Saturday; this is Wednesday. They are clean, madam." "Last Saturday! You must wash that windows any way this week!" I told her it is foolish to waste money and it is more so to waste energy. "Do you know to whom you are speaking?" said she. "Do it now!" Finding no use to argue with her I went on to clean the windows. As soon as that is done I told Miss Detective I want to leave instantly; it is perfectly nonsense to work to such a person to enslave myself. Miss Detective, finding me beyond her control, send me up to the head of family. The old gentleman said: "Say, B., do you understand the law protect you and me." "No, sir; not always for a servant. The law might protect you and your millions are ample enough to break the law," said I in a sulky mood. "All I can do is to escape from the law. You can get rid of your servant when you dislike him. If I insist to quit immediately you can withhold my wages and could compel me to stay till the month out, as I have been engaged so, by resorting to the law." He said I must stay till my successor be found. Finally we have compromised that I should stay five days more.

Greatest trouble and disadvantage to be a domestic servant is that he has to be absolutely subjected under the emotional rule of the mistress. No amount of candid or rational argument will avail. No matter how worthy your dissenting opinion be, if it does not please your mistress you have to suffer for it. Once I worked for a widow lady whose incomes are derived from the real estate, stock and bonds. She is economizing so strictly that often handicapped me. One day, taking the chances of her good humor, I told her that her well meant efforts are the misapplication of her energy, trying to save her pin money through the economy of gas bill and grocery bill in the old-fashioned way while neglecting to avail herself to the "modern high finance scheme" hereby she may improve her resources. The reward of this speech was an honorable discharge! To be a successful servant is to make yourself a fool.

This habitual submission will bring a lamentable effect to the one's brain function. Day after day throughout the years confined into the kitchen and dining-room, physically tired, unable to refresh yourself in the way of mental reciprocity, even the bright head will suffer if stay too long as a servant. Of course, one's character will be greatly improved and refined by serving the employer like Mr. C. and Mrs. B. But they are exception. Majority of employer will not be interested in their servants.

The motive of my engaging in the domestic work, no matter how meritorious it may intrinsically be, our people look with me the scornful eyes if not with positive despise. The doors of prominent Japanese family closed before me. Sometimes I was unrecognized by the fellow students from Japan, who are sons of wealth. I wrote one day a few lines to console myself:

Who does scorn the honest toil
Mayest ungraceful post thou hail
When the motive is true and pure
The wealth of learning to store.

O! never say that my humble lot
Does harm the fame of fortunate sons
Of Yamato. Disgrace me not.
How wilt thou feel, were it thine once.

How I suffer within knowest thou not;
Aspiring hope alone animates weary heart.
Year after year and day after day.
To realize the hope dear to my destiny.

Unknown to shape my destination
My heart sobered with resignation.
Put far from to be the misanthropist
The love of life giving the keener zest.

I kneel down for the silent prayer,
Concealing my own I toil and prepare
Over the rough sea I steer my heart,
And absorbed the whole my thought.

O what joy how blessed I am!
With inspiring hope for my future aim
To consecrate my own for Truth and Humanity,
To this end I devote with honor and sincerity.

Some say Japanese are studying while they are working in

the kitchen, but it is all nonsense. Many of them started so, but nearly all of them failed. It is all well up to college, where there are not much references need to read. After you have served dinner, washing dishes and cleaning dining-room, you are often tired when you commence to write an essay. You will feel sometime your fingers are stiff and your arms are ache. In the afternoon, just when you began concentrated on the points in the book, the front door bell rung—the goods delivered from the stores, or callers to mistress, or telephone messages and what not. How often you are disturbed while you have to read at least three hours succession quietly in order to make the outline and dug up all the essential points. I have experience, once I attended lecture after I have done a rush work in the kitchen. I was so tired felt as though all the blood in the body rushing up to the brain and partly sleepy. My hands would not work. I could not take the note of professor's lecture, as my head so dull could not order to my hand what professor's lecture was.

Many Japanese servants has told me as soon as they saved sufficient amount of money they would start the business. But many young Japanese, while their intentions are laudable, they will find the vile condition of environment in a large city like New York has a greater force than their moral courage could resist. Disheartened from the hard work or excessive disagreeableness of their environment often tempt them to seek a vain comfort in the misdirected quarter; thus dissipate their preciously earned money. Even those who have saved money successfully for the capital to start the business, their future is quite doubtful. When they have saved enough money it will be a time that their business ability melted away or by no means are sharp. Years husbanding of domestic work, handicapped and over-interfered by mistress, their mental abilities are reduced to the lamentable degree. Yet, matured by these undesirable experience, most of them are quite un-conscious of this outcome as little by little submissive and depending habit so securely rooted within their mind. It will be an exceedingly hard to adjust themselves immediately to the careful and shrewd watch required in the modern business enterprise, though they may be assisted by the instinct of self-interest. Most deliberate reflection is required from these

unconscious servile habit of action to restore to their previous independent thinking mind. The sooner they quit the kitchen the better, though needless to say there are a few exceptions.

Above all I am so grateful to the members of the Japanese Consulate, prominent citizens of our colony, editors of Japanese papers, ministers and secretaries of Japanese missions co-operating each other to help out young Japanese to secure their more agreeable and harmless position, and also they are throwing their good influence to induce Japanese domestic servants to go over to Korea and Manchuria to become a pioneer and land owner in these country, instead of to be the co-worker with the Venus in the American commissary department.

16. THE LIFE STORY OF

A CHINAMAN

Mr. Lee Chew is a representative Chinese business
man of New York. He expresses with much force the
following opinions that are generally held by his
countrymen throughout America. The interview
that follows is strictly as he gave it, except as to detail
of arrangement and mere verbiage.

THE VILLAGE where I was born is situated in the province of
Canton, on one of the banks of the Si-Kiang River. It is called a
village, although it is really as big as a city, for there are about
5,000 men in it over eighteen years of age—women and children
and even youths are not counted in our villages.

All in the village belonged to the tribe of Lee. They did not
intermarry with one another, but the men went to other villages
for their wives and brought them home to their fathers' houses,
and men from other villages—Wus and Wings and Sings and
Fongs, etc.—chose wives from among our girls.

When I was a baby I was kept in our house all the time with
my mother, but when I was a boy of seven I had to sleep at nights
with other boys of the village—about thirty of them in one
house. The girls are separated the same way—thirty or forty of

them sleeping together in one house away from their parents—and the widows have houses where they work and sleep, though they go to their fathers' houses to eat.

My father's house is built of fine blue brick, better than the brick in the houses here in the United States. It is only one story high, roofed with red tiles and surrounded by a stone wall which also incloses the yard. There are four rooms in the house, one large living room which serves for a parlor and three private rooms, one occupied by my grandfather, who is very old and very honorable; another by my father and mother, and the third by my oldest brother and his wife and two little children. There are no windows, but the door is left open all day.

All the men of the village have farms, but they don't live on them as the farmers do here; they live in the village, but go out during the day time and work their farms, coming home before dark. My father has a farm of about ten acres, on which he grows a great abundance of things—sweet potatoes, rice, beans, peas, yams, sugar cane, pineapples, bananas, lychee nuts and palms. The palm leaves are useful and can be sold. Men make fans of the lower part of each leaf near the stem, and waterproof coats and hats, and awnings for boats, of the parts that are left when the fans are cut out.

So many different things can be grown on one small farm, because we bring plenty of water in a canal from the mountains thirty miles away, and every farmer takes as much as he wants for his fields by means of drains. He can give each crop the right amount of water.

Our people all working together make these things, the mandarin has nothing to do with it, and we pay no taxes except a small one on the land. We have our own Government, consisting of the elders of our tribe—the honorable men. When a man gets to be sixty years of age he begins to have honor and to become a leader, and then the older he grows the more he is honored. We had some men who were nearly one hundred years, but very few of them.

In spite of the fact that any man may correct them for a fault, Chinese boys have good times and plenty of play. We played games like tag, and other games like shinny and a sort of football called yin.

GROUND PLAN OF LEE CHEW'S FATHER'S HOUSE

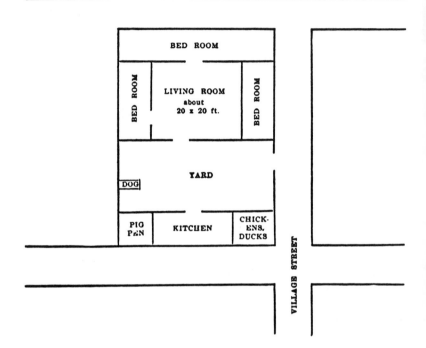

We had dogs to play with—plenty of dogs and good dogs—
that understood Chinese as well as American dogs understand
American language. We hunted with them, and we also went
fishing and had as good a time as American boys, perhaps bet-
ter, as we were almost always together in our house, which was a
sort of boys' club house, so we had many playmates. Whatever
we did we did all together, and our rivals were the boys of other
club houses, with whom we sometimes competed in the games.
But all our play outdoors was in the daylight, because there were
many graveyards about and after dark, so it was said, black ghosts
with flaming mouths and eyes and long claws and teeth would
come from these and tear to pieces and devour any one whom
they might meet.

It was not all play for us boys, however. We had to go to school, where we learned to read and write and to recite the precepts of Kong-foo-tsze and the other Sages, and stories about the great Emperors of China, who ruled with the wisdom of gods and gave to the whole world the light of high civilization and the culture of our literature, which is the admiration of all nations.

I went to my parents' house for meals, approaching my grandfather with awe, my father and mother with veneration and my elder brother with respect. I never spoke unless spoken to, but I listened and heard much concerning the red haired, green eyed foreign devils with the hairy faces, who had lately come out of the sea and clustered on our shores. They were wild and fierce and wicked, and paid no regard to the moral precepts of Kong-foo-tsze and the Sages; neither did they worship their ancestors, but pretended to be wiser than their fathers and grandfathers. They loved to beat people and to rob and murder. In the streets of Hong Kong many of them could be seen reeling drunk. Their speech was a savage roar, like the voice of the tiger or the buffalo, and they wanted to take the land away from the Chinese. Their men and women lived together like animals, without any marriage or faithfulness, and even were shameless enough to walk the streets arm in arm in daylight. So the old man said.

All this was very shocking and disgusting, as our women seldom were on the street, except in the evenings, when they went with the water jars to three wells that supplied all the people. Then if they met a man they stood still, with their faces turned to the wall, while he looked the other way when he passed them. A man who spoke to a woman on the street in a Chinese village would be beaten, perhaps killed.

My grandfather told how the English foreign devils had made wicked war on the Emperor, and by means of their enchantments and spells had defeated his armies and forced him to admit their opium, so that the Chinese might smoke and become weakened and the foreign devils might rob them of their land.

My grandfather said that it was well known that the Chinese were always the greatest and wisest among men. They had invented and discovered everything that was good. Therefore

the things which the foreign devils had and the Chinese had not must be evil. Some of these things were very wonderful, enabling the red haired savages to talk with one another, though they might be thousands of miles apart. They had suns that made darkness like day, their ships carried earthquakes and volcanoes to fight for them, and thousands of demons that lived in iron and steel houses spun their cotton and silk, pushed their boats, pulled their cars, printed their newspapers and did other work for them. They were constantly showing disrespect for their ancestors by getting new things to take the place of the old.

I heard about the American foreign devils, that they were false, having made a treaty by which it was agreed that they could freely come to China, and the Chinese as freely go to their country. After this treaty was made China opened its doors to them and then they broke the treaty that they had asked for by shutting the Chinese out of their country.

When I was ten years of age I worked on my father's farm, digging, hoeing, manuring, gathering and carrying the crop. We had no horses, as nobody under the rank of an official is allowed to have a horse in China, and horses do not work on farms there, which is the reason why the roads there are so bad. The people cannot use roads as they are used here, and so they do not make them.

I worked on my father's farm till I was about sixteen years of age, when a man of our tribe came back from America and took ground as large as four city blocks and made a paradise of it. He put a large stone wall around and led some streams through and built a palace and summer house and about twenty other structures, with beautiful bridges over the streams and walks and roads. Trees and flowers, singing birds, water fowl and curious animals were within the walls.

The man had gone away from our village a poor boy. Now he returned with unlimited wealth, which he had obtained in the country of the American wizards. After many amazing adventures he had become a merchant in a city called Mott Street, so it was said.

When his palace and grounds were completed he gave a dinner to all the people who assembled to be his guests. One hundred pigs roasted whole were served on the tables, with

chickens, ducks, geese and such an abundance of dainties that our villagers even now lick their fingers when they think of it. He had the best actors from Hong Kong performing, and every musician for miles around was playing and singing. At night the blaze of the lanterns could be seen for many miles.

Having made his wealth among the barbarians this man had faithfully returned to pour it out among his tribesmen, and he is living in our village now very happy, and a pillar of strength to the poor.

The wealth of this man filled my mind with the idea that I, too, would like to go to the country of the wizards and gain some of their wealth, and after a long time my father consented, and gave me his blessing, and my mother took leave of me with tears, while my grandfather laid his hand upon my head and told me to remember and live up to the admonitions of the Sages, to avoid gambling, bad women and men of evil minds, and so to govern my conduct that when I died my ancestors might rejoice to welcome me as a guest on high.

My father gave me $100, and I went to Hong Kong with five other boys from our place and we got steerage passage on a steamer, paying $50 each. Everything was new to me. All my life I had been used to sleeping on a board bed with a wooden pillow, and I found the steamer's bunk very uncomfortable, because it was so soft. The food was different from that which I had been used to, and I did not like it at all. I was afraid of the stews, for the thought of what they might be made of by the wicked wizards of the ship made me ill. Of the great power of these people I saw many signs. The engines that moved the ship were wonderful monsters, strong enough to lift mountains. When I got to San Francisco, which was before the passage of the Exclusion act, I was half starved, because I was afraid to eat the provisions of the barbarians, but a few days' living in the Chinese quarter made me happy again. A man got me work as a house servant in an American family, and my start was the same as that of almost all the Chinese in this country.

The Chinese laundryman does not learn his trade in China; there are no laundries in China. The women there do the washing in tubs and have no washboards or flat irons. All the Chinese laundrymen here were taught in the first place by American women just as I was taught.

When I went to work for that American family I could not
speak a word of English, and I did not know anything about
housework. The family consisted of husband, wife and two
children. They were very good to me and paid me $3.50 a
week, of which I could save $3.

I did not know how to do anything, and I did not understand
what the lady said to me, but she showed me how to cook,
wash, iron, sweep, dust, make beds, wash dishes, clean win-
dows, paint and brass, polish the knives and forks, etc., by
doing the things herself and then overseeing my efforts to
imitate her. She would take my hands and show them how to
do things. She and her husband and children laughed at me a
great deal, but it was all good natured. I was not confined to
the house in the way servants are confined here, but when my
work was done in the morning I was allowed to go out till
lunch time. People in California are more generous than they
are here.

In six months I had learned how to do the work of our house
quite well, and I was getting $5 a week and board, and putting
away about $4.25 a week. I had also learned some English,
and by going to a Sunday school I learned more English and
something about Jesus, who was a great Sage, and whose
precepts are like those of Kong-foo-tsze.

It was twenty years ago when I came to this country, and I
worked for two years as a servant, getting at the last $35 a
month. I sent money home to comfort my parents, but though
I dressed well and lived well and had pleasure, going quite
often to the Chinese theater and to dinner parties in China-
town, I saved $50 in the first six months, $90 in the second,
$120 in the third and $150 in the fourth. So I had $410 at the
end of two years, and I was now ready to start in business.

When I first opened a laundry it was in company with a
partner, who had been in the business for some years. We
went to a town about 500 miles inland, where a railroad was
building. We got a board shanty and worked for the men
employed by the railroads. Our rent cost us $10 a month and
food nearly $5 a week each, for all food was dear and we
wanted the best of everything—we lived principally on rice,
chickens, ducks and pork, and did our own cooking. The Chi-
nese take naturally to cooking. It cost us about $50 for our

furniture and apparatus, and we made close upon $60 a week, which we divided between us. We had to put up with many insults and some frauds, as men would come in and claim parcels that did not belong to them, saying they had lost their tickets, and would fight if they did not get what they asked for. Sometimes we were taken before Magistrates and fined for losing shirts that we had never seen. On the other hand, we were making money, and even after sending home $3 a week I was able to save about $15. When the railroad construction gang moved on we went with them. The men were rough and prejudiced against us, but not more so than in the big Eastern cities. It is only lately in New York that the Chinese have been able to discontinue putting wire screens in front of their windows, and at the present time the street boys are still breaking the windows of Chinese laundries all over the city, while the police seem to think it a joke.

We were three years with the railroad, and then went to the mines, where we made plenty of money in gold dust, but had a hard time, for many of the miners were wild men who carried revolvers and after drinking would come in to our place to shoot and steal shirts, for which we had to pay. One of these men hit his head hard against a flat iron and all the miners came and broke up our laundry, chasing us out of town. They were going to hang us. We lost all our property and $365 in money, which members of the mob must have found.

Luckily most of our money was in the hands of Chinese bankers in San Francisco. I drew $500 and went East to Chicago, where I had a laundry for three years, during which I increased my capital to $2,500. After that I was four years in Detroit. I went home to China in 1897, but returned in 1898, and began a laundry business in Buffalo. But Chinese laundry business now is not as good as it was ten years ago. American cheap labor in the steam laundries has hurt it. So I determined to become a general merchant, and with this idea I came to New York and opened a shop in the Chinese quarter, keeping silks, teas, porcelain, clothes, shoes, hats and Chinese provisions, which include sharks' fins and nuts, lily bulbs and lily flowers, lychee nuts and other Chinese dainties, but do not include rats, because it would be too expensive to import them. The rat which is eaten by the Chinese is a field animal

which lives on rice, grain and sugar cane. Its flesh is delicious. Many Americans who have tasted shark's fin and bird's nest soup and tiger lily flowers and bulbs are firm friends of Chinese cookery. If they could enjoy one of our fine rats they would go to China to live, so as to get some more.

American people eat ground hogs, which are very like these Chinese rats and they also eat many sorts of food that our people would not touch. Those that have dined with us know that we understand how to live well.

The ordinary laundry shop is generally divided into three rooms. In front is the room where the customers are received, behind that a bedroom and in the back the work shop, which is also the dining room and kitchen. The stove and cooking utensils are the same as those of the Americans.

Work in a laundry begins early on Monday morning—about seven o'clock. There are generally two men, one of whom washes while the other does the ironing. The man who irons does not start in till Tuesday, as the clothes are not ready for him to begin till that time. So he has Sundays and Mondays as holidays. The man who does the washing finishes up on Friday night, and so he has Saturday and Sunday. Each works only five days a week, but those are long days—from seven o'clock in the morning till midnight.

During his holidays the Chinaman gets a good deal of fun out of life. There's a good deal of gambling and some opium smoking, but not so much as Americans imagine. Only a few of New York's Chinamen smoke opium. The habit is very general among rich men and officials in China, but not so much among poor men. I don't think it does as much harm as the liquor that the Americans drink. There's nothing so bad as a drunken man. Opium doesn't make people crazy.

Gambling is mostly fan tan, but there is a good deal of poker, which the Chinese have learned from Americans and can play very well. They also gamble with dominoes and dice.

The fights among the Chinese and the operations of the hatchet men are all due to gambling. Newspapers often say that they are feuds between the six companies, but that is a mistake. The six companies are purely benevolent societies, which look after the Chinaman when he first lands here. They represent the six southern provinces of China, where most of

our people are from, and they are like the German, Swedish, English, Irish and Italian societies which assist emigrants. When the Chinese keep clear of gambling and opium they are not blackmailed, and they have no trouble with hatchet men or any others.

About 500 of New York's Chinese are Christians, the others are Buddhists, Taoists, etc., all mixed up. These haven't any Sunday of their own, but keep New Year's Day and the first and fifteenth days of each month, when they go to the temple in Mott Street.

In all New York there are less than forty Chinese women, and it is impossible to get a Chinese woman out here unless one goes to China and marries her there, and then he must collect affidavits to prove that she really is his wife. That is in case of a merchant. A laundryman can't bring his wife here under any circumstances, and even the women of the Chinese Ambassador's family had trouble getting in lately.

Is it any wonder, therefore, or any proof of the demoralization of our people if some of the white women in Chinatown are not of good character? What other set of men so isolated and so surrounded by alien and prejudiced people are more moral? Men, wherever they may be, need the society of women, and among the white women of Chinatown are many excellent and faithful wives and mothers.

Some fault is found with us for sticking to our old customs here, especially in the matter of clothes, but the reason is that we find American clothes much inferior, so far as comfort and warmth go. The Chinaman's coat for the winter is very durable, very light and very warm. It is easy and not in the way. If he wants to work he slips out of it in a moment and can put it on again as quickly. Our shoes and hats also are better, we think, for our purposes, than the American clothes. Most of us have tried the American clothes, and they make us feel as if we were in the stocks.

I have found out, during my residence in this country, that much of the Chinese prejudice against Americans is unfounded, and I no longer put faith in the wild tales that were told about them in our village, though some of the Chinese, who have been here twenty years and who are learned men, still believe that there is no marriage in this country, that the

land is infested with demons and that all the people are given over to general wickedness.

I know better. Americans are not all bad, nor are they wicked wizards. Still, they have their faults and their treatment of us is outrageous.

The reason why so many Chinese go into the laundry business in this country is because it requires little capital and is one of the few opportunities that are open. Men of other nationalities who are jealous of the Chinese, because he is a more faithful worker than one of their people, have raised such a great outcry about Chinese cheap labor that they have shut him out of working on farms or in factories or building railroads or making streets or digging sewers. He cannot practice any trade, and his opportunities to do business are limited to his own countrymen. So he opens a laundry when he quits domestic service.

The treatment of the Chinese in this country is all wrong and mean. It is persisted in merely because China is not a fighting nation. The Americans would not dare to treat Germans, English, Italians or even Japanese as they treat the Chinese, because if they did there would be a war.

There is no reason for the prejudice against the Chinese. The cheap labor cry was always a falsehood. Their labor was never cheap, and is not cheap now. It has always commanded the highest market price. But the trouble is that the Chinese are such excellent and faithful workers that bosses will have no others when they can get them. If you look at men working on the street you will find an overseer for every four or five of them. That watching is not necessary for Chinese. They work as well when left to themselves as they do when some one is looking at them.

It was the jealousy of laboring men of other nationalities—especially the Irish—that raised all the outcry against the Chinese. No one would hire an Irishman, German, Englishman or Italian when he could get a Chinese, because our countrymen are so much more honest, industrious, steady, sober and painstaking. Chinese were persecuted, not for their vices, but for their virtues. There never was any honesty in the pretended fear of leprosy or in the cheap labor scare, and the persecution continues still, because Americans make a mere practice of

loving justice. They are all for money making, and they want to be on the strongest side always. They treat you as a friend while you are prosperous, but if you have a misfortune they don't know you. There is nothing substantial in their friendship.

Irish fill the almshouses and prisons and orphan asylums, Italians are among the most dangerous of men, Jews are unclean and ignorant. Yet they are all let in, while Chinese, who are sober, or duly law abiding, clean, educated and industrious, are shut out. There are few Chinamen in jails and none in the poor houses. There are no Chinese tramps or drunkards. Many Chinese here have become sincere Christians, in spite of the persecution which they have to endure from their heathen countrymen. More than half the Chinese in this country would become citizens if allowed to do so, and would be patriotic Americans. But how can they make this country their home as matters are now? They are not allowed to bring wives here from China, and if they marry American women there is a great outcry.

All Congressmen acknowledge the injustice of the treatment of my people, yet they continue it. They have no backbone.

Under the circumstances, how can I call this my home, and how can any one blame me if I take my money and go back to my village in China?

17. THE LIFE STORY OF

A FLORIDA SPONGE
FISHERMAN

The friend of THE INDEPENDENT who obtained the
following article by Mr. Barker for us writes: "I am
sending you the sponge fisher's story just as it came
to me. He did not write it down, of course, but
'talked' it."—EDITOR .

I WAS born in a palm-thatched shack under the tamarinds, on
the green shores of Pelican Harbor, Bahama Islands. My father
was an English sailor, but my mother was a Cuban-born Span-
iard. I've got the dark look of my mother; I suppose I'm none
the fairer, either, for a long life on sunburnt waters.

I couldn't have been five years old when a bad piece of news
came to our little home. I remember, my two brothers and
myself were playing out in the shade of a cocoanut palm when
some one came running to tell my mother that the "Perdita"
had gone down with all on board. Small as I was, I instantly
knew what that meant. We had heard such tidings before of
other vessels, and we knew how to take in the meaning of the
dreadful words at once.

Life did not change very much for us then. We only went
from the tamarinds and cocoanuts of the Bahamas to those of
Key West, where my mother had a brother, a widower. She

kept house for him the rest of her life. My father had been constantly away from home, and now my uncle, likewise a sailor, was nearly all the time gone, leaving his three children to my mother's care. So things were much the same with us, except that there were more playmates and a bigger house to come back to when play was over.

But playing-time is short with folks like us. School days came very early to my little brothers and myself. There are good English schools in Key West, and my mother had not forgotten her English husband; so she sent us to them as early as we could be admitted.

"For you are not Conchs, remember," she charged us, her eyes flashing and voice ringing; "and you must never let them call you so. You are English, and I want you to speak English, and speak it well, besides reading it and writing it, like your father before you!"

Since I've seen more of the world I've come to know that Key West is a strange town unlike any other. There's an English part to it, and a Spanish part, the Spanish being bigger, but poorer, and alas! much dirtier. Several languages are spoken in the town; Spanish most of all, it seems to me. But, above everything else, our island-town is American; that's why so much money is made and lost in it, and so many business enterprises spring up.

And what did my mother mean by saying that my brothers and I were not Conchs? Well, but we were, I think. At least, we've mostly been called so, for we've sponged with crews that talked the Conch lingo and we've spoken it regular with them. Yet we were taught good English and I speak it all the time in my own home.

You see, the name Conch was given, generations ago, by our neighbors on the main shore of the States, to the Spanish-speaking, mixed-blood people of Key West. You know the great, slimy thing that crawls around in a conch-shell? Dig him out, and he looks like a lump of muddy, nasty jelly. Some of our poorest people along shore no doubt eat these, but the dish isn't known on better tables. I suppose the name was an insult at first; my mother said so, and felt it like a knife, because the Key Westers were said to use conchs as a staple article of food.

Anyway, the name Conch has clung, and most us don't care at all for it now. There's a funnier name than that among us: when one of us marries into a mainland family the children are called "Loggerheads." In my life-time lots of the Conchs have married about Tampa and Cedar Key; so lately the Loggerheads in our crews are numerous.

I told you my school days commenced early. They ended early, too. One day, when my uncle came home from a long cruise I ran down to the wharf to meet him. But for an hour he was too busy to notice me. He was talking excitedly to José and Manuel Silvas, two turtlers we knew well and they were handling and passing back and forth among the three some wet, dirty-looking objects that I did not recognize. When I got very close I found out that these dirty objects smelt very bad. How well I've come to know that smell in the half of a hundred years that's rolled over my head since then. Most of the months of those years I've been out on the water, with the deck of my boat piled up with these same dark-looking, nasty-smelling objects.

For, you see, these were sponges that José and his brother had found out on the reefs when they were looking for turtles; and they were showing them to my uncle because his judgment and knowledge were much respected among all the seafaring people that came in to the Key West wharves. The Silvas brothers kept telling my uncle over and over that there were wide fields of this strange growth out in the waters they had been turtling in, and my uncle, Alejandro Piestra, was running forward in his mind to the possibility of harvesting these and finding a paying market for them. Small as the incident appeared, a great United States industry had its beginnings right there.

As nearly as I can remember this happened about 1853 or 1854, and within a few months my uncle had fitted out two or three small boats for the sponging fields of José and Manuel. I was scarcely eleven years old, but he put me on one of the boats.

"It's going to be a money-making business, Elena," said he to my mother, in his far-seeing way; "not now, perhaps, but one of these days. Let the boy learn it from the start and grow into it."

Even so it has been. At the time all the sponges used in the United States were imported. Now our own markets, with their big demand, are almost wholly supplied from our own waters, and there's a large export of the grass sponge to England every year.

But it's only in the Florida waters that sponges are found, and nearly altogether on the west coast of the peninsula. The water is too deep and too cold on the Atlantic side, and the hurricanes too destructive to sea life. Sponging doesn't pay in the Atlantic.

The sponge fields in the Gulf of Mexico are big, and they are pretty widely worked the last few years. We call St. Mark's the northernmost tip of the fields, and they reach clear down to the reefs about Key West, stretching out fifteen or twenty miles from shore all the way. But they differ in fertility, just as the farmer's fields differ. The grounds that give us the richest yield lie between St. Mark's and Anclote Keys, and they are worked by a large force of men.

Yes, this is the finest and most valuable of all Florida's maritime industries, for it keeps several thousand men employed and a handsome fleet of vessels cruising along the western shores of the Gulf, and the yearly harvest means considerably over a million dollars to the State.

In those early days we had the awkwardest sort of sponge hooks and no water glasses, nor anything else to make our work easy or successful. I can't say we did succeed, either; we were not in the right place to succeed, even if we'd had good boats and the implements we use now. There are not enough sponges along the reefs we were on then, nor are the ones gathered there of fine enough quality. But even with all odds against us, we were by 1858 or 1860 bringing in some catches that sold quite well, and drew other folks' eyes to our business. Some more men began to fit up boats, as my uncle had done, and to send out sponge-fishing crews. In a few years turtlers, mullet-fishers and many others that followed the sea were leaving their old work and turning to the new, because it offered so many more changes. The gamble in it drew the Conch, you see. Soon the boats were getting bigger and finer, and every year they pushed up further north, until at last they got to St. Mark's, and the sponges ended.

Somebody soon invented a hook for catching hold of the sponge and pulling it loose from the rock or coral bed at the bottom of the sea, where it grows. The sponging glass had come early. This looks like a common water-pail, except that it has a glass bottom. It is tied with a rope to the side of the dinghey, and the hooker, laying himself breast down across the thwarts and facing the bow, looks over the side into the water through this glass-bottomed bucket, held in his left hand, while his long hooked pole is in his right. His mate, the sculler, is in the stern of the dinghey, and if he's as good at his business as he ought to be, is sculling so easily and smoothly that the boat glides like a fish. The hooker up forward holds his water-glass plunged several inches below the surface all the time: that's to lose the ripple and so have a clear view.

At first, when we didn't have glasses, we brought up many an object that wasn't a sponge, and many a sponge that was worthless. We were fishing in shallow waters in those days, too. But nowadays some of our poles are 45 feet long; for fishing deep, where the finest sponges grow. An expert sponger rarely ever makes a mistake in his catch. The minute he sights his sponge he lets loose his glass to grab his pole with both hands; he aims true, gives a peculiar little twisting movement, mostly with the wrist muscles, and dollars to doughnuts, he lands his catch in the bottom of the dinghey. If it's a fine, big sheep's-wool, worth something like $1.00 or $1.50 to us, maybe he and his mate take a minute to mirate over it; then back to business quick as a wink. The hooker faces down again, and reaches for his water-glass, which, of course, would have been lost if it hadn't been tied to the boat.

All of this looks easy. But when the new men try it they find it about as hard a job as they've ever tackled. Very few spongers are good hookers and scullers, too. It takes much more experience and skill to make a hooker. I sculled from the time I was twelve years old, but I never got to be a first-class hooker until I was away 'long in years.

Do our men pair off for a whole season at a time? Mostly,— just like what some visitors to the kraals tell me about the "dory mates" at cod fishing, in waters up North. But sometimes the mates don't agree, and the Captain has to change them. It strains the hooker awfully if the sculler is rough,

besides making it impossible to get a good catch. So there's plenty of room for quarreling over it.

No, our boats don't carry even-numbered crews in order to mate off. Where would the cook come in? And nobody's more important. All the sponging fleet carry odd crews; the small boats five or seven men, then nine, eleven, and so on up. Not many boats over fifteen in our fleet. The captain works, too; sometimes he's cook, but oftener a hooker, occasionally a sculler. There are as many dingheys, or small sponging boats, as there are pairs of mates. A crew of fifteen will carry seven dingheys. The unmated man is cook. He's housekeeper, too, and has charge of the boat all day while the dingheys are out. He has to be a pretty fair sailor, for, when the dingheys start out in the morning they may keep bunched and trail off together a great distance, and generally the cook is expected to sail the big boat in their wake, so he's ready on hand to pick up the men when meal-times come or their cargoes get heavy.

Nearly all our boats are owned and fitted out in Key West, tho lately there's an increasing number every spring from places like Tampa, Clearwater and Cedar Key. Not many spongers own their boats. Generally it's a business speculator in Key West, or some other port, who owns them. I know one man that sends out fifteen this season. My uncle had nine at work when he died. I always thought it a pity he had to die before he saw what a big thing he had started in this industry.

But I was telling you how the boats are owned, and that leads up to how we get our money out of the business. The owner fits up his vessel, and engages his crew for a trip; that's eight weeks; no less even if they catch; nothing more, unless the hurricanes, or something else, should hold us out.

When we have to lie up for bad weather we don't go back to Key West, or any other starting-point, but come to anchorage here in the neighborhood of our kraals, along about Bailey's Bluff.

The owner lays in "grub" for eight weeks, full measure, to start with. Then, at the end of the trip, when we sell our catch, one-half, or one-third the cash, according to the number in the crew, goes to the owner, and the balance is shared equally among the men, except that the one who's had the responsibility of being captain generally gets a little the most.

In good seasons we often divide big money. Now the trip just made by our boat was not a specially good one, but we calculate to share $54.00 to $57.00 to the man. Wait till we go the Rock Island trip; that's away up the coast, and we save it until late in the fall, because the sponging grounds are protected from the prevailing winds by the lay of the shore. Up there the waters are deep and the sponges fine, not only in size, but in color and texture. All these points count high in the value. When we come back from Rock Island, if good luck follows us there, as it ought, why, we expect to share close on to $100.00 apiece. We did the season before last.

Perhaps you don't understand the spongers' bounty system. Sometimes I think it's at the bottom of most of our troubles, at least of our men's not putting by something from the good money they make. I don't know whether it's fixed in many other businesses so that a man can spend first and then earn; but I know, if it is, it's the worse for the workers.

I'm afraid the spongers' bounty began with my uncle. He was always a liberal man, and so, when his crews asked for money in advance, they got it. When other men began to fit out sponging craft their fishermen demanded an advance, "such as José or 'Tonio had from Señor Piestra," and so it went.

Now never a man would ship on a sponger without his bounty. You don't understand it perfectly? I'll make it plainer. Take the boat I work on, the "Juana." She carries a crew of eleven this year. Let's go back to Christmas times, as I told you of them. We're all out of money when January comes. Then we live on our credit for a month or more. A good sponger always has credit to live on—more's the pity, I think. It's late February before the "Juana" is ready to start out; that's as soon as the best of them goes. The water is generally too muddy for sponging before March. The owner of the boat hunts up the eleven men he wants about the last of January; some of us are old hands with him, some are new. He comes up to the first one:

"Going to ship with me, Pedro?"

Pedro is likely to answer: "How much bounty you give us?"

The owner asks back: "What you owing out?"

Then Pedro counts on his fingers, so much to so and so for

"grub" since Christmas, and so much somewhere else, and maybe some other place. It mounts up to perhaps $25.00 or $30.00. The boat-owner is expected to stand for the debts first; then comes the bounty—that's always a cash advance.

"Thirty dollars on your debts, Pedro; I can't give you but $10.00 bounty."

Possibly Pedro takes it, perhaps refuses and goes to another master. But most likely he says:

"Rise to $20.00, Señor, and I'll take you!"

What does Pedro do with the bounty? Goes and spends the biggest part of it on a farewell "r'yster" before he ships, I'm afraid, leaving wife and family to be provided for while he's gone, maybe by the boat-owner, maybe some other haphazard way. There's tobacco to be laid in, too, from the cash, and sometimes clothes. Of course, the bounty and the debts must be squared to the owner out of what the sponger shares when the catch of this trip is sold. It won't leave much, if any. So into debt again, and another bounty before the next trip. You don't wonder I think it a bad system? But our men have grown to it till they wouldn't be willing to work under any other. Some people that have seen the world tell me the common run of farmers where they make cotton raise their crops with an arrangement pretty much like our bounties.

Well, our biggest squadron sets out from Key West in time to be on the grounds with the first fine weather, that comes so early in our climate. You can imagine you are starting with us, say, fifty boats together, our "Juana" leading. There'll be fifty more coming scattering later on, and another fifty, call it, from other ports. Our boats are of various builds and range from a 30-foot to a 70-foot keel.

If a gay little sou'wester sings through the rigging, so much the better; we won't mind crowding canvas if she's steady, for we're mostly good sailors. North'ard we scud, and jokes are cracked, yarns spun, and cards played in our tight little cabins. Smoke? I should say we do. Did you ever see a sponger without his pipe, except at meal-time, or he's hooking? We'd never stand the smell of the dead sponges if we couldn't smoke.

But on this outgoing there's no smell; our boats are clean as wax, and everything is jolly enough. We love the salt in our faces again.

Two or three days' fair sailing will bring us in hail of Egmont Light; that's off from Tampa. We scud past it, and head on up. Fifty miles further and we come to our own Light; that's this one here, Anclote, and we run in to anchor off Bailey's Bluff.

Yes, it's a good harbor we've got here and sea-room for all. Tight anchorage, too. This bay is about central in our best sponge-fields, and so it came to be hit upon for the kraals.

You can see what the kraals are. They're only pens in the water, made by driving stakes tight and fastening together with hurdles. They're to hold the sponges while the animal part is being soaked out. All the vessels of the Anclote fleet have their separate kraals, of course, here, in the neighborhood of the Bluff.

Generally we put out for the grounds Monday morning, setting sail anywhere from midnight to daybreak. With good weather we fish hard till Friday noon, or even Saturday morning, anchoring wherever we happen to be every night; unless it's squally and we're driven to harbor. By Saturday noon every vessel tries to make it back to the Bluff. The sponges that have soaked a week are taken out of kraal, and the new catch put in. Enough for the men to do a fill most of Saturday and sometimes part of Sunday. The week-old sponges must be carried ashore, to be cleaned and bunched. Every piece is cleaned separately by holding it in one hand while you beat it with a stick until the refuse is all out. When cleaned, they're gathered up and strung in bunches, according to size and quality, and the bunches then left to sun and air.

There's many, many a different kind of sponge, but only three we harvest for market: that's the sheep's wool, the finest, then the grass, and, last, the yellow. The sheep's wool brings us regularly from $2.00 to $5.00 a bunch. From seven to fourteen sponges make an ordinary bunch, but sometimes just one or two fine specimens will be bunched by themselves and bring $4.00 or $5.00.

The grass sponge isn't near so valuable, but it's been increasing steadily in price for the last five years, because England sends here for more and more every year. It sells now for three times as much as the yellow. You see, the yellow one looks muddy and coarse. It's very abundant all up and down

our shores, but it don't cut much figure with us in years when
we're getting good wool yield.

Our life looks easy enough to you when you see it this way,
with the sunshine everywhere, and our boats rocking here in
the Bay, the men lounging about or standing up for you to
take their pictures. Perhaps it is easier than many. I know I'd
die if you'd cage me up in big city and set me down to some
finicky piece of work. I've got to have searoom, and change my
muscles often, besides. I'm thankful to be a sponger, instead of
some factory or tenement fellow.

But maybe you've not thought of the hardest side? It isn't
the work; none of us mind the work after we get started, tho
a Conch's not the easiest man in the world to start. No, it isn't
the hard work. It's the long, lonesome nights out in the Gulf,
the murk and storm days, when there's nothing for us, when
work would be a blessing; but instead we've got to sit around
on deck, or be driven below by the rain or the smell, and have
nothing for hands or brain but cards, a little fiddling maybe,
and then dull talking to our few mates, and we know all they
know, all they've got to say to us.

Then the week's end comes. But once more I can be thankful,
for we've got the Pavilion now! Long, long years dragged over
when we had nothing better to, at the end of every week, than
just that same round of cards and pipes. Only we'd stretch our
legs ashore and see the other crews. What else was there,
unless we sailed up or down the coast to a breakdown in some
Florida fisherman's shack, or perhaps cruised off to some town
and tried a bad drunk on contraband rum? It's smuggled
through from Cuba in large quantities along here, in spite of
the cutters. You've no doubt heard the coast people speaking of
it as "auger dent," which stands for the Spanish "aguardiente."

I'd like to have it said for our men, tho, that drinking is very
uncommon among them out on the trips. Perhaps Conchs
know their own weaknesses; aguardiente makes us quarrel,
and quarreling would lead to killing every time when we're
penned up together on the boats. So if drunk it must be, we
wait till we're back in Key West.

But the Pavilion? It was Miss Stirling that got that for us.
She was down here spending her first winter, when she used
to visit the kraals and the Bluff, and see how lonesome and

dull the men were on Saturdays and Sundays; nowhere to go, nothing to do when we were through cleaning. Just sleeping on our boats at night, and in the day-time, if it wasn't work, just loafing around our sponge-piles, or the keeper's shack, till it was time to start on another week's round.

The first thing we knew, Miss Stirling had started a fund for a Pavilion up here above the kraals. She put in a good deal of money herself, and got some from people a long way off, then some from the boat-owners in Key West and other ports. When the building was well begun she came among us for contributions, and we gave her whatever we could. She gives us credit for helping lots. That was three winters ago. In a few months it was finished up, and you see now we've got something to be proud of and enjoy forever. Why, I expect my children's children to get good out of that Pavilion.

You don't wonder I like to say it over and over, "Thank God, they built the Pavilion in my day!" over, "Thank God, they built the Pavilion in my day!"

18. THE LIFE STORY OF

A HUNGARIAN PEON

[The following true story was told by Mike Trudics
to Alexander Irvine. Mr. Irvine spent several months
last winter as a manual laborer in the lumber and
turpentine camps of the South. In a café in Pensa-
cola Mr. Irvine entertained Mike and Mr. Sandor as
they exchanged experiences. Mr. Sandor was then
on his way to prison for his share in Mike's involun-
tary servitude.—EDITOR.]

"I AM going to America!"

The words of my father startled us that night, for we were
so quiet—out there two hours' walk from B____. It was to us
like saying he was going to be hung.

My father and mother were farmers. There were four of us
children—two boys and two girls. John was ten, Annie twelve,
I was seven and Mara sixteen.

We were at supper, but my father was not eating. "It is the
best I could provide," my mother said, thinking it was the
food.

"It is not that," he said. Then he spoke of America, and we
all looked at him with our mouths wide open.

Mother stopped eating and we children had more black
bread that night than we could eat. After supper we gathered
closely around the open fire. All of us got very close to father.
Annie sat on his knee, I sat on the hearth with my arms around

his leg, while John and Mara leaned their heads against him. Mother rocked and rocked, looking with big eyes into the fire all the time.

"Even if I owned a farm," father said, "what difference would it make? I need a mule, I need a plow—I need many tools. It breaks my back to do a mule's work, and the best I can do brings but black bread, and not even enough of that."

I did not understand what all this meant; I only knew in a dim kind of way that something had gone wrong. My father was a different man to me. My mother, too, looked strange. Her eyes were large, and she would look a long time at one place.

Our hearts were heavy. They were heaviest at night, but during the day I saw my mother weep and kneel for long periods at the ikon. We had all been baptized in the Russian Church, and one day the priest came and said a blessing for my father.

"Yes, yes," my father said when the priest was gone, "prayers are all right, but they are not black bread. They do not pay the rent. The priest says prayers and I sweat and give my blood; that is different."

My mother made the sign of the cross and said, "God is good! God is good!"

When my father picked us up one by one to say goodbye, he kissed us many times. Then, to please my mother, he went over to the ikon in the corner, and dropping on his knees crossed himself. We all sobbed aloud.

Nikof Jaros, our neighbor who lived alone, came with his mule to take father and his box; but we all cried so loud that he had to take us all. The journey was a fine holiday for us and we forgot our trouble on the way. It was different coming back.

"In two months," my father said, "I will send for you." We hugged him tight and hollered, tho there were crowds of people around. My mother still wept quietly and said, "God is good! God is good!"

"America is great," Nikof told us on the way home. "It is not a land of fat priests and skinny people. Everybody has plenty and every man is a lawyer. The people make whatever laws they like."

We thought Nikof was very wise—except when he was drunk.

We were very lonely. When the wood fire burned brightly on the hearth at night we all sat around it just thinking, thinking about father. Mother used to gather us around the ikon every night and make us say our prayers. John cut a nick in the door-post for every day the ship was at sea. One day, when the posts on each side of the door were covered with nicks, a letter with George Washington's picture on it came to B____. John got it. None of us could read it, but the feel of it was very nice and we all handled it in turn. We handled it over and over. Mother wept over it before she knew what was in it. Nikof was sent for—he can read. He came at night. It was a great night for us. We believed more than ever that Nikof was really a great man. He read the letter over to us. Indeed he read it so often that we could all repeat it by heart. For so much paper there seemed to be very little communication. It just said father was well and making a fortune very fast.

A week afterward the priest came to our house, and after telling him the good news, mother gave him the letter. We all watched his round, red face. There were so many expressions on it in a minute.

"Nikof is a liar!" he said. "Jan Trudics is dead! This letter is from a friend of his who says Jan walked the streets of New York looking for work until his feet were blistered. It says that at the end of a week he was taken ill and died. It says he died of a broken heart!"

My mother began to cry, and that started all of us.

"Be quiet!" The old priest said sternly. "God will be a father to the orphans. He will succor the widow in her distress!" But we cried all the louder. That night we gathered closely about mother.

John brought in extra wood and we sat silently by the fire watching the red flames as they leaped up the old chimney. Mother's face made us all cry. It was so pinched. Her lips were white and her eyes were sunken deep into her head, and for long hours she just looked steadily into the fire. We cried until one after another we went to sleep, and mother carried us to our bed in a corner.

Mother pined and prayed and spent much time before the ikon. As the days passed there was less and less black bread. Nikof came often, and always brought something to eat. He seemed to know our affairs, tho nobody ever told him. We liked him very much even tho he did read the letter backward. "For stupid peasants," Nikof said, "knowledge is a great curse. The less we know, the less we need." When he cursed the old priest only one of us agreed with him—that was Mara.

A year from the time my father went away my mother was in her grave, and the old priest and the doctor said that she, too, died from a broken heart. When we gathered around the fire again, we were a quiet, sorrowful lot. Nikof came and sat up late with us. He chopped plenty of wood and made some cakes with his own hands. he told us plenty of stories—good stories about God and another world than this, where father and mother were. "There," he said, "we will all be spirits and we will have no stomachs at all."

"The priest does not say we shall have no stomachs," said Mara.

"I know," Nikof said. "He is always making me out a liar— he is all stomach, the old—"

Mara put her hand on Nikof's mouth and stopped him.

Some kind-hearted folks in B——— took John and somebody took Annie. Mara and I were unprovided for. One day Nikof hitched up his old mule and took us for a ride. It was a long ride to the city, and Nikof and Mara seemed to have all the conversation to themselves. But I was glad of the ride anyway. And when we drove up to the old priest's door Nikof let me mind the mule while he and Mara went inside. When they came out again Mara's face had a different look. She looked as she did before father went away, and I was very glad. I thought she had gone for a blessing to the old priest, but Nikof said:

"That is not it at all. We have just got married."

I was very glad. Nikof took us to his own little farm a few miles from our old home and we lived there happily with him for a year. In a year Nikof got drunk just once. It was when he was with a soldier in the city. They got too much brandy and on the way home lay down in the snow. They found the soldier dead and Nikof had both his legs sawed off later.

I was taken to the city and given away. I was nine at the time. I did not see Mara for years after that, tho we were only two hours' walk apart. One day they told me that Mara had gone crazy and that she had left Nikof.

At fifteen I became apprenticed to a molder. It was a place where were made cornices—cornices of tin and zinc for churches and other fine buildings. I stayed there until I was twenty years of age. Then I worked at a number of things—at times a common laborer and again as a teamster.

After I was twenty I attended meetings of different kinds. I heard a lecture once on America by a man who had gone there as a poor emigrant and returned a rich man. He said America was a country of magic. He told of wonderful things men had done, but all the time I was thinking, thinking of my father, of his blistered feet and broken heart. It was not his talk, however, but a book by Louis Kossuth that stirred me up to go to America. It took me nearly a year to get enough money to come. I about half starved myself to do it.

It was in May, 1906, that I came to New York. I was then twenty-four years of age. It certainly did look wonderful from the ship! A well dressed man who spoke our language told us that the big iron woman in the harbor was a goddess that gave out liberty freely and without cost to everybody. He said the thing in her hand that looked like a broom was light—that it was to give us light and liberty too. I thought he talked like Nikof Jaros. Especially when he told us a man could stand inside the broom.

I thought the rich people lived in the big, tall houses, but he said that was a mistake; they just did business there. He said they lived in palaces that would make our eyes bulge out if we could see them.

At Ellis Island they put my life in a book and asked me a lot of funny questions. Did I believe in law? Was I in favor of government? etc.

When I got away from them I found my way to my mother's brother on East Third street, near the river. My uncle was a brass polisher, but altho he had been many years in New York, he had not performed any miracle; he had not seen any magic. He had an ordinary kind of a job that he held in an ordinary kind of a way for a number of years. I expected, of course, to

find him rich, but he laughed loudly at that, for he had that idea himself when he first landed.

The man my uncle lived with was an old friend of my father's. He gave me a corner in one of the two rooms. It was a good corner and I was happy in it.

Of course I looked around for the dwellings that were to make my eyes bulge out of my head. I saw only tenements, however. Maybe they were barracks. I was much bewildered by these big houses. They looked like big stone caves and the people were so crowded that they knocked each other about the streets. Indeed they rushed along as if they were crazy.

I got a job with my uncle at $10 a week. That seemed a very big price to get for my labor, but the price of board was so many times larger than it was in the old country. However, I was getting along very well until the factory was destroyed by fire. Then I had the experience of looking for work. It was easy as long as I had money to pay my board, but when my money had gone and I was dependent on my uncle and my father's old friend, I felt it very keenly indeed. I kept going, going, going, until my legs were very tired. Then a feeling of home-sickness came over me, and I came to the place where my father had been—I mean the condition he had experienced eighteen years ago. But I was young and had no one dependent upon me. I dreaded debt, and I would rather be beaten than called a loafer. Yet work I could not get. I ran up a board bill of $2. That worried me and I determined to go away and fight it out alone. I wrote a note and left it one the table. I promised to pay the bill as soon as I got work and asked them not to think unkindly of me because I left in a hurry.

I met on the street a Hungarian who had arrived on the same ship. He told me of an agency where they wanted men. So together we went there. The names of the employment people were Franks & Miller. My friend and I did not have much clothing, but what I had was good and strong.

"You will work in a sawmill," they said, "and you will get $1.50 a day and your food."

That seemed all right and I counted up on paper how much I could save in six months. It seemed big—very big. All my

fellow laborers seemed pleased. I thought of my father: how fortunate for him if he had found an agency like this!

The railroad fare was $18. That, of course, was paid for us by the agency, so they said, and we were to pay it back at the rate of $3 a month, and if we liked the work and stayed for so many months we would not have to pay it at all.

We looked at each other with wide open eyes.

"You bet I'm going to stay three months!" said Lanniger, a Hungarian friend I had met on the voyage. I determined to do so too.

Eighteen dollars seemed a lot to save by just holding on to a fine job, and the very thought of $45 a month made me laugh with joy. I imagined myself going back to Hungary rich!

We looked a queer lot as we went to the boat. There were so many nations represented and we were so differently dressed.

I had good, stout boots and woolen socks; a fine cap; a cotton shirt with cotton collar and a bright new tie. My clothes were strong and whole.

I was one of a gang. There were all sorts of men in it. We whipped from New York to Savannah by boat and from there to Lockhart by rail. A young man whom they called "doctor" met us at Savannah. I liked the look of him. He had large eyes and a fine, kindly face. It was July 18th, 1906, when we arrived at Lockhart. The first thing we saw was an immense saw-mill.

"This is our place," said Lanniger.

"Good!" I said. "I am glad to be so near a good, long job. I am tired out."

But we stayed there only an hour. Certain men were picked out to stay and others were ordered on board a little engine. I was of the latter, and soon we were crashing noisily thru the forest to the camp. The journey was about seven miles. A sort of dread seized me as we tore along. I was filled with suspicion, but I did not tell anybody. The camp was a train of box cars and around the camps were a lot of wooden sheds, stables and shops. My contract called for work in a saw-mill. I got enough courage to speak up.

"My contract says saw-mill," I said.

Gallagher, the boss, was chewing a toothpick while he

looked us over. He paid no attention, but just looked at me as if I were crazy.

"My contract"—I would have said more, but he waved me aside.

Gallagher is a stout little man with a revolver sticking out of his hip pocket, and before we were an hour in the camp we heard some examples of his fearful profanity.

"Put him on the railroad, Charlie," he said to the underboss. The men standing around laughed.

The food in the camp was very good and there was plenty of it. We sat down to meals in a box car around a long table. The table was covered with good things—pork, meat, potatoes, bread and cake. We had tin cups and tin dishes.

The bunks in the car were too close together and too many men slept in them, I could not rest easily. My mind was disturbed.

The hours of labor were from six to six.

The work in the woods sawing logs was hot—too hot and too heavy for me. I learned that the pay was $1 a day. I told them how the agency had told me that the pay was $1.50 a day and food. They smiled at that.

So here we were, out in a wild place, helpless and at the mercy of men who laughed at contracts and out of whose hip pockets bulged revolvers. I did a lot of thinking. I talked to Lanniger.

"I'll run the first chance I get!" Lanniger said.

"I won't wait for a chance," I replied. "I'll make one and go!"

Next day before it was daylight I left the camp—not knowing where I was going. I knew the lumber company was big and powerful and that I was less to them than a log of wood. I was afraid most of the time. I walked all the forenoon, not knowing where I was going. Every time I saw any one coming I hid in the woods. About noon time I saw some men coming along the road in a buggy. When they approached I knew Gallagher. Sandor, the Hungarian interpreter, was there, as was also Dr. Grace, the camp veterinarian. They had three bloodhounds with them.

"There's the son of a—," I heard him say as he leaped from the buggy and rushed at me.

The doctor was at his heels in a moment and seized me with his right hand, while he pointed a revolver at me with his left. Gallagher had a horse-whip and at once struck me on the hips. He coiled the lash around my back at every stroke. Sandor sat in the buggy. I screamed in Hungarian to him, but he dared not move or interfere. After a dozen strokes my back was raw and the lashes sank into the bloody ruts of their predecessors. It made me howl with pain. Gallagher whipped me until he was exhausted. Then they drove me like a steer at the point of revolver along the road toward Lockhart. I appealed in my native tongue again, but Sandor told me that just as surely as I ever attempted to run away again, they would kill me. I believed him. In the woods they can do anything they please, and no one can see them but God.

When we arrived at Lockhart, where the sawmill is, I again protested and showed my contract, for I thought I was in a town where perhaps there might be some law or civilization. But I soon discovered the kind of law lumbermen are accustomed to. Gallagher whipped me a second time—whipped me until my shirt was glued to my back with my blood. Then they tied me in the buggy by the arms and legs, and with a drawn revolver and yelping bloodhounds, we drove away thru the woods to the camp. That night armed guards kept watch over the laborers in the box cars. Hardly a day passed after that without some one being run down by the bosses or the bloodhounds and returned and whipped. There were some ghastly beatings in the broad daylight, but most of it was done in the barn.

In the daytime I had no time to think, but at night as I lay awake in my bunk, I made up my mind that not only most men, but most books also, were liars. I thought of that first picture of Washington on our letter at home; how Nikof thrilled us all with interest in it. I remembered the burning words of Kossuth on his impressions of America. But here I am with my own feet on American soil. I hear with my own ears; I see with my own eyes; I feel with my own feelings the brutality.

The bosses of the lumber company were put on trial and we told our stories; at least those of us who were still remaining. Of all the things that mixed my thinking in America,

nothing was so strange as to find that the bosses who were indicted for holding us in peonage could go out free on bail, while we, the laborers, who had been flogged and beaten and robbed, should be kept in jail because we had neither money nor friends. We were well treated, of course, but at first I felt like a criminal. I am not sorry now for that jail experience, for I learned more about America than I would have learned in a year in a night school.

Foster was an American. He had fought in the Spanish-American War. He told us about graft and politics. "To get on," he said, "you must be a grafter here. Honesty never pays. A tip to the lumber bosses that we would lie on the stand and we would be out of here by noontime."

Lanniger was with me. We laughed at the queer ideas of free men. We talked all day, every day.

"Is Gallagher a grafter?" I asked.

"No," Foster said. "He is just a common slave-driver."

"Do they flog men everywhere in this country?"

"No, just down here in the South where they used to flog niggers. Thirty thousand laborers are sent South every year. They come down to mines, they fill the camps of all kinds, but they never stay."

"Why not?" I asked.

"Well, for the same reason that none of us will stay—small pay and nothing to see."

I learned much English from Foster, especially slang. When conversation was dry I got very tired of iron bars and jingling keys. They hurt my mind.

"Say, Mike," Foster said, "you're dead in luck to be here. In the stockades you'd dig five tons of coal a day, and for a lump of black rock found in your coal they'd flog you raw. Over there across the way in the city prison you'd be squeezed in an iron cage seven by three feet"—he measured it off for me—"and you'd be forced to sleep in the excrements of the hobos that were there ahead of you. I've been there; I know."

Then I was more content with the county jail. The trial came off in November, 1906, and we went every day for weeks to the big Government building. In the trial I learned that there was law in America, but its benefits to the poor were accidental. I was glad to see Gallagher get fifteen months in

prison. I think he deserved much more. But Foster said he'd never serve a day. I asked him why, but he merely said, "Graft." Old Jordoneff and I got work on Fort Pickens in the Gulf of Mexico as laborers in the repair of forts, where I am working now. We have very good pay—$1.25 a day and our board. The boss is a gentleman. We work eight hours a day and get a day off every two weeks. But the men we work for, even the under-bosses, are humane and kind. Therefore we do far more work and far better work, and work is a pleasure.

Shall I become a citizen?

Why should I?

19. THE LIFE STORY OF

A SOUTHERN WHITE WOMAN

MY FATHER was the son of a Southern gentleman. Everybody knows the type—a man of courage and grace, more natural than ethical, not quite "up in his morals," but with superlative virtues that surpassed mere morality. The county I was born in and the nearby town were named for him. He was a member of the State Senate and had the proverbial "hundred negroes."

My father entered the Confederate army when he was sixteen, and walked home from Virginia four years later a ragged, dusty, defeated soldier, with some honorable scars and considerable family pride. But that was all he had. Negroes and lands had vanished. His father was dead and the State Government was in the hands of the "carpetbaggers."

He was so reduced, indeed, that nothing was left for him to do but to go a courting. And he has often told me that the next three years were the most strenuous of his life. There were

many beautiful girls in the county deprived until now of lovers, and it was my father's gallant ambition to supply them all with at least one. This led to an impromptu duel later on, when one of the girls married without burning my father's letters. The angry bridegroom did most of the shooting, I believe.

About this time he joined the Ku Klux Klan, and with other of his neighbors set about disciplining the negroes into a proper understanding of the Southern gentleman's idea of their freedom, more especially its limitations. This had been very thoroughly accomplished by the time I was born, in 1869. He had regained possession of the family estate by this time, a large plantation, and had it thickly settled with negro families, whose conduct and industry were all that could be demanded even by the most exacting landlord.

From the foregoing those who comprehend Southern conditions will understand at once that I belong to a class in the South who know the negro only as a servant. My experience is limited to the average individual of the race. The "educated negro" is an artificial production, which does not fit in with our natural order, and for this reason no distance is so wide as that between the people of my class and aspiring, wronged, intelligent, vindictive negroes. Just now we have much agitation among us concerning the redemption and education of ignorant negroes in the South, but it should be borne in mind that the very men and women who are exercising their spiritual faculties in this philanthropic way show upon the slightest provocation an intense race antipathy toward individuals of the very class they are attempting to create. There was not a Southerner present at the Richmond convention, where plans for the betterment of these people were discussed, who would publicly voluntarily have dined with Booker Washington or Bishop Turner, two of the noblest men the South has ever produced, because they are both negroes. Our race sincerity commits us to this social and ethical inconsistency, and for one I expect the aboriginal sincerity to outlast the moral stringency of our present attitude.

But if we get our notions of negroes from the servant class, the educated negro gets his conception of the white man's

character largely from the lower orders of society. The best he can do socially is to meet the factory elements, say, on their terms of insolent inequality. And the proof of the negro's innate vulgarity is that he is willing to do so. No matter how respectable he may be himself in character and intelligence, he will welcome to his board and hearth the meanest whites and feel complimented at their presence. I think our old Mammy had a better notion of self respect. "I wouldn't set down to the table with no white person as would ax me," she used to say, "for I'd know by dat dey was pure white trash and not fitten for me to notice!"

Our plantation was five miles from the nearest town. And as it was the social custom of that neighborhood for the best families to exchange stately visits only once or twice a year, it often happened that for two or three months I saw no one but my father and mother and the negroes on the place. The little black girls of my own age were the only playmates I had. And altho I imagined our companionship free from restraint, I know now that it was really controlled by the instincts and customs of our respective races. For instance, I never sought any playmates in the cabins where they lived, and I would no more have played with them in their own yards than I would now contemplate the lowest social connections. But they came to the "big 'ouse," and from that social eminence we ranged the country far and wide in search of childish adventures. And while I would not have taken a drink of water from a gourd after one of them, or eaten bread from a cabin, I was taught never to call them "niggers," or to hurt their feelings by referring to the quality of their hair. And I have never in my whole life used any expression in the presence of a negro that touched upon a mortifying race distinction. I have never discussed the "race problem" at a table where negroes served me, nor indulged in any conversation that could wound their sensibilities. And when I was a child, if I had struck one of my little black companions, I should have been severely punished.

Fortunately, I was never tempted to treat them unkindly. There was no question of "fair play" between us; for quite naturally I took all the advantages there were to be had. If we played "keeping house," I was the father and the mother of the family, they the children, subject to the most stringent

discipline. But we never played "come to see" one another, because they were negroes, and we felt the social impropriety of such a situation as that fact involved. If we played "horse"— and I regret to say that we did—they were the horses, I the driver. And not for the pleasure of being the wildest colt in the team would I have exchanged *rôles* and permitted one of them to drive me. In this connection I recall one young negro girl much stronger than the others, who, by getting down upon her hands and knees, could make of herself such a vicious "horse" that none of us was able to stay on her back. But the effort to do so was an experience I ever coveted. I would seat myself firmly, clasp my hands tightly in the wool on the back of her head, and wait for the delicious sensation of feeling her take a running, plunging start that invariably landed me over her head somewhere in the grass. I was often severely bruised and obliged to retire to my mother for ointments. But I never told the truth about the cause of my disasters. For in that case the girl would not only have been punished, but banished, and that was a loss I refused to contemplate.

With one exception all the little black boys on the plantation wore what were called "shirt tails," and nothing else. These were long, straight garments made of coarse white cloth and split to the knees. These ridiculous looking little wretches never came near us. Even the black girls professed to hold them in contempt, and used to shout the most appalling sarcasms at them if one appeared anywhere upon our horizon.

But the "exception" was a little mulatto boy, who not only wore trousers, but a hat. He had very bad "manners," and had even gone to the front door once when he was sent to the "big 'ouse" on an errand. Without knowing why one negro was black and another yellow I conceived a violent antipathy for this child,—for no other reason that I can now remember except that he had blue eyes and was "sulky." Therefore, one day I filled an atomizer with ink, and when he came as usual for a pitcher of milk I held him against the wall and sprayed his face until it was of a uniform, legitimate blackness. He ran bawling to my mother, and I expected punishment, but I felt the job was fully worth the pain I should suffer, and I followed with more pride than I could conceal. My mother was regarding the victim with a face that expressed no more emotion than a mask. Presently

she called a servant and said: "Take that child to his mother. Tell her he is nearer the right color than I ever saw him before, and tell her he is never to come into my sight again." And he never did. But when I was married, a dozen years later, he was still on the plantation, a yellow Ishmael, who worked when he chose and fought whenever opportunity offered, a veritable marplot to the peace of the place.

I had no brothers, and for this reason my father intrusted certain details connected with the management of the place to me at an early age. For instance, I attended to the weighting of "rations" on Saturday afternoon. To each of a score of hired hands was given three pounds of bacon, a peck of meal and a quart of sorghum (syrup made from sorghum cane). This was a business that brought out my preferences more than it developed my sense of justice. I gave the men I liked best more than the exact measure, and at the age of ten I will confess that I was easily bribed. A lump of fragrant sweet gum, a young squirrel, or my apron pocket filled with partridge eggs so prejudiced me that I invariably tipped the scales in favor of the giver. My sense of equity had an entirely romantic basis. I remember giving a young black bridegroom an extra quart of sorghum, and when a man with a large family protested at this partiality I replied: "But he married our house girl and she is used to sweet things!" However, when the dark honeymoon of their happiness terminated a month later in a fight and the bride went home in high dudgeon to her people, I was so indignant that I wished to cut the bereaved husband off with no syrup at all.

In many similar ways I came in contact with the older negroes on the place, and upon all occasions, tho often unattended, my presence insured the uttermost propriety of conduct. If a young buck so far forgot himself as to laugh loudly he was "cuffed" and admonished to "mind his manners." I have very good reason for believing that these negroes had an almost romantic devotion to my father and his family. Personally I never passed judgment upon them. So far as I knew God had done that when he made me white and them black. Naturally that fixed the basis of our relationship. I had an affection for them, but there was not the least conception of equality in it. I was not taught these race distinctions, I was

born with them, and I notice that they are intensified in each succeeding generation of white children. The curious thing to me is that the negro does not have them. His animosity against the whites is the forced response to our antipathy. He would have no such sensation, given social recognition, because he has no sense of race integrity.

By the time I was fourteen years of age the first set of free-born negroes were getting old enough to interpret life for themselves, and without the well disciplined experience of their parents, who had not only been slaves, but had passed through the very drastic training of the Ku Klux Klans after the war. Occasionally, therefore, one of them gave a white man some "impudence" and had to be dealt with accordingly. I remember a young negro man suddenly turned upon my father one day with an ax and would have killed him but for the intervention of another man. The boy escaped, but my father and his neighbors rode after him all night with dogs. The next morning they passed our house with him, entered the forest beyond, and having tied him to a tree, gave him a severe whipping. But that was all. Nothing further was ever said of the incident, and the man remained in my father's employ years afterward.

Still, the fight was on, the long, long battle that will never end now until one race or the other is absolute. Little by little a resistance sprung up between the newborn freedom-bred negroes and the former slave owners of the South, a resistance ever punished and ever renewed. Crimes never dreamed of before were committed. For the utter depravity of the negro was not developed during the period of his slavery. He lacked then the liberty to practice thoroughly all the evils of his degenerate nature.

Aside from the intangible fears of childhood the first realization I ever had of horror was when one morning word came that a planter living only a few miles distant had been coaxed from his home during the night and murdered in his own yard, after which the negro assaulted both his wife and daughter. From that day until this I have a revulsion and a terror of negro men that are well nigh uncontrollable. During the fifteen years following my first realization of the situation of Southern white women, these crimes were so frequent in the State

where I live that white women were never left alone even
during the day in country houses, and rural schools were made
a failure, because parents were unwilling to risk the lives of
their children upon the public highways. And the effect upon
the young white men of the South was to arouse a bloodthirsti-
ness in them for vengeance that shocked the civilized world.
There are many accursed trees and charred stumps to be seen
by the roadsides in this State where negroes have been lynched
or burned. The relations existing between the two races be-
came absolutely inhuman. The smallest pretext was reason
enough for taking a black man's life. Not long ago, as I sat in
a railway station, a crowd of whites ran past firing pistols and
shouting threats. They were chasing a negro who had offended
one of them with a blasphemous comment upon white charac-
ter. In the town where I now live a negro man who had been
guilty of some small offense escaped from his captors last year
and jumped into the river nearby. His pursuers stood on the
banks and shot him to death, altho it was already impossible
for him to escape. And no later than yesterday, when I asked
the meaning of successive pistol shots heard at no great dis-
tance, I was told that they were fired by young white boys at
"little niggers." The general impression prevailed that some-
body would be "hurt." But if the situation had been reversed,
and negroes were firing, however aimlessly, at white boys, a
mob would have gathered at once.

Meanwhile, the criminal career of this race is progressing
rapidly Northward. The crimes that first excited the fury of
Southerners against them are decreasing here so much that
now they are committed almost as frequently in those sections
of the North where negroes have immigrated. And they are
followed by the same fever for lynching in the whites there
that has long maddened Southerners. The truth is that within
a very few years the negro will be the most cordially hated
man in this world. Once his abolitionist friends get a rational
conception of his character they invariably desert him. And
the whole trouble North and South comes from a disposition
to hold the negro morally accountable, when really he belongs
to a decadent race, which taints every other it comes in contact
with, and is of itself incapable of regeneration.

And so degeneracy is apt to show most in the weaker indi-
viduals of any race; so negro women evidence more nearly the
popular idea of total depravity than the men do. They are so
nearly all lacking in virtue that the color of a negro woman's
skin is generally taken (and quite correctly) as a guarantee of
her immorality. On the whole, I think they are the greatest
menace possible to the moral life of any community where
they live. And they are evidently the chief instruments of the
degradation of the men of their own race. When a man's
mother, wife and daughters are all immoral women, there is
no room in his fallen nature for the aspiration of honor and
virtue. He is bereaved of hope and a pride that even the worst
white man always has to stimulate him to decency. I some-
times read of virtuous negro women, hear of them, but the
idea is absolutely inconceivable to me. I do not deny they
exist, but after living in a section all my life that teems with
negroes I cannot imagine such a creation as a virtuous black
woman.

There must be exceptions, of course, but as a rule education
is a superficial experience with the negro. My own observa-
tions convince me that the blacks have a uniformity of charac-
ter and disposition that education does not change, but inten-
sifies. To vary from the monotony of stupidity in my servants
not long ago I employed successively two college graduates.
But I did not notice any essential difference in character. Both
were manifestly immoral and they had deceit down to a fine
art. In illiterate negroes these vices seem so natural they fail
to shock the sensibilities or to excite aversion, but I conceived
a horror of these yellow Jezebels, who had come to me from
schools that have million-dollar endowments for the educa-
tion of negro girls.

The reason why Northerners fail to comprehend the almost
universal depravity of negroes is because they mistake the very
high moral tone of the negro's conversation as an evidence of
virtue. These people are very quick at catching a tune of any
kind, mental or musical, and they like the noble sound of
ethics as much as they enjoy musical harmony. Thus, it is very
rare, indeed, to find a negro who does not shine in a religious
discussion. They have, however, more piety of imagination

than of character. Recently a negro woman who has never been married, but has three different kinds of children, posed so pathetically as a virtuous, hard working "widow" to a Northern visitor here that she received quite a handsome sum from him. The innocency of his comments so touched the humor of the town that half a dozen other "widows" of similar reputation were directed to his attention, all of whom he succored with the tenderest compassion.

And, finally, it is never wise to judge a race by individuals, but by those evidences common to the whole mass of it. And, regarded from this standpoint, the negroes are at their worst. No other people are so heartless in their discriminations against one another. Their very aspirations are mean. I know of two "colored churches" where black skinned negroes are not eligible to membership. Social distinctions depend with them upon externals, not character. They have no *right* sense of honor or virtue. Recently I sat in the auditorium of a great negro university, and of the two or three hundred students present I saw only four full blooded negroes. Nearly all were mulattoes or octoroons, the offspring of negro women, but *not* of negro men. Whatever this intimates of the Southern white man's morals, it teaches two things clearly—that negro men are rarely the fathers of those individuals in the race who develop to any marked degree intellectually, and that negro women who are prostitutes are the mothers of these ambitious sons and daughters. In short, the whole race aspires upward chiefly through the immorality of the superior race above it. I do not know a more suggestive intimation of the real quality of the negro's nature and disposition than this. A mulatto girl expressed the whole economy and ambition of her people the other day when a full blooded negro called her a "stuck up nigger." "Maybe I is," she retorted, "but I thanks my God I ain't er out an' out nigger sech as you is!" And that is what they are all thankful for who have a drop of white blood to boast of. It is the measure of their quality and degradation that they can be proud of a dishonor which lightens the color of their skin.

20. THE LIFE STORY OF

A SOUTHERN
COLORED WOMAN

MY FATHER was slave in name only, his father and master being the same. He lived on a large plantation and knew many useful things. The blacksmith shop was the place he liked best, and he was allowed to go there and make little tools as a child. He became an expert blacksmith before he was grown. Before the war closed he had married and was the father of one child. When his father wanted him to remain on the plantation after the war, he refused because the wages offered were too small. The old man would not even promise an increase later; so my father left in a wagon he had made with his own hands, drawn by a horse he had bought from a passing horse drover with his own money.

He had in his wagon his wife and baby, some blacksmith tools he had made from time to time, bedding, their clothing, some food, and twenty dollars in his pocket. As he drove by the house he got out of the wagon to bid his father good-by. The

old man came down the steps and, pointing in the direction of the gate, said: "Joseph, when you get on the outside of that gate—stay. " Turning to my mother, he said: "When you get hungry and need clothes for yourself and the baby, as you are sure to do, come to me," and he pitched a bag of silver in her lap, which my father immediately took and placed at his father's feet on the steps and said, "I am going to feed and clothe them and I can do it on a bare rock." My father drove twenty-five miles to the largest town in the State, where he succeeded in renting a small house.

The next day he went out to buy something to eat. On his way home a lady offered him fifty cents for a string of fish for which he had only paid twenty cents. That gave him an idea. Why not buy fish every day and sell them? He had thought to get work at his trade, but here was money to be made and quickly. So from buying a few strings of fish he soon saved enough to buy a wagon load of fish.

My mother was very helpless, never having done anything in her life except needlework. She was unfitted for the hard work, and most of this my father did. He taught my mother to cook, and he would wash and iron himself at night.

Many discouraging things happened to them—often sales were slow and fish would spoil; many would not buy of him because he was colored; another baby was born and died, and my father came very near losing his life for whipping a white man who insulted my mother. He got out of the affair finally, but had to take on a heavy debt, besides giving up all of his hard earned savings.

My father said after the war his ambition was first to educate himself and family, then to own a white house with green blinds, as much like his father's as possible, and to support his family by his own efforts; never to allow his wife and daughters to be thrown in contact with Southern white men in their homes. He succeeded.

The American Missionary Association had opened schools by this time, and my father went to night school and sent his wife and child to school in the day.

By hard work and strict economy two years after he left his father's plantation he gave two hundred dollars for a large plot of ground on a high hill on the outskirts of the town.

Three years later I was born in my father's own home, in his coveted white house with green blinds—his father's house in miniature. Here my father kept a small store, was burned out once and had other trials, but finally he had a large grocery store and feed store attached.

I have never lived in a rented house except for one year since I've been grown. I have never gone to a public school in my life, my parents preferring the teaching of the patient "New England schoolmarm" to the southern "poor white," who thought it little better than a disgrace to teach colored children—so much of a disgrace that she taught her pupils not to speak to her on the streets. My mother and her children never performed any labor outside of my father's and their own homes.

To-day I have the same feeling my parents had. There is no sacrifice I would not make, no hardship I would not undergo rather than allow my daughters to go in service where they would be thrown constantly in contact with Southern white men, for they consider the colored girl their special prey.

It is commonly said that no girl or woman receives a certain kind of insult unless she invites it. That does not apply to a colored girl and woman in the South. The color of her face alone is sufficient invitation to the Southern white man— these same men who profess horror that a white gentleman can entertain a colored one at his table. Out of sight of their own women they are willing and anxious to entertain colored women in various ways. Few colored girls reach the age of sixteen without receiving advances from them—maybe from a young "upstart," and often from a man old enough to be their father, a white haired veteran of sin. Yes, and men high in position, whose wives and daughters are leaders of society. I have had a clerk in a store hold my hand as I gave him the money for some purchase and utter some vile request; a shoe man to take liberties, a man in a crowd to place his hands on my person, others to follow me to my very door, a school director to assure me a position if I did his bidding.

It is true these particular men never insulted me but once; but there are others. I might write more along this line and worse things—how a white man of high standing will systematically set out to entrap a colored girl—but my identification

would be assured in some quarters. My husband was also edu-
cated in an American Missionary Association school (God
bless the name!), and after graduating took a course in medi-
cine in another school. He has practiced medicine now for
over ten years. By most frugal living and strict economy he
saved enough to buy for a home a house of four rooms, which
has since been increased to eight. Since our marriage we
have bought and paid for two other places, which we rent. My
husband's collections average one hundred dollars a month.
We have an iron-bound rule that we must save at least fifty
dollars a month. Some months we lay by more, but never less.
We do not find this very hard to do with the rent from our
places, and as I do all of my work except the washing and
ironing.

We have three children two old enough for school. I try to
be a good and useful neighbor and friend to those who will
allow me. I would be contented and happy if I, an American
citizen, could say as Axel Jarlson (the Swedish emigrant,
whose story appeared in THE INDEPENDENT of January 8th,
1903) says, "There are no aristocrats to push him down and
say that he is not worthy because his father was poor." There
are "aristocrats" to push me and mine down and say we are not
worthy because we are colored. The Chinaman, Lee Chew,
ends his article in THE INDEPENDENT of February 19th, 1903, by
saying, "Under the circumstances how can I call this my home,
and how can any one blame me if I take my money and go
back to my village in China?"

Happy Chinaman! Fortunate Lee Chew! You can go back to
your village and enjoy your money. This is my village, my home,
yet am I an outcast. See what an outcast! Not long since I visited
a Southern city where the "Jim Crow" car law is enforced. I did
not know of this law, and on boarding an electric car took the
most convenient seat. The conductor yelled, "What do you
mean? Niggers don't sit with white folks down here. You must
have come from 'way up yonder. I'm not Roosevelt. We don't sit
with niggers, much less eat with them."

I was astonished and said, "I am a stranger and did not know
of your law." His answer was: "Well, no back talk now; that's
what I'm here for—to tell niggers their places when they don't
know them."

Every white man, woman and child was in a titter of laughter by this time at what they considered the conductor's wit. These Southern men and women, who pride themselves on their fine sense of feeling, had no feeling for my embarrassment and unmerited insult, and when I asked the conductor to stop the car that I might get off, one woman said in a loud voice, "These niggers get more impudent every day; she doesn't want to sit where she belongs."

No one of them thought that I was embarrassed, wounded and outraged by the loud, brutal talk of the conductor and the sneering, contemptuous expressions on their own faces. They considered me "impudent" when I only wanted to be alone that I might conquer my emotion. I was nervous and blinded by tears of mortification which will account for my second insult on this same day.

I walked downtown to attend to some business and had to take an elevator in an office building. I stood waiting for the elevator, and when the others, all of whom were white, got in I made a move to go in also, and the boy shut the cage door in my face. I thought the elevator was too crowded and waited; the same thing happened the second time. I would have walked up, but I was going to the fifth story, and my long walk downtown had tired me. The third time the elevator came down the boy pointed to a sign and said, "I guess you can't read; but niggers don't ride in this elevator; we're white folks here, we are. Go to the back and you'll find an elevator for freight and niggers."

The occupants of the elevator also enjoyed themselves at my expense. This second insult in one day seemed more than I could bear. I could transact no business in my frame of mind so I slowly took the long walk back to the suburbs of the city, where I was stopping.

My feelings were doubly crushed and in my heart, I fear, I rebelled not only against man but God. I have been humiliated and insulted often, but I never get used to it; it is new each time, and stings and hurts more and more.

The very first humiliation I received I remember very distinctly to this day. It was when I was very young. A little girl playmate said to me: "I like to come over to your house to play, we have such good times, and your ma has such good

preserves; but don't you tell my ma I eat over here. My ma says you all are nice, clean folks and she'd rather live by you than the white people we moved away from; for you don't borrow things. I know she would whip me if I ate with you, tho, because you are colored, you know."

I was very angry and forgot she was my guest, but told her to go home and bring my ma's sugar home her ma borrowed, and the rice they were always wanting a cup of.

After she had gone home I threw myself upon the ground and cried, for I liked the little girl, and until then I did not know that being "colored" made a difference. I am not sure I knew anything about "colored." I was very young and I know now I had been shielded from all unpleasantness.

My mother found me in tears and I asked her why was I colored, and couldn't little girls eat with me and let their mothers know it.

My mother got the whole story from me, but she couldn't satisfy me with her explanation—or, rather, lack of explanation. The little girl came often to play with me after that and we were little friends again, but we never had any more play dinners. I could not reconcile the fact that she and her people could borrow and eat our rice in their own house and not sit at my table and eat my mother's good, sweet preserves.

The second shock I received was horrible to me at the time. I had not gotten used to real horrible things then. The history of Christian men selling helpless men and women's children to far distant States was unknown to me; a number of men burning another chained to a post an impossibility, the whipping of a grown woman by a strong man unthought of. I was only a child, but I remember to this day what a shock I received. A young colored woman of a lovely disposition and character had just died. She was a teacher in the Sunday school I attended—a self-sacrificing, noble young woman who had been loved by many. Her coffin, room, hall and even the porch of her house were filled with flowers sent by her friends. There were lovely designs sent by the more prosperous and simple bouquets made by untrained, childish hands. I was on my way with my own last offering of love, when I was met by quite a number of white boys and girls. A girl of about fifteen years said to me, "More flowers for that dead nigger? I never saw

such a to-do made over a dead nigger before. Why, there must be thousands of roses alone in that house. I've been standing out here for hours and there has been a continual stream of niggers carrying flowers, and beautiful ones, too, and what makes me madder than anything else, those Yankee teachers carried flowers, too!" I, a little girl, with my heart full of sadness for the death of my friend, could make no answer to these big, heartless boys and girls, who threw stones after me as I ran from them.

When I reached home I could not talk for emotion. My mother was astonished when I found voice to tell her I was not crying because of the death of Miss W., but because I could not do something, anything, to avenge the insult to her dead body. I remember the strongest feeling I had was one of revenge. I wanted even to kill that particular girl or do something to hurt her. I was unhappy for days. I was told that they were heartless, but that I was even worse, and that Miss W. would be the first to condemn me could she speak.

That one encounter made a deep impression on my childish heart; it has been with me throughout the years. I have known real horrors since, but none left a greater impression on me.

My mother used to tell me if I were a good little girl everybody would love me, and if I always used nice manners it would make others show the same to me.

I believed that literally until I entered school, when the many encounters I had with white boys and girls going to and from school made me seriously doubt that goodness and manners were needed in this world. The white children I knew grew meaner as they grew older—more capable of saying things that cut and wound.

I was often told by white children whose parents rented houses: "You think you are white because your folks own their own home; but you ain't, you're a nigger just the same, and my pa says if he had his rights he would own niggers like you, and your home, too."

A child's feelings are easily wounded, and day after day I carried a sad heart. To-day I carry a sad heart on account of my children. What is to become of them? The Southern whites dislike more and more the educated colored man. They hate the intelligent colored man who is accumulating something.

The respectable, intelligent colored people are "carefully unknown"; their good traits and virtues are never mentioned. On the other hand, the ignorant and vicious are carefully known and all of their traits cried aloud. In the natural order of things our children will be better educated than we, they will have our accumulations and their own. With the added dislike and hatred of the white man, I shudder to think of the outcome.

In this part of the country, where the Golden Rule is obsolete, the commandment, "Love thy neighbor as thyself" is forgotten; anything is possible.

I dread to see my children grow. I know not their fate. Where the white girl has one temptation, mine will have many. Where the white boy has every opportunity and protection, mine will have few opportunities and no protection. It does not matter how good or wise my children may be, they are colored. When I have said that, all is said. Everything is forgiven in the South but color.

21. A NORTHERN NEGRO'S
AUTOBIOGRAPHY

[The three articles that we printed in *The Independent*
last March called forth more replies than any articles
we have recently published. We were obliged to reject
all of them, however, except the following, which dis-
cusses a phase of the negro problem not touched upon
by the three anonymous women, and often generally
overlooked by the American people. This article there-
fore supplements the others, and the four taken
together picture the negro problem from the feminine
standpoint in the most genuine and realistic manner
shown in any articles we have seen in print.—Editor.]

IN *The Independent* of March 17th last I read, with a great deal of
interest, three contributions to the so-called race problem, to be
found in the experiences of a Southern colored woman, a
Southern white woman and a Northern white woman.

I am a Northern colored woman, a mulatto in complexion,
and was born since the war in a village town of Western New York.
My parents and grandparents were free people. My mother was
born in New York State and my father in Pennsylvania. They both
attended the common schools and were fairly educated. They
had a taste for good books and the refinements of life, were pub-
lic spirited and regarded as good citizens. My father moved to
this Western New York village when he was quite a boy and was a
resident of the town for over fifty years; he was married to my
mother in this town and three children were born to them; he
created for himself a good business and was able to take good
care of his family. My parents were strictly religious people and

were members of one of the largest white churches in the village. My father, during his membership in this church, held successively almost every important office open to a layman, having been clerk, trustee, treasurer, and deacon, which office he held at the time of his death, in 1890. He was for years teacher of an adult Bible class composed of some of the best men and women of the village, and my mother is still a teacher of a large Bible class of women in the same Sunday School. Ours was the only colored family in the church, in fact, the only one in the town for many years, and certainly there could not have been a relationship more cordial, respectful and intimate than that of our family and the white people of this community. We three children were sent to school as soon as we were old enough, and remained there until we were graduated. During our school days our associates, schoolmates, and companions were all white boys and girls. These relationships were natural, spontaneous, and free from all restraint. We went freely to each other's houses, to parties, socials, and joined on equal terms in all school entertainments with perfect comradeship. We suffered from no discriminations on account of color or "previous condition," and lived in blissful ignorance of the fact that we were practicing the unpardonable sin of "social equality." Indeed, until I became a young woman and went South to teach I had never been reminded that I belonged to an "inferior race."

After I graduated from school my first ambition was to teach. I could easily have obtained a position there at my own home, but I wanted to go out into the world and do something large or out of the ordinary. I had known of quite a number of fine young white women who had gone South to teach the freedmen, and, following my race instinct, I resolved to do the same. I soon obtained a situation in one of the ex-slave States. It was here and for the first time that I began life as a colored person, in all that that term implies. No one but a colored woman, reared and educated as I was, can ever know what it means to be brought face to face with conditions that fairly overwhelm you with the ugly reminder that a certain penalty must be suffered by those who, not being able to select their own parentage, must be born of a dark complexion. What a shattering of cherished ideals! Everything that I learned and experienced in my innocent social relationships in New York State had to be unlearned and readjusted to these lowered stan-

dards and changed conditions. The Bible that I had been taught, the preaching I had heard, the philosophy and ethics and the rules of conduct that I had been so sure of, were all to be discounted. All truth seemed here only half truths. I found that, instead of there being a unity of life common to all intelligent, respectable and ambitious people, down South life was divided into white and black lines, and that in every direction my ambitions and aspirations were to have no beginnings and no chance for development. But, in spite of all this, I tried to adapt myself to these hateful conditions. I had some talent for painting, and in order to obtain further instruction I importuned a white art teacher to admit me into one of her classes, to which she finally consented, but on the second day of my appearance in the class I chanced to look up suddenly and was amazed to find that I was completely surrounded by screens, and when I resented the apparent insult, it was made the condition of my remaining in the class. I had missed the training that would have made this continued humiliation possible; so at a great sacrifice I went to a New England city, but even here, in the very cradle of liberty, white Southerners were there before me, and to save their feelings I was told by the principal of the school, a man who was descended from a long line of abolition ancestors, that it would imperil the interests of the school if I remained, as all of his Southern pupils would leave, and again I had to submit to the tyranny of a dark complexion. But it is scarcely possible to enumerate the many ways in which an ambitious colored young woman is prevented from being all that she might be in the higher directions of life in this country. Plainly I would have been far happier as a woman if my life up to the age of eighteen years had not been so free, spontaneous and unhampered by race prejudice. I have still many white friends and the old home and school associations are still sweet and delightful and always renewed with pleasure, yet I have never quite recovered from the shock and pain of my first bitter realization that to be a colored woman is to be discredited, mistrusted and often meanly hated. My faith in the verities of religion, in justice, in love and many sacredly taught sentiments has greatly decreased since I have learned how little even these stand for when you are a colored woman.

After teaching a few years in the South, I went back to my home in New York State to be married. After the buffetings, discouragements and discourtesies that I had been compelled to

endure, it was almost as in a dream that I saw again my school-mates gather around me, making my home beautiful with flowers, managing every detail of preparation for my wedding, showering me with gifts, and joining in the ceremony with tears and blessings. My own family and my husband were the only persons to lend color to the occasion. Minister, attendants, friends, flowers and hearts were of purest white. If this be social equality, it certainly was not of my own seeking and I must say that no one seemed harmed by it. It seemed all a simple part of the natural life we lived where people are loved and respected for their worth, in spite of their darker complexions.

After my marriage my husband and I moved to one of the larger cities of the North, where we have continued to live. In this larger field of life and action I found myself, like many another woman, becoming interested in many things that come within the range of woman's active sympathy and influence.

My interest in various reform work, irrespective of color, led me frequently to join hand in hand with white women on a common basis of fellowship and helpfulness extended to all who needed our sympathy and interest. I experienced very few evidences of race prejudice and perhaps had more than my share of kindness and recognition. However, this kindness to me as an individual did not satisfy me or blind me to the many inequalities suffered by young colored women seeking employment and other advantages of metropolitan life. I soon discovered that it was much easier for progressive white women to be considerate and even companionable to one colored woman whom they chanced to know and like than to be just and generous to colored young women as a race who needed their sympathy and influence in securing employment and recognition according to their tastes and ability. To this end I began to use my influence and associations to further the cause of these helpless young colored women, in an effort to save them to themselves and society by finding, for those who must work, suitable employment. How surprisingly difficult was my task may be seen in the following instances selected from many of like nature:

I was encouraged to call upon a certain bank president, well known for his broad, humane principles and high-mindedness. I told him what I wanted, and how I thought he could give me some practical assistance, and enlarged upon the difficulties that

stand in the way of ambitious and capable young colored women. He was inclined to think, and frankly told me, that he thought I was a little overstating the case, and added, with rather a triumphant air, so sure he was that I could not make good my statements as to ability, fitness, etc., "We need a competent stenographer right here in the bank now; if you will send to me the kind of a young colored woman you describe, that is thoroughly equipped, I think I can convince you that you are wrong." I ventured to tell him that the young woman I had in mind did not show much color. He at once interrupted me by saying, "Oh, that will not cut any figure; you send the young woman here." I did so and allowed a long time to elapse before going to see him again. When I did call, at the young woman's request, the gentleman said, with deep humiliation, "I am ashamed to confess, Mrs. _____, that you were right and I was wrong. I felt it my duty to say to the directors that this young woman had a slight trace of negro blood. That settled it. They promptly said, 'We don't want her, that's all.'" He gave the names of some of the directors and I recognized one of them as a man of long prayers and a heavy contributor to the Foreign Mission Fund; another's name was a household word on account of his financial interest in Home Missions and Church extension work. I went back to the young woman and could but weep with her because I knew that she was almost in despair over the necessity of speedily finding something to do. The only consolation I could offer was that the president declared she was the most skillful and thoroughly competent young woman who had ever applied for the position.

I tried another larger establishment and had a pleasant talk with the manager, who unwittingly committed himself to an overwhelming desire "to help the colored people." He said that his parents were stanch abolitionists and connected with the underground railway, and that he distinctly remembered that as a child he was not allowed to eat sugar that had been cultivated by the labor of the poor slave or to wear cotton manufactured by slave labor, and his face glowed as he told me how he loved his "black mammie," and so on ad nauseam. I began to feel quite elated at the correctness of my judgment in seeking him out of so many. I then said: "I see that you employ a large number of young women as clerks and stenographers. I have in mind some very competent young colored women who are almost on the verge of

despair for lack of suitable employment. Would you be willing to try one of them should you have a vacancy?" The grayness of age swept over his countenance as he solemnly said: "Oh, I wish you had not asked me that question. My clerks would leave and such an innovation would cause a general upheaval in my business." "But," I said, "your clerks surely do not run your business!" "No," he said, "you could not understand." Knowing that he was very religious, my almost forgotten Bible training came to mind. I quoted Scripture as to "God being no respecter of persons," and reminded him that these young women were in moral danger through enforced idleness, and quoted the anathema of offending one of "these little ones" whom Christ loved. But he did not seem to fear at all condemnation from that high tribunal. His only reply was, "Oh, that is different," and I turned away, sadly thinking, "Is is different?"

This still remains a sad chapter in my experience, even tho I have been successful in finding a few good positions for young colored women, not one of whom has ever lost her position through any fault of hers. On the contrary, they have become the prize workers wherever they have been employed. One of them became her employer's private secretary, and he told me with much enthusiasm that her place could scarcely be filled, she had become so efficient and showed such an intelligent grasp upon the requirements of the position. My plea has always been simply to give these girls a chance and let them stand or fall by any test that is not merely a color test.

I want to speak of one other instance. It sometimes happens that after I have succeeded in getting these girls placed and their competency has been proved they are subjected to the most unexpected humiliations. A young woman of very refined and dignified appearance and with only a slight trace of African blood had held her position for some time in an office where she had been book-keeper, stenographer and clerk, respectively, and was very highly thought of both by her employer and her fellow clerks. She was sitting at her desk one day when a man entered and asked for her employer. She told him to be seated, that Mr. _____ would be back in a moment. The man walked around the office, then came back to her and said: "I came from a section of the country where we make your people know their places. Don't you think you are out of yours?" She merely looked up and said, "I think I know my

place." He strolled about for a moment, then came back to her and said: "I am a Southern man, I am, and I would like to know what kind of a man this is that employs a 'nigger' to sit at a desk and write." She replied: "You will find Mr. _____ a perfect gentleman." The proprietor came in, in a moment, and ushered the man into his private office. The Southern gentleman came out of the office very precipitately. It evidently only took him a few seconds to verify the clerk's words that "her employer was a perfect gentleman."

It may be plainly seen that public efforts of this kind and a talent for public speaking and writing would naturally bring to me a recognition and association independent of any self-seeking on my own account. It, therefore, seemed altogether natural that some of my white friends should ask me to make application for membership in a prominent woman's club on the ground of mutual helpfulness and mutual interest in many things. I allowed my name to be presented to the club without the slightest dream that it would cause any opposition or even discussion. This progressive club has a membership of over eight hundred women, and its personality fairly represents the wealth, intelligence and culture of the women of the city. When the members of this great club came to know the color of its new applicant there was a startled cry that seemed to have no bounds. Up to this time no one knew that there was any anti-negro sentiment in the club. Its purposes were so humane and philanthropic and its grade of individual membership so high and inclusive of almost every nationality that my indorsers thought that my application would only be subject to the club's test of eligibility, which was declared to be "Character, intelligence and the reciprocal advantage to the club and the individual, without regard to race, color, religion or politics." For nearly fourteen months my application was fought by a determined minority. Other clubs throughout the country took up the matter, and the awful example was held up in such a way as to frighten many would-be friends. The whole anti-slavery question was fought over again in the same spirit and with the same arguments, but the common sense of the members finally prevailed over their prejudices. When the final vote was taken I was elected to membership by a decisive majority.

Before my admission into the club some of the members came to me and frankly told me that they would leave the club, much as they valued their membership, if I persisted in coming in. Their

only reason was that they did not think the time had yet come for that sort of equality. Since my application was not of my own seeking I refused to recognize their unreasonable prejudices as something that ought to be fostered and perpetuated; beside, I felt that I owed something to the friends who had shown me such unswerving loyalty through all those long and trying months, when every phase of my public and private life was scrutinized and commented upon in a vain effort to find something in proof of my ineligibility. That I should possess any finer feeling that must suffer under this merciless persecution and unwelcome notoriety seemed not to be thought of by those who professed to believe that my presence in a club of eight hundred women would be at a cost of their fair self-respect. I cannot say that I have experienced the same kind of humiliations as recited in the pathetic story of a Southern colored woman in *The Independent* of March 17th, but I can but believe that the prejudice that blights and hinders is quite as decided in the North as it is in the South, but does not manifest itself so openly and brutally.

Fortunately, since my marriage I have had but little experience south of Mason and Dixon's line. Some time ago I was induced by several clubs in different States and cities of the South to make a kind of lecture tour through that section. I knew, of course, of the miserable separations, "Jim Crow" cars, and other offensive restrictions and resolved to make the best of them. But the "Jim Crow" cars were almost intolerable to me. I was fortunate enough to escape them in every instance. There is such a cosmopolitan population in some of the Southwestern States, made up of Spanish, Mexican and French nationalities, that the conductors are very often deceived; beside, they know that an insult can scarcely go further than to ask the wrong person if he or she be colored. I made it a rule always to take my seat in the first-class car, to which I felt I was entitled by virtue of my first-class ticket. However, adapting one's self to these false conditions does not contribute to one's peace of mind, self-respect or honesty. I remember that at a certain place I was too late to procure my ticket at the station, and the conductor told me that I would have to go out at the next station and buy my ticket, and then, despite my English book, which I was very ostentatiously reading, he stepped back and quickly asked me, "Madame, are you colored?" I as quickly replied, "Je suis Français." "Français?" he repeated. I said, "Oui." He then called to the brake-

man and said, "Take this lady's money and go out at the next sta-
tion and buy her ticket for her," which he kindly did, and I as kindly
replied, as he handed me the ticket, "Merci." Fortunately their
knowledge of French ended before mine did or there might have
been some embarrassments as to my further unfamiliarity with my
mother tongue. However, I quieted my conscience by recalling that
there was quite a strain of French blood in my ancestry, and too
that their barbarous laws did not allow a lady to be both comfort-
able and honest. It is needless to say that I traveled undisturbed in
the cars to which my ticket entitled me after this success, but I car-
ried an abiding heartache for the refined and helpless colored
women who must live continuously under these repressive and
unjust laws. The hateful interpretation of these laws is to make no
distinction between the educated and refined and the ignorant
and depraved negro.

Again, the South seems to be full of paradoxes. In one city of
the far South I was asked to address a club of very aristocratic
white women, which I did with considerable satisfaction to myself
because it gave me an opportunity to call the attention of these
white women to the many cultured and educated colored women
living right in their midst, whom they did not know, and to sug-
gest that they find some common ground of fellowship and help-
fulness that must result in the general uplift of all women. These
women gave me a respectful and appreciative hearing, and the
majority of them graciously remained and received an introduc-
tion to me after the address. A curious feature of the meeting was
that, altho it had been announced in all the papers as a public
meeting, not a colored person was present except myself, which
shows how almost insurmountable a color line can be.

In another city I had a very different experience, which
betrayed my unconscious fear of the treachery of Southern prej-
udice, tho following so closely upon the pleasant experience
above related. I noticed, while on my way to the church where I
was advertised to speak to a colored audience, that we were being
followed by a half a dozen of what seemed to me the typical
Southern "cracker," red shirt and all. I was not thinking of moon-
shiners, but of Ku-Klux clan, midnight lynching parties, etc. My
fears were further increased when they suddenly stopped and
separated, so that my friends and myself were obliged to pass
between the lines of three so made. My friends tried to reassure

me, but I fancied with trembling tones, but my menacing escort then closed up ranks and again followed on. Finally they beckoned to the only gentleman with us and asked him what I was going to talk about. He told them the subject and hastened to console me. When we got to the church and just before I rose to speak these six men all filed in and sat down near the platform, accompanied by another individual even more fierce in appearance than they were, whom I afterward learned was the deputy sheriff of the town. My feelings are better imagined than described, but I found myself struggling to hold the attention only of this menacing portion of my audience. They remained to the close of the lecture and as they went out expressed appreciation of my "good sense," as they termed it.

This recital has no place in this article save to show the many contrasts a brief visit to the Southland is capable of revealing. It is only just to add that I have traveled in the first-class—that is, white—cars all through the South, through Texas, Georgia and as far as Birmingham, Ala., but I have never received an insult or discourtesy from a Southern white man. While, fortunately, this has been my experience, still I believe that in some other localities in the South such an experience would seem almost incredible.

I want to refer briefly to the remarks of one of the writers in *The Independent* with reference to the character and strength of colored women. I think it but just to say that we must look to American slavery as the source of every imperfection that mars the character of the colored American. It ought not to be necessary to remind a Southern woman that less than 50 years ago the ill-starred mothers of this ransomed race were not allowed to be modest, not allowed to follow the instincts of moral rectitude, and there was no living man to whom they could cry for protection against the men who not only owned them, body and soul, but also the souls of their husbands, their brothers, and, alas, their sons. Slavery made her the only woman in America for whom virtue was not an ornament and a necessity. But in spite of this dark and painful past, I believe that the sweeping assertions of this writer are grossly untrue and unjust at least to thousands of colored women in the North who were free from the debasing influence of slavery, as well as thousands of women in the South, who instinctively fought to preserve their own honor and that of their unfortunate offspring. I believe that the colored women are

just as strong and just as weak as any other women with like education, training and environment.

It is a significant and shameful fact that I am constantly in receipt of letters from the still unprotected colored women of the South, begging me to find employment for their daughters according to their ability, as domestics or otherwise, to save them from going into the homes of the South as servants, as there is nothing to save them from dishonor and degradation. Many prominent white women and ministers will verify this statement. The heartbroken cry of some of these helpless mothers bears no suggestion of the "flaunting pride of dishonor" so easily obtained, by simply allowing their daughters to enter the homes of the white women of the South. Their own mothers cannot protect them and white women will not, or do not. The moral feature of this problem has complications that it would seem better not to dwell on. From my own study of the question, the colored woman deserves greater credit for what she has done and is doing than blame for what she cannot so soon overcome.

As to the negro problem, the only things one can be really sure of is that it has a beginning, and we know that it is progressing some way, but no one knows the end. Prejudice is here and everywhere, but it may not manifest itself so brutally as in the South. The chief interest in the North seems to be centered in business, and it is in business where race prejudice shows itself the strongest. The chief interest in the South is social supremacy, therefore prejudice manifests itself most strongly against even an imaginary approach to social contact. Here in the Northern States I find that a colored woman of character and intelligence will be recognized and respected, but the white woman who will recognize and associate with her in the same club or church would probably not tolerate her as a fellow clerk.

The conclusion of the whole matter seems to be that whether I live in the North or the South, I cannot be counted for my full value, be that much or little. I dare not cease to hope and aspire and believe in human love and justice, but progress is painful and my faith is often strained to the breaking point.

Chicago, Ill.

22. LEAVES FROM THE MENTAL PORTFOLIO OF
A EURASIAN
by Sui Sin Far

WHEN I LOOK back over the years I see myself, a little child of scarcely four years of age, walking in front of my nurse, in a green English lane, and listening to her tell another of her kind that my mother is Chinese. "Oh, Lord!" exclaims the informed. She turns me around and scans me curiously from head to foot. Then the two women whisper together. Tho the word "Chinese" conveys very little meaning to my mind, I feel that they are talking about my father and mother and my heart swells with indignation. When we reach home I rush to my mother and try to tell her what I have heard. I am a young child. I fail to make myself intelligible. My mother does not understand, and when the nurse declares to her, "Little Miss Sui is a story-teller," my mother slaps me.

Many a long year has passed over my head since that day—the day on which I first learned that I was something different and apart from other children—but tho my mother has forgotten it, I have not.

I see myself again, a few years older. I am playing with another child in a garden. A girl passes by outside the gate. "Mamie," she cries to my companion. "I wouldn't speak to Sui if I were you. Her mamma is Chinese."

"I don't care," answers the little one beside me. And then to me, "Even if your mamma is Chinese, I like you better than I like Annie." "But I don't like you," I answer, turning my back on her. It is my first conscious lie.

I am at a children's party, given by the wife of an Indian officer whose children were schoolfellows of mine. I am only six years of age, but have attended a private school for over a year, and have already learned that China is a heathen country, being civilized by England. However, for the time being, I am a merry romping child. There are quite a number of grown people present. One, a white haired old man, has his attention called to me by the hostess. He adjusts his eyeglasses and surveys me critically. "Ah, indeed!" he exclaims, "Who would have thought it at first glance. Yet now I see the difference between her and other children. What a peculiar coloring! Her mother's eyes and hair and her father's features, I presume. Very interesting little creature!"

I had been called from my play for the purpose of inspection. I do not return to it. For the rest of the evening I hide myself behind a hall door and refuse to show myself until it is time to go home.

My parents have come to America. We are in Hudson City, N. Y., and we are very poor. I am out with my brother, who is ten months older than myself. We pass a Chinese store, the door of which is open. "Look!" says Charlie, "Those men in there are Chinese!" Eagerly I gaze into the long low room. With the exception of my mother, who is English bred with English ways and manner of dress, I have never seen a Chinese person. The two men within the store are uncouth specimens of their race, drest in working blouses and pantaloons with queues hanging down their backs. I recoil with a sense of shock.

"Oh, Charlie," I cry, "Are we like that?"

"Well, we're Chinese, and they're Chinese, too, so we must be!" returns my seven-year-old brother.

"Of course you are," puts in a boy who has followed us down the street, and who lives near us and has seen my mother: "Chinky, Chinky, Chinaman, yellow-face, pig-tail, rat-eater." A number of other boys and several little girls join in with him.

"Better than you," shouts my brother, facing the crowd. He is younger and smaller than any there, and I am even more insignificant than he; but my spirit revives.

"I'd rather be Chinese than anything else in the world," I scream.

They pull my hair, they tear my clothes, they scratch my face, and all but lame my brother; but the white blood in our veins fights valiantly for the Chinese half of us. When it is all over, exhausted and bedraggled, we crawl home, and report to our mother that we have "won our battle."

"Are you sure?" asks my mother doubtfully.

"Of course. They ran from us. They were frightened," returns my brother.

My mother smiles with satisfaction.

"Do you hear?" she asks my father.

"Umm," he observes, raising his eyes from his paper for an instant. My childish instinct, however, tells me that he is more interested than he appears to be.

It is tea time, but I cannot eat. Unobserved I crawl away. I do not sleep that night. I am too excited and I ache all over. Our opponents had been so very much stronger and bigger than we. Toward morning, however, I fall into a doze from which I awake myself, shouting:

"Sound the battle cry;
See the foe is nigh."

My mother believes in sending us to Sunday school. She has been brought up in a Presbyterian college.

The scene of my life shifts to Eastern Canada. The sleigh which has carried us from the station stops in front of a little French Canadian hotel. Immediately we are surrounded by a number of villagers, who stare curiously at my mother as my father assists her to alight from the sleigh. Their curiosity, however, is tempered with kindness, as they watch, one after another, the little black heads of my brothers and sisters and myself emerge out of the buffalo robe, which is part of the sleigh's outfit. There are six of us, four girls and two boys; the eldest, my brother, being only seven years of age. My father and mother are still in their twenties. "Les pauvres enfants," the inhabitants murmur, as they help to carry us into the hotel. Then in lower tones: "Chinoise, Chinoise."

For some time after our arrival, whenever we children are sent for a walk, our footsteps are dogged by a number of young French

and English Canadians, who amuse themselves with speculations as to whether, we being Chinese, are susceptible to pinches and hair pulling, while older persons pause and gaze upon us, very much in the same way that I have seen people gaze upon strange animals in a menagerie. Now and then we are stopt and plied with questions as to what we eat and drink, how we go to sleep, if my mother understands what my father says to her, if we sit on chairs or squat on floors, etc., etc., etc.

There are many pitched battles, of course, and we seldom leave the house without being armed for conflict. My mother takes a great interest in our battles, and usually cheers us on, tho I doubt whether she understands the depth of the troubled waters thru which her little children wade. As to my father, peace is his motto, and he deems it wisest to be blind and deaf to many things.

School days are short, but memorable. I am in the same class with my brother, my sister next to me in the class below. The little girl whose desk my sister shares shrinks close against the wall as my sister takes her place. In a little while she raises her hand.

"Please, teacher!"

"Yes, Annie."

"May I change my seat?"

"No, you may not!"

The little girl sobs. "Why should she have to sit beside a _____."

Happily my sister does not seem to hear, and before long the two little girls become great friends. I have many such experiences.

My brother is remarkably bright; my sister next to me has a wonderful head for figures, and when only eight years of age helps my father with his night work accounts. My parents compare her with me. She is of sturdier build than I, and, as my father says, "Always has her wits about her." He thinks her more like my mother, who is very bright and interested in every little detail of practical life. My father tells me that I will never make half the woman that my mother is or that my sister will be. I am not as strong as my sisters, which makes me feel somewhat ashamed, for I am the eldest little girl, and more is expected of me. I have no organic disease, but the strength of my feelings seems to take from me the strength of my body. I am prostrated at times with attacks of nervous sickness. The doctor says that my heart is unusually large; but in the light of the present I know that the cross of the Eurasian bore too heavily upon my childish shoulders. I usually hide my weakness from my family until I can-

not stand. I do not understand myself, and I have an idea that the others will despise me for not being as strong as they. Therefore, I like to wander away alone, either by the river or in the bush. The green fields and flowing water have a charm for me. At the age of seven, as it is today, a bird on the wing is my emblem of happiness.

I have come from a race on my mother's side which is said to be the most stolid and insensible to feeling of all races, yet I look back over the years and see myself so keenly alive to every shade of sorrow and suffering that it is almost a pain to live.

If there is any trouble in the house in the way of a difference between my father and mother, or if any child is punished, how I suffer! And when harmony is restored, heaven seems to be around me. I can be sad, but I can also be glad. My mother's screams of agony when a baby is born almost drive me wild, and long after her pangs have subsided I feel them in my own body. Sometimes it is a week before I can get to sleep after such an experience.

A debt owing by my father fills me with shame. I feel like a criminal when I pass the creditor's door. I am only ten years old. And all the while the question of nationality perplexes my little brain. Why are we what we are? I and my brothers and sisters. Why did God make us to be hooted and stared at? Papa is English, mamma is Chinese. Why couldn't we have been either one thing or the other? Why is my mother's race despised? I look into the faces of my father and mother. Is she not every bit as dear and good as he? Why? Why? She sings us the songs she learned at her English school. She tells us tales of China. Tho a child when she left her native land she remembers it well, and I am never tired of listening to the story of how she was stolen from her home. She tells us over and over again of her meeting with my father in Shanghai and the romance of their marriage. Why? Why?

I do not confide in my father and mother. They would not understand. How could they? He is English, she is Chinese. I am different to both of them—a stranger, tho their own child. "What are we?" I ask my brother. "It doesn't matter, sissy," he responds. But it does. I love poetry, particularly heroic pieces. I also love fairy tales. Stories of everyday life do not appeal to me. I dream dreams of being great and noble; my sisters and brothers also. I glory in the idea of dying at the stake and a great genie arising from the flames and declaring to those who have scorned us: "Behold, how great and glorious and noble are the Chinese people!"

My sisters are apprenticed to a dressmaker; my brother is entered in an office. I tramp around and sell my father's pictures, also some lace which I make myself. My nationality, if I had only known it at that time, helps to make sales. The ladies who are my customers call me "The Little Chinese Lace Girl." But it is a dangerous life for a very young girl. I come near to "mysteriously disappearing" many a time. The greatest temptation was in the thought of getting far away from where I was known, to where no mocking cries of "Chinese!" "Chinese!" could reach.

Whenever I have the opportunity I steal away to the library and read every book I can find on China and the Chinese. I learn that China is the oldest civilized nation on the face of the earth and a few other things. At eighteen years of age what troubles me is not that I am what I am, but that others are ignorant of my superiority. I am small, but my feelings are big—and great is my vanity.

My sisters attend dancing classes, for which they pay their own fees. In spite of covert smiles and sneers, they are glad to meet and mingle with other young folk. They are not sensitive in the sense that I am. And yet they understand. One of them tells me that she overheard a young man say to another that he would rather marry a pig than a girl with Chinese blood in her veins.

In course of time I too learn shorthand and take a position in an office. Like my sister, I teach myself, but, unlike my sister, I have neither the perseverance nor the ability to perfect myself. Besides, to a temperament like mine, it is torture to spend the hours in transcribing other people's thoughts. Therefore, altho I can always earn a moderately good salary, I do not distinguish myself in the business world as does she.

When I have been working for some years I open an office of my own. The local papers patronize me and give me a number of assignments, including most of the local Chinese reporting. I meet many Chinese persons, and when they get into trouble am often called upon to fight their battles in the papers. This I enjoy. My heart leaps for joy when I read one day an article signed by a New York Chinese in which he declares "The Chinese in America owe an everlasting debt of gratitude to Sui Sin Far for the bold stand she has taken in their defense."

The Chinaman who wrote the article seeks me out and calls upon me. He is a clever and witty man, a graduate of one of the American colleges and as well a Chinese scholar. I learn that he

has an American wife and several children. I am very much interested in these children, and when I meet them my heart throbs in sympathetic tune with the tales they relate of their experiences as Eurasians. "Why did papa and mamma born us?" asks one. Why?

I also meet other Chinese men who compare favorably with the white men of my acquaintance in mind and heart qualities. Some of them are quite handsome. They have not as finely cut noses and as well developed chins as the white men, but they have smoother skins and their expression is more serene; their hands are better shaped and their voices softer.

Some little Chinese women whom I interview are very anxious to know whether I would marry a Chinaman. I do not answer No. They clap their hands delightedly, and assure me that the Chinese are much the finest and best of all men. They are, however, a little doubtful as to whether one could be persuaded to care for me, full-blooded Chinese people having a prejudice against the half white.

Fundamentally, I muse, all people are the same. My mother's race is as prejudiced as my father's. Only when the whole world becomes as one family will human beings be able to see clearly and hear distinctly. I believe that some day a great part of the world will be Eurasian. I cheer myself with the thought that I am but a pioneer. A pioneer should glory in suffering.

"You were walking with a Chinaman yesterday," accuses an acquaintance.

"Yes, what of it?"

"You ought not to. It isn't right."

"Not right to walk with one of my own mother's people? Oh, indeed!"

I cannot reconcile his notion of righteousness with my own.

• • •

I am living in a little town away off on the north shore of a big lake. Next to me at the dinner table is the man for whom I work as a stenographer. There are also a couple of business men, a young girl and her mother.

Some one makes a remark about the cars full of Chinamen that past that morning. A transcontinental railway runs through the town.

My employer shakes his rugged head. "Somehow or other,"

says he, "I cannot reconcile myself to the thought that the Chinese are humans like ourselves. They may have immortal souls, but their faces seem to be so utterly devoid of expression that I cannot help but doubt."

"Souls," echoes the town clerk. "Their bodies are enough for me. A Chinaman is, in my eyes, more repulsive than a nigger."

"They always give me such a creepy feeling," puts in the young girl with a laugh.

"I wouldn't have one in my house," declares my landlady.

"Now, the Japanese are different altogether. There is something bright and likeable about those men," continues Mr. K.

A miserable, cowardly feeling keeps me silent. I am in a Middle West town. If I declare what I am, every person in the place will hear about it the next day. The population is in the main made up of working folks with strong prejudices against my mother's countrymen. The prospect before me is not an enviable one—if I speak. I have no longer an ambition to die at the stake for the sake of demonstrating the greatness and nobleness of the Chinese people.

Mr. K. turns to me with a kindly smile.

"What makes Miss Far so quiet?" he asks.

"I don't suppose she finds the 'washee washee men' particularly interesting subjects of conversation," volunteers the young manager of the local bank.

With a great effort I raise my eyes from my plate. "Mr. K.," I say, addressing my employer, "the Chinese people may have no souls, no expression on their faces, be altogether beyond the pale of civilization, but whatever they are, I want you to understand that I am—I am Chinese."

There is silence in the room for a few minutes. Then Mr. K. pushes back his plate and standing up beside me, says:

"I should not have spoken as I did. I know nothing whatever about the Chinese. It was pure prejudice. Forgive me!"

I admire Mr. K.'s moral courage in apologizing to me; he is a conscientious Christian man, but I do not remain much longer in the little town.

• • •

I am quite under a tropic sky, meeting frequently and conversing with persons who are almost as high up in the world as birth, edu-

cation and money can set them. The environment is peculiar, for I am also surrounded by a race of people, the reputed descendants of Ham, the son of Noah, whose offspring, it was prophesied, should be the servants of the sons of Shem and Japheth. As I am a descendant, according to the Bible, of both Shem and Japheth, I have a perfect right to set my heel upon the Ham people, but tho I see others around me following out the Bible suggestion, it is not my nature to be arrogant to any but those who seek to impress me with their superiority, which the poor black maid who has been assigned to me by the hotel certainly does not. My employer's wife takes me to task for this. "It is unnecessary," she says, "to thank a black person for a service."

The novelty of life in the West Indian island is not without its charm. The surroundings, people, manner of living, are so entirely different from what I have been accustomed to up North that I feel as if I were "born again." Mixing with people of fashion, and yet not of them, I am not of sufficient importance to create comment or curiosity. I am busy nearly all day and often well into the night. It is not monotonous work, but it is certainly strenuous. The planters and business men of the island take me as a matter of course and treat me with kindly courtesy. Occasionally an Englishman will warn me against the "brown boys" of the island, little dreaming that I too am of the "brown people" of the earth.

When it begins to be whispered about the place that I am not all white, some of the "sporty" people seek my acquaintance. I am small and look much younger than my years. When, however, they discover that I am a very serious and sober-minded spinster indeed, they retire quite gracefully, leaving me a few amusing reflections.

One evening a card is brought to my room. It bears the name of some naval officer. I go down to my visitor, thinking he is probably some one who, having been told that I am a reporter for the local paper, has brought me an item of news. I find him lounging in an easy chair on the veranda of the hotel—a big, blond, handsome fellow, several years younger than I.

"You are Lieutenant _____?" I inquire.

He bows and laughs a little. The laugh doesn't suit him somehow—and it doesn't suit me, either.

"If you have anything to tell me, please tell it quickly, because I'm very busy."

"Oh, you don't really mean that," he answers, with another silly

and offensive laugh. "There's always plenty of time for good times. That's what I am here for. I saw you at the races the other day and twice at King's House. My ship will be here for _____ weeks."

"Do you wish that noted?" I ask.

"Oh, no! Why—I came just because I had an idea that you might like to know me. I would like to know you. You look such a nice little body. Say, wouldn't you like to go out for a sail this lovely night? I will tell you about all the sweet little Chinese girls I met when we were at Hong Kong. They're not so shy!"

• • •

I leave Eastern Canada for the Far West, so reduced by another attack of rheumatic fever that I only weigh eighty-four pounds. I travel on an advertising contract. It is presumed by the railway company that in some way or other I will give them full value for their transportation across the continent. I have been ordered beyond the Rockies by the doctor, who declares that I will never regain my strength in the East. Nevertheless, I am but two days in San Francisco when I start out in search of work. It is the first time that I have sought work as a stranger in a strange town. Both of the other positions away from home were secured for me by home influence. I am quite surprised to find that there is no demand for my services in San Francisco and that no one is particularly interested in me. The best I can do is to accept an offer from a railway agency to typewrite their correspondence for $5 a month. I stipulate, however, that I shall have the privilege of taking in outside work and that my hours shall be light. I am hopeful that the sale of a story or newspaper article may add to my income, and I console myself with the reflection that, considering that I still limp and bear traces of sickness, I am fortunate to secure any work at all.

The proprietor of one of the San Francisco papers, to whom I have a letter of introduction, suggests that I obtain some subscriptions from the people of Chinatown, that district of the city having never been canvassed. This suggestion I carry out with enthusiasm, tho I find that the Chinese merchants and people generally are inclined to regard me with suspicion. They have been imposed upon so many times by unscrupulous white people. Another drawback—save for a few phrases, I am unacquainted with my mother tongue. How, then, can I expect these people

to accept me as their own countrywoman? The Americanized Chinamen actually laugh in my face when I tell them that I am of their race. However, they are not all "Doubting Thomases." Some little women discover that I have Chinese hair, color of eyes and complexion, also that I love rice and tea. This settles the matter for them—and for their husbands.

My Chinese instincts develop. I am no longer the little girl who shrunk against my brother at the first sight of a Chinaman. Many and many a time, when alone in a strange place, has the appearance of even an humble laundryman given me a sense of protection and made me feel quite at home. This fact of itself proves to me that prejudice can be eradicated by association.

I meet a half Chinese, half white girl. Her face is plastered with a thick white coat of paint and her eyelids and eyebrows are blackened so that the shape of her eyes and the whole expression of the face is changed. She was born in the East, and at the age of eighteen came West in answer to an advertisement. Living for many years among the working class, she had heard little but abuse of the Chinese. It is not difficult, in a land like California, for a half Chinese, half white girl to pass as one of Spanish or Mexican origin. This the poor child does, tho she lives in nervous dread of being "discovered." She becomes engaged to a young man, but fears to tell him what she is, and only does so when compelled by a fearless American girl friend. This girl, who knows her origin, realizing that the truth sooner or later must be told, and better soon than late, advises the Eurasian to confide in the young man, assuring her that he loves her well enough not to allow her nationality to stand, a bar sinister, between them. But the Eurasian prefers to keep her secret, and only reveals it to the man who is to be her husband when driven to bay by the American girl, who declares that if the half-breed will not tell the truth she will. When the young man hears that the girl he is engaged to has Chinese blood in her veins, he exclaims: "Oh, what will my folks say?" But that is all. Love is stronger than prejudice with him, and neither he nor she deems it necessary to inform his "folks."

The Americans having for many years manifested a much higher regard for the Japanese than for the Chinese, several half Chinese young men and women, thinking to advance themselves, both in a social and business sense, pass as Japanese. They continue to be known as Eurasians; but a Japanese Eurasian does not appear in the same light as a Chinese Eurasian. The unfortunate Chinese

Eurasians! Are not those who compel them to thus cringe more to be blamed than they?

People, however, are not all alike. I meet white men, and women, too, who are proud to mate with those who have Chinese blood in their veins, and think it a great honor to be distinguished by the friendship of such. There are also Eurasians and Eurasians. I know of one who allowed herself to become engaged to a white man after refusing him nine times. She had discouraged him in every way possible, had warned him that she was half Chinese; that her people were poor, that every week or month she sent home a certain amount of her earnings, and that the man she married would have to do as much, if not more; also, most uncompromising truth of all, that she did not love him and never would. But the resolute and undaunted lover swore that it was a matter of indifference to him whether she was a Chinese or a Hottentot, that it would be his pleasure and and privilege to allow her relations double what it was in her power to bestow, and as to not loving him—that did not matter at all. He loved her. So, because the young woman had a married mother and married sisters, who were always picking at her and gossiping over her independent manner of living, she finally consented to marry him, recording the agreement in her diary thus:

"I have promised to become the wife of _____ on _____, 189-, because the world is so cruel and sneering to a single woman— and for no other reason."

Everything went smoothly until one day. The young man was driving a pair of beautiful horses and she was seated by his side, trying very hard to imagine herself in love with him, when a Chinese vegetable gardener's cart came rumbling along. The Chinaman was a jolly-looking individual in blue cotton blouse and pantaloons, his rakish looking hat being kept in place by a long queue which was pulled upward from his neck and wound around it. The young woman was suddenly possest with the spirit of mischief. "Look!" she cried, indicating the Chinaman, "there's my brother. Why don't you salute him?"

The man's face fell a little. He sank into a pensive mood. The wicked one by his side read him like an open book.

"When we are married," said she, "I intend to give a Chinese party every month."

No answer.

"As there are very few aristocratic Chinese in this city, I shall fill up with the laundrymen and vegetable farmers. I don't believe in

being exclusive in democratic America, do you?"

He hadn't a grain of humor in his composition, but a sickly smile contorted his features as he replied:

"You shall do just as you please, my darling. But—but—consider a moment. Wouldn't it be just a little pleasanter for us if, after we are married, we allowed it to be presumed that you were—er—Japanese? So many of my friends have inquired of me if that is not your nationality. They would be so charmed to meet a little Japanese lady."

"Hadn't you better oblige them by finding one?"

"Why—er—what do you mean?"

"Nothing much in particular. Only—I am getting a little tired of this," taking off his ring.

"You don't mean what you say! Oh, put it back, dearest! You know I would not hurt your feelings for the world!"

"You haven't. I'm more than pleased. But I do mean what I say."

That evening the "ungrateful" Chinese Eurasian diaried, among other things, the following:

"Joy, oh, joy! I'm free once more. Never again shall I be untrue to my own heart. Never again will I allow any one to 'hound' or 'sneer' me into matrimony."

I secure transportation to many California points. I meet some literary people, chief among whom is the editor of the magazine who took my first Chinese stories. He and his wife give me a warm welcome to their ranch. They are broad-minded people, whose interest in me is sincere and intelligent, not affected and vulgar. I also meet some funny people who advise me to "trade" upon my nationality. They tell me that if I wish to succeed in literature in America I should dress in Chinese costume, carry a fan in my hand, wear a pair of scarlet beaded slippers, live in New York, and come of high birth. Instead of making myself familiar with the Chinese-Americans around me, I should discourse on my spirit acquaintance with Chinese ancestors and quote in between the "good mornings" and "How d'ye dos" of editors,

> "Confucius, Confucius, how great is Confucius, Before
> Confucius, there never was Confucius, After Confucius, there
> never came Confucius," etc., etc., etc.,

or something like that, both illuminating and obscuring, don't you know. They forget, or perhaps they are not aware that the old Chinese sage taught "The way of sincerity is the

way of heaven."

My experiences as an Eurasian never cease; but people are not now as prejudiced as they have been. In the West, too, my friends are more advanced in all lines of thought than those whom I know in Eastern Canada—more genuine, more sincere, with less of the form of religion, but more of its spirit.

So I roamed backward and forward across the continent. When I am East, my heart is West. When I am West, my heart is East. Before long I hope to be in China. As my life began in my father's country it may end in my mother's.

After all I have no nationality and am not anxious to claim any. Individuality is more than nationality. "You are you and I am I," says Confucius. I give my right hand to the Occidentals and my left to the Orientals, hoping that between them they will not utterly destroy the insignificant "connecting link." And that's all.

Seattle, Wash.

23. THE STORY OF

TWO MOONSHINERS

[In the city of Atlanta, Georgia, there are a couple who
are nearly middle aged and live, in fair comfort, upon
the income of the husband's small but independent
business. As it happened—in what manner it is need-
less now to tell—the fact was learned that, some few
years ago, they lived in Eastern Tennessee. And, as it
happened also—by what means it is impossible now to
tell—the fact was learned that, during their residence
there in Tennessee, they brewed and sold whisky
which bore no revenue stamps. Some urging was
required to induce the wife, a woman of education, to
prepare a brief account of their experiences and
observations. So far from the making of any endeavor
to have her deal with the squalid romances of the dan-
gerous trade, especial stress was laid upon the desir-
ability of explaining, by preference, its commonplaces
and its prose. But it would seem that criminality can-
not escape dangers; and so both aspects of the "moon-
shiner's" recurringly hazardous career appear in the
narrative, which is printed as it was received. —Editor.]

OUR FIRST STEP in the direction of lawlessness came when the doc-
tor said my husband's life depended upon an immediate and
permanent change of climate. Frank, who was born in
Philadelphia and had lived there always, feebly suggested that
the Quaker City was a pretty good health resort; but the doctor
declared it would not do at all, and the sooner he located in some
mountain district, the better it would be for him. We considered
all sorts of places, but the South seemed to be the most promis-
ing. The merits of Florida, Tennessee and North Carolina were
canvassed; the question was finally determined in favor of
Tennessee. Frank was fortunate enough to obtain employment
at his trade in one of the towns of East Tennessee and his wages
were sufficient to enable him to fulfil the parting injunction of

the doctor, which was that he live on the mountain side. He was able to do a great deal of work at home and thus got his fill of good mountain air. The effect was immediate. He improved from the first week. But the lonesomeness of it was something dreadful to contemplate.

Homesickness is comparable with nothing in the world except some forfeited affection. We were both in the cruelest stage of depression when we became acquainted with a tall, lank mountaineer, who sat on our porch in the evening and beguiled the long summer hours with a flow of anecdote, story and philosophy such as I have rarely heard. He frankly told us that he was a moonshiner, because moonshining was more congenial and more profitable than any other work he could undertake. Several times Frank, without giving serious thought to what he was doing, helped him to dispose of his product.

We lived on in this fashion for a year, when Frank lost his position by reason of a shut-down in the factory. It made him despondent, but he did his best to put on a brave face.

"My health is fine now," he said. "If we go back to Philadelphia I can get a good position right away."

"But, Frank," I exclaimed, with an anguish I could not conceal, "the doctor is sure you cannot live six months in the Northern climate."

He turned away without a word, and we moped the remainder of the day, two very miserable beings.

It is curious how slight circumstances can change the current of a person's life. That night we had our usual visitor in the person of the lean, lank mountaineer. Beneath his originality and quaintness there was a native shrewdness; it did not take him long to see that something was wrong in our little household. He was so kind, so friendly, that I told him the whole story. When I concluded he sat there, chewing tobacco, his lantern-like jaws working up and down with the precision and regularity of a piece of machinery, while their owner was thinking very hard but never saying a word.

At the end of five minutes he unlimbered his gaunt form, rose, and called Frank into the other room. They talked very earnestly for half an hour. When they came out they were smiling, and Frank's face was flushed a bit. The next day Frank became a moonshiner—yes, that is what it was. It all seemed so strange, and yet so natural. I, who had the advantage of good parentage and

the benefits of a seminary education, never, by the wildest stretch of the imagination, dreamt that I would be the wife of a breaker of the law.

Our little frame cottage, which was on a ledge half way up the mountain, was immediately utilized for business purposes. It seemed a desecration to condemn it to such base uses. Silvery streams threaded the valley below and cascades of water sped on their way to picturesque gulches.

Some few hundred feet in front of the house there was a disreputable looking road with a score of scraggy trees, tottering and trembling as if in mortal fear of the awful abyss below. Many a time have I wandered, lonesome, along the tortuous highway when all nature seemed filled with the pity of autumn. It wound round and round the side of the mountain like a circular stair. From my window I could see, here and there, a vine clinging from some crevice, where the wind had cast the seed, flaunting the fading remnant of a diseased and paralyzed life. The ragged tramp of a road crept along, clinging to the side of cliffs, whose walls were scarred by the ages. Along the ravine below a brook was fleeing madly, as tho fearful to remain longer in the unbroken solitude, in which it seemed to be the only living thing.

Frank had learned the full meaning of the fact that the Government exacted a tax of $1.10 for every gallon of whisky distilled in the United States; he was already mentally calculating the profits to be derived from the business. Our house was painted white, with green shutters. We had yellow shades and lace curtains on the windows, and altogether it presented the appearance of a very respectable and very tidy abode. Now, where do you suppose Frank put his distilling outfit? *Why, in the parlor of that house.* I remonstrated at first; but, as I had yielded to his resolve for the business, I could not object to precautions for our safety. The still was a copper boiler upon two rows of bricks. That part of the floor was covered with sheet iron. In the corner of the room was an old-fashioned parlor organ, standing rather high, and so arranged that it could be used as a complete cover for the distilling plant. Our greatest difficulty was with the glass tubes that caught the fumes, which became mist and melted out in the form of whisky or mountain dew. The apparatus was finally so planned that it could be quickly separated from the remainder of the plant and hidden in the interior of an old hair-cloth sofa.

A lead pipe ran from the still to the tub in a bathroom built on the first floor, and this was used as a means for disposing of the refuse. As a precaution the lead pipe was built under the floor. To me it was the observance of the law or the death of my husband. I had made my choice. I was a full partner in the concern, and I threw conscience to the winds.

Our product was small but sure. We used corn, chiefly, and the whisky was afterward sweetened with molasses or rye flavoring. At first my husband carried it to town in big jugs and disposed of it to men who were willing to take the always dangerous chances. As time went on he became bolder and shipped it away by the barrel in the guise of potatoes. The tops and bottoms of the barrels were filled with real "spuds," grown in our little garden, and the tops were covered with burlap. This is the common form of handling contraband whisky. Many a barrel, shipped to prohibition towns, is carefully made up to resemble rolls of carpet. I have known some moonshiners to mark on the outside of the packages "Use no hooks," and "Handle with care." In certain sections of New Jersey and Maryland the "wet goods" are shipped in the guise of oysters. We used corn in the making of the whisky, but I am told that certain shrewd Yankees in Vermont have, in emergencies, made it of prunes, raisins, pears, apricots and similar fruits.

From this time on I noticed a gradual deterioration in my husband's moral character, and—I write it shamefacedly—I fear that I shared in the transformation. We became more and more like those most abject of all creatures—the poor whites of the Southern mountain districts. We were very healthy, but not quite happy. Corn meal was the staple food. Nature was generous in many ways. We had mountain trout and wild fowl in abundance. Our truck patch supplied all of the vegetables we needed. Fresh meat was unknown and bacon rather a luxury. Our neighbors lived about as well as we did, except that they sold many of the things we reserved for our own table.

There were half a dozen stills in operation in this district. None of the people were our equals in education or breeding. They were genuine mountaineers—phlegmatic, unfeeling, dull. But between us there existed a sort of rude freemasonry, by which the interests of one were made the concern of all. Other residents of the mountain, while law-abiding, were in silent sympathy with us. There is a

widespread feeling that the laws which interfere with a man who wants to manufacture a few gallons of whisky are essentially wrong, and that he has the same inherent right to run a still as he has to maintain a cider press or to grow potatoes. Many of the men who persistently violate the Internal Revenue laws are church-goers and they lead moral lives. They lie to shield themselves, but do not regard the offense as any very grievous sin.

"Was it not proven in court, over at Asheville, that you swore to a lie?" was asked of a man in a North Carolina State Court.

"W-a-al," said he, "s'pos'n I did. Wasn't that in the United States Court?"

While Frank was out one day he was led into an altercation with a neighbor. He came home worried.

"You should not fret over such a trifle," I said. "You do not fear the man, do you?"

"Not physically," he said. "But he may put the revenue officers on us."

His apprehensions were verified. About dusk one evening we were startled by the sharp report of a rifle three times in succession. It was the neighbor's signal that the revenue men were about. We quickly removed all traces of the business. The organ was placed over the still; the glass worm and the other paraphernalia were hidden in the old sofa. I took my place on the organ stool and began playing an old-fashioned hymn. Frank sat on the sofa, directly over the evidences of crime, with a hymn-book in his hand, singing in a very excellent baritone voice. Our parlor door was unlocked.

The two government officials, without knocking, bolted in, pistols in hand. The scene seemed to embarrass them. Both pocketed their revolvers and instinctively took off their hats. The deputy marshal, who was one of your genuine Southern gentlemen, said:

"I fear, madam, we have made a mistake."

I pretended to be indignant, exclaiming:

"I should say you have!"

"A thousand pardons," he begged, bowing again. "But in the excess of our zeal we have come into the wrong place."

He said he had received an anonymous letter stating that a still was in operation in our house. The deputy raiding collector joined the marshal in trying to explain their "error." In a little

while we were the best of friends. Nothing would do but that we
go on with our interrupted song. They joined in the chorus. I set
them out some cold lunch in the dining-room. They left in time
to reach town before midnight. As the sound of the horses' hoofs
died away in the distance we regarded each other with a look of
intense relief.

We agreed that we could not afford to risk another adventure of
that kind, and the next morning the plant was removed from the
house and placed in a cave about a mile away. It was ideal for the
purpose. It had been carefully dug out and was covered with logs
and dirt and leaves thrown over the logs. A spring of mountain
water—so essential to the successful work—ran near by waiting to
be utilized. The natural advantages of the situation were manifest.

Many persons formed the habit of coming to us for a jug of whisky,
but we never did any direct business with them. If they were put on
the witness-stand under oath they could not swear we were violating
the law. The jug was placed near the stump of a tree—with the money.
The customer took a stroll and, on returning, found the money had
gone, to be, in some strange manner, replaced by the whisky. Another
method that worked very well was to sell a half peck of apples or pota-
toes for a dollar and throw in a jug full of whisky as a present. The pre-
sents were not reserved for the holidays, but were freely dispensed at
all seasons of the year. They had the effect of making us quite popu-
lar in the neighborhood and incidentally helped to fatten the
account which we were beginning to keep in a savings fund.

Various attempts were made to entrap us. One day a young fel-
low, nattily dressed, came into the neighborhood and said he was
there to introduce a new style sewing machine. A neighbor, four
miles below us, got the bead on him and gave him just five minutes
to leave the neighborhood. He admitted that he was a raw revenue
officer, and he departed with his life and without ceremony. Again,
a colored barber, enlisted in the government service, came hang-
ing about the mountain side. He paid a girl guide the "location fee"
of ten dollars and found himself in the very heart of the moonshine
district. Such vain things as shaves, hair cuts and shampoos were
unknown in our simple entourage. The colored tonsorial artist was
escorted out of the district on a sharp fence rail, with the intima-
tion that, if he ever returned, he would be tarred and feathered.
One of our neighbors—to be exact, the very man who induced us
to go into the business—was caught in the act of distilling whisky.

His lawyer told him his case was hopeless; he promptly dismissed the lawyer. When the case was called he confessed his guilt, but— shaking like a leaf—said he was making the liquor in order to use it for his chills and fever. The tender-hearted judge was impressed and the prisoner left the court-room a free man.

In another case a young mountain girl made a fearful sacrifice to save her lover from the penitentiary. He had been arrested for moonshining, and the chief witness against him was a woman of notorious character, whose last name chanced to be the same as that of the sweetheart. The witness was spirited away. When her name was called the sweetheart took the stand and testified that she knew nothing of the guilt of the young man and had never known him to violate the law. The commissioner, who knew the real witness by sight, detected the fraud. Turning to the girl in the witness box, he said:

"Are you the person for whom the subpoena was intended?"

She was filled with confusion. She had come to protect her lover by concealing the truth, but she had no thought of com- mitting so revolting a perjury. It was a terrible ordeal. She would have to confess the truth or carry out the lie. She chose quickly. Hanging her head, she replied:

"I am."

The commissioner was relentless. He continued, sharply:

"Then you are also the person who was convicted of stealing two years ago?"

Her embarrassment and shame were intense, but she answered in a low voice:

"I am."

The commissioner determined to make her drink the cup to the dregs. In scathing tones he demanded:

"Then, of course, you are the same person whose loose morals have created so much scandal in this community?"

In a voice that was scarcely audible she whispered:

"I am the same."

She was led, half fainting, from the stand, and the moun- taineer was freed. The case has now become historic and it can be found in the records of the United States Courts in Tennessee.

Frank's first and only experience of a real battle with govern- ment officials was as a spectator. He was away, on the other side of the mountain, when a force of ten mounted deputy internal

revenue raiders rode up. They asked for information regarding a notorious moonshiner, which Frank naturally refused to give.

They rode straight ahead on to their destination, a big log house behind a clump of trees. They knocked at the door, but were refused admittance. The door was promptly battered down. As it fell inward two women, screaming hysterically, ran out, and the men in the house, all equipped with rifles, began firing at the raiders. One deputy was killed and one wounded. Two mountain men were killed; the rest were captured, tried and convicted. The story of that bloody encounter horrified me and, I think, it had a sobering effect on Frank. I knew from that moment that I should never be happy until we quit the business. My task was to wean him from it. That I succeeded—not in a day or a month— is evidenced by the fact that I have now, not without some reluctance, consented to place an imperfect story of our experiences upon record. The life had its fascination and its profits; but it also had its drawbacks, not the least of which was an uneasy conscience and the constant dread of meeting the officers of the law. I look back on it as a troubled dream, but also with a pleasant, indulgent and charitable feeling toward the rough, kind-hearted, but misguided, mountaineers of East Tennessee.

Atlanta, Ga.

24. THE EXPERIENCES OF
A CHORUS GIRL

[The following story is not a very inspiring one, but it faithfully depicts the life of the average girl on the stage, and as a human document has its place in our series of "Lifelets." It is of some pertinence now when the press of the whole country is publishing columns about a sensational theater tragedy.—Editor.]

I WAS BORN in the city of Philadelphia, of French and Italian parents. As early as I can remember I was crazy for the stage, anxious to mount a platform and display my airs and graces. I danced, danced, danced, all the time. Nobody taught me. I never had a dancing lesson in my life. And my parents were positively scandalized. I made up dances, and practiced every spare minute I could get. My parents were religious people in good circumstances, and I was as much a puzzle to them as a duck is to an old hen who has hatched it out among her brood of chicks.

There was a big mirror in my room, and I would pose for hours before that mirror, studying grace, admiring myself, and thinking what a tremendous sensation I would create if I could only prance before the footlights in some great New York theater.

Mother did everything to discourage me, and at last she said: "Jeanne, just as sure as you're born, one of these times, when

you are making such a wicked display of your vanity, the devil will grab you and fly away."

That frightened me so much that I was afraid to pose before the glass any more. Nevertheless, it did not at all daunt my ardor for the stage, and I danced, danced, danced, in season and out of season. But for safety's sake I always covered the glass with my clothes, so that if Old Scratch did come I would not see him.

While still a child I had the opportunity of appearing upon the amateur stage at various church functions; and the applause that I received was generous enough to satisfy even me. People went wild over me, and told me that I was a beautiful child, "such a clever child" and "a genius"; all of which I firmly believed. I had black hair and big brown eyes, and I was a pretty child when in a good temper.

Of course, I was spoiled, but not by mother. I spoiled myself, and perhaps was born spoiled—I was so full of vanity. And I was a little spitfire, too. When mother used to scold me, I was very insolent. I would not answer back, but I would rest my left elbow on my knee or on a table, and my chin in my hand, and sing as long as the scolding endured. Mother broke me of this one time. She gave me a scolding on account of some outrage that I had committed, and I assumed the indifferent attitude that I have described, and with my chin in my hand sang "Daisy Bell" all through the scolding.

"Daisy Bell" had just come out at that time, and was very popular. Mother kept scolding, but I sang along with much placidity, laying a special stress on the chorus:

> "Daisy, Daisy, give me your answer, do!
> I'm most crazy, all for the love of you!
> It won't be a stylish marriage, I can't afford a carriage,
> But you'll look sweet upon the seat
> Of a bicycle for two."

Finally my mother said: "I like that song very much, my dear." She took me by the ear and led me upstairs to my room and made me sing "Daisy Bell" for two hours steadily, while the tears ran down my face; and I never again interrupted her lectures with my singing performances.

Nevertheless, I danced, danced, danced in all my spare time, and I still had exquisite visions concerning the manner in which the

whole world would fall down and worship me if my cruel parents would only give me a fair chance to get out and exhibit my charms. When mother scolded me I used to threaten that I would run away and go upon the stage. I did that so often that at last she grew tired and answered me very sweetly:

"Very well, dear, if you are so determined to run away, I might as well help you. Come along, and we will pack your valise."

So she packed a little grip for me and put me out on the veranda, saying, "Now run away."

I was terribly frightened, for I was only eleven and a half years old; but after a time I got on a street car and rode to my aunt's house, and there I cried and cried until my aunt sent to mother and she was induced to forgive me and take me home again. After that I never told mother that I would run away from home, and I suppose that if mother had lived I never would have run away at all. But mother died when I was about thirteen years of age, and I and four other younger children of our family were left for my father to struggle with.

He sent me to St. Joseph's Convent and I stayed there about a year, at the end of which time the authorities conferred upon me the degree of G. B. in consideration of certain exercises which I performed with one of the teachers. This teacher had me standing up before the class for two hours, and something she said concerning me added the final touch that exploded my temper; whereupon I threw an inkwell at her, whereupon the authorities eliminated me.

Of course, when I went home father was far from satisfied with the degree which I had received from the convent, and of course, also, I was even further from satisfaction with his dissatisfaction. Every time he scolded I threatened to run away, and at last I actually did run away. My aunt was keeping our house at the time, but I took my eldest brother into my confidence, and he assisted me in getting my steamer trunk out of the house with a lot of my things packed in it. My brother was the eldest of the other children, and only a little younger than I. I told him about my scheme, and he believed in me and was sympathetic and willing to help in any way that I asked him to.

So we got clear of the house, and I made a race for New York. I was fourteen and a half years of age when I got to New York, and I did not know whether or not I knew a single soul in the

1251111

entire city. About a year before I had met two New York girls, actresses attached to a theatrical company that had played in Philadelphia. They gave me their addresses at the time of our meeting, but for all I knew they might have been in Hong Kong at the time when I ran away from home. Nor did I have their addresses so particularly noted that I could go right to their house; but I knew that they had told me that they lived in a certain part of Thirty-sixth street, and accordingly I went to Thirty-sixth street, and rang the bell of every house in the street for two blocks along, until at length I lighted upon my acquaintances. When they saw me they nearly fell dead.

"Why, child," said they, "what in the world are you doing here?"

Then I told them the entire story, about the heartless manner in which I had been treated, and the dreadful tyrants who prevented me from conquering the world. They were very sympathetic and promised to give me all possible help. And the next day they took me around to the offices of various theatrical managers, to whom they recommended me as a wonder, with the result that I actually did get an engagement with a "Faust" company, my part being a little dance in the first act, for which I received $18 a week.

Our company went to Boston, and there my real stage experiences began. I will never forget the first night when I had to go on. I was ashamed to tell the other girls in the dressing room that I did not know how to make myself up, so while they were making up I stood around and watched them. Presently when they had all gone on the stage, I dipped my finger in the rouge and smudged it on my lips, giving myself a mouth that made me look like a "coon." But I had no doubt that I was charming and so was marching boldly on the stage when the manager caught sight of me and nearly had a fit. He sent me back to my room in a hurry and appointed another girl to make me up in a proper manner.

Then and always I found the other girls good-hearted. They were always good to me. They knew that I was a greenhorn, but, instead of laughing at me and playing tricks, they helped me out.

The public of Boston did not exactly go into ecstasies over my performances. I received applause, but nothing so very notable, and it was evident from the placid interest with which audiences regarded me, that they imagined they had seen others who were almost, if not quite, as clever.

This to me was something of a disillusion and disappointment, and other experiences that I had in that company were also disappointing.

It had never occurred to my high and mighty personality that life on the stage might, to a greater or less extent, limit one's freedom. But now I found that instead of the management consenting that I should come and go at my own sweet will and pleasure, they demanded that I should be present, ready to go on, at certain places at certain hours; and when I failed to obey their rules they fined me heavily. So that very soon I was in quite deep trouble. I never had had any experience before in taking care of money, and I soon discovered that so far as this particular art went I was not at all an apt scholar. My salary was $18 a week, and I spent about three times as much, and at last found myself stone broke in Boston, with most unsympathetic creditors unanimously demanding payment.

So I wrote home and told my eldest sister just what my circumstances were, and asked her to give me a lift; and she sent me money from time to time, and then I got a place with a New York theater, where they wanted a good dancer. The theater stipulated that the person whom they engaged must be a graduate of a first-class dancing school, and I had to do a little fibbing. Nevertheless, I did secure the place and kept it for a year and a half; and no one ever questioned my ability to fill it properly.

While dancing one night I gave my left ankle such a wrench that I sprained it, and the injury proved so serious that I was laid up in bed for six weeks. This was a miserable time for me, because my salary stopped, while my expenses increased. I had not a cent saved, and my sister in Philadelphia could not supply me with sufficient money to keep up my old way of living.

Luckily I had some friends. One of them was named "Queenie": her other name does not matter—probably the whole name was assumed. She was a very beautiful girl, Polish, and a great talker, tall, supple, dark, with a gypsy face. She traveled a good deal and had lived all sorts of a life—or said she had—and she was carelessly generous and always doing impulsive things.

So she took me to her room on Seventh avenue, away up under the roof, and there she trained me to join her in the grand opera chorus. I learned the choral parts of ten operas lying in bed, and as I have a fair light soprano voice, "Queenie" said that I would do very well and a slight limp would not matter.

The chorus at the Metropolitan Opera House does not have to dance, and there are no difficult evolutions to be performed—no Amazon marches or anything of that sort. The things considered in selecting the chorus girls are voices and repertoires. Each voice must be like an instrument in the orchestra, so that all can be woven into harmony.

As soon as I could I went to the Opera House and secured a place there. "Queenie" introduced me to the chorus leader, who tried my voice and examined me in regard to repertoire. I proved satisfactory.

The chorus rooms for girls are on the Fortieth street side of the Metropolitan Opera House, and are up one flight of stairs, and in comparison with accommodations elsewhere they are convenient and comfortable.

But the management is strict. Girls must get to a performance half an hour in advance of its beginning, and there are fines for lateness and fines for absence. Every girl as she enters must register her arrival by pressing a button on which is her number. Some get around this regulation by having a relative or friend press the button, but if they are caught it means discharge.

The first time I sang in the chorus I was a simple village maid in the back row and therefore inconspicuous. "Queenie" stood beside me and introduced the people in the boxes, in spite of the orders against whispering. The best-known women in the country were there, loaded with jewels, and "Queenie" said: "If I had my rights I would be there, too, outshining them all."

Most of the girls in the chorus were Poles and Italians, who had had experience in their own countries, and we got to know a few of them. There were only about six American girls. Very few are taught in this country. They lack the opera traditions, and that makes it more difficult for them. At the same time there are plenty of good girls' voices in America, while male voices are poorer in quality, taking the average.

At the end of the first season I had a repertoire of eighteen operas, and altho I was able to dance again I kept on for another season, because, tho the money received was smaller, my expenses were not so great as when traveling, and the work was not so exacting. I received $15 a week, and it cost me $8 a week to live, $5 for my share of our room and $3 for food and washing.

By the end of the season I had nothing saved, and if I had not secured a summer engagement in Manhattan Beach it might have gone hard with me.

"Queenie" went with me, and there as usual she fell in love with one who she confided to me was the "noblest being on whom the sun ever shone." He was a good-looking American Hebrew, almost as nervous as "Queenie" herself. I had to give up my share of "Queenie's" room when she was married, but she insisted that I take the adjoining room, which I did, sharing it with a Western girl named Campbell, who had joined the chorus.

"Queenie" and her husband were certainly lively neighbors, for when she felt that her nerves demanded it she would fill herself up with paper and clay and slate pencils and things from the drug store and then have a desperate fit of remorse for her past, confessing to her husband some of her marriages, elopements and crimes. He would howl, bury his face in the lounge and tear out his long, curly, carefully oiled hair by handfuls. Then she would kneel by his side and wildly call upon him to forgive her.

"Maurice! Maurice!" she would cry, "speak to me! Ah, my God, he is dead! No, no, it cannot be. His heart is beating. Speak to me! In mercy speak! See, I kneel to you. Oh, forgive me! Guilty as I am my love is all yours. I could not bear to deceive you. I felt that I must tell you all. Oh, forgive me!"

Maurice would kick and squeal upon the lounge in dreadful agony for a long time and would then gradually become calm and raising his head inquire:

"Have you told all, all?"

And Queenie would respond: "All, all, Maurice. You know the worst. How could I deceive you."

"Then I forgive you," Maurice would say, and the curtain would fall with the sun shining and the birds singing.

But two or three nights later "Queenie" would confess a lot more marriages and crimes, and poor Maurice's agony would begin all over again.

Once Miss Campbell blew red pepper thru the keyhole while "Queenie" and her husband were in the middle of one of their scenes and totally spoiled all the pathos. "Queenie" raged about the house with a revolver and a sword, looking for the miscreant.

She and Maurice only lived together for about six months, but he had more experiences in that time than he would have had in sixty years with another wife.

Generally we had little to do with the other girls of the chorus, but once we accepted an invitation from an Italian girl to go to a

party at her house. It was a birthday party, and took place in an Italian tenement, up five flights of stairs. Eight Italian chorus girls lived in a room that was about twelve feet square, and seemed to think it ample. Every other room in the old building was quite as crowded, and when the party was over I understood how it was that the foreign-born chorus girls were able to send money to their people in the old countries.

After two seasons with the opera I went to musical comedy, singing and dancing and having little parts. But next season I will bid musical comedy good-by and devote myself to the drama. I have a good offer of engagement for next season.

Taken on the whole, I have had a very good time in the chorus. I have been on the stage to my heart's content. I have been in every large city in the Union, playing. I have been received in good society, especially in Boston, and have made many valuable friends.

Nevertheless, the life is a hard one, and if ever I have a daughter I won't allow her to go within a thousand miles of the stage if I can help it. The life is so hard that, healthy as I was when I began six years ago, my constitution is now much weakened. I have had diphtheria and scarlet fever, and that may account for some of my trouble; but at any rate I am in a highly nervous state, and have had to rest for two weeks lately, for fear of complete breakdown.

Few people think what a hard time the chorus girls have in pursuit of their profession. At country hotels the clerks have fits if we ask for single rooms. They say: "We can't give a room to one person. Can't you double up?" And they try to crowd four of us into a room. Some of the country theaters are like barns. On account of our light clothing we are exposed to great danger from draughts. Then there is no such thing as proper accommodation for the player outside of the great cities, and of course the chorus gets the worst of whatever is going. Not that the stars are mean to the girls—far from it. So far as my experience goes, they are uniformly kind and considerate, and the impression that they are snubby has no good foundation.

But of course it is only in accordance with common sense that the people with the most important parts should have the best accommodations, and so, when we go to such a place as the old theater in Annapolis, Md., the chorus girls are jammed twelve in a room to dress, with not a chair to sit on, not a mirror in the

place, no nails or pegs for our street clothing, and the water coming thru roof and walls.

I suppose that $18 a week looks good to many working girls, but after all it does not amount to as much relatively as the $8 a week that the salesgirl gets; because, for one thing, it is not steady, year in and year out, and, for another thing, the chorus girl's life is naturally an expensive one.

She lives in a show, and she must make a show herself if she is to keep up with the procession. The girl who does not dress expensively might just as well give up the business. If she is not finely gowned she may haunt the managers' offices day after day in vain, for she will get no engagement; but if she has a fine dress, everybody in the place is immediately deferential, and she is treated to the best the manager can produce.

The street dress has no possible connection with the girl's appearance on the stage, as she wears what is provided by the management; yet a girl can get a good situation thru the grace of a fine dress, tho she may not be able to sing, dance or do anything else well, while a girl with real talent and a poor dress will be turned away. Of course, a beauty is snapped up immediately, even if she is stupid and can do nothing more than stand still. Plain girls, on the other hand, are all turned down, no matter what they can do.

So, whether we like it or not, we must dress expensively. Then, again, our board is expensive. We are traveling about so much that we cannot settle down and find a boarding house to suit us. And so we have to stop at hotels, and of course they all fleece us. Then the whole atmosphere about us suggests spending money freely. Money comes in so easily that it naturally flows out with equal ease. We are thrown into the company of people who are spending a good deal, and we ourselves like to be good fellows. As I have said, when I first began in the business I earned $18 a week, and spent three times as much, which, as any financier knows, is simply ruination. I am now making a great deal more than $18 a week, and, tho I manufacture all my own dresses and hats, and am looked upon by my friends as a marvel of economy, I find it extremely hard work to keep out of debt.

Then, again, we don't get a cent except when we are actually playing. We receive no pay for rehearsals, and the rehearsals sometimes take up as long a period as ten weeks, during all of which time the ladies of the chorus must eat, sleep and wear clothes.

So it isn't always blue sky and sunshine in the country of Miss Tottie Footlights, however Miss Tottie may smile at those who come to see her in her professional capacity. To tell the honest truth, Miss Tottie is a very much misunderstood young lady. In proportion there are just as many good girls in the chorus business as are to be found in any other profession. Some chorus girls are very religious. One with whom I roomed for a considerable time used regularly to get up at five o'clock in the morning to go to mass, and she was by no means a great exception. I think that a large part of the "wicked chorus girl" tradition is to be credited to low class illustrated newspapers, which select chorus girls as heroines of mythical adventures, because those girls are to a certain extent public characters, and because the clothing which they wear on the stage lends itself to the peculiar pictures which such papers find attract their patrons.

A little while ago I was invited to a supper in Boston. I have said that I am frequently invited out into society, and that is one of the pleasant privileges of stage life. I was the only actress present at this party of which I speak, and I was very considerably surprised when, after supper was over, cigarets were passed around and the ladies all smoked. They were greatly astonished to discover that I did not smoke, and still more astonished when I told them that I had never smoked a cigaret in all my life, and knew very few chorus girls who did smoke. Some people imagine that where the stage and society meet, society runs quite a little danger of being corrupted, but my own experience seems to indicate that the boot is quite likely to be on the other foot.

I have spoken about the hard times which the chorus girls frequently experience, her exposure to evil sanitary conditions, and the long period when she is earning no salary at all. Also the spendthrift atmosphere and compulsory wearing of expensive clothing. All of which help to make the life hard and profitless. But there is another sort of thing that provides a very strong reason why I will never let my daughter go upon the stage, provided I ever have a daughter. The girls are often exposed to great temptation. In some instances rich men who have much to lose will set their hearts upon capturing a certain girl, and will pursue her with the utmost boldness and persistence. It can hardly be possible but that sometimes this sort of thing produces tragedy; yet concerning these chorus girl tragedies, which I suppose do happen, I know nothing at all. On

the other hand, I have seen some comedies. A girl who had been steadily pursued by a wealthy young man at last agreed to meet him at Rector's, each of them bringing a friend.

On the evening in question the girls met the men, and found a most elaborate banquet provided and a band of musicians. The young gentleman who was striving to uplift the stage had not spared expense. Immediately after greetings the girls said they must withdraw for a moment to telephone.

They went and never returned, and I don't know what the young men did.

One evening a few weeks ago I observed a young man in the front row orchestra seats staring at me in a most lugubrious manner. After that he appeared each night and stared with more and more mournful reproach, and at last I got a letter from him. He wrote that I was his ideal, and that he wanted me to love him, and, of course, asked for an interview. He said that he was seventeen years of age and wealthy. I was tempted to ask him to consult his mother. And he was only a little more absurd than the usual "Johnnie."

I have not said anything about the chorus girl's troubles with her stage clothes. The green girl has an awful time at first playing Amazon or sailor or wearing tights; she is as clumsy in a boy's clothes as a boy would be in her clothes, and as uncomfortable. The drills, too, are no play. Plenty of girls whose parents are comparatively well off come on the stage, attracted by the glitter of the life, but they soon depart again, glad to get back to their homes. Many a time I've been sorry that I ran away from home, but my father never forgave me and probably never will.

New York City.

25. AUTOBIOGRAPHY OF

A FOOTBALL PLAYER

[Every year at the end of the season the football crit-
ics select the eleven supposedly best players from the
colleges of the country to form what they call "The All
American Team." Theoretically these players are
chosen from any of the colleges in the land, but as a
matter of fact Harvard, Yale and Princeton generally
make up nearly the entire list. The following article
was given in an interview for *The Independent* by a
member of last season's "All American Team"—the
unqualified choice of all the critics.—Editor.]

WHEN I WAS a boy of ten or twelve years I began to play football.
I played in a small yard with other small boys, and tho we were
ignorant of rules and deficient in science we knew something
of football traditions, and, clad in sweaters and wearing impro-
vised armor, we ran about the arena or wallowed on the sod
most bravely.

Soon after I was twelve years old I was sent to a small academy in
Massachusetts, where they had a team composed of the larger boys
who played against other teams of similar schools. It was a good team
as far as it went, and had the respect of us small boys, who carried
water for the struggling heroes; but it didn't live up to the extreme
rigor of the game. It omitted practice on account of rain, there was
no strict training, and no one cared very much whether the school
won or lost. In fact, at this school football was treated as an ordinary
amusement instead of being made an end in life. If a fellow made a

bad play the thought of it did not torture him so that he would want to go and die. Football here was classed with golf and tennis.

We small boys admired the members of the football team in this school, but we felt that they were of our own clay and human. Not so was our attitude toward the members of the teams of the great colleges to which we were going. In our imaginations those giant figures seen afar off loomed as demi-gods; we never for a moment doubted that Beecher, the Traffords, the Poes, and their like were superhuman. This feeling lasted till we actually reached college and came in contact with our heroes. Sometimes it lasted even longer.

After I had attended the little school for two years I was sent to one of the great preparatory schools, where they had a splendid football team which played matches with the best schools of the vicinity, sometimes going as far as fifty miles for a match. During my first year I only played on the second eleven, yet they carried me around as a substitute, so that I had all the fun and excitement of the matches without the anxiety of the actual player.

Next season, however, I was put on the big team, and I shall never forget what happened to me the day after I played my first game. It was at once apparent to me that I had become a different man in the estimation of my schoolmates. I was pointed out as I walked across the yard, and was even cheered as I entered the class room. I began to taste the intoxication of fame. I soon found that practicing with such a team that makes work of sport was very different from anything I had experienced on the academy team. The sense of responsibility was oppressive, and I knew what it was to lie awake worrying over my own deficiencies and those of the team, in which the honor of the school was involved.

Besides, life during the training season was slavery. It was work from morning till night, and the restrictions were very annoying. All our afternoons were given over to field practice, and all our evenings to running through signals, tackling the dummy, and so forth, on the floor of the gymnasium.

In addition to this we had to keep up with our studies and attend recitations in the mornings, so that as we were obliged to go to bed at ten o'clock there was hardly a minute of the entire day that we could call our own.

Membership in that school team was a great honor, but it had its drawbacks.

People of no football experience regard the matches as the hard features of the players' season, but that is a mistake.

I was never hurt in any of the matches in which I participated while at this school. That is to say, I received no injury that laid me up. I got bumped at times, and was sore in places for a day, and once I received a muscle bruise that kept me from play for two days, but such things don't count. I never wore a nose guard in any of these matches.

The school teams that we played against were all decent and fair; there was no foul play, but a fair struggle of the men on their physical merits, with "May the best men win" the prevailing sentiment.

Football, under any circumstances, is a fierce game, and no matter how fair players are injuries are liable to come. Every man who plays at the colleges and big schools loses five or six days out of a season on account of petty injuries, and by the end of the season two or three men out of the thirty who comprise the team and its supports are pretty well "bunged up," but tho I have been following football for many years there never was a man permanently injured while playing on any of the teams of which I was a member. The worst that ever happened to any of my comrades was a strained knee, putting him out for a seasons. But football is above all a game of personal encounter, and as long as this is the case—and it would not be football without it— there will always be more or less physical danger connected with the sport.

From the large school of which I have spoken I then went to college, which I reached at the age of eighteen. I was a big, husky, heavy limbed fellow, one of several hundred freshmen. I was not entirely a stranger, because my fame had preceded me from the preparatory school, and some of the boys of the school I had just been attending came on with me. I might parenthetically add, however, that several of the smaller colleges had already asked me to come to them, and offered me all kinds of inducements except money.

A few days after arriving at the college the newspaper of the institution invited all freshmen who desired to try for places on the football team to present themselves to be tried out. I was one of about a hundred freshmen who answered this call for candidates.

We went to a part of the football field and there were taken in hand by two coaches appointed by the captain of the 'Varsity team. These coaches were experienced men. They took in our points very fast; in fact, could tell a good deal about us by our general appearance. They are generally graduates working for love of their alma mater.

The first day we practiced falling on the ball, the coach dribbling the ball along the ground and calling on a man to show how well he could fall on it. The coach superintended the operation very closely, rebuking any lapses of art, speed or vigor, and showing the correct style—for the coach is always one who in his day has been a "crack."

Falling on the ball may, to the outsider, seem a very simple thing, but it is not quite so easy as it looks. There is art in learning how to fall without hurting one's self. It has to be done quickly under exciting circumstances, and the clutch on the ball has to be sure. Some men never can learn how to fall on the ball, just as some men never can learn how to dive.

After a day or two of drill in falling on the ball we were set to tackling the dummy. The dummy is a suspended stuffed figure of the size, weight and shape of a man. The player rushes at it, seizes it and throws it down, just as if it was a running opponent. This is about as good practice as tackling a real man; and, of course, tackling a real man is hard on the man tackled, as he gets heavy falls. So the dummy suffers in his stead.

After four or five days of this preliminary work the coaches had come to some conclusions about the men as material, and having picked out a freshman team began making us run through signals.

These signals are given by the quarterback, calling out numbers like 7-14-12, 3-11-9, etc. The variety of these signal systems is infinite. They are arbitrary, and the secret of them is known only to the coaches and the players. At the call of, say, 9-8-4, the play which that represents is made, and by making it often thus in practice the men engaged in the movement reach a certainty and swiftness and massed strength that cannot be obtained in any other way, and are very effective against an enemy who does not understand what is coming. Of course, in this preliminary work there was no opposition to the execution of our maneuvers, and this made it much easier for us.

In the fullness of time I got a place on the freshman team, tho I had not as yet shown any football genius.

I had never been really ambitious, but rather a humble minded follower of football; in my wildest dreams it never had dawned on me that I might one day be selected to play on the 'Varsity. In my eyes the 'Varsity men were still superhuman, and I was awestricken in their presence. I did not for a moment imagine that I could withstand one of these heroes.

This spirit gave me a setback that might have had serious effects on my future, for one day I was called upon to go in as a substitute, and match my force against that of the great ones. I was afraid to try my best, for fear of breaking some rule and angering them. Practically I let them do as they liked with me, because I thought that with all their great experience they must know what was right. The consequence was that never again during that season was I called in to play with the 'Varsity, and for a long time I never knew the reason.

Meanwhile, I took part in the matches of the freshmen. As long as we played against other colleges all was well, but one time our opponents were members of the Young Men's Christian Association, and then we found a great change.

Our match with these young men took place in a Connecticut city of about 10,000 inhabitants that was fairly bursting with local pride or vanity.

We had traveled far to play the match, and we were very kindly treated by our opponents and their friends at the Young Men's Christian Association building before the play began. They seemed very pleasant, decent fellows.

But on the football field a marked alteration was seen. The people were bitterly hostile to us. They wanted to see the local men win, no matter how, and leading them on was the Mayor and all the city officials. The players participated in this spirit, and we soon found that we were in the hands of the Philistines. Both referee and umpire were local men, and while keen to catch us violating rules so as to put us off the field, they allowed their own players to commit all sorts of rule violations. It was a very nasty experience for us. The young Christians standing opposite us assailed us with foul names, tempting us to strike them, so that we could be ruled out. They slugged, they kicked and committed all sorts of fouls, and finally wound up by seizing the ball which we

had fairly gained on a touchdown, running with it, and making a touchdown themselves.

We protested: but the crowd was howling for our blood, and the referee ruled against us. A little later time was called, and we were declared defeated. As soon as we returned to the Young Men's Christian Association building our opponents were as sweet as ever.

In the following spring I went out for spring practice.

During the succeeding fall I received from the captain of the 'Varsity a circular note, asking me to get back to college early so as to try for the 'Varsity team. I knew that I was one of many to receive such invitations, and I had little hope of success. Still I turned up at the appointed time, and spent a week getting toughened by falling on the ball, tackling the dummy, etc.

One of the coaches gave me a tip to the effect that the coaches generally were prejudiced against me, because it was thought that I had made a "sandless exhibition" at the time when I was called into play in the 'Varsity field. This was hint enough, and I could see where I had made a mistake. Luckily when I had an opportunity to redeem myself I was lined up against a 'Varsity man, who was not an overstrong player, and when I found that I could hold him even, it gave me a great deal of confidence.

I soon found that I had to play hard, and I did play hard. A man can't stop to be polite in football.

The coaches were very different in their methods. Some were great drivers, whipping the men with their tongues, and dispensing opprobrium that is as brutal as it is, to nineteen men out of twenty, ineffectual—for instance, telling a player that he was "quitting;" others were quiet and civil, never abusing the men, but trying to make them use their wits to play a "heady" game. Some told us how to evade the rules; how, for instance, to hold a man unseen by the umpire.

I don't think there is much foul play in the big games now. I know that, fine as my opportunities were, I saw little of it. Of course, there is rough tackling, and men are thrown heavily, but that is allowed by the rules. There used to be a trick by means of which when one of the backs was kicking for goal, three or four of the opponents made a dash through the line and threw him heavily. The result of that was to make him nervous. Next time he went to kick at goal he would be thinking more of the men who were to

fall on him than of the drop kick he was to make. It was a good trick, but the new rules have wiped it out.

After the usual preliminaries I was, much to my surprise, actually appointed to a place on the 'Varsity team. Then the serious business of life began. I had to go to the training table, and came under the despotic authority of the manager of that institution.

All smoking and drinking had to be given up, except such drinking as might be prescribed by the manager, an old and most experienced coach, who watched us with the utmost vigilance and austerity. Most of the men were cut entirely off from ales, wines, beers and alcoholic liquors, but there were exceptions. Some were advised to drink ale for their appetites, and in my case they gave me whiskey in ginger ale. Once in a great while some player is given champagne. Of course, no one is forced to drink against his principles.

The food is plain, but of the very best; beef is the staple, and steaks and chops in great demand. We could have pretty nearly anything we wanted with the exception of pastry. We were allowed tea and coffee. Toast took the place of break, and we had fruit to any extent.

But we were under orders all the time, and we could not eat as much as we wanted for lunch. We could eat heartily as we liked at breakfast and dinner, but for lunch we were on short allowance, as the struggle in the football field could not be entered upon just after we had eaten heartily.

Saturday nights this rigor slackened off, as we had all day Sunday in which to recover any tone lost by feasting, so we were allowed to have a regular table d'hote dinner, beginning with oysters and ending with ice cream.

The 'Varsity games are on an ascending scale. Our first trials each season are against teams from the smaller colleges, which, we think, we can easily defeat. At this period the team is not yet determined upon. Some of the men have only been chosen tentatively, and may be removed for cause seen by the captain without the benefit of any civil service rules. As the season advances the games grow harder and harder, and the team solidifies.

Yet the games which I felt to be most severe have been those which came earliest in the season, before I became toughened and while the weather was still hot. By the time that the real big games arrived we were all in such condition that we were never

out of wind, and at the game's end could have gone on playing about as well as ever.

In practice and in all the early games we wore protective armor and nose guards, but we stripped for the big battles, being contented to risk a broken nose and a few injuries if we could increase our speed. We took much of the padding out of our trousers and wore lighter shoes.

I was in all the big games of two seasons, and had all the ordinary experiences of a man in such position, and what I found hardest of all was not playing, but waiting.

There comes now and then a moment when the other side has the ball on the thirty-yard line, and is kicking at your goal, and by the rules you have to wait in crouching expectancy for the ball to be put in play. If your opponent takes his time it is misery—supreme, helpless misery.

The qualities of a football player vary with the position to which he is assigned. The center and two guards should each weigh about 200 pounds or more. They should be six footers, broad shouldered and deep chested. What is required is that they shall be strong, so that they can push hard, and will have the weight to back it. The center should be cool and good at guessing what the other side are about to do. The tackles and ends should be selected chiefly for speed and tackling ability.

For a quarterback the essentials are speed and quickness of mind and body. He must be able to run fast and to dodge well. Of course, he must have courage, be able to tackle effectively, and have all the qualities of a general perceiving the weakest spot in the enemy's line, and taking advantage of any mistakes made by his opponents. The quarterback should weigh about 150 pounds.

For fullbacks the coaches get the heaviest men possible without sacrificing speed. They generally weigh from 170 to 180 pounds. The halfbacks are lighter.

Football has not hurt me, and I doubt if it has hurt the colleges. It is a strenuous and most engrossing game, and when the season is on the men of the team are quite likely to have so much on their minds that their studies do not get the attention they would ordinarily receive. The body is so tired and the nerves so prostrated that it is generally a physical impossibility to turn one's faculties to study between the practice hour and bedtime. But, on the other hand, the football season is short, and the game

and its traditions are vigorous and healthy. Football tends to keep men from other evils, which might include smoking, drinking, gambling and dissipation.

Before closing it may be interesting to note some of the side incidents of football, such as being interviewed by reporters, invitation to make speeches at Young Men's Christian Associations and public dinners, and feminine adulation, which frequently takes the form of letters written by unknown sentimental young ladies, and general all around college idolatry. But, after all is said, I freely acknowledge that football, as now played, is no longer a recreation. It cannot be played for the pure fun of playing. The game is too hard, and we players are always thankful when the umpire blows his last whistle at the end of the season. But our sacrifices are worth all they cost, for we have fame and the emoluments of fame. And is not fame, when it is honorable and deserved, considered by all men one of the greatest prizes in life?

26. THE CONFESSIONS OF
A WOMAN PROFESSOR

I HAVE SOMETIMES wondered how my destiny would have shaped itself if the first-born of my parents had been a boy. If I had been just his little sister, instead of falling heir to the ambitions that would legitimately have been centered upon an eldest son, should I now be fulfilling the womanly mission approved by the Emperor of Germany, the President of the United States and sundry others in authority instead of belonging to that class variously and elegantly described in contemporary literature as composed of creatures who "smoke, swear, tan hides and write theses," and "have about ten to one less chance of being married than a Digger Indian"?

When I recall my infantile years, I seem to note considerable evidences of innate femininity. I was notoriously vain of my ruffles; I played with dolls until I was fifteen—and I'd like to do

it yet! Perhaps the most startling revelation with which I could open these "Confessions" would be to set forth in naked truth the emotions inspired in me by the toy shop windows at Christmas time. But somehow the consciousness of a responsibility to fill the place of that non-existent big brother pervaded all my atmosphere, and so it is not strange that I early began to make fame the leading feature of the romances which I wove for my dolls. My favorite doll (who always represented myself) was successively female suffrage lecturer (at the age of eight I knew one of whom I was much enamoured), authoress and distinguished actress, until, being at fourteen permitted to teach a lower class in the academy where I was a pupil, I found a new *rôle* for her, and it was as college professor that she regularly appeared until the near prospect of freshman dignity made me reluctantly admit that I was "too old for dolls."

I have ventured these childhood reminiscences because they bear upon a point which I think explains much in the attitude of my maturer mind; it is that I could not then, and I cannot now, see any necessary incompatibility between dolls and quadratic equations. In other words, it has never been quite comprehensible to me why the professional woman should be supposed to be a freak; why, in short, to be a student should involve the sacrifice of those gentler affections and interests which are called womanly.

Of course, it may be that in this I am not a fair type of the woman professor. As I am conscious that a somewhat peculiar environment has made my professional experiences in many respects unique, so it is possible that subjectively as well as objectively I have been too little typical fairly to represent my sisterhood. Except for a short period just after my graduation during which I served as instructor in a co-educational college, my entire pedagogic experience has been in a section where the idea that a young woman may take up a profession voluntarily and *as a permanent thing* has been slowest to gain a foothold. The woman who teaches in public schools or takes private pupils has, of course, long ceased to be a novelty, and is as easily explainable to the public mind as the stenographer or the dressmaker, and upon the same hypothesis. They are all to be lumped together as the class of women who are working for their living because they have no one else to support them, and this is a reason too convincing for any one to fail to understand. But the woman who has cared to devote that time and

labor to study which the holding of a college professorship pre-supposes encounters much the same sentiment which in more "advanced" parts of the world meets the woman lawyer or minister and still in many instances the woman physician.

When lately a man said to me that I was a sort of Dr. Jekyll and Mr. Hyde to him, my "womanly" qualities standing for the former and my professorial ones for the latter, he, being himself too scholarly to be intimidated by even a high degree of feminine erudition, was, of course, only joking; but I seem to find that what he said to tease me represents a solemn conviction with the large majority of the people by whom I am surrounded. I could not begin to enumerate the instances in which people have con-fessed to me their surprise at finding me a person who spoke the language of humanity and evinced a vigorous and intelligent interest in the fashions. About the close of my first year in my present position a man confided to me that he was thankful that when we first met he had no idea what I was, because if he had he would have taken to his heels the moment our introduction was over. And as illustrating another side of the same thing, it may not be amiss to quote the remark of a lady of the "old school" before whom I had been airing, somewhat recklessly, I fear, cer-tain of my views as to woman's sphere. When I paused she exclaimed in tearful tones, "Oh! Miss _____, do you *really* believe such things? And you *look* so sweet and modest!" It was the first revelation of me to myself in the character of a whited sepulcher. Closely associated with this notion that the so-called "intellectual woman" is somehow abnormal is the peculiarly prevalent fallacy that between her and men's society there is a great gulf fixed. One could wish that the discussion of the professional woman did not keep the matrimonial question quite so steadily to the fore. It seems indelicate, not to say vulgar, to drag into print what the most of us are actually old fashioned enough to believe to be our own individual business and not that of gentlemen with the-ories about the state of the census reports. But since it is a sub-ject much discussed now by people apparently sane, perhaps it may not be wholly undignified to deliver some utterances upon what appears to have become a matter of public concern. After all, it is probably one of the subjects which properly differentiate the confessions of the woman professor from those of the man; for it is not in our class rooms or in cases of scholastic discipline,

I fancy, that we encounter the experiences which called for the insertion of a sex adjective in the heading of this paper. Will it be too much for human credulity if I assert that the woman professor does have love affairs? Altho not a statement which can be proved by statistics, I am prepared to stake much upon the universality of its truth. I would add that some of the peculiar features of her social position and of her usual views of life tend to complicate the matrimonial problem as it is presented to her to solve. Now I am not going to take the public into my confidence concerning the details of my *affaires-de-coeur*, because I bow to a general sentiment which restricts ingenuous frankness upon this tender subject to married ladies and *débutantes* alone, but I *will* say that more than one suitor and I have split upon such rocks as whether in furnishing our home his income (it always seems to be "his") would more properly be expended upon the purchase of a piano or a sewing machine. To descend from metaphor (tho I hope this one is not obscure) and to speak seriously, altho I know what bad taste it is to be serious, even anonymously, I have not found that ready masculine comprehension which I could have wished of my very deep-seated, and as I think legitimate, feeling that it would be an unspeakable sacrifice to exchange the work to which my best efforts and dearest ambitions have been given for a life of pure domesticity merely for the considerably overestimated boon of being supported, no matter how well.

The male attitude of mind I have found to vary from a mild objection to my ideas of professional life for a married woman as "impracticable" to a fierce jealousy which refuses to tolerate the suggestion that a woman may possibly love at once her profession and her husband.

But save for these episodes which ruffle our philosophic calm, I think we may justly pronounce our relations with mankind peculiarly enviable, for we have substituted for that hoary humbug ycleped "platonic affection" a good fellowship based upon the many interests which we share with intelligent men, interests in which marrying and giving in marriage are not elements at all.

To those gentlemen who are at present disquieting themselves over the momentous question why the higher educated woman will not marry, perhaps the foregoing may offer a hint. May it not be because when her relations with all men are so agreeable she

hesitates to exchange them for the highly problematical delights of a relation with one? Being the superficial sex, we naturally value more highly the bird in hand of congenial interest than the two of a conjugal felicity which is very much in the bush.

Personally, I have found that if my professional life can at all be said to have caused me deprivations socially, it has been in my friendships with women. This I take to be due to the fact that my feminine environment consists so largely of women whose supreme concern is their children's whooping cough or their own raiment (vital matters, no doubt, but hardly to the exclusion of all others) and of my own pupils. While from one point of view there is nothing which makes my life seem more worth while than my friendship with my girls, it is still inevitably a one-sided affair. You listen to your pupil's heart secrets, but you never tell her yours. The pedestal upon which she has mentally placed you lifts your joys and sorrows above the level of her ear, and she thinks, as I used to think of my father and mother, that of course it is easy for you to be good. The teacher who is the object of what is termed in the language of the schools "a crush," simply has an altar erected to her upon which worshipful sacrifice is made. I am no less sensible of the delights of incense which takes shape in violets, matinée tickets and Huyler's chocolates than any other mortal who has been thus deified, and yet there are many times when I would fain exchange it all for one commonplace, comfortable friendship.

I sometimes incline to the belief that the craving to escape this splendid isolation is partly responsible for what troubles one woman professor more than almost any phenomenon of her experience. The very horror of being stigmatized as a person whose conversation smacks of text-books tends to a distinct effort always to talk down to the level of our every-day social circle, and it is almost inevitable that the price of this assiduous cultivation of the art of small talk should be a diminution of the ability to rise to higher planes even when we would. At least in my more pessimistic moments I am almost persuaded that this is why our opinions seem to count for little, and our public utterances are commonly branded as "a woman's view." Personally, it may be due to a lack of pounds and inches (to say nothing of some other qualities not physical) that I am frequently made to feel that I have never progressed much beyond the original point of being regarded only as a rather studious girl; but since some of our distinguished

educators have described as mere child's play the work even of women who are indubitably serious (and tall), I may suppose that I am not alone in this somewhat humiliating experience.

Sometimes, of course, the thing is brought home to me by episodes too funny to hurt much. A few years ago, at an educational meeting, there came up for discussion a subject to which I was known to have given special attention, and I was appointed with two men as a committee to prepare a report upon it for the next meeting. The president later said to me somewhat apologetically that he did not appoint me chairman of the committee because he thought it might be embarrassing for me to arrange for meetings with two men. That would not have occurred to me, I confess, since it was purely a business matter, but chairmanship of committees being one mark of greatness for which I do not sigh, I very contentedly set myself to preparing a few suggestions to be offered when a meeting was called. It never was.

At the next meeting of the association, our report being called for, the chairman arose, and after some cleaving of throat stated that it had never seemed possible for all the committee to get together, but he had prepared a few points which he would offer to the meeting. The "points" proved too elusive even to be discussed, and the matter was dropped. I am still wondering what made it impossible for the committee to "get together." Another incident occurred with a woman, who was manifestly staggered by the discovery that I was not teaching preparatory work.

"But," she said, "I thought *those* things were taught by the *professors.*"

Upon my modest intimation that I was a professor myself, she exclaimed, "Oh, yes! but I mean a man."

This person, one of the widows who have "seen better days," and a would-be teacher, later applied for private instruction to "that girl," about whom, if I may believe what I heard, she had expressed opinions with considerable freedom. When I stated my price, a modest one, as I thought, she said:

"Oh! I don't think any one would expect to pay you that much. Only our best teachers here have ever commanded as high prices as that." These things, of course, only make us laugh, but there are also experiences which produce a different sensation.

As a believer in co-education (tho not employed in a co-educational college) I am hardly inclined to condemn that

application of the co-educational principle by which teachers of both sexes are placed in the faculties of even women's colleges, and yet I suspect that one unfortunate tendency results from it; that the men (whom we cheerfully admit to be the aggressive sex), assume the direction of matters of organization and discipline, while the women are only persons who hear classes recite. Certainly in the institution whose catalog is decorated with my name I have always felt that it is from courtesy alone that an expression of opinion is asked from the women of its faculty, not from any intention of either president or administrators to act upon their suggestions. Even when their advice is undeniably sound its merits are admitted with expressions closely allied to the gratifying encomium which, so far as I can recall, I have heard passed upon about every achievement to which I am able to point—that it is "very good—for a woman."

Among other things, I am frequently told that I receive "a remarkably good salary for a woman." How true that is I have realized on the rare occasions when I have been persuaded to test the ability of teachers' agencies to substantiate their seductive offers of assistance in "bettering my position." One well-known agency at last confessed:

"We have been able to do nothing for you, for, as you yourself know, positions for women with such a salary as you already receive do not grow on every bush."

I do not care to discuss the well-worn subject of a woman's right to the same remuneration for her work as a man, but in connection with the letter from which I have quoted there arises a point which to me is growing increasingly serious. It does not matter to me half so much that the men professors by whose side I am teaching are paid annually several hundred dollars more than I, as that I seem to have reached a limit beyond which I cannot advance. There are generally openings for the five hundred dollar woman teacher and the five thousand dollar man; the ranks of the former are thinned out annually to fit the supply of schools by the marriage of the younger and nervous prostration of the older, while the ranks of the latter are never overcrowded. But the twelve and fifteen hundred dollar teachers, male and female, are all grimly holding on to what they have, each conscious that if he lets that go nothing awaits him in exchange for his safe mediocrity. And should a vacancy occur, the college

which can pay a salary whose first figure is not a one will invariably elect to pay it to a man. I am offering no opinions upon the comparative merits of men and women teachers. I wish only to record that at this stage of my experience I have encountered a very large fact which makes a pet theory of mine—that a woman will be admitted to every position in life which she proves herself able to fill—seem a little less self-evident than I thought it four or five years ago.

If the above may seem to ring with a discouraged note, let me add that I am wont still to cheer myself not only with the orthodox hope of a reward in heaven, but also with the thought of an earthly compensation. For the supreme compensation of the college professor, to my thinking, is that she is not the worker who must steal from some uncongenial task a few poor hours to bestow upon the needs of her higher being, but if she loves her work she develops in and with it, not in the hours when she can get away from it. And I have my seasons of exaltation when I know that this is worth more to me than anything which can be paid me in dollars or applause.

27. THE STORY OF
THE WAITRESS

[The relator of this tale, who insists upon the con-
cealment of her identity, is a slim Irish-American of
more mind than body. She is and has been for some
time working and sacrificing in order to better con-
ditions for herself and her fellows.—Editor.]

I AM ONE of those New York girls who are greatly interested in the
attempt to organize a waitresses' union that will be strong
enough absolutely to improve conditions in the trade. I am espe-
cially interested because of my own experiences as a waitress, for
I know how great the necessity is that the girls should get together
and stand up for their rights, as in many instances at the present
time they are terribly ill treated.

I became a waitress when I was about nineteen years of age, pre-
vious to which time I had been a milliner up in the North. I learned
the millinery business there, but found reason to go from my par-
ents' house to the house of my brother in Massachusetts, and there
I discovered that the milliner's art, as it had been taught to me,
would not at all do for the more critical customers of my new home.
So I had to try a new business, and the best thing I could think of
was waiting.

Accordingly I started in a private boarding house and found myself fairly comfortable. I received $3.50 per week, board and room. The hours were from 6 o'clock to 9, and in addition to the waiting I had to launder all the linen connected with the dining room. After a year and a half of this I went on to Boston and got employment there at $6 per week, working six days a week, nine hours a day. That also was comfortable and fairly well paid when I compare it with conditions as they exist in this city. The room that I had in Boston I paid for at the rate of $1.25 per week, and it was such a room as a girl could not secure here even if she paid $2.50 per week. I got my meals in the restaurant and also had the privilege of doing up my own laundry in the kitchen. I stayed in that place for a year and a quarter and then secured work as a waitress in the Quincey House, where I was one of fifty girls, all in the same business. That also was pleasant; I got $4.50 per week, the hotel did our laundry for us, our rooms were nice, only two girls in a room, and the tips were quite generous. So, take it on the whole, it was a very desirable place.

However, there was something that seemed still more desirable, and so I married and gave up business for five years. My husband started a little restaurant in Boston and things looked quite smiling for a time, and then the clouds blew up and we had storm after storm. My husband fell sick, his partner robbed him, our two children died and we were completely broken up. My doctor advised me to leave Boston, because, he said, that otherwise I would always be melancholy. So then we came to New York—I and my husband. That was about six years ago. For about a year I did nothing, my husband having secured work at a fair salary. At the end of that time I got employment in a well-known white restaurant on East Twenty-third street. They have three schedules of pay there, $5 per week for half time, which means from 10.30 to 3 o'clock; $7.87 for working from 11.30 to 7.30, and $10 a week for what they call the twelve-hour watch. I was one of the $7.87 girls. Take it on the whole, that is one of the best places in the city for a girl to work. They have a system of shops scattered throughout New York and Brooklyn, and the general management seems to desire to be fair to the girls. Nevertheless, there are a number of impositions; for instance we were compelled to buy three white waists at a high price, sometimes 99 cents each, while we ourselves could have bought the materials and made those waists, all three of them, for about 90

cents. Then, again, the laundry bills were heavy and we had to pay them. The waists cost us 45 cents, three aprons cost us 30 cents for laundry, and three sashes cost us 24 cents, so that each week the laundry bill, which we could not avoid, made a noticeable hole in our salaries. Another thing was the charge for breakage. This was fixed by the head waitress, and we never could tell how she made up her mind as to which girl broke which dish. She may have hired a trance medium to tell her, or she may have arrived at conclusions by examining the leaves in her tea-cup after drinking her tea. Certainly she had some extraordinary means of information and the results were exceedingly erratic, and very surprising to the victims. Besides that, an excessive charge was always made for the broken dish; thus a dish which could be bought for 5 cents or 10 cents would be charged at 25 cents or more, and there was no appeal. If a girl lost a check from the slips that are given her in the morning she was fined 10 cents and if a customer stood up before he received his check there was another fine of 25 cents.

So the girls were at the mercy of the head waitress and the cashier. I am certain that the head waitress many times used her power of assigning responsibility for broken dishes in order to secure her little revenges. While all the cashier had to do in order to get even with the girl who had offended was to destroy some of her checks and then declare that they had never been turned in. The girls' protests made no difference. The cashier's word was always taken, and the waitress had to pay for the missing checks. Such things were done.

I was there for two years and then I quit because they charged me for breakage which was not mine. Afterward I found reason to feel sorry for my haste, for, taken on the whole, that was a very much better place than the others into which I have since found my way. The food was good, the girls were pleasantly treated, and were allowed time to sit down during the day; we were allowed to go downstairs and sit down for half an hour. That is a great relief for a girl who has been on her feet for three or four hours. We had fifteen minutes for breakfast and half an hour for lunch, while we took our supper in our own time.

My next place was downtown, long hours and exceedingly heavy work. The pay was $4 for half time, and $7 a week for full time—full time being nominally from 7 to 7 o'clock, but actually beginning at 6.45, because that particular place opens with religious service.

There is a marble floor there, and walking about on that marble floor for twelve hours is tremendously hard on a girl. Besides, we had to carry heavy trays of dishes, and our work in pushing about the bottles and the sugar bowls, etc., was very exhausting. No time was allowed us to sit down and rest, and we only had fifteen minutes in which to take our meals. We were fined for breakage, and all fines imposed in the other restaurant were also imposed here, so that during the six weeks I worked in the place I did not draw one full week's pay. The butter is cut into blocks and a big lump of ice is put on each lump of butter. The electric fans melt the ice fast, and if a girl doesn't watch out, the water from the ice will overflow the plate which receives it. Then there is a fine of 25 cents. I had been getting more and more angry all the time on account of the conditions, and when my envelope came to me on Saturday with the total of 85 cents deducted for fines I refused to submit to it and made a protest to the manager. Usually it wasn't any good talking, and another girl wouldn't have dared to persist, but I could afford to be independent and I intended to leave, so I fought with the manager for an hour, and at last I got my full week's pay and left the place.

After that, for a considerable time, I took a rest, but got very tired of doing nothing. Besides, there is really an attraction about the business, when the place is fairly good. There is a great deal of excitement and one meets and talks to many people. I wouldn't like anything better than waiting if the conditions were all right.

So I went back to work again; this time to a very large restaurant connected with a very large store. There are 150 waiter girls there who get $3 per week for working from 10.30 to 5.30 o'clock. I took the long day and the $4.

The fiction of the managers is that this is a good place for tips, and tradition also declares that this was a good place for tips, but that isn't so now. They used to serve dinner for 39 cents; now it costs 44 cents. When it cost 39 cents a customer would give the girl 50 cents and keep the change. Now, if she gets a tip at all, it's only the odd penny from 44 cents, as the customer feels that she is paying quite enough for her dinner, and so slips the odd nickel in her pocket.

All the fines that I have spoken of are in operation in this place, and about the only good thing that the waiters get there is good air. It's up on the eighth story, and the air is the best that

the locality affords. The food given to the waitresses is unfit for any human being to consume. It consists of all that has been left over after the customers, the cooks, the dishwashers and all others except the waitresses have been served. I have seen things done with that food that made me feel sure that it was something good to leave alone; for instance, I have seen members of the dish-washing aristocracy help themselves from one of the leftover plates, take a bite and throw the food back on the plate, and then I have seen that same food served to the waitresses. Often the food that is thus served up is spoiled and in a condition which makes it actually dangerous to health. A friend of mine regaled herself with deviled lobster, with the result that she had to call in a doctor at 2 o'clock in the morning.

The chef and the manager are responsible for the condition of affairs in regard to the food; the chef, of course, gives what he can, while the manager is a famous economist in such small matters, tho under his régime there has been a notable falling off in sales.

The waitresses have the choice of three alternatives: They can eat what is provided, they can starve or they can steal. Some do one thing, some another. It's pretty hard to go all day long carrying good food, with the savor of it always in your face, and you not to touch any. One girl told me that she stole a sandwich, and her friend commented that she was a fool not to steal a chicken.

The chief owner of the store is a celebrated philanthropist, and we girls do not believe for one moment that he knows how we are being treated.

One day, when I could not eat any meat, I went in the kitchen and asked for French fried potatoes, and the cook took my number, and complained to the manager that boiled potatoes were not good enough for me. The manager promptly took up this case and laid down to me the law of the establishment, which was that never again under any circumstances must I demand French fried potatoes. Even our head waiter, a man, is not allowed any relishes, such as tomato catsup or pickles.

Another grievance which the girls have is in regard to the treatment. They are quite often sworn at. If a girl breaks a dish she is sworn at and fined; if she breaks three dishes she is discharged.

Fines are so numerous that a friend of mine, who worked six days, only received $1.18 at the end of the week, while it had cost her 26 cents a day for carfare.

A year or two ago I would have thought that this place where I now am was the worst possible, but the agitation which has been stirred up by reason of the effort to organize here a strong union of waitresses has shown me that there are others far worse off than I am. One system of restaurants in this city, in addition to working its girls twelve hours a day, deducts $1 a week from their pay for the first seven weeks, and holds that against them, so that if they leave without giving a week's notice they are fined that week's pay. Nevertheless, the management doesn't give the girls a week's notice when it concludes to dispense with their services.

Some of the restaurants where girls are now employed are altogether unfit places for them morally.

The question is sometimes asked, "Why do not we abused waitresses go into domestic service?" Well, the waitresses are a pretty independent body of working girls. They want their evenings and they want their Sundays. They also fear to be put down in a lower class, for the majority of American women do not look upon a working girl as their equal. So far as I am concerned I'd sooner starve than work for some people.

If those who are attempting to organize a strong union can have their way, the waiting business will be put on a sound and respectable basis, with $12 a week as the minimum wage and all tips abolished. The reason that our wages are now so low for such long hours is that we are supposed to receive so much in tips; in many cases this supposition is not borne out by the facts. In any case the tip is a degradation. When I accept a tip I feel that I am not the equal of the person who gives it to me. It's a bad thing. We are hard working, we earn our living, and we would like to be self-respecting.

The union has been going for about three years and has encountered many difficulties. One of these is due to the feeling among girls themselves. A great many of them do not want to be known as waitresses, and they are afraid that if they join the waitresses' union their friends will perhaps gain the impression that they are not stenographers or bookkeepers or school teachers, and so will respect them less. Why, I have seen girls who would much prefer to have people believe that they were salesladies rather than waitresses, but that seems to me a very stupid thing, because certainly the waitress, with the large territory to cover between the tables and the kitchen, and the fifteen or twenty possibilities of

fines to be avoided constantly in her mind, is a person of much more personal responsibility than a girl who stands in one place behind a counter and just hands out from a small stock of goods whatever the customer desires.

In the West waitresses' unions are strong, the business is on a high plane, the hard work is fairly paid, and the working women who are engaged in it are self-respecting and respected by all who know them. They are distinctly high class, and so it can be here, if the girls will get together and work.

I believe that there are in the neighborhood of 6,000 girls engaged as waitresses in this city, many of them employed under most miserable conditions, which exist in violation of the law and defiance of the Board of Health, and which cannot be altered until the girls themselves unite and are willing to support a movement for remedy.

The union here has had bad luck, as the first organizer ran away with the funds, and the second organizer, a young woman, tangled things up in an extraordinary manner, depleted the treasury, let the membership go down, and made default in as great an amount as she could.

However, the girls who are back of the movement are full of pluck; they have a good cause, and are beginning now to make headway. Those whom they are getting into the union are the best girls in the city. They maintain a death benefit fund now, and they are trying to establish a sick benefit fund, and also to pay off the debts with which they were saddled by the dishonesty of their organizers. They have a hard row to hoe, but are sticking it out and bound to win in the end.

I have spoken of the waitresses as girls, but I believe that the majority are really married women. I know that of 160 who were questioned on the subject, 100 were found to be married, and frequently young-looking waitresses bring their children to the meetings of the union, which take place at the rooms, 220 East Fifth street, on the first and third Thursdays of every month.

New York.

BIBLIOGRAPHY

1. Original Places of Publication and References to Related Items

THE LIFE STORY OF A LITHUANIAN: Antanas Kaztauskis, "From Lithuania to the Chicago Stockyards—An Autobiography," *Independent* 57 (August 4, 1904): 241–48. See also Ernest Poole, *The Bridge: My Own Story* (New York: Macmillan, 1940), p. 95.

THE LIFE STORY OF A POLISH SWEATSHOP GIRL: Sadie Frowne, "The Story of a Sweatshop Girl," *Independent* 54 (September 25, 1902): 2279–82. For a related life story see Rose Schneiderman, "A Cap Maker's Story," *Independent* 58 (April 27, 1905): 935–38, and her autobiography, *All for One* (New York, 1967).

THE LIFE STORY OF AN ITALIAN BOOTBLACK: Rocco Corresca, "The Biography of a Bootblack," *Independent* 54 (December 4, 1902): 2863–67.

THE LIFE STORY OF A GREEK PEDDLER: "Life Story of a Pushcart Peddler," *Independent* 60 (1906): 274–79.

THE LIFE STORY OF A SWEDISH FARMER: Axel Jarlson, "A Swedish Emigrant's Story," *Independent* 55 (January 8, 1903): 88–93.

THE LIFE STORY OF A FRENCH DRESSMAKER: Amelia des Moulins, "The Dressmaker's Life Story," *Independent* 56 (April 28, 1904): 939–46.

THE LIFE STORY OF A GERMAN NURSE GIRL: Agnes M., "The True Life Story of a Nurse Girl," *Independent* 55 (September 24, 1903): 2261–66.

THE LIFE STORY OF AN IRISH COOK: "The Story of an Irish Cook," *Independent* 58 (March 30, 1905): 715–17.

THE LIFE STORY OF A FARMER'S WIFE: "One Farmer's Wife," *Independent* 58 (February 9, 1905): 294–99. For the controversy caused by this lifelet, see "Women on the Farm," *Independent* 58 (March 9, 1905): 549–54.

THE LIFE STORY OF AN ITINERANT MINISTER: "The Story of a Handicapped Life," *Independent* 59 (November 9, 1905): 1104–1108. For his saddening further life story, see "My Superannuation," *Independent* 70 (March 23, 1911): 595–98.

THE LIFE STORY OF A NEGRO PEON: "The New Slavery in the South–An Autobiography by a Georgia Negro Peon," *Independent* 56 (February 25, 1904): 409–14. See also Clifford L. Miller, "A Negro Student's Summer Vacation," *Independent* 56 (June 16, 1904): 1364–69, and "What It Means to Be Colored in the Capital of the United States," *Independent* 62 (January 24, 1907): 181–86.

THE LIFE STORY OF AN INDIAN: Ah-nen-la-de-ni, "An Indian Boy's Story," *Independent* 55 (July 30, 1903): 1780–87. Illustrated.

THE LIFE STORY OF AN IGORROTE CHIEF: Fomoaley Ponci, "Views of an Igorrote Chief," *Independent* 59 (October 5, 1905): 779–85. Illustrated. Further photographs of Igorrotes appear in the *Independent* 70 (June 1, 1911): 1144 and 1147.

THE LIFE STORY OF A SYRIAN: "The Story of a Young Syrian," *Independent* 55 (April 30, 1903): 1001–13. The original headnote makes no mention of the composite character of this life story.

THE LIFE STORY OF A JAPANESE SERVANT: "The Confessions of a Japanese Servant," *Independent* 59 (September 21, 1905): 661–68.

THE LIFE STORY OF A CHINAMAN: Lee Chew, "The Biography of a Chinaman," *Independent* 55 (February 19, 1903): 417–23. Illustrated.

THE LIFE STORY OF A FLORIDA SPONGE FISHERMAN: Carlos Barker, "Fifty Years of a Sponge Fisher's Life," *Independent* 56 (April 21, 1904): 884–91. Illustrated.

THE LIFE OF A HUNGARIAN PEON: *Independent* 63 (September 5, 1907): 557–64. Illustrated. See also *From the Bottom Up: The Life Story of Alexander Irvine* (New York: Doubleday, Page, and Co., 1910), 256–73.

THE LIFE STORY OF A SOUTHERN WHITE WOMAN: "Experiences of the Race Problem by a Southern White Woman," *Independent* 56 (March 17, 1904): 590–94. This and the following chapter were part of a multifaceted reflexion on race that also included "Observations of the Southern Race Feeling by a Northern Woman," *Independent* 56 (March 17, 1904): 594–99, and Fannie Barrier Williams, "A Northern Negro's Autobiography," *Independent* 57 (July 14, 1904): 91–96. The first of the contributions carried the following headnote: "The present article and the two following ones on the negro problem which we print this week are respectively by a Southern colored woman, a Southern white woman, and a Northern white woman now a resident of the South. We know of no women in the whole South better qualified to write on this painful topic from their various standpoints. The articles are especially timely owing to last week's race war in Ohio, and are remarkable for their extraordinary frankness. For reasons that will be evident to the reader and that concern their social if not personal safety, the names of the writers are withheld—EDITOR"

THE LIFE STORY OF A SOUTHERN COLORED WOMAN: "The Race Problem—An Autobiography by a Southern Colored Woman," *Independent* 56 (March 17, 1904): 586–89. The issue of race from women's point of view also appeared in "The Negro Problem: How It Appears to a Southern Colored Woman" and "How It Appears to a Southern White Woman," *Independent* 54 (September 18, 1902): 2221–28.

2. Reviews of the First Edition

Annuals of the American Academy 28 (July 1906): 176.

*"The Transformation of the Alien into the Citizen." *Arena* 36 (September 1906): 320–29.

**Brooklyn Eagle* (August 20, 1906).

**Critic* 49 (July 1906): 92.

Rebecca Harding Davis. "Undistinguished Americans." *The Independent* 60. (April 26, 1906): 962–64.

**Dial* 41 (August 16, 1906): 94.

*Francis Hackett. "The Common People." *Chicago Post* (June 16, 1906).

"Humble Folks." *New York Times* (May 5, 1906): 290.

*E. P. Powell, *Unity* (1906).

*W. I. Thomas, *American Journal of Sociology* 13 (1906): 273–74.

*Included in Hamilton Holt's Scrapbook # 33 at Rollins College Archives

ACKNOWLEDGMENTS

I AM INDEBTED to the pioneering biographical and bibliographical work by the late Warren F. Kuehl, both in his definitive biography *Hamilton Holt: Journalist, Internationalist, Educator* (Gainesville: University of Florida Press, 1960) and in "A Bibliography of the Writings of Hamilton Holt," *Rollins College Bulletin* 54, no. 3 (CMS) (September 1959): 1–32; to Ernest Poole, *The Bridge: My Own Story* (New York: Macmillan, 1940) as well as to Poole's article "Abraham Cahan: Socialist—Journalist— Friend of the Ghetto," *Outlook* 99 (October 28, 1911): 467–78 (CMS); to references in David M. Katzman and William M. Tuttle's *Plain Folk* (Urbana: University of Illinois Press, 1982) with selections from the *Independent*; to the most energetic archival assistance by Professor Kathleen J. Reich and Trudy Laframboise at the Rollins College Archives Department; and to the discussions by colleagues and students at Harvard College, the Ecole Normale Supérieure, the Universität Bern, the Università degli Studi, Rome; finally, I am most grateful to Ellen Ruggles, Cheryl Turner, and Mr. Fittipaldi in the Harvard Extension School program for helping me dig up further materials in the *Independent*.